# URBAN LEGENDS

# URBAN LEGENDS

## THE SOUTH BRONX IN REPRESENTATION AND RUIN

### Peter L'Official

Harvard University Press

*Cambridge, Massachusetts*

*London, England*

2020

First printing

*Library of Congress Cataloging-in-Publication Data*

Names: L'Official, Peter, 1980– author.
Title: Urban legends : the South Bronx in representation and ruin / Peter L'Official.
Description: Cambridge, Massachusetts : Harvard University Press, 2020. | Includes
    bibliographical references and index.
Identifiers: LCCN 2019056425 | ISBN 9780674238077 (cloth)
Subjects: LCSH: Urban folklore—New York (State)—New York. | Bronx (New York,
    N.Y.)—Civilization—20th century. | Bronx (New York, N.Y.)—In art. | Bronx (New York,
    N.Y.)—Social life and customs.
Classification: LCC F128.68.B8 L64 2020 | DDC 974.7/275—dc23
LC record available at https://lccn.loc.gov/2019056425

For Sylvia Quiñones L'Official

# CONTENTS

# URBAN LEGENDS

WHEN LEGEND BECOMES FACT

Patricia Roberts Harris was not the first person to think about the ruins of the South Bronx. However, as secretary of Housing and Urban Development (HUD) for President Jimmy Carter—and the first African American woman to serve in a US cabinet—she was well placed to try to do something about them.

On October 1, 1977, Harris sent Carter a memorandum report in advance of the president's impending trip to New York City, wherein a visit to see the South Bronx had become, by many accounts, a virtual necessity. Earlier proposed schedules of Carter's New York City visit, the main feature of which was for the president to deliver a speech to the United Nations (UN) General Assembly, did not include such a tour. As of mid-August, Carter was meant to give his speech, meet with foreign dignitaries and members of the UN Secretariat, attend a dinner and a breakfast, and return to Washington—a brief, busy two-day stay. Members of Carter's staff, over a flurry of intraoffice memos, intervened to suggest one significant alteration to the president's schedule. Thinking it "unwise" to spend two days in New York "without devoting a half-day" to a public event in the city itself (Carter had already visited New York three times that year to attend various fund-raisers and UN addresses, all events that were closed to the public), staffers noted that the administration had been criticized for not touring the South Bronx or not inspecting the fallout and damage from the infamous 1977 electricity blackout, which had affected much of the city in July.

By late September, after a few false starts and several trial presidential schedules later, a "South Bronx Tour," via motorcade, was devised, and Harris personally visited and vetted each stop on the proposed tour. After all, as the report warned, "To go back a third time," without such a visit, would "generate criticism across the country about insensitivity about

1

inner-city problems." Harris's memo to Carter ahead of his South Bronx visit was intended to prepare him for what he would find there.[1]

That the Carter administration believed that perceived insensitivities to America's "inner-city problems" could be allayed by a presidential visit to the South Bronx suggested one thing: that the South Bronx was imagined as inextricable from "inner-city problems." To the administration and to the public at large, the two were one and the same.

By late 1977, the South Bronx was America's "inner city." Though the problems of the South Bronx were also present in urban centers around the country—poverty, racism, unemployment, building deterioration, and urban disinvestment knew no regional bias—it was the abandoned buildings of New York, and particularly the South Bronx, that came to define and embody, for a time, an iconography of urban ruin in America. What Harris's memo to Carter attempted to provide him was a way not only to understand the metonymic, symbolic resonance of a place synonymous with urban ruin, but also to trace for the president—and now, by virtue of the archive, for us—a line back toward understanding the fact of the South Bronx and any place like it. Harris's report is, as many reflections upon ruin tend to be, quite poetic—surely it ranks among the more lyrical intraoffice memoranda sent through the channels of the federal government. But its lyricism does not lose sight of the historical processes and social and economic forces that made the Bronx as an international symbol of urban decay. Harris's poetics has the force of argument, because she does not merely attempt to define for Carter "the final meaning" of places like the South Bronx. She takes what, to someone else, might appear an innocuous memo as an opportunity to defend the right of people "to have urban life as a real choice—not only the option of the rich or the fate of the poor" with the US president as an audience. As Harris saw it, Carter's visit to the South Bronx could decide not just the fate of the South Bronx but the future of American cities and urban life as we know it.[2]

What Harris saw in the South Bronx was the "end product of a process of decline and decay" that was also taking place in many older American cities. But what set the South Bronx apart, what made it unique, was that, in Harris's estimation, The Bronx was at the final stage of this process. What Harris meant by this was that the South Bronx that became an American and international shorthand for the failures of urbanity was the end result of the interplay of a variety of forces over time: the physical deterioration of inadequate housing and insufficient income to maintain aging properties; a lack of jobs due to a deindustrializing economy;

high population density compounded by the mass migration of African American and Latinx communities searching for vanishing industrial jobs; and a desire on the part of previous administrations to invest in urban disinvestment, precisely at a moment when the commitment of resources was crucial to the survival of urban America. The Nixon administration shut off federal investment in cities and accelerated the decline of areas like the South Bronx. As Harris's report makes clear, the South Bronx didn't just happen overnight.

Nor would it be rebuilt overnight, and Harris's memo to the president is, most broadly, an impassioned appeal for a long-term, national, and federal commitment of resources to achieve "visible results" and thereby preserve the possibility—the very idea—of urbanism. Such an appeal was characteristic of Harris's tenure as secretary at HUD, where she would reshape the focus of the department by pouring millions of dollars into such projects as the renovation and upgrading of apartments in deteriorating neighborhoods, rather than demolishing them through so-called slum clearance.

And yet, like many convincing arguments, Harris's emerges from the subtlest of openings, which disarms as it gently dissembles: "I thought it might be useful to provide you with some background on this area and some thoughts on its meaning as it relates to the Administration's policies and the purpose of your visit." But Harris's argumentative strategy is effective not simply because she displays a light touch with acute existential concerns, but because she recognized that this environment, this setting, this symbolic landscape of the South Bronx, even by the time of her writing, had already attained the quality of myth. That myth was strong enough to serve as the visual emblem of a broader federal initiative to address urban decay in American cities.[3]

And that myth also invites something like a literary analysis. Though I make no claims toward rivaling the economy of argument on offer in Harris's adroit memo—which offers her own perceptive, humane gloss on the Bronx and places like it—this book responds to a similar invitation. It takes the meaning and legacy of that mythology—the urban legends of the Bronx, and their visual and literary manifestations—as its central subject.

In 1977, two scenes—separated by less than two weeks and about two miles, as the crow flies—established the visual and literary discourse by which generations hence would understand the South Bronx and urban America. Each scene captured, in its own way, the relationship between fact, myth, and symbol; each dramatized the dialectic between reality and

representation; and each even offered its own theory of literature—depending on your point of view. The first was Carter's visit. And the second never happened.

The proposed route for the president's South Bronx Tour began on the Grand Concourse, a high-density residential boulevard designed in 1890 by a French immigrant to the Bronx and modeled on the Champs-Elysees. The Concourse was lined with six- to eight-story buildings, many of which were among New York's finest examples of the Art Deco style of the 1930s. An apartment there was a status symbol for many aspiring Jewish families from the Lower East Side of Manhattan after World War I. Carter's staff included the Concourse to demonstrate that its structures remained, for the most part, sound housing stock that could be used as a building block for the restoration of surrounding areas. The presidential motorcade would then turn east on East Tremont Avenue and south on Bathgate Avenue into the Bathgate section of the Bronx, where the "extensive deterioration" of the South Bronx would come clearly into view. Primarily residential and characterized by dilapidated and decayed tenements and garbage-strewn lots, Bathgate would give Carter both a taste of what lay in store on the rest of his brief visit, and a ray of hope: a building at the corner of 168th Street and Washington Avenue that had been redeveloped—with solar energy panels for heating—with government loans and "sweat equity" (a term commonly used to refer to labor contributed by current or future tenants toward the repair or rehabilitation of a building) by the People's Development Corporation, a local group composed of neighborhood residents. Finally, Carter would arrive at the intersection of Boston Road and Charlotte Street, "a vantage point from which can be seen the end result of the process of urban disinvestment and decay." In "every direction," Carter's advance report read, "the view is of abandoned and burned-out apartment buildings and the area is completely dilapidated." Though Carter's itinerary suggested two further locations that would give a more rounded view of the condition of the South Bronx—and of then-flourishing community-organized efforts to rehabilitate its housing just a few blocks away—it would be the views from Charlotte Street that would live on in the collective memory.[4]

As intended, on October 5, 1977, the presidential motorcade made its way from the United Nations Plaza Hotel on Manhattan's East Side to the Bronx. Despite the months of planning on the part of the administration, in concert with officials from the New York City government, the trip was largely a surprise to the public. Six motorcycle escorts with sirens blaring

4

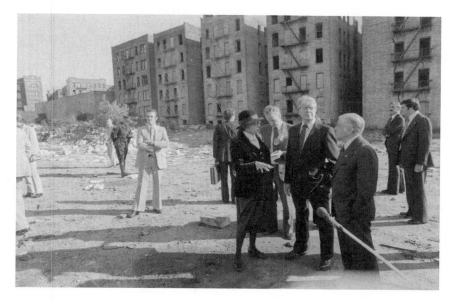

HUD secretary Patricia Harris, President Jimmy Carter, and New York mayor
Abraham Beame tour the South Bronx.
National Archives and Records Administration.

disabused one of any notion that this was a covert enterprise. The term
"photo opportunity" is a Nixon administration coinage, and though Carter
and Secretary Harris surely would have disavowed any such influence, this
was a "photo op" par excellence.[5] The motorcade's fleet of limousines ar-
rived at Charlotte Street's four- to six-block area of vacant lots and aban-
doned buildings, and with police helicopters hovering overhead, and jour-
nalists, photographers, and television cameramen following on the ground,
Carter stepped out onto the street and told his Secret Service agents, "Let
me walk about a block."[6] Accompanied by Harris and New York City's
lame-duck mayor, Abraham Beame, Carter stopped to look at "eight-foot-
high piles of trash and weedy undergrowth," as the group picked its way
through "acres of rubble" and gazed at "burned-out hulks of buildings"—the
remains of what, a little more than a decade before, had been "one of the
most densely populated residential areas of any city in America."[7]

There were once fifty-one apartment buildings on Charlotte Street and its
companion blocks, Wilkins Avenue and East 172nd Street, which contained
more than one thousand apartments housing more than three thousand
people. In the 1920s, Charlotte Street was lined with fine brick apartment

houses, some with elevators, with embossed tin and carved-granite cornices, wrought iron stair rails, and polished brass mailboxes and marble lobbies.

At the time of Carter's visit, only nine buildings stood. As a *New York Times* article describes, six of them had their windows and entrances blocked off with cinder blocks and concrete, and two of them were "fire-blackened hulks."[8] Unconsciously echoing Harris's assessment of the South Bronx in her memo, the *Nation* later described the scene as "the terminal stage of the nation's most deplorable case of inner city decay and abandonment."[9] On the national news that evening, and over images of the president walking through what the *New York Times* described as Charlotte Street's "urban prairie," CBS's Bob Schieffer opined that the Bronx—perhaps unintentionally broadening the scope of the crisis beyond Charlotte Street's few blocks to include the entire borough—was "the worst slum in America."[10]

Two weeks later, and with one out in the bottom of the first inning of the second game of the 1977 World Series between the Dodgers and the hometown Yankees, ABC's broadcast momentarily lost interest in the game and drifted elsewhere. An aerial camera trained its attention on an area beyond the recently renovated stadium's famed arched facade, where an abandoned school building was ablaze. The scene, captured live, was as sobering as it was unexpected in the midst of a baseball game. What happened next was either a testament to the power of the human collective imagination to will its desires into being, or to the twin strains of impishness and hero worship that run deep within sports journalism. Likely it emerged from somewhere in between.

"There it is, ladies and gentlemen, the Bronx is burning." You, like me, can watch the entirety of this game—indeed, the entirety of the 1977 World Series—and never hear announcer Howard Cosell say the words that he is so renowned for saying. No matter how irresistible it sounds to our ears today, no matter how many times the broadcast cuts away from the game to check the progress of the fire, no matter how perfectly it seemed to capture the historical and situational moment, it didn't happen. Neither Cosell nor play-by-play announcer Keith Jackson spoke the words that came to define an era in urban history, though what Cosell *did* reference (erroneously, as per its location) was the fact of Carter's visit just eight days earlier. Cosell's solemn bon mot at the expense of the Bronx, one of the most legendary lines in the history of televised commentary, is, in actuality, exactly that: born of legend, not of fact.

The alliterative phrase dates, rather, to five years earlier, when the BBC aired a documentary called *The Bronx Is Burning* about the borough's arson epidemic. And in March 1977, seven months before the World Series and Carter's visit, PBS broadcast a documentary on the same topic, hosted by Bill Moyers, called, with a nod to James Baldwin, *The Fire Next Door.* By the time ABC's cameras cut from the World Series to that Bronx fire, a visual, even cinematic, template for the scene already existed in the minds of viewers. Images of the Bronx as a burning borough had already been singed onto the public retina. Both documentaries, as well as the indelible images of Carter standing on Charlotte Street, taken just days earlier, are part of this visual script, and Cosell's quote, its signature and wholly imagined literary line. In the annals of memory, infamy, and mythology regarding the South Bronx of the 1970s and 1980s, what was, and what was willed into being were often—as Cosell's phantom quote illustrates—indistinguishable.

Near the end of John Ford's 1962 film *The Man Who Shot Liberty Valance,* the audience learns that Jimmy Stewart's "Senator Ransom Stoddard" has built virtually his entire reputation on the myth that he killed an outlaw named Liberty Valance. At this revelation, the reporter interviewing Stewart's Senator Stoddard rips up his story notes, thereby ensuring Stoddard's legend lives on, and says, "This is the West, sir. When the legend becomes fact, print the legend." When Cosell's legendary "the Bronx is burning" utterance *became* fact, the world printed the legend.

I begin with these two tales, first, because they exemplify the kind of urban legends I am interested in, and second, because—in their juxtaposition—they illustrate how fact and symbol and history and myth often operate: in tandem, at cross-purposes, as proxy for one another, or each chasing the tail of the other, the two forever tantalizingly out of reach. A word about the urban legends here described: Cosell's phantom utterance is one such example, but I encourage us to think about concepts like the "inner city," "blight," the "ghetto," "wasteland," and "no-man's-land"— metaphorical constructions of place that continue, to this day, to be used to characterize cities and, more pointedly, the people in them—as versions of urban legends as well.[11] These are all euphemisms, ways to describe a city so that people don't have to think any deeper about why it looks the way that it does, a shorthand for describing problems so complex, systems of oppression so entrenched, that the realization of their uncomfortable proximity produces a kind of willful distancing via language. They are coded spatial signifiers for race. Historically, their use has been a pretext

for residential displacement. They are also, themselves, placeholders for narrative, as much as they are the scenes and settings for narrative, schemas, stereotypes, and all of the stories we tell ourselves about the places we think we have seen or read about, driven by or flew over, listened to someone sing about, or tried our best to ignore.

But I also begin here because urban legends—whether Cosell's, or the discourse over what constitutes blight—like urban ruins, possess the ability to obscure their own origins and their links to processes, power dynamics, and institutions. Such urban legends also obscure human desires, hatreds, frustrations, and misunderstandings. They are symbols that may or may not have root in fact, and their symbolic language is as visual and cinematic as it is literary. *Urban Legends*—my version—examines the South Bronx as a text: as both an urban legend unto its own, and a rich repository for these myths and symbols, these realities and representations of urban America. As the Brooklyn Bridge was for the historian Alan Trachtenberg, the South Bronx was, and is, both fact and symbol, image and terrain, both metaphor and lived, material reality.

"Facts become symbols instantly—often long before they are understood," argued the Marxist scholar Marshall Berman in 1987. For Berman, images of the South Bronx in ruin represented the collective troubles of the city, and—thanks to New York's preeminence as a world communications center and all the mass media located there—those images traveled instantly across the world, elevating them to "something mythical." New York was, by the late 1960s, already a symbolic vector of danger and urban violence, yet, as Berman observed, such violence was not endemic to the city in particular, but present throughout American society. What was unique, however, was how that symbolism was considered New York's problem and no one else's. Popular and journalistic media "mythicized" New York into what Berman calls "America's Other," and blamed it for everything that the country "didn't want to see in itself." New York, and the Bronx in particular, appeared to the nation as a spreading plague. The metaphor of the city-as-illness has roots in the city as a solution to society's ills, a cornerstone of Corbusier-style modernism. But by the early 1970s, that metaphor had become inverted, and the city, as both place and concept, became something to be abandoned, and the South Bronx became an affliction—a contagion assumed to produce societal and environmental illness. Such representations of the city instructed the public beyond New York City to see places like the Bronx as an inhuman envi-

8

ronment, either absent of or incapable of sustaining life—assessments that were all too easily conveyed to the people who *did* actually live there as well. In this way, the mythic South Bronx that emerged as "America's Other," representative of the decline of American cities and as a legendarily tragic place, transits full circle from Berman's assertion, out of myth, and becomes its own kind of fact—a colorful detail to be deployed in middle-brow dinner party conversation, a mere confirmation of swirling suspicions and bias. Thus do urban legends become fact, facts become symbols, and cultural representations inspired by both spiral out in an endless strophe, far beyond the realities that produced them.[12]

This South Bronx, the product of a discourse, is more a projection than a real place, an invention of many needful imaginations: the political right, paranoids, racists, suburbanites, downtowners, out-of-towners, to name but a few. Entire vocabularies were honed in order to describe places like the Bronx. Terms like "blight," "slum," "the inner city," and "the ghetto"—a veritable lexicon of urban decline—enabled advocates of "urban renewal" (yet another euphemistic term) to reorganize and segregate cities across the nation, physically displacing certain populations from neighborhoods. Often, these advocates employed such neutral, but coded, language to gesture not just at the places so designated but mainly at the black and brown populations that called them home. As South Bronx community organizer and Puerto Rican activist Richie Perez (featured in Chapter 6 of this book) keenly observed of his own borough's fate, "Solutions proposed for the South Bronx are clearly presented with one eye on the rest of America, and residents of urban ghettos throughout the United States watch closely knowing that for most of America and the world, there is little difference between the South Bronx, the Lower East Side, Bedford-Stuyvesant, Chicago's South Side, and Watts." Calling a neighborhood "blighted" imposed a narrative upon that neighborhood, forestalling its present, and altering its future. As Perez notes, such decisions—and such descriptions—could have far-reaching effects, well beyond the ever-shifting-northward borders of the South Bronx. As the symbolic capital of American urban ruin, the South Bronx was freighted with such narratives, surrounded by them, obscured by them; the borough shouldered their burden on behalf of South Bronxes in other cities, and, in many cases, was sustained by them.[13]

This book, then, is about these narratives. It is about symbols and images, and the way that they interact with competing, occasionally contradictory narratives. On one hand, it focuses on artists, writers, and thinkers

who engaged with the South Bronx as both fact and symbol, myth and built space, urban legend and site of urban ruins. But *Urban Legends* is also about how these highly localized representations, in turn, revealed, resisted, replicated, or refashioned the broader realities of what it meant to live and share in any urban space. It reads these symbols and images and narratives—these representations of the South Bronx—as representative of material realities and of political and social forces that, as works of art, could more easily be disseminated to audiences beyond the borders of the borough.

*Urban Legends,* at bottom, argues that the gothic portrayals of the South Bronx obliterated the lived reality of urban life in the 1970s, 1980s, and 1990s, while the same ruins that inspired those portrayals formed generative sites for literary and artistic renderings of decline and decay. Such renderings were often designed to counter or upset the myths and symbols circulating throughout the public imagination. The South Bronx, then, drifted between fact and symbol, but neither myth nor material could be left fully behind. Bronx ruins did not define the borough entirely, yet they marked its inextricable connection both to the larger city and to the processes that produced the problems of urban America. That connection was present but obscured. The figuration of ruin obscured systemic processes and problems, often imputing them to the people who populated the Bronx's neighborhoods.

These representations constitute a dizzying, often bewildering set of texts. They are found in countless archives, famous and obscure, in the journalism of the era, property tax records, municipal memoranda, best-selling novels and short stories, legal citations, sculpture, photography, film; on subway trains and building facades; and on once-cutting-edge laser discs meant to last into the new millennium. My interest in this diverse set of texts emerged first from my desire to understand the Bronx—the borough that raised me—and how it became an outsized symbol for crime, drugs, decay, and danger in the media and popular culture. That symbolic Bronx loomed large over my youth. Saying one was from the Bronx meant certain things; one received certain looks, in response, depending on the respondent. I was curious to see how far the shadow of that symbol stretched. The pursuit of that understanding, and what I found along the way, led me to a story about that place that was somehow different from many of the stories that I was told, had read, watched on television, or experienced myself.

Two narratives have dominated understandings of the Bronx: one of urban crisis and the other of urban renaissance. Both South Bronx narratives have, like the borough itself, assumed near-mythic proportions, for

good or ill, and their power—like Cosell's phantom line, or the idea of "the inner city"—persists in discussions of how distressed and decaying urban environments in other cities are understood even today. The frame of crisis was often used, as we have seen, to proclaim the failure of urbanism, there and elsewhere. Yet, that same South Bronx also produced the most powerful and lasting American artistic and cultural innovation of the past fifty years: hip-hop. The tale of how the South Bronx rose from the depths of what the world saw as urban disaster is often, but not always, framed largely as one of cultural renaissance produced by, in relation to, or adjacent to the creation of hip-hop—a brilliant, transgressive, trenchant, and endlessly interesting frame (as well as the music that raised and sustains me today)—but a narrative frame nonetheless. Growing up in the Bronx, one becomes familiar with both narratives from an early age. Because of this rare privilege of familiarity afforded the born-and-bred Bronxite, said Bronxite also wonders what tales might be obscured by these two grander narratives, what sources might still lay untapped, what other stories there are to tell.

I became attracted to the Bronx that I found in the archives, entranced by voices that I had not heard before, beguiled by views of a borough that I realized I only thought I knew. *Urban Legends* is indebted to the work of writers, critics, and scholars like Greg Tate, Tricia Rose, Jeff Chang, Joan Morgan, Nelson George, and Dave Tompkins, who have chronicled the emergence of hip-hop's cultural movement and envisioned its futurity as well as its playfulness and mutability in classic texts and essays, and there are too many journalists to name here whose writing on hip-hop often does the work of scholarship better than scholarship can.[14] And scholars like Marshall Berman, Alan Trachtenberg, Suleiman Osman, and Kim Phillips-Fein provided models both tried and true and refreshingly new for conceptualizing the space between built space and idea, between myth and history, and the relationship between the "invention" of neighborhoods and how those inventions can lead to economic and social marginalization.[15] Formative also in the interdisciplinary approach of this book was a 1999 exhibition at the Bronx Museum of the Arts titled *Urban Mythologies: The Bronx Represented since the 1960s,* curated by Lydia Yee and Betti-Sue Hertz, and whose catalogue featured essential contributions from Rose and Berman, Rosalyn Deutsche, Lucy Lippard, and others.[16] My work builds upon these historical, journalistic, literary, and art historical understandings of social and political organizing, economic upheaval, the invention of hip-hop, and urban studies. It also searches

11

between and across these fields and well-told histories—and through a diversity of archives—to offer renderings of the South Bronx that display the complexities masked by layer upon layer of legend. If I am drawn to the visual and the literary as opposed to the musical, it is not simply because they have received comparatively less attention but because—as evidenced by Carter's walk and Cosell's apocryphal call—it was through visual, literary, and journalistic means that America and the world first encountered the South Bronx. If *Urban Legends* centers upon word and image rather than music—in which hip-hop forms our typical under-standing of the Bronx's cultural production, though epochal revolutions in salsa and Latin jazz also occurred during this era—it is because these images and words have received comparatively less attention not only as matters of perception but also as matters of civil rights. The South Bronx existed, for a time, as a relentlessly imagined space; the images and repre-sentations that I uncover in *Urban Legends* are testament to this, and all the limits and possibilities that imagination offered. But, in the broadest sense, they also serve as evidence of how—throughout the history of the American built environment—ideas about race and built space are not merely constructed and proliferated but also inextricably intertwined.

There are shadow archives of Bronx life, and they exist within the many official and unofficial archival sources that document its countless representations across media. It seemed to me that to write even an in-complete cultural history of these shadow archives of the Bronx—often found where official and unofficial narratives meet, or where grand state-ments meet more earthly signifiers of life—necessitates not simply looking at "broken glass, everywhere," the famous first lines of the first verse of Grandmaster Flash and the Furious Five's "The Message," and a repre-sentation of Bronx ruin that has already found a prominent place in an-thologized canons of American literature.[17] To my mind, it requires also looking at the glass, the street, and the buildings—the material "every-where" that Melle Mel describes. One can read "The Message" as urban reportage, as an example of lyric and poetic dexterity, and certainly as a work of literary and musical protest—in other words, as poetry or soci-ology, fields in which academic discourse has often invoked hip-hop—yet one can also read Melle Mel's lines as trenchant spatial, environmental, or ecological critique. Such a reading acknowledges what the pages of any anthology might find difficult to accommodate: its kinetic visual element, in the form of the evocative video that was made to accompany the song, and the black and brown bodies that dare show mastery of urban space.

This nonmusical Bronx archive has remained untapped. In one sense, *Urban Legends* is, indeed, about the physicality of broken glass, streets, and buildings, but it is also about the broader metaphorical resonance of these visual and literary figures of the city as a cipher of twentieth-century life. These figures describe, to me, a set of possibilities: What other information lingers in the background of the images that we have viewed countless times, always visible, yet rarely truly seen? What narratives run parallel to the ones we know too well? While some speak with the loudest of voices, whose sage whispers echo in the background, knowing their voices carry only loud enough for those who need to hear them? These shadow archives of the Bronx exist between and behind the versions of the stories that we have heard, or that we think we know, and often, they emerge most vividly after having been placed alongside each other.

For these reasons, *Urban Legends* is driven by the tension of reading resonant, but radically different, texts against one another. Various forms of institutional authority are placed in conversation with individual acts of resistance and remaking. The inquiry is multidisciplinary because the South Bronx itself is a synthesis—not merely of physical, visual, literary, and artistic material but also of once-individual, extant neighborhoods that came to lose their specificity to the aggregate, to a floating, spreading signifier that slowly progressed northward through the borough. In considering what representations of the city to focus upon, I was drawn more to the peripheries of aesthetic engagements, and particularly the relationship between those peripheries and whatever centers they may orbit. This thinking drives the book's juxtapositional aesthetic. The distinctions between "popular," "fine," and "high" art have always been fascinating to me, and the representations of the Bronx of this era that populate this book complicate and cross these distinctions.

*Urban Legends* opens, perhaps naturally for a book about myth and history, with a first chapter that serves as a prologue of sorts, examining the central metonymic image of the South Bronx—the lone, abandoned tenement building—as both fact and trope. In Chapter 1 we begin our consideration of the relationship between representation and material reality by interrogating the concept and problem of metaphorical urban legends like blight and the inner city. What constitutes "abandonment"? What was the actual scope of abandonment in the Bronx, and how was this rendered in the press and other media? And what was the view from within this trope? From the lone tenement, we broaden our consideration of the built space of the South Bronx with two aesthetic interventions that

attempted to address building abandonment in ways that, at first, seemed at cross-purposes, but in actuality shared more than one might imagine.

Chapter 2 considers the unlikely pairing of "high art" and what I term "municipal art"—state-sanctioned attempts at beautifying, or at least making tolerable, the Bronx's abandoned buildings in the form of trompe l'oeil decals that covered broken windows and doors. Against this rudimentary facsimile of life and stability I explore the early artwork of artist Gordon Matta-Clark, many of whose "building cuts"—architectural alterations in walls, floors, and ceilings that revealed the interiors of structures—were performed in abandoned buildings in the South Bronx. Both projects—of high art and municipal art—reveal different fictions within their respective window frames, some that illuminated the social and material conditions present in these neighborhoods, while others masked more urgent South Bronx stories. In reading these two responses to urban ruin alongside each other for the first time, we begin to understand how questions of visual perception and perspective, often relegated to the province of art historical or public art debates, in fact shaped how the American public grew to understand and experience the messy realities of urban environments like the Bronx—abandoned or forgotten by some but not by all.

Chapter 3 pursues a similar dynamic of juxtaposing fine art and "municipal art" and fixes upon an attempt by the city government to "see" the entirety of the Bronx, and in fact all of New York, via photographs, alongside more self-consciously artistic efforts to see South Bronx ruin. From 1983 to 1988, data collectors in the New York City Department of Finance photographed every block and lot on New York's streets—from vacant lots in the Bronx to the canyons of downtown Manhattan skyscrapers—resulting in more than 800,000 photographs, around 85,000 of which depict the Bronx and which preceded similar projects like Google's Street View by twenty years. Known as the Real Property Tax Card Record System for Computer Assisted Mass Appraisal—or "tax photos" for short—these photographs were captured and filed by city officials, not professional photographers, as systematically as in any archival project. One can, as I do, read these photographs as an unintentional archive of South Bronx ruin. Alongside the work of photographers like Jerome Liebling and Ray Mortenson, these two forms of visual documentation constitute a hybrid form of visual narrative that evades more spectacular or sensationalistic aspects of familiar images of the Bronx, while providing testament to the lives and narratives of Bronx residents—

largely African American and Latinx—who existed within, or often just outside the photographic frame.

From projects that attempted to capture or imagine the enormity of an entire borough within the photographic image, we turn to ones that navigated the projections and receptions of the symbol of the South Bronx abroad. Chapter 4 charts the emergence of what is a seeming contradiction in terms: a "global Bronx," a symbolic vernacular of urban ruin that communicated its familiar syntax across international borders. Fashion Moda, an influential Bronx-based alternative art space established by Viennese émigré Stefan Eins, engaged over the course of its existence with the physical site of the Bronx, and with its symbolic representations that resonated at home in the American public sphere as well as internationally. Fashion Moda was also renowned for its essential role in bringing the work of African American and Latinx graffiti writers like Crash, Daze, Lady Pink, and Lee Quiñones into the space of the art gallery. In 1982, Fashion Moda "exported" its South Bronx gallery in the form of Fashion Moda stores to the Documenta 7 international art exhibition in Kassel, Germany, a transnational exchange that revealed how some art objects—and the places and spaces that they claim to represent—functioned in and beyond their original cultural contexts. Fashion Moda's temporary, international incarnation at Documenta is, here, read against its local, Bronx-based manifestation. Representations can ricochet back to their sites of origin in conflicted and contradictory ways; Fashion Moda was no different. Yet, its example suggested that certain representations of Bronx ruin—even the site and symbol of the Bronx itself—could be made transportable, reducible, ripe for abstraction, or commodified far beyond the borough's borders.

In Chapter 5, the literary figure of the South Bronx takes shape under the guiding question—with apologies to Ralph Ellison—who, then, speaks for the South Bronx? From the largely understudied short stories and fiction of Puerto Rican South Bronx native Abraham Rodriguez Jr., who writes in the Nuyorican urban literary tradition of Piri Thomas (as much as he bristled at the comparison), to the maximalist "social novels" of authors like Tom Wolfe and Don DeLillo, we consider three competing literary modes of South Bronx writing. To what extent were the gothic horrors and urban wilderness of Bronx legend necessary to animate such sprawling works like *The Bonfire of the Vanities* (1987) and *Underworld* (1997)? Could fiction writers to escape the most well-worn tropes of ruin and renaissance? How to represent a place that has been so relentlessly

15

represented? And what happens when one's lived reality exceeds the wildest fictions?

Chapter 6 returns us to where this Introduction began: Charlotte Street, a place that not only became a metaphorical repository for the paranoid urban fantasies of the nation, but also a literal arena for them as well: as a film set. That those paranoid fantasies quickly became fodder for Hollywood and a host of other filmic renderings of the South Bronx is, after one has considered so many other representations of ruin, perhaps not surprising. In reimagined westerns like Daniel Petrie's *Fort Apache, The Bronx,* it was the black and brown residents of the South Bronx who played "wild native" to beat cop Paul Newman's under-siege police precinct. The films's style ranged from guileless to exploitative, especially in representations of African American and Latinx populations of the Bronx, though most shared the same relentless commitment to a visual iconography or language where the city—or the people living within it—had fallen into ruin. *Wolfen,* a supernatural thriller, in its novel form and filmic adaptation, offers altogether different forms of paranoid threat. An intelligently plotted and politically minded social thriller about werewolves in 1980s New York, *Wolfen* renders class, racial, and spatial anxieties as constitutive of similar concerns about real estate, urban renewal, and changing populations of the city. The "paranoid style" of South Bronx film, conversant in the presentiments of ruin or its aftermath, approaches the kind of paranoia seen and described in historian Richard Hofstadter's 1964 essay "The Paranoid Style in American Politics." This style transcended political ideology. That is, the cipher of Charlotte Street was so powerful—as inscrutable as it was easily offered as shorthand for urban dystopia—because conservative and liberal outsiders were able to project different visions upon it, and both did so through a paranoid gaze. And, as so often happens when a place that becomes a potent a vehicle for the projection of emotions, Bronx residents organized around the specter of Charlotte Street and the "Fort Apache" name that had been projected upon them and, via protest and in courts of law, demonstrated what happens when a trope speaks back.

*Urban Legends* concludes with a set of reflections on the legacy of the image and metaphor of the Bronx today. What facts and symbols linger, what myths have been dispelled, and what new legends have come, now, to replace them? How have tales of decline and fall have been repurposed to new ends? If the long shadow of the symbolic Bronx has waned, are there new shadows—gentrification, real estate expansion—that threaten

to displace and disrupt Bronx populations in different ways? Where, if anywhere, might the symbol and signifier of the South Bronx float next?

Not every urban legend has a birthday. Born in the Bronx in 1922, the author and social activist Grace Paley remembers "the day that the East Bronx began to become the South Bronx, though no one realized it at the time." Throughout her youth, she was witness to much real estate development in her neighborhood near Vyse Avenue and East 173rd Street, but, as she writes, "In only a few years out of the frantic good-time winds of the Nineteen Twenties, the merciless Depression sprang forward, stalking money, houses, people." It was the Great Depression that "was the first great blow to the unfinished Bronx." Already unfinished, the Bronx had an aging housing stock that had begun to decline in the late 1920s, and throughout the 1930s and 1940s the borough was characterized by the transience of its residents. Great numbers of Puerto Rican and African American families new to New York City that were shunted to Harlem and the Bronx; the Depression and a post–World War II decline in manufacturing jobs left them scant access to employment or adequate housing. As Paley observes, "Normal American racism never did let everyone into the melting pot at the same time." For her, and residents like her, Robert Moses's Cross Bronx Expressway was only the second great calamity in the Bronx's physical and social undoing: she locates it as the end point of years of choices "made . . . on all levels of government, to sacrifice the poor and middle class, the communities in change as well as the stable communities of the mid-Bronx, to the arrogant dreams of engineers, politicians, real estate developers." Out of "years, decades of instability, abandonment, devastation, fire," was the South Bronx as we know it born.[18]

That South Bronx was Morrisania, Mott Haven, Hunts Point, Longwood, Melrose, Morris Heights, and Crotona Park East. Eventually, it was also Tremont, East Tremont, and maybe even University Heights and Fordham. These were individual neighborhoods, each with a unique identity that had, in many cases, been established since the late nineteenth century. They all came to constitute a southern Bronx in this, the northernmost borough of the five that make up the city of New York; the only borough that is part of the American mainland; a place that was once submitted for consideration as the permanent capital of the nation.[19]

Lewis Morris, a signer of the Declaration of Independence and owner of the land that became known as Morrisania, argued its merits as national capital in Congress on October 1, 1790: "The said manor is more

advantageously situated for [Congress's] residence than any other place that has hitherto been proposed to them, and much better accommodated with the necessary requisites of convenience of access, health, and security." He offered the land—which sits at the heart of what we know today as the South Bronx, and which then contained part of the original land formerly owned by the Bronx's namesake, Jonas Bronck—as the site of the US capital. We know the outcome of Morris's offer. One marvels, however—due to the simple fact of this refusal—at what legends, myths, and alternate histories we will never know.

# 1

## THE LONE TENEMENT

Any story with abandonment at its core might do well to first establish a sense of what is being abandoned. To hear that the South Bronx was the "most extensively abandoned piece of urban geography in the United States" by the late 1970s, one imagines extremes: collapsed walls, open lots brimming with detritus, and discarded newspapers as urban tumbleweeds, gusting down silent and deserted streets—a citified ghost town left to rot. Yet, urban ghost towns are still composed of materials, of physical monuments, of structures, and even of residents, which are certainly more tangible if perhaps not as lasting as the metaphors that are used to describe them. Though the South Bronx's built environment may have suffered through a prolonged state of un-building, it was still by virtue of its status as part of the city of New York composed of parcels of real estate, upon which stood tenements, single- or multiple-family homes, attached houses, larger apartment complexes, and the like—housing stock that aged, perhaps improved with care, or deteriorated with lack of maintenance. What was once in the late eighteenth and early nineteenth centuries a collection of farms, estates, and small villages had become thoroughly urban—thoroughly built—by the twentieth century. Indeed, as statesman Elihu Root once observed of the city, the primary agent for neighborhood creation and growth was "the real estate operator [who] . . . gets hold of tracts of land here and there which he can map and cut up into blocks and building lots and advertise and sell. . . . He is the man who very largely determines the growth of a city." It was real estate that brought residents to neighborhoods in the 1910s and 1920s, and it would be real estate—the Bronx's buildings, blocks, and lots—that was left behind when those neighborhoods became untenable within but a few decades.[1]

Though the South Bronx came to characterize abandonment itself in later years, it was its overcrowded neighborhoods and the transience of

its population that characterized the borough in its earliest urbanized years. As historian Evelyn Gonzalez observes, some of the greatest population densities in the Bronx could be found in the section centered around Westchester Avenue and in the region immediately southwest of Crotona Park, "namely in those spots that were abandoned and synonymous with urban decay but that in 1920 contained 200 to 300 people per acre, living in blocks of fully tenanted apartment buildings."[2] The *North Side News* observed that the "tenement house law is permitting as horrible congestion [in the Bronx] as that which damns Manhattan" and chronicled how a Crotona Park East block went from empty lots to tenements in about a year—the same block, on Charlotte Street, that would be visited by presidents Jimmy Carter and Ronald Reagan seventy years later in ignominious recognition of the South Bronx as the world's foremost metaphor for urban ruin.

The essential point that Gonzalez lodges here and elsewhere in her portrait is that the Bronx was a borough that has been historically characterized by the "excessive transiency" of its residents: it offered improved accommodations from downtown slums, it was a first port of call for newly arrived immigrant communities, it was a borough composed of neighborhoods full of renters, young tenants, and those whom the rest of the city did not welcome immediately with open arms.[3] What's more—and most important for the focus of this chapter—is that its housing stock, built haphazardly by real estate speculators desirous of a quick return on investment in the late nineteenth and early twentieth centuries, had already begun to decline by the 1920s, and certainly by the 1940s when great numbers of African Americans from the South and Puerto Ricans began to settle in its neighborhoods.[4] Those neighborhoods were hardly constructed with the idea of building a coherent neighborhood in mind; neither were they allowed the kind of maintenance or indeed top-to-bottom renewal that mortgage loans provided by the Federal Housing Authority or private lending might have offered due to large-scale redlining of areas of the South Bronx.[5] Even so, as Gonzalez highlights in her recounting of the decline of the borough, "poverty and old buildings do not inevitably lead to crime, abandonment, and arson, for there had always been slums in the city."[6]

Building abandonment was the result of "an interaction between the housing market and the socioeconomic condition of the building," but also of a self-perpetuating "perfect storm" of conditions that exposed an aging housing stock—into and out of which scores of increasingly unemployed

residents cycled through, unable or unwilling to pay rent for landlords themselves unwilling to maintain or improve their properties—to a city increasingly short on funds. That city was forced to cut down on crucial infrastructural maintenance like firehouses, further exposing that aging housing stock to owner-profiteers who accelerated decay in their own buildings in order to eventually collect on low-premium fire insurance policies once they burned.[7] Such a dreadful cycle of factors repeated itself from block to block, lot to lot, and from building to building, growing both the physical area and the idea of the South Bronx until its very name became a metaphor for abandonment, and an urban legend in its own right. The South Bronx was simultaneously "the inner city," the "ghetto," a "no-man's land," a notoriously "blighted" area of the city, and the nation's most famous "slum" all at once. In the minds of many outside observers, the Bronx of the 1970s and 1980s was often reducible to a visual metonym: that of an abandoned, burned-out building, a single structure that stood for countless others. But what, if anything, did that metonym—that metaphor for ruin—mask? What modes of thinking, what narrative frameworks lay behind this familiar iconic façade? What—and whose—stories weren't being told?

These and other metaphors for abandonment and ruin are not merely curiosities of language and semantics, but also ways of processing the difficult realities that places like the South Bronx presented. In a 1979 essay, the philosopher Donald Schön understood there to be two traditions of metaphor: the first as a "species of figurative language which needs explaining, or explaining away," and the second as a kind of product, a "perspective or frame" and a "process by which new perspectives on the world come into existence." He called this process "generative metaphor." When applied to the domain of social policy, Schön observed two frameworks of thought regarding metaphor that are important for understanding the kinds of urban legends that defined the Bronx: problem-solving and problem-setting metaphors. If, as Schön notes, the dominant view in the development of social policy ought to be considered as a "problem-solving enterprise," his view suggests an oppositional approach that focuses on the framing of the problem to begin with: rather than selecting the optimal means for solving a particular social problem—finding the "solution" to a societal problem—Schön believed that the true difficulties lay with the "ways in which we frame the purposes to be achieved." That is, "problem-settings" are defined by the stories that people tell about complex and troublesome situations, stories that are already undergirded by metaphors that can dictate the directions that problem solving may take.[8]

21

In other words, how might one reckon with the fact of large-scale building abandonment and arson in South Bronx neighborhoods? One constructs a metaphor from an already familiar concept or field that attempts to make sense of the unfamiliar or unthinkable condition: such neighborhoods, once healthy, have become "blighted"—as if they were possessed of a disease. We understand a slum as a blighted area, so it is that blight that must be surgically removed if the area is to be healed. "The metaphor," as Schön observes, "is one of disease and cure." If, on the other hand, the neighborhood is viewed as a "natural community," a response less drastic than removal via surgery may be in order. But given the imprecision of language, and the likelihood that such slipperiness will allow racism, not reason, to dictate what neighborhoods are "natural" and "unnatural," some metaphors are more suitable than others, and many are grossly inadequate, which can lead to similarly inadequate solutions. But, as Schön is careful to point out, one man's blight may be another man's folk community. On what or whose criteria was the South Bronx diseased?[9] As we will shortly see, some who were engaged in social policy debates around housing attempted to carefully outline the criteria by which concepts like blight and abandonment were judged and defined. Their work, and the broader discourse of urban ruin, demonstrated the difficulties inherent to producing rigorous analysis of such complex problems.

## With Love and Affection: Vacancy, Abandonment, and Infection

By 1980, Charlotte Street was the bleakest whistle-stop on every national politician's tour of urban America. In March of that year, Ted Kennedy stood on the very same spot that Carter had three years earlier; Ronald Reagan visited Charlotte Street in August, remarking upon emerging from his limousine that he "hadn't seen anything like this since London after the Blitz." In a sense, the national recognition and acknowledgment of the ruined South Bronx brought the neighborhood both closer to and further away from those who watched from afar—even those who watched from elsewhere in New York. The structural and systemic problems of municipal disinvestment, urban abandonment, and neglect that had combined with a host of other factors to create such a wounded environment—as well as the visual markers of that environment itself—would not be un-

familiar to residents of many other cities like Chicago, Detroit, Cleveland, Philadelphia, Pittsburgh, and Newark. However, what the nationally broadcast images helped to fashion was a mind-set that viewed the South Bronx as a relative example of the "urban crisis" in their own cities while simultaneously allowing many to conceive of it as always happening somewhere else. By becoming the nation's shorthand for urban American ruin, the South Bronx simultaneously made that ruin more difficult to see everywhere but in the Bronx.

If the South Bronx first entered the American imagination as exemplar of the national "urban crisis" in 1977 after President Jimmy Carter's appearance on Charlotte Street, residents of the Bronx neighborhoods Morrisania, Melrose, and Mott Haven and of Brooklyn's Brownsville would have been chagrined at the nation's relatively late recognition of their plight. A February 1970 report of the Citizens Budget Commission, one of the earliest public reports to concern itself entirely with the problem of New York's abandoned buildings, registered alarm at what was then already becoming an "emergency situation" in parts of Brooklyn and the Bronx. Seeking remedies for what it called "the greatest housing crisis in [New York's] history," the report attempted to divine both the causes and underlying conditions of building abandonment and the solutions for possible renovation.[10] It discussed methods for dealing with the physical entity of the abandoned building, whose detrimental effects on the surrounding neighborhood were legion and, in some cases, life-threatening. Structurally unsound, vacant buildings posed a constant threat of collapse, and due to the atmosphere of desolation that they engendered in their immediate vicinity, these husks were havens for drug trafficking and other crime.[11] New York City housing commissioner Roger Starr himself was a famous—or, rather, infamous—proponent of the idea of "planned shrinkage" as a solution to abandonment and the issues facing the South Bronx. The idea, related to Senator Daniel Patrick Moynihan's earlier idea of "benign neglect" toward issues of race (offered in a 1970 memorandum to President Richard Nixon), suggested that rather than committing the millions of dollars it would take to quite literally fix the South Bronx, shifting people into more compact areas and effecting an overall reduction in city services and their costs would pave the way for renewal in the left-over spaces. One 1978 proposal to the city for addressing building abandonment and housing in the South Bronx boldly rebutted Starr's controversial proposal, stating that

23

such "planned shrinkage" is less an urban policy than the lack of one. It calls for closing down communities rather than building them up. It makes assumptions that are untenable in a democratic society. Who decides which people leave—or where they go? Government re-settlement programs are no answer. The answer to the South Bronx is in the South Bronx.[12]

But what constituted "abandonment" in the first place? Who, exactly, abandons, and what do they leave behind? These are questions that, in 1977, the Women's City Club of New York (WCC), a nonpartisan, non-profit civic activist organization, tried to answer. The WCC (still extant, though rebranded as Women Creating Change as of March 2019) was founded "on the eve of women's suffrage" in 1915 and began advocating for issues like safe working conditions in garment factories in 1915 and allowing physicians to give birth control information in 1917; it also drafted and ensured passage of New York State's first child labor laws in 1924. Early members included muckraking journalist Ida Tarbell, Eleanor Roosevelt (while still first lady of New York State), actress Helen Hayes, and Ruth Watson Lubic, founder of the National Association of Child-bearing Centers. In the 1970s, many of the WCC's efforts focused upon issues of housing and voting redistricting, among many others. Its report, titled *With Love and Affection: A Study of Building Abandonment*, serves as a useful entry point into the amorphous issue of abandonment, its causes, its effects, and possible solutions.[13] The report locates its analysis near the geographic heart of Bronx abandonment and shrewdly devises a framework and method that establish the tenement block as its unit metric, thereby grounding the more abstract notions of "ruin" in clear, relatable, and empiric terms. Beneath what often appeared in the media as a sea of churning rubble, and against against popular conceptions of the abandoned inner cities of America and the Bronx, this was analysis at a level that at least approached the granular. If it was to be the abandoned tenement building that would visually define this era of urban ruin in the Bronx, then beginning any empirical study of the Bronx with its buildings was the most natural point of origin.

The study examined two blocks in the Bronx, "one a square block facing Crotona Park and the other, a linear block nearby," located in the Morrisania and Tremont sections of the borough.[14] Once part of the extensive manor of Fordham, created under a patent by Charles II in the seventeenth century, as the report rather portentously observes, "There is nothing manorial about them now."[15] The site was chosen because it contained 38 residential buildings constructed between 1899 and 1929

24

whose condition ranged from "fairly good" to "grossly deteriorated" and which were classified as either abandoned or occupied. In June 1970, 11 of the 38 buildings were abandoned and 27 were occupied. By 1976, 11 of the occupied buildings had become vacant or had been demolished, and two others were almost completely vacant. In the ten years following the first instance of abandonment in the study site, 1966 to 1976, nearly 60 percent of the 38 buildings were destroyed.[16]

Census Bureau statistics were just as revealing as the WCC report. In 1970, the bureau counted 763,518 people living in the South Bronx; in 1980, it counted 453,925. In 1983, the Bronx's unemployment rate remained the highest in New York City; south of Fordham Road, at that point the latest northern boundary line for the South Bronx, it approached 15 percent. Estimates for the number of abandoned individual units of housing vary notoriously, but one 1983 report of the South Bronx Development Organization placed the number at fifty thousand. Approximately two thousand dangerous abandoned buildings dotted the landscape in that year. Certainly, thousands of dwellings were at a substandard level of upkeep, with only limited repair monies available.[17] Standing mute to the world, but never unintimidating, abandoned buildings were a constant nuisance and threat to neighborhoods and, of course, to their residents. Two solutions existed for such structures: demolition or rehabilitation. Demolition assured riddance of a dangerous nuisance, but practiced on a large scale, it left wastelands rather than neighborhoods—hence the then common reference to large swaths of the South Bronx as a "no-man's-land." Demolition also presented its own problems. Typically, demolished buildings were collapsed into their own foundations, usually eight feet deep. The result of this demolition-into-foundation was an unstable surface of poorly compacted rubble, unable to support new construction above it.

The second solution, rehabilitation, was doomed to failure if the conditions of large-scale abandonment had already taken hold and the social conditions in the neighborhood were not also sufficiently and simultaneously ameliorated.[18] Thus, the pressures for demolition and clearance were just about equally intense in all parts of the South Bronx. Living adjacent to abandoned buildings posed the dangers of squatters, scavengers, and arson. But spot clearance—demolishing some of the vacant buildings on a block and leaving others—hardly improved the environment for residents, nor did it create development opportunities.

Abandoned buildings were, following the WCC report's definition, ones "in which no rents are collected and no services are provided by the

landlord."[19] Abandoned buildings as such could still have tenants—that is, they were not always the husk of a structure that we imagine—but those tenants simply no longer paid rent. Often lost in the miasma of decay and despair surrounding abandonment was the fact that, in the legally accepted definition, it was the owner of the building who abandoned it, rather than its residents. Also important to observe was that abandoned buildings were not necessarily deteriorated; indeed, in some cases, owners continued to pay real estate taxes on their property. "Vacant" buildings so defined were those that lacked tenants; squatters and others who might otherwise occupy vacant apartments were not considered tenants. Vacant buildings were required by law to be properly sealed, usually with either tin sheets or masonry seals over windows and doors, and it generally fell to the owner to do so; if not, the city would either seal them or enter them into the "demolition pipeline." Again, like the nebulous idea of the South Bronx and its ever-shifting boundaries, abandonment, in essence, more usefully described a condition or a process. To wit, it was extraordinarily difficult to discern precisely when a building could be said to be abandoned: building services likely decreased, rent collections tapered off, and tenant abandonment might take place after these services are curtailed, but before the landlord abandons the building.[20]

Frustratingly, the report concluded that "no single cause or simple set of causes" for abandonment could be identified. Population shifts, building and neighborhood deterioration, disinvestment, incompetent management, tenant malfeasance, rising costs of rent and maintenance, and inadequate city services all play their own part, but as the report's authors conclude, "to what extent they are causes and to what extent, results, is not clear." Abandonment eroded the city's tax base, and assessed valuations were lowered on even occupied buildings when neighboring buildings were abandoned, compounding the lack of funds available for the city to attempt rehabilitation.[21]

The report's descriptive powers are exceptional. Alluding to its own inadequacy in addressing the enormity of the issues facing the city and the Bronx in particular, it notes that "the number of dwelling units lost through abandonment gives no picture of what is happening in extensive areas of this City." From there the report's authors attempt to sketch the scene:

> Block after block contains hulks of empty buildings, some open and vandalized, some sealed, standing among rubble-strewn lots on which other buildings have already been demolished. In the midst of this desolation there

is an occasional building where people are still trying to live. Abandonment has by no means been limited to slum areas and old decrepit structures. The blighted conditions we describe are to be seen in what were even very recently, attractive neighborhoods. Some . . . are in the vicinity of, or directly opposite spacious parks and include broad avenues and boulevards. Many of the dead or dying buildings were fine, well-built structures with roomy apartments that might have continued to provide comfortable, dignified living quarters, had they not been abandoned.[22]

The language and tone are exceedingly straightforward, giving the images conjured a sober poetry. What the report's authors are able to excellently convey is not only the idea of abandonment as a "living thing" in the metaphorical epidemic sense but also the idea that—perhaps more important— even amid abandonment, people lived. The enormity of the problem is only perhaps outstripped in its power to disturb by the rapidity with which it took hold—yet another point driven home by this passage's reference to the abandoned dwellings that would have still offered shelter to those in need. The report's authors also offer an evocative tableau of an abandoned street that prefigures some of the literary and filmic evocations of the South Bronx that are the subjects of Chapters 5 and 6 of this book:

The streets and sidewalks where building abandonment occurs are not pretty sights. They are littered with rubbish, with shattered glass out of the gaping doors and windows. Often there are remains of abandoned cars. Packs of hungry, lean dogs move at will in and out of the buildings. At any stage, standing or demolished, abandoned buildings assault human sensibilities. Standing, they harbor society's derelicts, addicts, and alcoholics, who manage to overcome the City's best efforts to seal the buildings. Demolished, they leave an empty lot strewn with debris and rubble on which, within a very short time, garbage and rubbish are heaped. It is a strange and unreal world in which weeds become a welcome sight because they are alive and growing.[23]

This epidemic of abandonment—what the WCC report called a "virulent source of contagion"—affected more than merely the facades of the neighborhoods in which it took hold. The title of a 1975 *New York Times* "Week in Review" article poetically articulated the South Bronx's relationship not only to the rest of the city but also to the nation in the minds of its readers: "To Most Americans, the South Bronx Would Be Another Country." Even to Americans then mired in a recession, with unemployment soaring, the landscape of the South Bronx would have appeared a foreign land.[24] Worth a moment's meditation here, the article locates its

implicit critique of the South Bronx status quo in the geographic figure of an abandoned apartment building in the Morrisania section of the borough. One occupant thereof, an out-of-work African American house painter named Edward Smith, discovered—only in the middle of the night when his electricity and heat were suddenly shut off—that the building had been condemned. When Smith was forced to stay with relatives, but unable to afford to store his furniture and belongings, his and his partner's apartment was stripped clean in two days' time. Another young man named Curtis Hill noted that he supported himself and his ailing mother in part by, "travel[ing] around going into condemned buildings picking up brass and copper tubing," to be sold to junk dealers.[25] Life, though dysfunctional, depressed, and often desperate, did exist amid the ruins, leaving bodies struggling both within and against the borough's own decaying brick and mortar "bodies," and with ever-diminishing returns.

Echoing those journalistic reports, the WCC study made space to hear the voices of those tenants who inhabited—or were forced out of—the buildings within its purview. Tenants were asked how long they had lived in the study site, where they had come from, the size and composition of their households, and the amount and source of their income.[26] According to what the tenants told their interviewers, 15 percent had lived in the study site less than one year, 60 percent had lived there from one to five years, 15 percent had lived there from six to ten years, and 10 percent had lived there more than ten years. The great majority of those interviewed were not born in New York City but instead were from other areas of the United States, from Puerto Rico, and, somewhat imprecisely, as the report notes, "from a few from other Spanish-speaking areas." Most, however, had moved there from other parts of New York. Fewer than half (47 percent) of the heads of households were said to be employed; the rest included a few who were "retired," and most others were "not working." As the report notes, assuming their incomes were steady and yearlong, the median income would have been approximately $6,700, with a range of $3,000 to $16,000 a year. According to US Census figures, the median income for New York City in 1968 was $6,800. Twenty-six households reported incomes over $6,800, and the other eighty-six reported income from welfare assistance, unemployment insurance, and Social Security, in a range from $576 to $6,448, with a median at $3,600. Combining the income for the two groups of employed and unemployed tenants resulted in a median income of about $4,600, which was, as the report clearly notes, "very substantially below the median for the City."

The median household size in the study site was 5.0, while the median household size for New York City in 1968 was 2.2.[27] Of the approximately 660 persons living in the households that were interviewed, more than 200 were children under eleven years of age. About half of the households were headed by women. And in terms of space, four- and five-room apartments predominated, which provided an average of less than one room per person.[28] Thus, socioeconomically the residents of these Bronx blocks were already disadvantaged at a time when the city itself was encountering a fiscal crisis that severely impinged on its ability to address the kinds of problems that had already begun to affect the neighborhoods of the South Bronx.

Residents in the study were asked to describe their neighborhood's conditions, including particular likes and dislikes, what they thought could be done to ameliorate building abandonment, and whether or not they felt theirs was a desirable or undesirable place to live. More frequently mentioned as a reason for dissatisfaction than anything else was the presence of addicts and alcoholics (55 times); next in line came poor sanitation services (48 times), lack of security and inadequate police protections (39 times), unacceptable behavior of other people in the neighborhood (16 times), and, finally, fires that occurred in vacant buildings (16 times). The physical condition of the streets emerged as the second most frequently mentioned neighborhood problem for the residents, who talked of garbage accumulations, unswept streets, rat infestation, malfunctioning sewers, holes in streets and sidewalks, and a lack of adequate street lighting. Their complaints ranged from the general ("The streets around the building are dirty all the time") to the specific ("They should clean the sewers because whenever it rains they're stopped up for days") to the sadly poetic ("It's been going on so long, we believe it's meant to be this way"), but they all expressed a concern, care, and alarm for the built environment that was their own. Comments that characterized the people in the two blocks were often adverse if not downright bigoted in tone and tenor ("New tenants are pigs"; "Welfare people don't care about the way they live"; "They are shiftless, dirty and unconcerned about the dirt they cause"), demonstrating with a sharp point the similarly virulent prejudice that was always tacitly part and parcel of any metaphors of abandonment as "illness," given the largely black and Latinx populations that made up the majority of the South Bronx after World War II.[29]

City services certainly did not escape the tenants' censure. When asked what services needed to be improved, tenants mentioned sanitation (84

times), police protection (46 times), and the city's responsibility to assure decent housing (41 times). To them, it was the city's responsibility to enforce the laws concerning building maintenance; to demolish vacant buildings; and, wherever and whenever possible, to repair, rehabilitate, and rebuild. Helplessness was the most common refrain: "I have been to just about every agency that controls the housing. Inspectors came [without results] They don't care about us up here." With regard to the Sanitation Department: "They wouldn't dare do on Park Avenue what they do here." The report—and, indeed, the group of tenants living within the landlord-abandoned buildings who were interviewed—speaks to what was an almost complete breakdown of services and maintenance, security, and sanitation in and around the buildings, resulting in what were largely "unspeakable" living conditions: filthy halls, broken windows and doors, no lighting in the hallways, garbage everywhere, open drug activity, dogs running in and out, and fires in vacant apartments. One tenant described rats "big enough to take you away," and another told of "people on the first floor who had garbage almost in their windows."[30]

Violations as recorded and reported by a city housing inspector occupied their own indefinite space in the nebulous universe of building abandonment. Though they had legal status, they were established only as the result of action by an inspector who found and reported a specific condition that failed to meet the standards of the City Housing Maintenance Code or the State Multiple Dwelling Law. Inspections were made, with few exceptions, only in response to complaints lodged by tenants with the complaint bureau of the city's Department of Rent and Housing Maintenance. Thus, if there were no complaints, or if an inspector was not sent out, or if an inspector was indeed sent but did not witness the condition in question, or merely failed to report it, there *was* no violation. In the 27 occupied buildings included in the study in June 1970, and in the 11 abandoned buildings (as of the date of their last inspection before the issuance of a vacate order), the 38 buildings had a total of 1,398 violations; these included violations within apartments and in public areas of the buildings, and 145 were rent-impairing.[31] As the report concludes, by the time abandoned buildings were ordered vacated, they had an inordinately large proportion of the total violations and of the rent-impairing violations in the 38 buildings; however, under the city's code enforcement system, it was possible for substandard conditions to exist in occupied buildings without being listed as violations. The city's code enforcement procedure "did almost nothing to prevent building abandonment." It

merely recorded building deterioration and "began to be more or less thorough in this effort only when the end of the building was already in sight." Though the WCC's *With Love and Affection* report could determine whether building deterioration was the cause of—or the result of—abandonment, it did make clear that the maintenance of housing stock was crucial, and perhaps the crucial area of lack, in terms of preventing abandonment and providing its interviewed residents and tenants with decent living accommodations.[32]

The methods and metaphors used to describe abandonment in these early advisory reports, and in much of the governmental and journalistic literature of the period, implied—or imposed—a corporeal sensibility on the discourse about how abandonment proliferated in a neighborhood. Time and again, reports and reporters referred to an abandoned building's ability to "infest" an entire block and "cause wholesale abandonment in short order."[33] Such metaphors recall Donald Schön's notion of generative metaphors and the need to engage in critical reflection on how these metaphors are constructed, and whether they address the problems that they describe sufficiently. As Schön writes of the discourse of blight, "It is precisely because neighborhoods are not literally diseased that one can *see* them *as* diseased. It is because urban communities are not literally natural that one can see them as natural."[34] These ways of seeing are both powerful and useful, and can be used to more easily communicate difficult and troubling ideas like building abandonment. However such tacit metaphors, if not identified and critically examined as the narrative frames that they are, can distort or obscure the realities that they purport to describe.[35]

The "building-as-body" metaphor has a long history not limited to strictly architectural lines of thought—though one can certainly trace its usage back to classical antiquity and the first, most important architectural treatise to have survived, Vitruvius's *Ten Books*. But often, this discourse of "infection" bore a slightly more sinister tone than merely acknowledging a functional and proportional relationship between, say, a column's base, shaft, and capital and a human's feet, torso, and head. This discourse, which calls to mind a spreading plague, grows increasingly problematic when one also considers the ethnic composition—largely Puerto Rican and African American—of these buildings' occupants, who became inevitably associated with the physical condition of their environment, as somehow having produced it entirely. In this way, the discourses of blight, ruin, and disease that were invented to reckon with

31

the complex processes of building abandonment, if left unexamined and imprecise, could be—and often were—imputed to the *people* who were left behind in such neighborhoods, and whether tacit or explicit, was almost always racialized. This building-body metaphorical relationship formed the basis for one of many extant metaphors du jour for the South Bronx in this era: a first was a distinctly postwar trope—"like Dresden after the war." Another viewed abandonment in the Bronx as housing commissioner and proponent of "planned shrinkage" Roger Starr did: as an illness, or "a fierce malignant urban cancer." And a third saw the Bronx as "a wilderness"—a formless wasteland or, as curator Lydia Yee observes, "a blank slate on which any number of myths could be overlaid."[36]

Corporeal metaphors of illness were not restricted solely to human bodies either. In the introduction to his 1971 book *Housing Crisis U.S.A.,* Joseph Fried, a *New York Times* housing beat writer, described a politician's visit—not unlike the famous President Carter Charlotte Street stop—to the Brownsville section of Brooklyn and its "vacant and vandalized husks . . . lying like vulture-nibbled carcasses amid a herd of diseased and starving cattle."[37] More striking than abandonment metaphors befit for any nature documentary are the words of Roger Starr in a 1982 *New York Times* editorial, after having left office as housing commissioner:

> An abandoned New York tenement with broken windows is like a corpse with open eyes. The city government ultimately comes and closes the lids by nailing gray sheets of galvanized steel to the exterior frames. It hopes to discourage vandals from breaking in. But they come, starting fires and terrifying neighbors until they move. The city has no vaccines to keep ill buildings alive.[38]

Abandonment is here presented not merely as a symptom of "urban crisis" but as a kind of virulent infection of a building's "body" that threatened replication across any landscape, block, or street—an infection that, like the imagined geographic area of the South Bronx, spread from building to building, from block to block. The "lone tenement," then, functioned first as symbol, then as symptom. As concepts related to urban crisis, they were closely linked; as metaphors for ruin, they were arguably one and the same.

In this way, the very term "South Bronx" often functioned as a blanket epithet, a way of condemning an urban landscape and its people to a kind of invisibility. It was erasure by agglomeration—an ever-encroaching specter that many knew by name and, conveniently, had the luxury to

forget. It was, as Marshall Berman observed, "America's Other"—a new urban wilderness to the north against which the city to the south could define itself—and its abandoned buildings and empty lots performed urban decay to much of the rest of the world.[39] It was municipal failure concretized, but also imagined as a kind of virulent infection that presented its symptoms as ruins—an idea that could be weaponized as a threat, with suggestions of its replication across landscapes both urban and suburban. To those outside of it, the South Bronx *was* its ruins, and wherever that ruin spread—from one tenement to the next—there was a South Bronx.

## PERCEPTION IS REALITY

The building at 960 Third Avenue was photographed, around 1940, as the squat and angular six-story brick structure that it would remain until its death sometime in the early 1970s.[1] Perched at the corner of Third Avenue's intersection with Boston Road and the gentle grade of Teasdale Place, the building stood sentry on its triangular lot, overlooking a wide, busy thoroughfare in the Morrisania section of the Bronx. Like many buildings throughout the neighborhood, it was ennobled by distinctive architectural features that enlivened the profile of the neighborhood's streets. The building carried a heavy cornice and pleasantly repeating triglyphs beneath, together meeting the sky brusquely but not without grace. Sets of doubled flat columns and pediments articulated the Teasdale Place facade into three proportionally larger bays (from east to west, Teasdale to Third Avenue), leaving a thinner end bay, as if the building's encounter with the larger avenue forced its attenuation. Attractive brick stringcourses cinched the building at its waist, almost an impolitic nod at a core volume that perhaps needed slimming. A rusticated Richardsonian arch served as visual anchor for the building's mass and—with its heavy masonry span—appeared to secure it against the rising slant of the street.

The building's gesture to those who beheld it from the perspective of the avenue was forward: welcoming, unpretentious, even charming. Striped awnings, reminiscent of a barber's pole—low-slung and shading much of each window casement—decorated the upper stories. The neighboring tenements on Teasdale Place featured similarly lively awnings—indeed, many Bronx apartment buildings did. To a contemporary eye they may appear at first a jarring cosmetic extravagance—perhaps equivalent to learning that Greek and Roman sculptures were often riotously painted in azures, ochres, and various flesh tones rather than being the "pure" white marble objects that are displayed in museums today. Sifting through

archival photographs of Bronx buildings, so similarly and generously appointed, underscores how such quaint touches can be almost entirely forgotten.[2]

At ground-floor level at the cropped corner of 960 Third stood the Bronx County Trust Company. That such an establishment had ensconced itself on this seemingly cozy corner of the borough lent both real and metaphorical import to the building, tying it to its community by virtue of economic and fiduciary commitments to its clientele—"trust," in both word and deed—but also in a more concrete and physical sense. Occupying the sharply angled structure at its vertex, the bank—and by extension the building itself—directly addressed the street corner with large glass windows and a wide entry vestibule, opening itself to the world. Looking at the 1940s photograph, one can make out a few figures just outside the bank's entrance, some in short sleeves, out for a stroll.[3] The Third Avenue El is just visible in the upper-left-hand corner of the frame. The streets themselves, Third Avenue and Teasdale Place, are recognizable as cobblestone, and they, along with the building's south-facing brick facade, reflect the bright sunlight of what looks like a beautiful day.

Today, 960 Third Avenue no longer exists, either as a building or as an address.[4] Perhaps the final recorded testament to its unspectacular existence is a photograph taken by the artist Gordon Matta-Clark in 1972 (not included here) that appears in a layout for a publication proposal titled "Quadrille."[5] Shot from an angle that captures a broader swath of its wider Teasdale facade, the building takes on a more imposing air than it did in the 1940s. There are a few reasons for this. Gone are the cobblestone streets and the fanciful awnings from every window. Gone, for the most part, are the windows themselves. Crudely shattered or bereft of their casements entirely, 960 Third's windows are, in Matta-Clark's photograph, open to the world in another sense—to wind, rain, and sunlight, admitting all who would seek entrance and keeping no secrets except what lay in darkness at the building's deeper reaches. It presented as a massive husk—the literal shell of the home it once was.

For the building as photographed by Matta-Clark, privacy—as reality or concept—no longer seemed to obtain. The building's cornice still met the sky at sharp angles, yet those angles now find uneasy echoes in the jagged shards of the remaining windowpanes. The Bronx County Trust Company is no longer resident, its brass lettering stripped from above the entrance, leaving behind an oxidized ghost of its name. In its place is, or was, an establishment called the Trinity Bar & Restaurant—also shuttered.

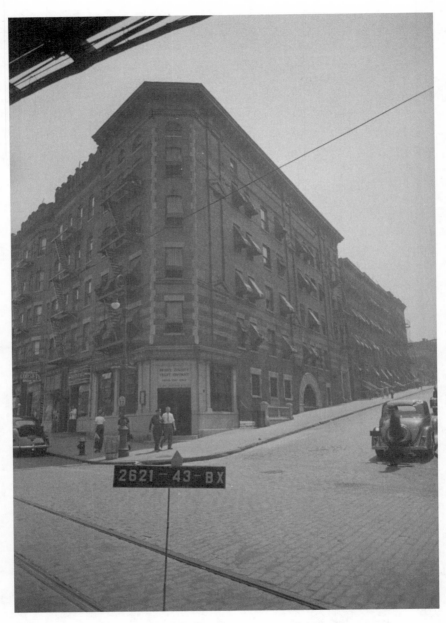

960 Third Avenue. Department of Finance, Bronx 1940s Tax Photographs,
nynyma_rec0040_2_02621_0043.

Its windows, surprisingly intact, are papered over with posted bills. In Matta-Clark's photograph, 960 Third was abandoned, left for dead. Its ground-floor windows were sealed with plywood, graffiti adorned the space under the graceful curve of the heavy masonry arch, and the building's whole form taunted the viewer with an indifferent, perhaps indecent, and certainly perverse concept of shelter. Yet, whereas once the building stood proudly over a broad intersection, it now appeared unremarkable.

To understand why, we must look to its neighbors. The adjoining building on Teasdale Place, once competing for style with 960 Third in the 1940s photograph with its own decorative awnings and slim, rounded-arch upper-story windows, was also boarded up and abandoned—simultaneously open and closed to the world. The lot that occupied the photograph's foreground is crudely fenced off, strewn with weeds and the detritus of the building that once stood there. In the lower left corner of the photograph, down Third Avenue, another six-story tenement is just visible, its windows sealed by concrete blocks. Measures of architectural distinction had by then faded from the fanciful—in the 1940s photograph—to the phantasmal here and in many elsewheres throughout the Bronx by the 1970s.

What links these buildings' facades in our visual memory is no longer an idiosyncratic flourish of an unexpected design element or a restrained version of a classical entablature on a roofline. Instead, it is the crushing realization of their unrelenting sameness and alarming abundance in the environment. Vacant and broken or burned and boarded, the condition of abandonment had grown so pervasive in New York by 1970 that buildings like 960 Third—despite their devastated condition—had become unremarkable in their ubiquity.

The story of the Bronx is, in many ways, also the story of this building. How we get from the 1940s photograph to the 1970s photograph charts a descent in the social and environmental fabric of the city so rapid and violent and widespread that isolating a solitary structure, even for a moment or simply as a metaphor, hardly does justice to the narrative. Matta-Clark's photograph of 960 Third Avenue captures the brutal end of an era in Bronx history, the halcyon vision of its 1940s facade very nearly eradicated, yet it also marks a generative point, a response, a way of looking that admits both visions alongside each other—perhaps even the two overlaid.

## Gordon Matta-Clark and Municipal Trompe L'oeil

The building at 960 Third Avenue was the site of some of the earliest of Gordon Matta-Clark's "building cuts"—performative and sculptural works of art (documented via photograph) that consisted of the artist sawing out chunks of floor, wall, door, and ceiling to admit light, to reveal structure, and to create unexpected views through the abandoned buildings (usually condemned or awaiting demolition) in which he worked. And it would be to this same ruined geographic landscape that New York City would later apply its own response in an effort to quell the proliferation of arson and abandonment. First experimented with on derelict buildings in 1981 and expanded in 1983, the New York City Department of Housing Preservation and Development's (HPD) "Occupied Look" (alternatively, "decorative seal") program consisted of painted vinyl decals that depicted a "lived-in" look of windows, curtains, shades, shutters, and flowerpots that were applied to sealed openings in a building's facade. The program had operated, until its 1983 expansion, largely by resident request in various neighborhoods, including the South Bronx and parts of Brooklyn but was eventually extended to adorn buildings along the Bronx's most well-traveled corridors—perhaps most famously, Robert Moses's Cross Bronx Expressway, the ten-year construction of which (directly through the heart of extant and vibrant neighborhoods) is largely credited by Marshall Berman and other scholars of urban history as perhaps *the* first and major blow that brought about the borough's collapse.[6] Such an intervention in the built environment of the South Bronx was, for all intents and purposes, what we might call a kind of "municipal art"—a Bronx trompe l'oeil, if you will—and one with a broadly functional purpose.

This phenomenon, the municipal government of New York City resorting to a centuries-old art historical form—the trompe l'oeil—to create discrete and illusionary spaces, bound to the sashes of a window or the jamb of a door, as a kind of aesthetic palliative to distressed neighborhoods, is both peculiar and fascinating. Hewing close to the classical ideal of the art form, trompe l'oeil sought to both deceive and delight the eye in various measures—both of which were on offer here in different degrees—and in other ways, proposed a radically different perceptive process within its particular context. Quite literally "eye-deceiver," the French term *trompe l'oeil* is commonly used to describe paintings that represent things in an especially deceptive way, so that the representation of the thing seems to *be* the thing itself.[7] Though the phrase itself first appeared

38

as a noun in 1800, the style of painting it described had a history that reached back to classical antiquity, and throughout centuries in Europe it was used to describe paintings whose imitation of the world was convincing. Trompe l'oeil can be described as "the art of portraying the unreal as though it were real, but this is only half the story—after all, every perspective painting imitates reality."[8] A great deal of the interest in and pleasure of experiencing trompe l'oeil lies not only in understanding the work's intention to deceive the viewer, but also partly, as the art historian Michael Leja has described, in the delight the viewer finds in being seduced.[9] Trompe l'oeil—its tactics, its theatricality, and its enforcement of a more studied practice of looking—is also what links these two seemingly disparate interventions in the Bronx built environment. And while the Occupied Look decals might seem at first glance a cynical deployment of this art historical form, and Matta-Clark's daring and playful alterations and "samplings" of abandoned Bronx buildings might appear, at best, an opportunistic architectural curio, it is through the figure of the trompe l'oeil that each work makes visible the material and social conditions surrounding it.

The Bronx-based work of Gordon Matta-Clark and the city's Occupied Look program are separated by almost a decade's time—Matta-Clark worked in the Bronx in the early 1970s, and the city's decals first appeared in the early 1980s. As a form of artwork, on the one hand, and what one might call "working art," on the other, Matta-Clark's work—as one of the most influential artists of the late twentieth century—has received a great deal more critical and scholarly attention than the Occupied Look decals, which existed briefly as objects of curiosity for local and national journalists during their heyday but rarely, if ever, as art historical objects. Both artworks appear here, pointedly juxtaposed, for the first time. This contrapuntal juxtaposition is designed to emphasize that the premises and implications of each stem from the same source—the Bronx built environment—and in their own ways, both projects illustrate how questions of visual perception and perspective, often relegated to the airy province of art historical or public art debates, were crucial tools in shaping the American public's daily understanding of urban environments like the Bronx. Further, both works are responses to the same condition—abandonment—in the same geographic space, affecting the same populations and physical landscapes, and not only can they be productively read alongside and in conversation with each other, but in doing so, each work illuminates the other. That is, we can, in fact, use the trompe l'oeil of the

Anthony B. Gliedman and others watching the installation of decorative window and door seals in an abandoned building. HPD Photo: HPD_1980_029_11.

city to better understand the work of Matta-Clark, just as we may witness Matta-Clark's work in many ways anticipating that of the Occupied Look, even as the work—and the artist himself—begins to imagine worlds beyond the boundaries of a simple window frame. In the theatrical spirit of looking back through a scrim to see the scene illuminated behind it, we will begin by looking at New York's municipal trompe l'oeil, through which we might understand how Matta-Clark's earlier work made use of some of the same perceptual effects and practices.

## The Occupied Look: New York City's Picture Windows

New York's growing population of abandoned buildings, by the time Ed Koch took office as mayor in 1978—the same year that Gordon Matta Clark died—had been effectively under assault by arsonists and scavengers stripping buildings of valuable, salable fixtures.[10] The city had, in 1981, inaugurated a program that sent teams of fifty fire marshals into the most affected neighborhoods to convey a strong presence to both residents and undesirables—drug dealers, scavengers, and addicts alike.

Men at a Brooklyn workshop demonstrating the decorative seal process. HPD Photo: HPD_1982_042_5.

Courtesy NYC Municipal Archives.

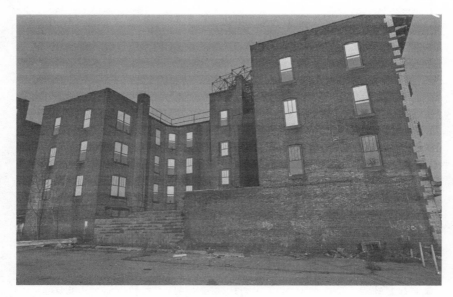

Decorative seals in the window of a four-story multiunit building in Coney Island.
HPD Photo: HPD_1984_109_7.

Courtesy NYC Municipal Archives.

Combined with another preventative program that sealed up vacant build-
ings with concrete blocks, sheets of hammered tin, or hurricane fencing
to prevent access, a reduction of arson was effected citywide.[11] Effectively
unwitting blank canvases, the surfaces to which the HPD's Occupied Look
window decals would be applied—the facades that they adorned as a form
of literalized architectural tracery—were blank, mute, and sheer, *already*
closed to the world.

The first buildings in New York to have their tin-sealed windows dec-
orated with decals were not in the Bronx but in Greenpoint, Brooklyn.[12]
Depicting curtains and shades, shutters, and flowerpots, the decals cov-
ered each window of the four stories of 89 and 93 Eagle Street; larger
decals were affixed to the sealed entryway vestibule in a simulation of
Dutch doors. According to Anthony B. Gliedman, then the city's commis-
sioner of housing preservation and development, under a $50,000 pro-
gram the city would affix this particular aesthetic solution at $6 a decal
to about one hundred vacant buildings located on otherwise well-kept and
still-residential blocks in an effort to boost local morale and prevent fur-
ther deterioration rather than to fool those who would seek to gain entry.

A spokeswoman for the department noted that the program would be reserved for "basically good blocks that have only a few eyesores. . . . We're not going to put them up on bombed-out streets. . . . [T]hat would be foolhardy."[13] However, foolhardy is exactly what some New Yorkers immediately thought of the project. In a letter to Staten Island congressman John Murphy, dated the same day that the Occupied Look first appeared in the pages of the *New York Times,* a local realtor reacted dismissively to photos of the Greenpoint experiment and, particularly, to the city's monetary commitment to it, noting to Murphy, "I just thought you might want to let the taxpayers know where their money is going. It might also be of interest to those who cannot find decent housing, since it would seem more intelligent to spend those funds to rehabilitate a building and provide housing instead of pretending that the housing exists."[14] Prompted by Congressman Murphy for a response to such objections from his constituency, Mayor Koch's reply was, characteristically for a politician fond of a quip, quite pointed in reference to Murphy's aggrieved complainant, though it is sober and well judged elsewhere:

> Commissioner Gliedman advises me that the "Occupied Look" is a community initiated program, developed and implemented by HPD as a result of the many complaints received from community organizations and residents concerning unsightly tin sealed buildings and the deleterious effects of these buildings on their communities. Particular concern was expressed for vacant buildings located on various blocks where the majority of the housing is occupied and reasonably well-maintained.
>
> HPD conducted studies which indicated that the most practical and attractive method of sealing would be to cover the galvanized tin, used for sealing the doors and windows of vacant buildings, with weather resistant 4-ply vinyl decals with pressure sensitive backing. Decals consist of designs simulating windows and doors and are used for all visible façade openings. Designs are in three pieces to allow for window size variations.
>
> Implicit in HPD's mandate to preserve housing is also the obligation to preserve and stabilize communities. We think that an expenditure of $5.50 per window for a decal that enhances the dreary tin seal is a small price to pay for a program which improves the quality of life in New York and at the same time promotes community involvement and cooperation. New Yorkers living on blocks with "Occupied Look" seal-ups tell us that they consider this money well spent.
>
> We do not claim that the "Occupied Look" is the answer to our overall housing problems. However, it does address itself to keeping our City an attractive place to which people want to move. We feel that until a vacant

building on a viable block again serves as housing for people, an attractive seal goes a long way in keeping community morale high, maintaining real estate values and stabilizing still viable areas.[15]

Enclosed with Koch's response to Murphy are "before" and "after" pictures of the Eagle Street building utilizing the Occupied Look decals. Rarely missing an opportunity to make an emphatic point, Koch ends his letter with a question: "If you had a vacant building on your block which would you prefer?"[16]

The exact origin of the experimental program is much in doubt—indeed, the original "artist" may be lost to history, if there is one hand behind the decals—but there are two competing origin stories. A 1981 Columbia News Service article picked up on the wire by the *Milwaukee Sentinel* suggested that the idea to use decals came from "an emergency repair crewman who became tired of looking at ugly tin sheets tacked up on the buildings." Supposedly this nameless crewman painted the tin sheets white, then brushed on a black cross to simulate a windowpane. The article then perhaps strains its own credulity—while affirming our capacity for wonder—by suggesting that one of the repairman's supervisors, upon hearing about the idea, drove out to the work site to have a look. Allegedly, the supervisor "drove right by the structure without realizing it was an abandoned building."[17]

This suggestive though seemingly apocryphal tale of municipal misperception (no matter how entertaining) participates in what art historian Wendy Bellion describes as a "familiar literary topos of authority figures deceived by artists."[18] There exists a rich history in many accounts of early modern art where "powerful individuals, such as kings, counts, and popes, fall prey to illusionistic pictures, professing to be tricked by images that look extraordinarily like real things," according to Bellion.[19] The crucial turn to such tales was often that this confusion—what Bellion describes as a "perceptual error"—on the part of the individual was knowingly committed in deference to the skill of the painter. While it is nearly impossible to discern from this wire service story whether the municipal supervisor's misperception was a knowing and effective bow to the illusionistic gifts of his repairman's brush hand, this potential origin story, however fanciful, still retains significance. Like the early modern accounts that Bellion describes, this Bronx tale humorously performs a similar function in that the supervisor's error illustrates precisely the effect the repairman's improvised trompe l'oeil window was supposed to have. Yet

the story also politicizes the image by implication: the representative of the state—here, the supervisor—is deceived by the power of an image created by one of his own workers. The state then, in effect, fools itself, and in doing so discovers a useful tool of further productive deception.

On the other hand, historian Jonathan Soffer suggests that Ed Koch himself may have conceived of the idea—as he did take the credit and criticism for it—either all or in part. On March 13, 1961, following the death of his mother and during a year off from law and reform politics, the young Koch applied for a patent for something called the "Simulated Vehicle Toy," which he called the "Boxmobile." The Boxmobile was a set of decals that could be affixed to a box to make it look like a car or a locomotive. Surprisingly, they did not sell well. Koch, of course, returned to his career in the law, though perhaps the window decal idea, as Soffer claims, was an outgrowth of this youthful invention scheme.[20] In a 1983 *New York Times* article, asked for comment on the decal program, Koch himself said that he had suggested the program four years earlier, as a way of putting abandoned properties "in cold storage" and making neighborhoods more livable until money for restoration became available.[21] Emphasizing even further the widespread metaphor of ruin as spreading epidemic, Koch observed, "I recognize that it will take hundreds of millions of dollars to restore all of the abandoned buildings in the city of New York. . . . In a neighborhood, as in life, a clean bandage is much, much better than a raw or festering wound."[22] Regardless of the idea's actual origin, or by what hand these designs came into being, they would continue to be controversial and would be debated in editorial pages across the nation as the program expanded and its profile grew.

Roger Starr, the then–former commissioner of the HPD, was among the first to publicly term the window decals trompe l'oeil in his 1982 *Times* editorial titled "Seals of Approval: Why Fake Art Deters the Vandals at Empty Tenements."[23] It is a masterful exercise of sustained engagement with the success and failure of the enterprise, and of satire: of public and personal reckoning with their effect on the landscape and populace, and of the costs of living in such a restless city as New York, increasingly unknowable in its entirety. "Why does this *trompe l'oeil* work?" Starr asks, a third of the way into the piece. "The sealed building is as empty with decals as without them. Its temptation to vandals, at least as great. Perhaps the vandal heart is soothed by blandishments of artifice and art."[24] Starr's view of the program's perceived effectiveness is cynical, almost to

the point of malice, yet his conclusion—which gestures at the historical fact that white flight from urban spaces like the Bronx helped hasten its decline—is worthy of consideration: "Perhaps the department has stumbled on the great secret that led people from the city to the open spaces outside it: it's easier to live next to mute lawns and hedges than alongside a building that forever wheezes, coughs and complains. Tired of trying to make them coincide, most of us may have chosen appearance as more important than reality."[25] Buried under impressive levels of sarcasm here is an essential point: the city's response to the kind of ruin presented by abandoned buildings in the form of the Occupied Look was a response to problems of vision and perception as much as it was to the present and potential dangers contained within these haunting structures. Indeed, such "fake art" revealed the extent to which aesthetics and perception played a massive part in city politics.

Yet, more broadly, one also can view the entire project and prospect of the Occupied Look as helping to define art, writ large, not only as *not at all* a frivolous pursuit or an extended exercise in genteel or esoteric "blandishments"—to use Starr's term—but also as one that, in this particular instance, had a use value that was specifically designated and endorsed by the municipal government. Two unidentified Greenpoint, Brooklyn, women interviewed on a 1980s NBC *Nightly News* broadcast segment about the program noted for viewers exactly how the decals functioned and registered in the visual environment of their neighborhoods. The first interviewee pragmatically suggested that "anything was better than looking at a shack, and the way it was, it was easy for vandals to get in; now, as this way it's boarded up and the kids stay out." The second's woman's opinion was decidedly mixed: "To me, it's beautiful, but what they spent for it, listening to the radio this morning, they should have put into renovating the houses."[26] Both responses are telling. "Art"—however fake, banal, or simplistic—was here marshaled in service of the city, to have real significance beyond its more typical domains of meaning, the symbolic or spiritual. No arguments exist attesting to these municipal trompe l'oeil as great and lasting works of art. Nor should they; one would be hard-pressed to describe them as such. What they do represent in their moment, in their milieu, however, is art, *at* work.

But what should "fake art" look like? Should it look, as in the case of the city's decorative seal program, like "fake life"? What, then, does that resemble or comprise? And, more pointedly, how might one, exactly, dress a fake window? With a casually half-opened shutter? Or a healthy house-

plant? Why even gesture at life behind the glass in the first place? Might not the simple image of an unbroken window—or a closed shutter seemingly offering protection—accomplish the tasks at hand? The artist Marcel Duchamp once offered a more ironic clever gesture in the form of one of his readymades, a French window titled *Fresh Widow*, presented as a small-scale wooden casement window made opaque by black leather—its "openings" closed to light and ventilation, its function reduced to mere association with the iconic architectural feature. Was there room for irony and avant-garde play in an art that was designed to be solely functional? Perhaps the illusionistic open shutters and verdant window boxes are meant to be taken as winking acknowledgment of what these buildings lacked. Even so, how does one illustrate such a life and, furthermore, one designed to be perceived and comprehended in a few seconds? Finally, what do we do when these fictive signifiers of life are themselves imaginary elements that perhaps never corresponded to any real inhabitants?

The program had, between 1980 and 1983, focused largely on neighborhoods where the residents themselves requested the window decals on a case-by-case basis, affixing them to about 325 buildings across the city. However, in 1983, the US Department of Housing and Urban Development made a $300,000 block grant to the city to expand the three-year-old program citywide. More specifically, the city intended to use the funds to pay for decals that would decorate the buildings that lined the Bronx's most heavily traveled arteries, which included the Cross Bronx Expressway. "The image that the Bronx projects—and projects to potential investors—is the image you see from that expressway, and our goal is to soften that image so people will be willing to invest," said Robert Jacobson, director of the Bronx office of the City Planning Commission. "Business people," he continued, "make decisions on perception." The value of perception here took two distinct forms: one was monetarily quantified in Jacobson's conception, and the other was articulated by Commissioner Gliedman: "I recognize that this is superficial . . . [b]ut [rebuilding] will take years and require tens of millions or hundreds of millions of dollars. And while we're waiting, we want people to know that we still care. . . . Morale is very real. . . . Perception is reality."[27] The centrality of neighborhood residents' self-perception to any evaluation of the program's success cannot and should not be ignored—there were still, after all, six hundred thousand residents of the South Bronx living in and among these ruins—though critics of the program often did just that in

its day. Indeed, one wonders whether, as Mayor Koch himself observed, the only error lay in calling "the dressing for these [urban] wounds 'decals'" and not "*trompes l'oeil*" instead.[28] The mayor's comment—particularly the pointed art historical reference—was lodged with perhaps a great deal of his characteristic wry venom, but it, like Starr's, is revelatory if we remember trompe l'oeil's long, ancient heritage.

That we find it employed even in rudimentary form in the ruined Bronx of the 1980s is perhaps not so strange or surprising at all. In fact, as Norman Bryson has observed, trompe l'oeil's very history "essentially comes to us as a ruin"—that is, partly in fragments of painted *xenia* (a category of still life mosaic) from Roman villas buried by the explosion of Vesuvius, "minute fraction[s] of the still life of antiquity."[29] Much in the same way that Bronx ruins have often been compared, along a historical continuum, to Dresden, 1945, to San Francisco, 1909, and so on, so, it would seem, can the trompe l'oeil that decorated their facades. And though it may be somehow fitting, painfully ironic, or both, together, that this relationship between ancient *xenia*, which depict a "still life" of antiquity, and the stilled life of abandoned Bronx apartment buildings endures, what is significant is that it does—the two are inextricably linked. Bryson's characterization of these images painted on Roman villa walls as depicting "things standing still" rather than "still life" is more than faintly echoed in Koch's impassioned defense of the decorative seal program as a neighborhood stabilization tactic to stave off further abandonment while also attending to the morale of local residents. If a kind of stasis of both physical structure and social self-perception was indeed the intended goal, then perhaps trompe l'oeil—with all its spatial, conceptual, and especially temporal dimensions that productively complicated the process of perception—was the perfect solution.

The decorative seals were, however, not viewed without criticism; in fact, such criticism was legion. Local and national newspaper columnists took to damning the program with quotes from outraged Bronx residents in tow, and often with unreserved glee. The city was building "Potemkin Villages" in the Bronx, some claimed; others declared that the government was committed to pretending that a "deceased section of the city" still hummed with life; some asserted the decals were more of an embarrassment to New York than the condition of the South Bronx itself; and still others pointed to a myriad of other uses for the money than on such a superficial solution.[30] Clever residents of the Crotona Park neighborhood, through which the Cross Bronx Expressway makes its way, cleverly sug-

gested that the program ought to be expanded to provide designer clothing decals to place over the ragged apparel of impoverished neighborhood denizens, or offer decals of strip sirloins for them to eat. One *Los Angeles Times* article positively frothed with delight at being able to respond to "Eastern critics" of Los Angeles and the movie studio false front as "metaphor for the sham of life in our cultural wasteland" with the rejoinder "Look who's living behind false fronts now."[31] However, the author gradually reveals that, despite the often vicious criticism of the program, he "sees nothing meretricious in giving these Bronx apartments an occupied look"—in fact, his only quibble with what he positively identifies as trompe l'oeil is with the program's actual aesthetics. The vinyl windows, depicting venetian blinds, shutters, potted plants, or drawn curtains, were deserving of criticism not because they were fraudulent but because, to his mind, they were ugly.

The thought of Hollywood back lots, filled with the painted and wooden facades of drugstores, barbershops, saloons, and clean, well-lit rows of apartment building stoops, in aesthetic conversation with New York's trompe l'oeil window project is a provocative one, with implications for our understanding of how these decals functioned, both in conception and in practice. What was their "site" proper, and how did they functionally transform the space around them? At Eagle Street, the decals seemed to operate as classical architectural trompe l'oeil; that is, they are painted panels that are representations of a "real" architectural feature—a window, a door—and that also open up a fictional space receding beyond the plane of the panel itself. Most often, classical architectural trompe l'oeil decorated interior walls, floors, and occasionally ceilings, yet the spatial imagination of these window decals conjured an interior space, and state of occupancy, from an exterior viewing point rather than the more common illusionistic exterior landscape imagined from an interior space.

These were, indeed, "paintings-as-windows," as Leon Battista Alberti would have seen them, suggesting not only an architectural interior but also a healthy domestic interiority to what were, in reality, husks. But whose domestic interiority was it? The renderings of flower boxes and shutters were banal almost to the point of blankness—extraordinarily basic, rudimentary representations of simple objects against a background that faintly gestured at depth behind it that one might even describe as, yes, ugly, or at the very least unconvincing. Yet how else to represent, to simulate life? Even so, these shutters were still merely an imitation of life as formerly lived—a ghost of the past, a two-dimensional version of the

striped awnings that once decorated 960 Third Avenue, fading memories that remaining residents of the South Bronx might have trouble recalling or believing ever existed at all.

Whereas a Renaissance interior might imagine fanciful double doors to open up an otherwise bare wall, bringing illusionistic light into a room, the Occupied Look decals were imagined windows *on* windows, painted doors *on* doors. The frame here is the basic unit of space, creating a literal picture of habitability and domesticity—a rudimentary theatricality sketched in a few strokes.[32] The "fabricated superficiality" of an entire Hollywood false front here appeared in miniature and, in its application to the exterior of a real abandoned Bronx building, had the effect of allowing the entire facade—the entire building—to be read as a false front as well. Conceived of in the aggregate, the decals might be said to have turned neighborhoods of the South Bronx, at forty miles per hour from the Cross Bronx Expressway, into the equivalent of Hollywood stage sets. The parallel is hardly unmerited. As Anne Freidberg observes, the architectural window frame has also been viewed, historically, as a proscenium whose "edges hold a view in place."[33] And, as Hubert Damisch has chronicled in *The Origin of Perspective,* the effects of trompe l'oeil have long been inscribed within the histories of scenography and stage design since the Renaissance and the architectural perspectives of Sebastiano Serlio and Baldassare Peruzzi, among others.[34] Impressions of theatricality are therefore not at all strangely divined where trompe l'oeil is concerned, yet the scale of deception intended by the window decals—located in public, on the city's often-gridded streets, creating an indelible intervention within the built environment because of their peculiar interaction with it— suggests effects of magnitudes greater than what might be accomplished with conventional stage backdrops. The relationship between the Hollywood studio back lot and the western "ghost town"—both of which share the figure of the facade, whether false or left derelict, as a common vernacular language—finds an analogue in the Bronx's decal-adorned abandoned buildings. Whether calling it "theatrical," "superficial," or merely ugly, both the staunchest proponents and detractors of the Occupied Look alike might agree that its most curious and haunting effect was never the gesture of masking of Bronx ruin but, rather, conveying the false impression to those who drove by at great speed that no one lived in the South Bronx at all. After all, as Robert Jacobson observed, "Behind those [abandoned] buildings are 600,000 residents of the South Bronx. There are 100,000 to 150,000 jobs here."[35]

Group posing in front of an abandoned building sealed with decorative window and door seals. HPD Photo: HPD_1980_029_16.

Yet it is precisely that quality of perception-at-speed that illuminates yet another dimension of the decals' mechanism of deception—namely, that of the temporal. As Wendy Bellion describes, and as has been discussed in part here, there is a kind of "picture time possibly unique to *trompe l'oeil*"; that is, the image "prolongs observation by inducing wonder, beckoning inspection, and tempting the proof of touch."[36] This is time spent looking, questioning, admiring the trompe l'oeil object, perhaps even investigating the nature of what, exactly, appears before one's eyes. This "picture time" would, of course, differ for the pedestrian and the driver, and for those who lived near a building with decorative seals and those who were merely passing through, contracting and expanding the spectrum and duration of responses to the illusion.

Yet the Occupied Look also presented viewers with a kind of visual paradox—a contradiction in terms and in time. If the decorative seals were intended to preserve abandoned structures from vandalism and other ills, to achieve a kind of stasis that resisted entropic forces until the structures could be improved or demolished, then the picture that they presented to the viewer was one that placed stasis—in the unchanging, infinite moment of the trompe l'oeil window—alongside the disorder of the building that housed it. Within these windows time was, in effect, frozen while its ravages were more evident in the structure that surrounded them. This achieved, from the viewer's perspective, a rare temporal effect—a kind of paradoxical simultaneity of vision that charted both the progress of time and its uncanny arrest.

In either case, these bizarre senses of temporality engendered by the Occupied Look decals are, in many ways, already part of the logic of trompe l'oeil. That is, the nostalgic tone of the images and objects depicted therein and the attempted stabilization of an idea of the past against the passage of time and the wages of decay are as in line with the strategies and themes of trompe l'oeil artists like William Harnett and John Frederick Peto as they are with the architectural trompe l'oeil of classical antiquity. In their endeavor to arrest decay within their neighborhood setting, the Occupied Look decals—like the work of Peto and some of his contemporaries—acknowledge the rapidity of passing time, just as they register a sense of an active viewer passing by and processing their images while on the move.[37]

It is fitting that these issues of perception, perspective, illusion, and theatricality induced by the intervention of the Occupied Look into the city's built environment were not only located but also contested within the public space of the street—within the context of the everyday. The street, by the

early 1970s, had become a popular arena in which to situate works of art and from which to critique media, culture, and cultural institutions, particularly the museum.[38] Artists like Christy Rupp, whose public interventions into New York City's streets famously included wheat-pasted, life-size images of rats on trash-filled streets (which took on greater meaning in the context of a three-week garbage strike) in her 1979 piece *Rat Patrol*, and Gordon Matta-Clark, whose interventions in the city's built environment we will encounter presently, purposefully located their work in or near the communities or environments upon which they commented, stripping away layers of what scholar Claire Grace deems "aesthetic distance" and engaging more directly not only with everyday life but also with social activism and political confrontation.[39] New York's own artistic intervention into its city streets in the form of municipal trompe l'oeil decals could be seen in some respects to participate in this trend, yet its contribution is peculiar.

In one sense, the program was a keenly offered solution to the desperate problem of building abandonment that affected communities throughout the city. But in another, the very mechanism by which it operated—deploying illusion, theatricality, and deception to counter an already calamitous public perception of areas like the South Bronx—supplied its critics with the very arguments that might be used to attack its efficacy. Yet, in putting the Occupied Look into artistic context with the work of an artist like James Casebere, whose photographed miniature architectural models are staged and lit like movie sets engendering what art historian and theorist Hal Foster calls "reality effects" that are "suspended in a no man's land between model and referent, fiction and document," we can also see exactly how unique this project, its program, its method of operation, and its site were in its day.[40] The Occupied Look's own "reality effects"—placid scenes, pictured in windows, yet unsettled by the surrounding decay—placed representation immediately alongside reality, each enforcing a slight distortion of the other and perhaps suggesting a further disruption of our own perception of the two.

## Anarchitecture: Gordon Matta-Clark's Bronx Trompe L'oeil

On July 10, 1971, Gordon Matta-Clark wrote a letter to Harold Stern, the assistant commissioner of the New York City Department of Real Estate. The letter began with purpose and politesse: "In regard to the many condemned buildings in the city that are awaiting demolition, it . . . seems possible to me to put these buildings to use during this waiting period.

Recently I called Mr. Jones . . . of the Real Estate Dept. asking if it were possible to rent a building or some space in a building . . . from the city. He suggested I write you stating my needs."[41] Matta-Clark outlined his artistic pursuits and practices, noting his interest in "turning wasted areas such as blocks of rubble, empty lots, dumps into beautiful and useful areas," and made reference to his contributions to a sculpture show underneath the Brooklyn Bridge, which he suggested helped arouse interest among the other participating artists "in learning of the abandoned areas of New York." This was one of a series of letters Matta-Clark would write to various city government officials, public art and design consultants, real estate board members, college art museum curators, nonprofit organizations, federal grant programs, and even a building demolition concern that specialized in explosives—all in search of soon-to-be-vacated or otherwise abandoned buildings within which he might work. Stern's response, as was the case from many of Matta-Clark's addressees, was not forthcoming. The artist would, of course, eventually take matters into his own hands.

Even before his encounter with the South Bronx and 960 Third Avenue, Matta-Clark had demonstrated a sustained engagement and multifaceted fascination with waste, urban detritus, the forgotten, and the left behind.[42] One of twin sons of Anne Clark (later, Alpert) and the Chilean surrealist Roberto Matta-Echuarren (they broke up soon after their sons' births), Matta-Clark spent time as a boy in Chile and Paris but grew up in the ambience of New York modernism, with artists like Robert Motherwell and Isamu Noguchi as frequent guests to his home. The artist Marcel Duchamp was, reputedly, his godfather. Trained as an architect in Cornell University's five-year undergraduate program, Matta-Clark returned to the city of his birth to work as an artist some time after graduation and— most important—participated there as a volunteer assistant in the *Earth Art* show at Cornell's White Art Museum (which featured artists such as Robert Smithson, Dennis Oppenheim, Walter de Maria, and Hans Haacke).[43] In the time between his return and his premature death in 1978 from pancreatic cancer at the age of thirty-five, Matta-Clark's work was consumed with the idea of decay—exploring its many physical and social manifestations, contending with its particular dangers, and imagining often fantastic and dreamlike alternatives in response to its seemingly rapid spread throughout the urban geographic environment.

For the "Brooklyn Bridge Event" that Matta-Clark refers to in his letter (organized by Alanna Heiss, then program director of the Municipal Art Society), the artist contributed a few pieces. The first, titled *Jacks* (1971),

consisted of piled-up junk cars on automobile jacks and other debris scattered beneath the massive two-story piers of the bridge and photographed by Matta-Clark himself.[44] A second, alternatively titled *Fire Child* or *Fire Boy*, was a filmed part-installation, part-performance piece that featured Matta-Clark constructing a wall of trash from on-site debris then layered into a wire-mesh frame (which "recycled," in effect, an earlier work: 1970's *Garbage Wall*, subtitled "Homesteading, an Exercise in Curbside Living") alongside documentary-style images of Manhattan's distressed Lower East Side landscape, its itinerants, and its homeless.[45]

Matta-Clark was hardly alone in his notice of abundant refuse as a proliferating urban environmental condition; indeed, it would have taken a near complete breakdown of the senses to avoid the sight or stench of garbage in New York at that time, as only three years earlier large parts of the city were waist high in it. The nine-day sanitation workers' strike of 1968 left an estimated ten thousand tons of garbage to accumulate each day on the city's streets, prompting the *Times* to describe New York as "a vast slum as mounds of refuse grow higher and strong winds whirl the filth through the streets." Mayor John Lindsay noted that the condition of the Lower East Side—which encompassed the location of the "Brooklyn Bridge Event"—was "the worst" that he had seen.[46] The site underneath the bridge was, according to Matta-Clark's widow, Jane Crawford, "basically a dump" anyway, and served as a microcosm of a widespread condition—an accumulation point for obsolescence, for the discarded, and for scavengers who were forced to sift through, and live in, similar junk piles.[47] Matta-Clark would engage both implicitly and explicitly with New York's relationship—at times intimate and otherwise oblivious—to its own waste products in works such as 1972's *Open House,* an open-air, interior space of variously-sized rooms constructed inside of a dumpster, and *Freshkill,* a short film chronicling the final hours of the artist's own red panel truck named "Herman Meydag," driven out to Staten Island's Fresh Kills landfill, where it was summarily smashed by a bulldozer while seagulls scavenge the massive dump's nigh-postapocalyptic landscape.

The drive from Fresh Kills to Melrose and Morrisania in the Bronx is almost always interminably long, no matter by what highway—or in what decade, for that matter—one makes the trip. In the early 1970s, however, these two seemingly disparate environments were perhaps closer in their respective evocations of decay—one intended, the other not—than their location on a map might suggest. Matta-Clark's own trips to the South Bronx from SoHo traversed not as great a distance as that from Fresh

Kills, but rather importantly, neither were these urban landscapes then as physically dissimilar as they appear today. SoHo, as is well documented by scholars like Sharon Zukin, was hardly always the tony monument to retail and multimillion-dollar loft living it is today. Rather, it was a former industrial zone that had housed textile factories and other light manufacturing concerns in cast-iron buildings that by the late 1950s had been largely abandoned and left derelict. But neighborhoods to the immediate south were similarly abandoned as well.

In the late 1960s, a government-initiated program of enforced abandonment and planned demolition—in a large-scale urban renewal project that later included the construction of the World Trade Center—erased what in many cases was a pre–Civil War neighborhood of Lower Manhattan. Thrust into a physical purgatory of sorts—almost entirely vacated, crumbling, and awaiting the wrecking ball—Lower Manhattan's collection of collapsing and demolished structures, "fossils of a time past," was captured powerfully by photographer Danny Lyon in his 1969 book, *The Destruction of Lower Manhattan*.[48] In many cases, the "macabre views that resulted from chance overlappings of partially and wholly demolished structures" as described by curator and scholar Lynne Cooke closely prefigure the building cuts (and resultant photographic documentation) that Matta-Clark would soon perform in the Bronx.[49]

As a native New Yorker who grew up in downtown Manhattan and moved back after returning from Cornell, Matta-Clark would have been familiar with this section of the city (both pre- and postabandonment), perhaps as well acquainted with it as with the Lower East Side that made it into his film *Fire Child*—and to which he would return with later work. To be sure, the idea of ruin interested Matta-Clark throughout his relatively short artistic practice: unpublished personal photographs from a personal trip taken with his then partner, Carol Goodden, to the western and southern United States frequently depict empty, decaying shells of buildings, windows open to the air, absent roofs, buildings that are mere frames for the landscape and sky beyond, and which appear more as if they are growing up from their rocky outcroppings rather than collapsing into them.[50] The photos are, seemingly for Matta-Clark, akin to sketches, figure studies composed by the ravages of time and nature's hand, interrupted and captured by his camera. They depict the 960 Third Avenues of the American West.

It is of no small importance when considering Matta-Clark's New York work that his upbringing was that of a native New Yorker; indeed, he

claims as much in a 1977 interview, responding to a question about why he was so attracted to "unattractive and derelict" situations: "The first thing that has to be considered is the fact that I grew up in New York in this kind of environment. . . . It is the prevalence of this wasteland phenomena that drew me to it."[51] New York meant something to him, and to see it in such a state was cause for concern. His widow, Jane Crawford, retrospectively attested to Matta-Clark's affinity for and geographic mastery of his home city in a 2003 lecture, noting his "great empathy with the city and its derelict buildings" especially in the areas in which "people weren't interested."[52] Time and again in his letters and artist statements, Matta-Clark himself reveals this profound concern for what then was an imperiled city, expressing a very real belief that the city was locked in a process of decay, hastened at its fringes where the poor, destitute, recently migrated, or soon-to-relocate dwelled. "I would like to say that New York," he wrote in a 1976 letter to Franco Raggi (a designer, artist, and former editor of Milan's *Casabella* magazine), "compared to any other major center, is looking in a far worse state of maintenance and development than any European city. The sociocultural conditions here are in such an advanced state of disintegration that I feel, more than ever, to have done the blighted waterfront of New York a service by my 1975 summer project," referring to his celebrated cutting of a New York City pier, called *Day's End*.[53]

Matta-Clark's concern for and fascination with the geography of New York is further evidenced by his collection of maps, partly for unrealized projects and partly for his own edification. His papers from 1970–1978 contain a surfeit of highway, topographical, population density, neighborhood, and subway maps of the city, occasionally annotated, and certainly worn with use.[54] His facility with the geography of New York fueled his explorations in the urban metropolis, often meticulously documented in his own photography. One such sortie chronicles a drive north from Manhattan to the Bronx on the Major Deegan Expressway, underneath the wild concatenation of bridges, exit and entrance ramps, and cloverleafed highways that occurs near the Highbridge section of Manhattan, as Interstate 95 becomes the Cross Bronx Expressway.[55]

In one of his most well-known typewritten statements theorizing his artistic practice, Matta-Clark relates the performance and documentation of his building cuts directly to his keen awareness of the perilous state of many of the city's neighborhoods and his own critical view of the city's solutions to the growing problem: "Work with abandoned structures began with my concern for the life of the city of which a major side effect

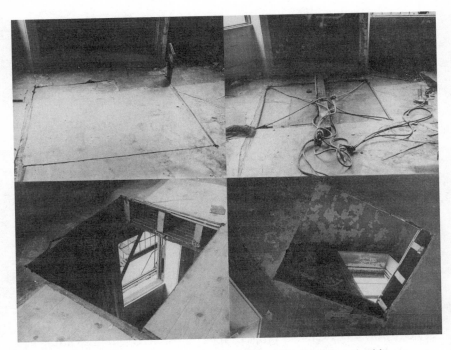

Gordon Matta-Clark, *Bronx Floors: Threshole*, 1972. Sculpture [building fragment left from the work "Bronx Floors," in which the artist modified a building with various cuts], 74.3 × 105.4 × 29.2 cm.
© 2019 Estate of Gordon Matta-Clark/Artists Rights Society (ARS), New York.

is the metabolization of old buildings. Here as in many urban centers the availability of empty and neglected structures was a prime textural reminder of the ongoing fallacy of renewal through modernization." It was, according to Matta-Clark, the "omnipresence of emptiness" that drew him to neighborhoods like Morrisania or Williamsburg, Brooklyn. It was "abandoned housing and imminent demolition"—which also brought photographer Danny Lyon to Lower Manhattan—that brought Matta-Clark to 960 Third Avenue in the Bronx. In another typewritten statement of the same year, Matta-Clark would underscore this sentiment: "As a native New Yorker my sense of the city as home runs deep being full of an honest regard for its state and the quality of life available there, while also as a long time student of architecture and urban design my attitudes are still keener as regards an awareness of prevailing conditions and the need for improvement."[56]

Matta-Clark's Bronx building cuts at 960 Third and elsewhere are well known to art historians, architects, and urbanists alike and have been lauded for registering, in their dissection and preservation in sections of floors and walls what amounted to accreted layers of information, of history, and of a past seemingly hastened by the threatened present. It was Matta-Clark's contention that people leave behind evidence in the places that we inhabit, in his words, "like a layer of skin on the walls of the buildings in which we occupy," and by cutting through the walls and floors he was "exposing the layers of history down to the heart and bones of the building."[57] His sensitivity to the large-scale and widespread urban condition of abandonment is visible in the very gesture of exploration of what he called "New York's least remembered parts." It is the revelation of the human residues of time recorded in peeling linoleum and well-trod floor paneling—the impressions and traces of those who were there, but are no longer—that, in part, personalize sculptural artifacts that also presented a universalized aspect of urban decay. In this way, one might view Matta-Clark not merely as an "urban archaeologist" but also as a kind of archivist who, with ramshackle precision, extracted samples of rapidly deteriorating sections of the city as both testament to and protest against the prevailing urban condition.[58]

The *Bronx Floors* fragments themselves, first installed at 112 Greene Street in 1972 along with a series of colored photographs of decaying exterior walls taken in the Bronx titled *Walls Paper,* presented as curious objects. As scholar Pamela Lee describes, the artist displayed the pieces vertically, "partially enabl[ing] the fragments to begin to read as sculpture—and not yet quite." Lee perceptively reads the "garish linoleum surfaces that covered the floorboards" as being made the object "of a certain visual scrutiny, each layer a kind of historical stratum to be discerned and parsed by the careful spectator," neither "obscur[ing] the ground upon which they stood nor conceal[ing] their former use" but, rather, establishing a correspondence between "floor and floorpiece."[59] In considering Matta-Clark's sampled floor fragments, we might think back to, and think through, Bryson's characterization of how, in part, we have encountered trompe l'oeil across history— "essentially . . . as a ruin"—in fragments of painted walls rescued from ruined Roman villas. Those "minute fraction[s] of the still life of antiquity" are here replicated in Matta-Clark's modern architectural artifacts of the stilled life of an abandoned tenement—empty, nearly forgotten, waiting to be demolished. The "garish linoleum surfaces" featuring ornamental flower blossoms and fanciful patterns then look even more as if, perhaps through

Gordon Matta-Clark, *Bronx Floors* [Detail: Wall hole], 1972. Building modified by cutting holes in walls, floors, and ceilings.
© 2019 Estate of Gordon Matta-Clark/Artists Rights Society (ARS), New York.

ancient eyes, they might have been sampled, if not from Pompeii, certainly from a location whose continued existence was so under threat that it partly suggested the idea of extracting them in the first place.

Recognition of the centrality of such contextual "residue" to Matta-Clark's Bronx work was, however, not always thus. A 1973 *Artforum* review of an exhibition of *Bronx Floors* questioned whether "a section of wall, a hunk of floor or ceiling (depending on how you look at it) becomes a work of art when it is transferred to the setting of a gallery." Dismissive

of the installation space itself, 112 Greene Street—the SoHo gallery space run by Jeffrey Lew and in part reclaimed from the former manufacturing warehouse it once was by Matta-Clark's own architectural know-how—the critic noted how the work "looks like the sites from which his pieces have been removed," thereby making it difficult to see his work as art. Here, and in a lengthy discussion (reprinted just below) of whether the pieces have any worth as art objects or indeed any at all, Matta-Clark's critical point—which, indeed points at the invisible, ignored sections of the city with its very title as well as the people bound to such casually forgotten landscapes—is perhaps made, inversely and at the critic's expense, more succinctly than if he could have uttered it himself:

> There is also the problem of whether we want to see the chunks of squalor he has resurrected and is recycling for us. Or not; and whether they have any meaning for us as art objects. Their shaping is crude and determinedly careless. The materials—dirty lath, crumbling plaster, old wallpaper, linoleum, worn floor boards and rotten beams—are common and ugly in themselves. Still they testify to the fact of the existence of the various people who had contact with these surfaces over the years, which is of touching associative interest. The "poesie" of all those lives spent hoping and despairing, etcetera, registers on the gallery visitor as fast as a campy interest in the wallpaper's vintage and the quality of the linoleum pattern.[60]

That the "touching associative interest" engendered by a momentary consideration of those whose residential environment was akin to a postwar wasteland could be reduced, as so much hope and despairing, to an "etcetera" might have angered Matta-Clark if it did not so perfectly illustrate the critical and political pose that his work was calculated to upset.

Even despite Matta-Clark's avowed beliefs about contextual residue and his own artistic intentions here and in subsequent cuts, the removal of these "chunks of squalor" certainly pointed to—in the language of Rosalind Krauss in her 1977 essay "Notes on the Index, Part 2"—the buildings both in the Bronx and in similarly affected New York neighborhoods from which they came.[61] But, as sculptural objects displayed in downtown galleries, the inherent social, economic, and racial exclusions that, in effect, created the raw material for the artist's samplings weren't always immediately apparent to audiences or, at worst, became even further obscured. Beyond Matta-Clark's and some of his collaborators' own glancing mentions of encountering either police, or drug addicts seeking out shelter in an abandoned structure while he was carrying out the work of *Bronx*

*Floors,* there is little evidence that Bronx residents from the neighborhoods the artist visited saw any of Matta-Clark's building cuts in fragment or photographic form, either in the Bronx or displayed downtown. Yet when compared with other artists of the era who located work in the Bronx— take Richard Serra's 1970 installation *in* a city street, *To Encircle Base Plate Hexagram Right Angles Inverted,* on 183rd Street and Webster Avenue—such lack of an audience seems less inconspicuous, and more a product of the difficult character of the neighborhoods within which they were situated. Serra himself rather coldly dismissed the borough entirely in a 1980 interview in *Arts Magazine:* "The place in the Bronx was sinister, used by the local criminals to torch the cars they'd stolen. There was no audience for the sculpture in the Bronx, and it was my misconception that the so-called art audience would seek the work out."[62] Serra's dismissal notwithstanding, the problem of engaging audiences who reside in the areas of the city from which one draws not only inspiration but also raw material was real. In some ways, Matta-Clark's building cuts faced much the same question as the Occupied Look window decals: Can one adequately represent the lives of the people who lived within these walls and behind these windows? If so, how? And what *can* we see in Matta-Clark's windows, if not the bodies and persons who once walked through these now ruined structures? Perhaps the question ought not to be *what* it was that Matta-Clark's work allows us to see, but rather *how.*

*Bronx Floors* did not merely make visible to other sections of the city the tenements that were falling into ruin; Matta-Clark's Bronx building cuts suggested—or, rather, revealed—an entirely novel form of perception *through* and *between* structures. If New York City's painted picture windows were indeed trompe l'oeil, designed to fool the eye, then Matta-Clark's own reconstruction of interior space—the removal of doors, floors, walls, and ceilings and the creation of unexpected views, concordances, passages, and pitfalls—too, fooled the eye. Yet, his work bears a more complicated relationship to trompe l'oeil as well. In the theatrical, experiential on-site encounter one might have had with his Bronx building cuts (no longer—if ever—possible in person), but especially in the photographic representations of their locations that documented their effects, Matta-Clark's Bronx works establish a dialogue with the perceptual processes of trompe l'oeil that at once replicates and subverts these processes, playing within and without its games of deception and revelation.

To sketch this particular likeness of visual and perceptual systems requires a brief sojourn to ancient Rome. As Norman Bryson has observed,

the tilework of ancient Roman floor design was often engineered with the goal of producing a certain perceptual uncertainty with regard to the depth of field. Patterns that deliberately confused the sense of the pavement as an opaque, solid foundation underfoot were chosen, enhancing a sense of "downward recession" and often suggesting that the entire surface would open "down into a void."[63] A similar kind of perceptual uncertainly is at play in Matta-Clark's floors, where this sense of vertigo is made all the more precarious by the very removal of that "foundation"—a portion of the floor itself—offering the very real threat of an unexpected plunge to the floor beneath. This precariousness is doubled, in a sense, by the far-from-legal presence of the artist working in abandoned buildings such as these in the first place. Their effect in person would have been immediate, forceful, and extraordinarily destabilizing, and these effects are replicated in the artist's photographs. Moreover, the visual affinities between the effects present in Matta-Clark's photographic documentation of his Bronx work and the characteristics and conventions of architectural trompe l'oeil—and indeed, of the Occupied Look—perhaps are more clearly seen when one considers Matta-Clark's *Walls Paper* as a companion piece to *Bronx Floors*. After all, both were executed over a similar span of time in 1971–1972 in the Bronx and were installed and displayed together at 112 Greene Street.

The version of *Walls Paper* that appeared at 112 Greene Street consisted of Matta-Clark's colored and serialized photographs of Bronx walls developed on newsprint, taped together in long strips, and hung vertically from ceiling to floor along one of the gallery's long walls. Lee describes Matta-Clark's chosen mode of display as registering "an acute correspondence between walls and wallpaper," which served to "throw the still functioning site of the gallery into a certain relief, locating the outmodedness of a building elsewhere by reproducing the structures of its walls on another building's surface."[64]

Yet Matta-Clark's work here demonstrates correspondence not merely between walls and wallpaper but with other forms of a building's surface decoration as well. In these almost window-sized newsprint sheets—upon many of which were printed images of shattered windows and dilapidated exterior walls—Matta-Clark presents a partly comic, partly tragic version of architectural trompe l'oeil: the faded, bleached qualities of its prints suggest and even resemble similarly faded frescoes found on the ruined walls of classical antiquity. They are modern—and perhaps even mocking—versions of architectural trompe l'oeil painted interiors that might depict

Gordon Matta-Clark, *Walls,* 1972. Gelatin silver print. Print: 15×20.75 inches, 38.1×52.7 cm.

finer moldings or elaborate traceries, or suggest a view to some imagined exterior space. Matta-Clark's *Walls Paper,* too, imagined exterior space within an interior, yet these were far from idealized images; rather, they were all too real. Machine-printed wallpaper had, since the nineteenth century, made it possible for most classes of society to afford the luxury of such decoration, however cheaply it may have been produced, though its ability to "transform a living-room into a bucolic garden" was extremely limited.[65] Matta-Clark's *Walls Paper* aped that form and gesture of "bringing the outside in," but that outside was far from bucolic. In view of the Occupied Look window decals, Matta-Clark's improvised wallpaper stands as a neat inversion of their form and gesture: rather than imagined bucolic exteriors featuring neat shutters and windowpanes that prompted one to look past while preventing entry, one finds instead in *Walls Paper* the real ruin of the city brought inside.

In looking at the photographs of Matta-Clark's *Bronx Floors,* at first glance, the work seems to forgo attempts to fool the eye at all. It allows you to, quite literally, see *through* a ceiling or floor where before there was only a fixed boundary, revealing what was hidden, making visible the methods and materials of construction, while making unsubtle the interplay between private and public. It takes architectural

trompe l'oeil's directive to open up a fictional space beyond that which is set by the architecture itself one step further by creating that space behind, beyond, or just beneath. Yet there is a way that an encounter with a work like *Bronx Floors: Threshole* (only possible today through its attendant series of photographs) plays with both the classical conventions of perspectival painting and those of trompe l'oeil as well.[66] The famed metaphor of the painting as a window through which one views scenes that are suggested behind the membrane of the picture plane can be traced back to the fifteenth century and its inventor, the Italian architect and theoretician Leon Battista Alberti.[67] Architectural trompe l'oeil—to draw an important distinction between it and a trompe l'oeil canvas painting that might render an object on a two-dimensional surface, suggesting a three-dimensionality that appears to move "toward" the viewer—proceeds by Alberti's metaphorical mechanism, simulating and suggesting a world beyond the surface, "in the window." Matta-Clark's work might be said to perform a similar function, drawing the viewer into the "window" that he himself has fashioned in the structure, creating space with no membrane, a world with no veil through which to gaze.[68]

It is in this process that the comprehension of his work might entail a kind of double mechanism akin to the cognitive operations associated with architectural trompe l'oeil. It first "fools" the eye in the sense that the view presented through a ceiling seems immediately and radically unconventional (if not impossible), which causes the viewer to doubt one's own perception; subsequently, it confirms the truth of the viewer's first instinct: that there does indeed exist a world on the other side of the crudely fashioned cutout window. The deceptive, dizzying views engendered by Matta-Clark's cuts would be followed quickly, in turn, with a sense of delight in the viewer (not to mention Matta-Clark as well, who spoke of his work often in seemingly ecstatic bursts of excitement) at the surprise, the freedom of structure created by the cut.

Trompe l'oeil, as Wendy Bellion observes of it, "anticipates the spectator's gaze, even as it attempts to evade detection." Matta-Clark's Bronx cuts perform the first of these processes, tempting the viewer to comprehend the disorientating "image" framed by the cut, gesturing at both deception and revelation.[69] It is within this space of time, during this spell of perceptual labor that oscillates from curiosity to confusion to eventual discovery and delight, that both Matta-Clark's art and trompe l'oeil work. If part of the trompe l'oeil painter's aim was to achieve, as Bellion writes,

"a synthesis of picture and environment that works to persuade viewers of the reality of the scene," then Matta-Clark's Bronx cuts are an early example in his oeuvre of the same impulse: they place the outside inside, and "reality" is everywhere—both inside and outside the frame.[70] The frame, in fact, activates the scene: it both delimits the view through to the space beyond while remaining part of the viewer's environment, a rudely fashioned hinge linking foreground and background that works to distort the viewer's sense of each.

Additionally, there is a temporal element that subtly complicates the experience of perception. Walking about the interior space of 960 Third and seeing the shift from architectural wall to cut window or floor to floor below, always effecting a literal crossing of thresholds, one also perceives a similar shift of tempo, a kind of quickening as foreground and background—the frame and the space beyond it—are brought closer together in that instant in a manner that is unique to the cut's effect. The move is dramatic—almost wholly theatrical—and entirely predicated upon the desire to transgress the boundaries of structure, to overcome the physical limits of an architectural interior in order to expose that space to what lay just beyond it. If the Occupied Look presented its viewers with a temporal contradiction—stasis alongside entropy—then Matta-Clark's Bronx cuts both exaggerated and complicated this framework. Having made his cuttings "as guerilla actions" illegally, largely from buildings scheduled for demolition, the work's on-site existence remained contingent upon how long the building stood.[71] The condition of the structure that contained the work was always under threat, its lifeline precarious, proceeding toward entropy and certain "death," yet the frames created within its walls—and documented in photographs—captured views that served to effectively "freeze" time and perspective at a single point, an infinite moment. These "reality effects" might then be seen as combining syntaxes—of architecture, of language, of rates of decay and relative stasis—that are rarely put in conversation with one another. In vertigo-inducing views through walls and ceilings we see fragments of sentences and of lives, futures and pasts, thrust against each other, approximating much the same paradoxical simultaneity of vision that New York's municipal trompe l'oeil seemingly achieves.

Indeed, the "fake art" of the Occupied Look finds yet another analogue in Matta-Clark's own *Fake Estates* project of 1973. *Fake Estates* involved the purchase of slivers of land that Matta-Clark termed "gutterspace" or

"curb property," which in actuality were microparcels of land whose odd shape and location often resulted from the occasionally arbitrary or random property line drawing of a surveyor or city planner.[72] Similarly forgotten, abandoned, and sometimes inaccessible as the buildings Matta-Clark mined for his cuts, they are representative of the artist's interest in the "space between" buildings, structures, properties—an interest characteristic also of his "Anarchitecture" collective also active at this time—and in transgressing those spaces, looking and moving through and between them. It is the inaccessibility of these spaces, as Pamela Lee observes, that is central to their interest to the artist, having noted Matta-Clark's excitement at their being described as "inaccessible" when he first bought them at auction: "spaces that wouldn't be seen and certainly not occupied" is how he describes the *Fake Estates* plots—a description that could equally be applied to the abandoned Bronx buildings where Matta-Clark worked. Yet it is in the concept of inaccessibility as suggested by *Fake Estates* and *Bronx Floors* that one again finds parallels to New York's municipal trompe l'oeil project.

Designed as decoration for masonry- or tin-sealed abandoned buildings, a central feature of the Occupied Look was inaccessibility—indeed, it prevented access—even if its initial visual promise, in the image of an open window, was one of interiority. The decorative seals were, like both Matta-Clark's Bronx cuts and his slivers of near-useless real estate, a kind of artwork staged in the middle of the city, yet somehow still difficult to access. In a similar way to Bronx residents for whom a downtown art gallery might seem "inaccessible" for reasons of perceived class or cultural distinctions, the Occupied Look decorative seals were just as inaccessible for downtown populations: there were few who sought them out as would an audience, and indeed, to be overlooked was part of their design program. It was this quality of the overlooked, the left behind, that so fascinated Matta-Clark.

Finally, there is a way here that the Occupied Look decals might be thought of as creating "Fake Estates" themselves: not only do they take the form of what Roger Starr termed a "fake art" of imagined, placid domesticity in its painted windows, but when employed wholesale upon the facades of buildings, the program enforced these structures into a kind of stasis or, at the very least stabilization, essentially converting what was once a lived space and real property to false fronts—props fit for a movie or, at least, fake real estate. The Occupied Look illustrated a nostalgia for a time seemingly long past, a time that had been captured in the 1940s

photograph of 960 Third Avenue, and then reimagined within the window frames of the Bronx's abandoned buildings forty years later.

Like the municipal trompe l'oeil program, Matta-Clark's Bronx-born work productively complicated the process of perception—indeed, the very ways that we see and perceive ourselves in relation to an urban space as vast and multifarious as New York—simultaneously referencing peripheries and populations that might otherwise be forgotten, while conjuring elsewheres that are suggested just beyond their frames. If architectural trompe l'oeil could be said to open up a wall or a room—perhaps even making the wall "vanish entirely"—then Matta-Clark's work cleverly literalizes this notion.[73] His building cuts reconstituted the viewer's relationship to the actual architecture of the building, suggesting and creating new relationships beyond the limits imposed by the plane of the wall or floor. Any deception on the part of Matta-Clark or his windows, liberated through the Bronx's abandoned buildings, is partly the result of the excess of reality revealed at the limits of one's vision.

In some ways, both projects also encapsulated much the same problem that the idea of the "South Bronx," writ large, presented. The South Bronx was more a symbol of a particular kind of crisis than an actual place in the minds of many. If one was not careful in one's consideration, the ruins of the borough, captured in countless photographs, journalistic accounts, films, and other media of the era—like the municipal trompe l'oeil window decals and Matta-Clark's disembodied building cuts—might overshadow, if not entirely obscure, the lives still lived within. Yet, paradoxically it was works like the Occupied Look, like Matta-Clark's *Bronx Floors,* designed in their own highly specific ways to deceive, confuse, astound, or present a kind of inaccessibility of various forms, that, rather, enforced a confrontation with ruin, forced the viewer to look and look harder and to notice how real the ruin that surrounded it was. The assumption that the South Bronx was nothing but devastation was a false one; the Occupied Look and Matta-Clark's Bronx cuts were, in their own idiosyncratic ways, attempts to change that image.

## *Window Blow-Out:* Matta-Clark, Lost and Found

Around 3:00 a.m. on a December night in 1976—four years before the first vinyl window decal would be applied to a New York building— Gordon Matta-Clark shot out the seven windows that lined the wall of the Institute for Architecture and Urban Studies in Manhattan with an

68

air rifle. Within each window casement he placed one of a group of photographs of apartment buildings—some abandoned, some occupied, but all with broken windows—that he had taken on a recent drive through the South Bronx. Windows in broken windows, the gesture should be by now familiar. The next morning, when the fellows of the institute arrived at its West Fortieth Street brownstone, they were not pleased. The architect Peter Eisenman, a fellow and then the institute's director, likened the scene to *Kristallnacht*. When Matta-Clark arrived later that day for the opening, the glaziers had already repaired the broken windows, and his photographs were neatly wrapped in brown paper and string. He was not invited in.[74]

For Matta-Clark, the heavily theoretical work of the "New York Five" also included in the show—that of Eisenman, Richard Meier, Charles Gwathmey, and Michael Graves—represented the kind of architecture that he had grown to despise: a "paper architecture" of refined drawings and models, not at all engaged with its immediate urban contexts or the communities it was intended to serve. Matta-Clark's pictures were intended as a rejoinder to the conceptual urban solutions on offer; they were nothing if not snapshots of urban wounds and were a concrete model of the desperate housing conditions found only a few miles northeast of the institute. They were also a (literally) cracked premonition of the Occupied Look, and—as Matta-Clark was ever an impish artist—made rather neatly and concretely absurd the idea of "pictures-as-windows," yet again "made visible" the conditions in the South Bronx.[75] It was also a more violent reapplication of an approach that he had taken with his 1972 *Walls Paper*, which consisted of photographs of exposed walls in buildings that had been partially torn down around New York, printed in soft-colored hues on newsprint and installed on the wall (hence the punning title) at 112 Greene Street accompanied by cuttings from *Bronx Floors*. In any case, the institute's near-instantaneous repairing of the windows, as the art historian and critic Thomas Crow has observed, made a critical point in a manner perhaps better than Matta-Clark might have hoped: if a state of such small-scale devastation was intolerable to Eisenman and his colleagues, why was it tolerable as the status quo for nearly an entire borough?[76]

If you look hard enough around any city today, you just might find a version of an Occupied Look decal.[77] After all, the process of securing vacant and abandoned buildings—which, conveniently, did not simply disappear after the South Bronx began to walk the long road to seminormalcy—is by now so rote that books are written on the subject.[78] "Aesthetic boarding" is now one of three suggested "Alternative Approaches to

Securing Vacant Properties"—the other two being "'hurricane' fencing" and "prohibitive boarding." To wit:

> The idea of painted boarded doors and windows to make the building look more appealing was pioneered in the city of New York during the 1980s, when the boards on many apartment buildings were painted to give a crude impression of occupancy to the buildings. While New York City's program was widely derided at the time as a vain attempt to camouflage a disastrous situation, the idea, if well executed, may have value. The quality of the aesthetic treatment is critical. A crude or unattractive treatment that fools no one may be no improvement. An attractive, professionally executed treatment may help mitigate some of the harm of the abandoned property and discourage vandalism and break-ins.[79]

It is, in many ways, haunting that the legacies of both Gordon Matta-Clark and the Occupied Look—both bound up almost entirely in the buildings that they either adorned or "sampled"—are, like those same buildings, almost nowhere to be found. The original Occupied Look decals have surely been lost to demolition or the scrap heap (presumably after rehabilitation), and only Matta-Clark's photographs and films, assorted artifacts, and the removed sections of floors, ceilings, and other cuttings exist as evidence of his ten-year artistic output. You cannot today visit a site-specific Gordon Matta-Clark work of urban art as you might a museum, though, if you are curious, one "site" of his work does still remain intact, though entirely renovated. And it has a Bronx address.

On the corner of 147 Street and St. Ann's Avenue is 550 East 147th Street, a development of the New York City Housing Authority, now known (or at least listed in its register) as the Betances Houses. It is among the more recognizable structures photographed by Matta-Clark for *Window Blow-Out*—the familiar dark brown brick of New York City housing projects, humanized by its smaller-than-typical five-story scale. Its windows, if you were to walk by them today—unlike in 1976 when Matta-Clark photographed them, or 960 Third Avenue's in 1972–1973 for that matter—are still intact.[80]

# 3

## DEATH AND TAXES

Of the destruction of the city of Berlin after 1945, the writer Wolfgang Schivelbusch offers two imagistic modes of thinking. "To the historical-romantic gaze," he writes, "[Berlin] appeared as a field of wreckage of antique greatness, timeless like the Forum Romanum." Conversely, "viewed in a modern-surrealistic way . . . one could see in the image of shattered houses and ruined streets not eternal witnesses of transience, but the slain victims of a destruction still recent and reeking." These were, in his words, "ruins of uncanny life."[1] Seemingly contradictory, both ways of looking at a devastated city admit, in actuality, more than a little of each other's method into their own visions. What unites them is the idea that life—uncanny or not—once drew breath there. Somewhere between myth and history and between destruction and its aftermath lay the ruins of the lives that once inhabited these buildings and walked the streets surrounding them, their narratives embedded in each pile of rubble and every structure left standing. Those narratives are made ruins too, and they are just as present in each vision of the city—whether that vision is romantic, surrealistic, or even coldly empirical—and they are made manifest in the documented evidence of what is left behind.

Yet the condition of urban ruin finds its most typical and immediate visual register in the broken-down or barely enduring facades of buildings, rather than in the figures of those buildings' inhabitants. "Ruins" are, to the popular imagination, crumbling concrete walls or masonry worn smooth by time and a thousand hands touching; bricks gouged out by the elements and internal pressures; entire streets devastated by shifting earth or rushing waters. Ruins are the Acropolis, they are towns abandoned by drought or disease, and they are countless postwar landscapes, all defined by their detritus. The writer Rebecca Solnit urges us to think

of ruin in two stages: "One is the force—neglect or abandonment, human violence, natural disaster—that transforms buildings into ruins. . . . The second stage of ruin is the abandonment or the appreciation that allows the ruin to remain as a relic—as evidence, as a place apart, outside economies and utilitarian purposes, the physical site that corresponds to room in the culture or imagination for what came before."[2]

As we have seen, it was a combination of neglect on the part of landlords, the "planned shrinkage" of municipal infrastructural maintenance, arson, and a host of other economic and social factors that collectively produced the ruins of the South Bronx. However, as Solnit observes, "the great urban ruins" have been situated on what is real estate, rather than sacred or hallowed ground. They are, even despite their condition, real property, owned and operated by a landlord, "constantly turned over for profit" in Solnit's terms, and part of the economic landscape of the city—and consequently assessed, valued, and taxed as such. In this way, urban ruins and real estate are inextricably linked. And in the South Bronx of the 1980s, New York City's Department of Finance provided illustrative and meticulously archived proof of this assertion.

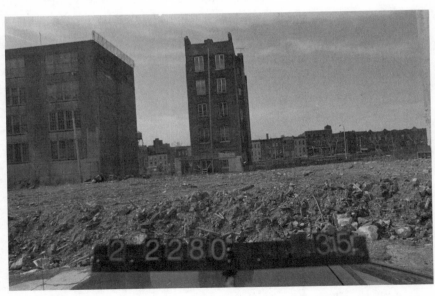

458 East 136 Street. Department of Finance, Bronx 1980s Tax Photographs, 1983–1988, dof_2_02280_0035.

Courtesy NYC Municipal Archives.

72

From 1983 to 1988, data collectors in the Department of Finance photographed the entirety of New York's streets—from the vacant lots in the ruins of the South Bronx to the canyons of office buildings in downtown Manhattan—resulting in more than eight hundred thousand photographs. It was "Street View" twenty years before Google ever drove its cameras down a city street, cataloguing building after building, avenue, boulevard, and cul-de-sac. It was a project that did not merely imagine the totality of the image of the city but endeavored toward—and succeeded in—capturing it. Known in New York City municipal governmental documents as the exceedingly specific Real Property Tax Card Record System for Computer Assisted Mass Appraisal, these "tax photographs" were captured and archived as systematically, and perhaps prosaically, as the collection's title might suggest. Stored using an example of that era's leading-edge, if not lasting, technology—the laser disc—this was in 1988 the largest collection of archival photographs on videodisc in the world. And, as befitting a collection of photographs of real estate that, by extension and with regard

George Bellows, *The Lone Tenement*, 1909. Oil on canvas, 91.8×122.3 cm.
National Gallery of Art (U.S.), Washington, DC, United States, 1963.10.83.

73

to the South Bronx in particular, was also a collection of photographs of ruins, one encounters within it a multiplicity of striking images.

Consider, for instance, the Department of Finance's photograph of 458 East 136th Street in the South Bronx. A photograph of a devastated landscape, yes, but it was primarily conceived of as the visual supplement to a municipal record—part of a system designed to keep account of and appraise each parcel of real property in New York City. What was already a grand exercise in counting was lent, by photographs such as this, a visual dimension—a systematic practice of looking. Photographic documents like that of 458 East 136th Street are hard evidence that blocks and lots and sites of ruins have not yet, as Solnit describes, fallen out of "the financial dealings of a city." Yet, as is often the case with figures of ruin, they are also suggestive of previous images and representations of ruins from the realms of history, art, or even personal experience that we are perhaps also familiar with. To wit, alongside the photograph of 458 East 138th Street, consider George Bellows's 1909 painting *The Lone Tenement*.

Bellows's painting depicts an orphaned tenement building, an architectural straggler in a landscape in the midst of redevelopment. Figures huddle around a fire in the foreground with the span of the Queensboro Bridge looming above. New York's past and future are collapsed into a single, crowded frame: what is there now, and what makes way for what is to come. The painting reveals Bellows's sensitivity to change in the urban environment as the disorder represented by the figures crowded around the ash can below is seemingly tempered by the beautiful light of the setting sun warming the top story of the tenement. In the Department of Finance's photograph, our eye is drawn immediately to a similarly stranded building in the center of the composition, seemingly floating atop a sea of rubble. As in Bellows's painting, the archive's photograph demonstrates a similar sensitivity to urban environmental upheaval, engaging with disorder and beauty as a matter of civic obligation and duty, here fiscally to the municipality of New York.

The two visual images encapsulate well the tension between these two kinds of "ruins of uncanny life." Additionally, these two images appear to, also uncannily, resemble each other. One looks at the photograph of 458 East 136th Street and can see shades of Bellows's 1909 painting. Both carry more than faint whispers of a building's impending doom. If we look at Bellows's *The Lone Tenement* long enough, we might even see it through Schivelbusch's "historical-romantic lens": the figures in the foreground

dwarfed by the tenement, itself diminished by the monumental piers and beams of the bridge.

The scale here is reminiscent of that in the work of neoclassical French painter of ruins Hubert Robert and of his older contemporary, Italian printmaker Giovanni Battista Piranesi, both of whom imagined scenes where ruins of classical antiquity towered over the human form.[3] In this way we are, as Schivelbusch imagines, brought temporally back to the Forum Romanum in but a few steps. The colossal piers of the Queensborough Bridge, suggestive of Roman aqueducts, stand in absurd contrast to the tenement's whisper-thin form. We look at both images and see not merely an art historical lineage of forms, and not merely an architectural lineage of tenement construction and destruction; we also need to note the *way* of looking itself—a way of looking at the built environment that draws upon previous visions and images of our surroundings, images that form the visual vocabulary for this highly referential language of looking. Together, they constitute a visual dictionary of reference and allusion whose entries are inscribed in stone, in paint, and within the photographic frame.

Yet, if we "read" the Bronx photograph in the manner of a tax assessor, looking first at the title card that confronts the viewer with address and location, and then at the advancing sea of rubble in the foreground, a different realization is forced. It is, for the tax assessor, the empty plot of land and this cresting wave of bricks that are the photograph's intended subject—not the slender structure that draws our visual attention. In fact, the lone tenement of the tax photograph is mere background to the field of detritus in the foreground.

There was little romantic about 458 East 136th Street for its residents. Between 1970 and 1981, the Bronx lost more than 108,000 dwelling units, or one-fifth of its housing stock, to abandonment, arson, or demolition, amounting to one-third of the estimated 321,000 dwelling units abandoned in the entire city. Life was hardly romantic for the figures in the Bellows painting six decades prior either. Transients or perhaps even lone tenement dwellers, their environment wasn't any less harsh or abrasive. Destruction is, in the crumbled brick on the Bronx sidewalk and in the smoke wafting up to the span of the Queensboro Bridge, "still recent and reeking."

To ask which way of looking at such images—as either an "assessor-archivist" or an art historian—ought to take precedence is, perhaps, to ask the wrong question. Like ruin and real estate in Solnit's conception,

they are inextricably linked. Rather than interrogating the value of looking or not, or at which vision carries more import, what is most important here is the act—the method of looking itself. That is, one ought to be sure to "look *both* ways" and see these modern ruins in their long art historical context of "ruin-gazing" while also never losing sight of the fact that such environments were not yet archaeological sites but rather scenes of recent environmental upheaval or decay.

This chapter attempts to sketch a schematic, or framework, for this method of looking—to explore the many avenues of this dual-purposed ethic of viewership—while setting that framework within and alongside the story of the place depicted: the South Bronx. It reads some of the more evocative examples from this municipal photographic archive both independently and alongside the South Bronx–based work of professional photographers Jerome Liebling and Roy Mortenson, in part to describe the extent to which a visual archive can be read as art and, inversely, how self-consciously artistic works can be read in the archival or documentary modes. Attendant to those readings, the chapter also views the municipal photographs within long art historical contexts and alongside more recent strains of conceptual, "factualist" photography of the 1960s and 1970s whose practiced mode of dispassionate empiricism and drive for a brand of "total representation" approaches that seen in the product of the anonymous Department of Finance's "tax photographers." I see the tax photo project as possessing a double-functioning element, to borrow a term from the architect Robert Venturi: it's a still-accessible archive that can be read specifically as an archive of Bronx ruin, and can therefore serve as an episode in the history of visual culture.

Yet, the photographs also serve as proof that "ruin" was a condition that did not define the borough in its entirety. The photographic archive and its semiautomatic, perhaps even boring, processes, likened here to the experiments of modern conceptual artists and photographers, importantly—and counterintuitively—helped to puncture the myth of the sameness of urban ruin and to resist the synecdoche that imagined a single tenement standing for an entire borough and its people. In this way, the archive's double function allows for the recovery of the actual life of Bronx residents, largely African American and Latinx, many having recently immigrated to New York, that existed within and around the photographic frame. Taken a step further, the chapter also suggests that this systematic, administrative, archival mode—which would seem to prefer to dispense with or elude narrative entirely with the disinterested eye of the building

census taker—actually brings the archive into a surprising alignment with narrative, the narrative of a city, of a place, and of a people living amid ruins. That is, the empirical here—no matter how much it intends to avoid narrative subject matter—becomes rather productive of the empathetic, demonstrating through countless examples from the archive just how embedded both in these images and within ourselves is our need to contextualize, historicize, and ultimately narrativize the world around us. Looking at this photographic archive of a city's ruins suggests that whether we are aware of its historical or visual forebears, we will always implicitly search our internal image bank for *The Lone Tenement* or something like it when confronted with an image of a lone tenement; it is an impulse toward narration that is as seductive as it is impossible to ignore. By measuring the dimensions of this municipal photographic project against professional, "high-art" projects that are themselves mindful of long art historical and architectural contexts, we might also draw the outlines of a practice of looking at the city while employing this dual vision.

In photograph after photograph of building after building, what consumes our thoughts is not the physical ruin that is often displayed but rather our impulse to note even the most minute of human interventions in these spaces—the subtle triumphs of African American and Latinx populations to subsist in these environments—and then to narrativize these minor revelations of life. It's rarely the decaying facade that fascinates and affects as much as it is our recognition of the object as a visual register of time passing in the world and in ourselves. What's more, in a collection of images that often depict depopulated environments, traces of human elements emerge with greater force, personalizing the photographs in a way that suggests, and often confirms, a presence, however haunted or real. Of course, when humans do enter the photographic frame—especially in an archive whose elements have been organized and serialized by geographic address and can therefore be viewed sequentially—narratives take shape that are bound in everyday realities as opposed to imagined myth.

The "administrative mode" that characterizes the process, the presentation, and even the spirit of the municipal archival photographs of the South Bronx produces a connection to its buildings and built environment that was not merely fiduciary. Indeed, these municipal photographs, by virtue of their status as documents of real property, as evidence of ownership, and as testament to not only the existence but also the appraisable value of the South Bronx—despite its ruins—bound it and its inhabitants to the administrative and economic systems of the city, ensuring that these

spaces and places and people could not be left behind. In other words, the municipality's own efforts toward "total representation" had the consequences of assuring that the South Bronx could not pass entirely into myth.

## Real Property: Building a Census of Buildings

The primary mission of the New York City Department of Finance is the collection of all city-administered taxes. In addition to this duty, the department is charged with "the responsibilities of inspecting and assessing, for tax purposes, all real property in the City and with managing and safe-keeping all monies paid into and out of the City treasury."[4] The mandate is abundantly clear: inspection and assessment, acquitted as expansively and exhaustively as possible. If any governmental body need be associated with the execution of two large-scale photographic documentary projects, the Department of Finance might be the last one anyone would associate with such a task. However, it was the creation of the 1940s collection of tax photographs that made it possible for tax assessors of that era and subsequent ones to more accurately track demographic changes in New York. This was precisely because the images of each building served as "visual parallel[s] to census data."[5] Yet by the early 1980s, the 1940s collection was sorely in need of overhaul.[6] Its currency as useful reference for the city's assessors had been far outstripped by the pace of transformation of the city's real property.

On September 7, 1978, Mayor Ed Koch signed Executive Order No. 19, which mandated the "physical re-evaluation of all real property within the boundaries of the city at 100% full value."[7] The order has the air of a papal edict, though the city government's proclamations were rarely carried out with the same supreme efficiency. The implementation of the order did not take immediate effect but instead would "require a major commitment by the Department over the next four to five years." It was expected that in addition to various outside consultants, "fifty to one hundred new employees" would have to be hired "to perform the re-evaluation procedures according to the rules of the State Board of Equalization."[8] The total estimated cost of the project was between $30 and $50 million.

What had become clear to both the Department of Finance and the city government at large was that reappraisal was necessary, but not merely because the city's real property image bank was out of date. According to the 1977 Census of Governments, New York City had the fourth-worst record of dispersion of property tax assessments of the thirty largest cities

in the country.[9] A study of the city's real property tax policy prepared by the Graduate School of Public Administration at New York University deemed the current "non-system"—in its words—of assessments "hideously inequitable." In assessing the poor state of city assessments, the authors of the report were similarly blunt in their condemnation: "They produce a vast amount of litigation; they accentuate the decline of troubled neighborhoods and properties; they create an aura of uncertainty about prospective tax liabilities that surely must marginally discourage new investment; and they enormously complicate the task of determining full value for all the constitutional and statutory purposes for which that is required."[10] By 1980, the system of real property assessments was so broken, so out of step with current market values, so racked with a lack of uniformity within and among property tax classes that it could, according to the report, "fairly be described as a classification system with 830,000 classes—each parcel of real property . . . its own class."[11]

Revamping the system in its entirety became, then, not only desperately needed but also a point of pride for a city that "was once the best-governed of large American cities," now left to ponder its own embarrassment at the depths to which the system had sunk. The costs of correcting numerous other deficiencies of the city's infrastructure—the cleanliness of the streets, the educational performance of its schools, the suitability of its housing stock—were enormous compared with the cost of installing a system of fair assessment of property tax. The report's principal recommendation advocated that the city "move as quickly as possible to implement a new assessment system in which all real property is assessed at market value, with the assessments kept up to date each year with the use of computer-aided mass appraisal techniques and any other methods necessary to do so."[12] These recommendations were implemented within the next year.

By April 1981, Department of Finance commissioner Philip R. Michael had separated the Real Property Assessment Bureau into two divisions: the Real Property Assessment Division, which was charged with overall responsibility for the assessment of the 850,000 parcels of real estate within the city, and the Division of Equalization and Planning to oversee and enhance the more research-intensive aspects of assessment.[13] In addition, Michael authorized a pilot project for computer-assisted mass appraisal in the Bronx and Staten Island, of which the photography project was to be an important part. The Bronx pilot project was fully operational by January 1982, with five thousand property records, and provided the

assessment staff with access to physical and sales information that enabled them to analyze and update data quickly while also allowing for the calculation of both full market value and a tentative assessed valuation—a marked improvement over the "non-system" formerly in place.[14]

As computing power and computers' ubiquity increased, city governments and archivists alike began to rely upon them for an increasing number of tasks.[15] Thus the story of the 1980s tax photographs, which were an integral part of this new computer-assisted assessment initiative, in addition to being born out of a fiscal need for fairness and equitable distribution is also a tale that charts a technological shift, a leap in the capacity of the archive to record and more rapidly catalogue and access information at a time when the end product of that information—property tax revenue—was sorely needed by the city.

What, then, did this new system look like? And how did it function? Was there a method to the madness of cataloguing the entirety of a city as massive as New York? The municipal government had grand hopes for what was then a technologically advanced system. Not only would a well-designed system allow for accurate determinations of value that might assure an equitable distribution of the tax burden, but computerization also would allow for the instant retrieval of records, of which each property's photography played a central role, thereby allying a kind of instantaneous vision with the goal of precise valuation. Taken together, these dual modes of perception might be read as producing an intensification of vision in the outcome of each photographic act. That is, each tax photograph is a record of two operations associated with seeing: apprehension and estimation. The first plainly documents the appearance of the city's built environment; the second provides a means to monetize that very vision, giving what one might call the "currency" of the image a real economic analogue.

## Reel Property: Shooting the South Bronx

That the municipal government of New York City carried out a documentary project of such unprecedented scale—the systematic photographing of every building, block, and lot in the five boroughs—is perhaps not surprising. In fact, the city completed it twice. Between 1938 and 1943, sponsored by the Works Progress Administration (WPA) and during the Great Depression, the city made more than seven hundred thousand black-and-white photographs of every piece of New York real estate for the purpose of a fairer and more equitable property tax assessment.[16]

Forty years later—again in the midst of a recession that had wreaked a different manner of catastrophe upon New York—between the years 1983 and 1988, the Tax Department updated its body of what became more commonly known as "tax photographs," this time in color, consigning the previous collection not to the dustbin but to the Municipal Archives. The 1980s tax photographs have now, too, been relegated to the archives but, just as the 1940s collection sees lively and continued use by both scholars and sentimentalists, the 1980s photos have been given their own new lease on life. The entire collection of more than eight hundred thousand photographs—first extracted from the rolls of 35mm film used to shoot each borough and recorded onto laser discs in 1989—is now digitized and easily searchable on the archives' website.[17] The 1940s images capture New York in the process of leaving its nineteenth-century shell of tenements and row houses behind; those in the 1980s collection—particularly those photos produced of the Bronx—depict, with the same systematic and process-oriented eye, a more catastrophic historical moment in the city's history.[18]

The photographs that populate the collection were taken from 1983 to 1988 with Staten Island being the first borough to be captured and catalogued. At the peak of the project, there were sixty people in the field, working in teams of two as photographers and data collectors. Whereas the project's earlier, federally funded iteration—in which WPA work relief assignments were based on an employee's work history—required the hiring of professional, experienced photographers to satisfy what the government defined as a "skilled, non-manual Class III worker" to secure full funding, the 1980s project had no such restrictions. In fact, the Department of Finance went out of its way *not* to hire professional photographers. Photographers, on the whole, want to take good photographs. The Department of Finance, a rather obviously cost-conscious municipal entity, wanted fast photographs. Therefore speed, rather than any intrinsic aesthetic value, was prized above all in the project. It would seem that any aesthetic pleasure that *did* register in the photographs was incidental—perhaps even accidental. And though the department expressed preferences that affected the policies and procedures for the taking of photographs, there was no figure at the department comparable to Roy Stryker of the Farm Security Administration, editing the photographic results for objectionable content.[19] Speed, however, was an aspect of the process that was actually welcomed by some photographers. Given that the project was required to photograph the entirety of the city, photographers often

traversed crime-ridden neighborhoods. Their solution, rather than potentially lose their equipment, was to occasionally refuse to leave their cars to take pictures, preferring to shoot them, seated, through their car's windows.[20]

To view these photographs, to spend hours lost down foreboding alleyways strewn with trash and old furniture, with empty, darkened buildings large and small, with vast open fields of undulating rubble, is to confront the ruins of a city that, though seemingly struck here by some unfathomable cataclysm, was not entirely abandoned. Life lingers at the edges of these images: men and women hustle out of frame or linger just long enough to cast a cool eye at the camera, children improvise games in otherwise deserted streets, dogs roam free through the urban wilderness. What is surprising about this vast collection of views of the Bronx is how—in a project born entirely out of practicality, executed by municipal employees in the most pragmatic of fashions, and intended strictly to achieve a public good—a particular, though perhaps unintentional, aesthetic emerges. It's an aesthetic so workmanlike in character that it seems to refuse identification with ideas of style, beauty, or the sublime. But it's only in the process of immersing oneself in this agglomeration of images that one discovers their capacity to record, to suggest, to seduce, to repel, to instruct, to confound, and to create narrative where seemingly only absence reigned. It is an archive where the mechanistic never entirely forecloses the spiritual, and the condition of urban ruin that it catalogues is only one of many shadow archives of the urban scene contained within. It's also an archive that, unlike the tax photos of the 1930s and 1940s due to the excellent work of the architectural historian Gabrielle Esperdy, has received little scholarly attention to date, and none that—in the manner of art historian Robin Kelsey's *Archive Style*—examines the aesthetics of the archive.

The art historian and theorist Hal Foster suggests in a footnote to his article "An Archival Impulse" that "perhaps, like the Library of Alexandria, any archive is founded on disaster (or its threat), pledged against a ruin that it cannot forestall."[21] Given the Bronx's peculiar case of empirically documented ruin in the midst of a city, perhaps the archive and the ruin are, as Foster wonders, linked by the former's ultimately futile attempt to forestall the latter's advance. Whatever the case may be, it becomes apparent upon sustained viewing of this Bronx archive that even a photographic project whose intended use was as a municipal document forces fissures in the frameworks that were designed to contain it, and forges—at the broken places—new networks of associations, of forms, of

styles, of perspectives, and of meanings. It is an archive whose most inter-
esting actor is chance, and it is out of that chance that narratives emerge.
And it is in the multiplicity of images that depict what lies beside, within,
or even without the ruin—where the continuities of life within the city as
a whole reside—that the archive performs its greatest function.

## Every Building, Stripped: The Bronx Tax Photo in History

The impulse to capture such an assemblage of views of a city—ruined or
not, resplendent or ravished—is one that participates in a much longer
history. One could trace the roots of such a class of images as far back as
Dutch or Italian *vedute* (cityscapes) of the sixteenth through eighteenth
centuries through the evocations of Roman ruins in the work of French
painter Hubert Robert; to American George Barnard's photographic
chronicle of Sherman's March through the Civil War South; to Berenice
Abbott's dramatic depictions of a rapidly modernizing New York; to
Danny Lyon's views of a soon-to-be-leveled lower Manhattan in the late
1960s; to Ed Ruscha's urbanist-completist's dream of an artist's book,
*Every Building on the Sunset Strip* of 1966.[22] Many individual images here
unconsciously draw from the same deep repository of art historical im-
agery. The 1980s archive, itself an exercise in rephotographing the city's
many properties, can be thought of in context with the 1977 Rephoto-
graphic Survey Project of rephotography pioneer Mark Klett, who located
the vantage points of nineteenth-century photographs of the American
West and reframed them with his camera a hundred years later.[23]

The tax photo project as a whole was nothing if not an effort at total
representation: What else could one call a project whose goal was to col-
lect photographs of all of the 901,860 parcels of property that made up
the five boroughs of New York City? And the tax photographs, along with
their accompanying property cards on which all of the building data would
be recorded, offered their own small-scale brand of total representation:
image, combined with metrics of measurement, classification, structure,
use, and the building's relationship to its surroundings, displayed their sub-
jects in as full a measure as could be possible.

A similar impulse for approaching, or at the very least approximating,
total representation—not to mention also experimenting with what could
be called archival, administrative, and "fact-finding" practices—could be
divined in the photographic work of certain artists of the late 1960s and
early 1970s that makes for instructive comparisons at certain points with

the 1980s New York tax photo archive. One such artist, whom the art historian Joshua Shannon suggests created works that were "models for a total representation rather than instantiations of it," is the American conceptual artist Douglas Huebler.[24] For his *Variable Piece #70 (In Process) Global,* Huebler proposed to photograph "everyone alive . . . to the extent of his capacity."[25] Based on Huebler's proposal toward such an effort, which the art historian calls "delightful and funny," Shannon contends that "a truly exhaustive mode of representation—even if it were possible—would not only be useless but also painfully uninteresting."[26]

If one considers the archive a comprehensive "picture" of the five boroughs of New York City, then perhaps the Bronx tax photographs prove a rare example to the contrary; they are anything but uninteresting. Indeed, Shannon observes that Huebler's insistence on including a profusion of "empty" facts in a seeming refusal of any kind of artistic significance was in actuality a "teasing submersion or diffusion of it." Huebler knew that a "purely factualist or materialist representation of the world . . . was impossible." Projects like his that, as a pose, either conceived of or gestured at total representation—without ever quite achieving it—would always be, in Shannon's words, "loaded with the qualities they tried to reject."[27] Huebler himself would admit "obliquely at least once to a lyrical or romantic quality in his work," and his *Variable Piece #70,* much like the similarly process-oriented municipal tax photographs, "cannot help but provoke our desire to narrate and hierarchize experience," to organize and make sense of the world through narrative, metaphor, allusion, and parallel. Shannon suggests that whatever "intriguing dynamics" we might see in Huebler's intentionally dull photo projects, or indeed in all pictures, are the product of our own subjectivities and are thus "imposed and may be erroneous," but that they are also necessary and, perhaps also, inevitable.[28] The same would then be true for the tax photographs. Despite their original intent as mere supplementary tax records, as photographic documents they resist simple categorization as a tangential visual metric of value and force their viewer into the imposition of narrative that—in the case of the Bronx photos of the 1980s—was already embedded within the photographic frame. Indeed, it is the archive's commitment to an exhaustive, total representation of a city—to amassing both photographic and physical empirical facts on such an unrivaled scale, all grist for the mill of narrativizing urban experience—that allows it to reach measures of visual sublimity time and again.

Yet even before Huebler, the artist Ed Ruscha's work—particularly his photobooks that began with *Twentysix Gasoline Stations* prepared in 1962 and published in April 1963—demonstrates an interest in a kind of archival practice, presenting as what Matthew Witkovsky calls "a wayward notary" who "certif[ies]the existence of a provocatively random selection of '26' '34' '9' 'some' or 'a few' examples of common and/or corporate structures or objects," with an obvious analogue to the totalizing prescription of the New York archives in the figure of the 1966 book *Every Building on the Sunset Strip,* which featured a 2.5-mile stretch of the 24-mile boulevard.[29] Rather than whether Ruscha was able to represent *every building* in his fold-out, twenty-five-foot-long photobook, what is interesting about the project and what is relevant to the discussion at hand is the impulse as an artist to ape, in conception and partly in execution, what was the work of the bureaucratic functionary or, more appropriately, the municipal photographer. The concept as delivered seems utterly "informational," and the mood of presentation is thoroughly deadpan, a rote presentation of archival information than a work of conscious artistic production, yet the experience of looking at the physically lengthy document— much like the experience of studying the massive Bronx archive that, as we will see, *is* the work of bureaucratic functionaries—is anything but. In "fact," so to speak, it is in looking at the Bronx archive that we can see works like Ruscha's with new eyes.

"Real estate *tout court*" is Hal Foster's designation of Ruscha's Los Angeles photobooks, and at first glance this seems apt.[30] Yet there is a kind of spare lyricism that emerges somewhere during the process of scanning along a twenty-five-foot-long document printed with two continuous views of the Strip on the top and bottom of the page, a fascinated commitment on the part of the artist—or archivist—that borders on the romantic. Such qualities are to be admired since, given the wealth of visual information conveyed in these macropanoramic photographs about this particular place in the world, we cannot help but to imagine ourselves there and, by doing so, perhaps lay claim to fuller knowledge of that place. The tax photograph archive is, too, "real estate *tout court,*" yet as we will see, both in individual photographs and in the process of looking at the online macro-panorama of the archive itself, manifold notions of temporality and duration emerge that resist both the bare display of visual facts and the kinds of systematic data collection imperatives placed upon its photographers. Fond of his own systematic attempts to inject randomness

and pure factualism into his artwork, Ruscha famously said, "My pictures are not that interesting, nor the subject matter. They are simply a collection of facts."[31] Yet, no matter how much Ruscha or any "factualist" conceptual artist might claim to the contrary, both their work and that of the tax photographs help prove that things that want to be merely collections of facts often end up collecting, and containing, much more.

One could trace the taste for the kind of systematization of photographic practice practiced by Ruscha and others—and of a decidedly more rigorous bent—in the work of the German artists Bernd and Hilla Becher, who in the late 1950s began to photograph industrial German architecture and infrastructure in the Ruhr valley. Their photographs, of objects such as water towers, barns, grain elevators, gas tanks, cooling towers, blast furnaces, and coke ovens, present a straightforward and "objective" point of view, the objects of their compositions centered with austere precision. These photographs were then organized in what might be thought of as an archival mode by what the artists referred to as "typologies," classified by similar forms and structures for display (usually within a grid), which highlighted similarities of design and encouraged comparison between them. The Bechers' photographic practice, which inspired students such as Andreas Gursky, Thomas Ruff, Thomas Struth, and Candida Hofer, sees its mirror in many ways in that of the New York tax photos. Not only are there similarities in the strict self-imposed photographic conventions—the intent of which saw "objectivity" as the end for alternatively artistic or justly evaluative purposes—of the Bechers and the tax photographers, but also in the taxonomies of structural typologies that separated single-family homes from commercial structures and brownstone row housing from modernist apartment blocks, just as the Bechers grouped storage silos and coal bunkers.

Indeed, the photographic conventions of the 1980s New York tax photo project remained largely unchanged since the Depression era—predating the work of the Bechers by at least a decade—and it is worth examining them more closely. Photos generally featured a frontal, or nearly frontal, view of the building with the particular angle determined by the building's size and the width of the street. Superimposed like a title card in a film in the foreground of each image is a sign identifying the building by its address, borough, and block and lot number. In the 1940s images, this sign was an actual, physical presence in the photograph, equipped with a triangular pointer that helped to distinguish the building in question from its contiguous neighbors. In the 1980s photos, an updated ver-

sion of that sign was used on site (indeed, one of the photographic staff developed the metal arm that attached to each camera so that the block and lot number would be in focus with the aperture stopped down), but once the images were computerized, a regularized label was superimposed over each photograph. In an approximation of those methods—and of today's Google Maps and Street View projects—the artist Jeff Wall proposed in his *Landscape Manual* to capture a drive around the city of Vancouver using three car-mounted movie cameras.[32] Such examples demonstrate related interests in travel, its documentation, and the desire to record the existence of things using increasingly mechanical methods that removed, in varying ways, aesthetic choice from the photographer's hands and replaced it with a system for image capture that approached the automatic. Oftentimes for "factualist" photographers and other similar artists, the process or prescriptive program for taking the photos was more interesting than the photographic results. In most cases, the photographers were pleased with such an outcome; indeed it was often the intent. With regard to the Bronx tax photographs and the larger archive in general, the photographic mandate that produced them mirrored in many ways the carefully engineered processes or photo-by-directive systems of artists like Huebler or Ruscha to remove "interest" or any sense of the picturesque from their photograph and represent New York objectively, as it was—in fact, that mandate was undergirded by that of the Department of Finance for fair and equitable assessment—yet it was the condition of parts of the city itself that made what may have originally been designed to be "uninteresting" entirely compelling.

It was the system that defined much of the photographic practice of conceptual photographers of the 1960s and 1970s, and it was a similar directive for systematization that produced the Department of Finance's tax photographs. Indeed, it is by virtue of its integration into the Department of Finance's real property tax card system—and, by extension, the economy of New York City—that the Bronx built environment, all of that real estate, could not be left to ruin and forgotten entirely. By mandate, neither block nor empty lot, no matter its state, was left behind.

## Block by Block, Lot by Lot: Looking at the Bronx Tax Photos

In the 1940s tax photographs, one often encounters bustling urban scenes full of people within the frame. The 1980s images, especially those of the Bronx, are less populated; photographers often explicitly avoided

including people so as to prevent any incidents from occurring, though there are certainly many interesting examples of people captured by—and sometimes even meeting the gaze of—the camera's eye. Often people were suspicious that the teams of photographers were undercover police officers, so much so that the photographers took to wearing their Department of Finance badges displayed prominently.[33] Such suspicions, for a populace already heavily under the watchful eye of law enforcement, were entirely justified. Though the project was designed to cast a dispassionate, equalizing eye across all five boroughs of the city, assessment involved both abstract and concrete concepts of numeracy, which, when tied to perception, made it so that the panoptic eye of the "state"—here, the municipal government—was effectively focused on the city, its streets, neighborhoods, and occasionally its people. Discipline and control would hardly be foreign concepts to such forms of surveillance. Any information gathered by such a program, visual and otherwise, could theoretically be shared across platforms and multiple levels of governments and agencies, which of course at least opened up the possibility for potential misuse, even though the rephotographic project was propelled initially by a desire to correct injustices to the populace—not commit further examples of them.

Still, the archive is home to many a strange and unsettling portrait of Bronx residents. The photograph of 894–898 East 163rd Street depicts two older men to the left of center in the frame, one of whom sports a classic guayabera shirt. The photograph is curious not because of the excellent sartorial taste on view but rather because the men's heads are cropped entirely out of the frame, the unsettling effect of which leaves two decapitated figures standing sentry in front of a fence bordering the vacant and weeded lot behind them. Within the ethic of the tax photo archive, the photographer's gesture to avoid eye contact is potentially—more than likely—one of respect, measures of which are afforded these two men who may or may not have objected to having their photograph taken. The archive is silent on this point. Yet the photograph retains a disquieting aspect, forever withholding, for good or ill, the identities of these men who animate—perhaps even take precedence within—the photograph, yet were hardly its intended subject. The same tension arises whenever the tax photographs capture people within their frames. We as viewers understand the project's municipal and photographic mission as such: this is a photograph of 894–898 East 163rd Street, Block 2696, Lot 100, and therefore, the photograph refuses, in a way, the presence of those who populate it. Its title card calls attention to its site; yet, that site cannot hold our atten-

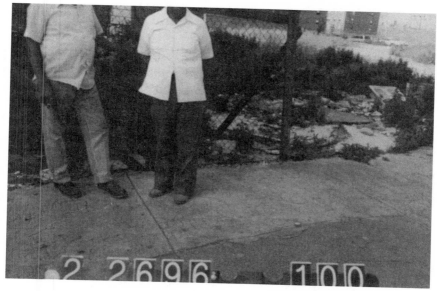

894–898 East 163rd Street. Department of Finance, Bronx 1980s Tax
Photographs, 1983–1988, dof_2_02280_0035.
Courtesy NYC Municipal Archives.

tion for very long. It is, in fact, the presence of the bodies within the frame
that resists the banality of that site, lending visual interest and humanity
to the composition, even despite the violent interruption of the bodies at
their necks. That refusal, even the violence done to these figures by way
of the photograph's cropping, provides the source for countless potential
narratives spun from this single shot.

The presence of people complicates the Bronx collection in myriad
forms and fashions. Two photographs—the first of 164 Brown Place
(Block 2263, Lot 14) and the next of Brook Avenue (Block 2263, Lot
12)—depict the same fedora-wearing man strutting through their frames.
In the first photograph, the man appears having just stepped off a curb
into a crosswalk at the extreme left of the frame, his eyes shielded by the
hat's low-slung brim or perhaps even by sunglasses. It's impossible to
tell whether he is making eye contact with the camera, though it's likely
that he is aware of its presence given the starkness of his surroundings.
The lot at 164 Brown Place is vacant and overgrown with weeds, and
the absence of any structure on the property affords a clear view of the
towering slabs of housing projects that dominate the upper half of the

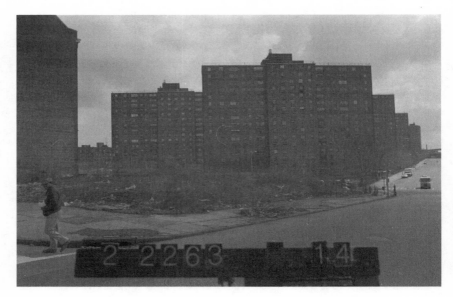

164 Brown Place. Department of Finance, Bronx 1980s Tax Photographs,
1983–1988, dof_2_02263_0014.

Courtesy NYC Municipal Archives.

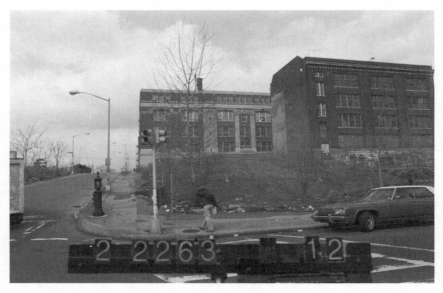

Brook Avenue. Department of Finance, Bronx 1980s Tax Photographs,
1983–1988, dof_2_02263_0012.

Courtesy NYC Municipal Archives.

photograph, receding into the distance and recalling in spirit and serial form some of Dan Graham's photographs from his famous series *Homes for America*.

The Brook Avenue photograph, not a mirror image of the first though its subject is also a vacant lot, depicts largely what would have been the point of view of the fedora-wearing man (absent the photographer, of course), though it has been taken a few seconds later. We know this because the same man is shown, back to the camera, having crossed the street and having already surmounted the opposite curb to climb a hill topping off beyond the horizon. Crowning the hill and the upper right portion of the frame is a Bronx public school building, a building typology immediately familiar to any native of the city, standing alone on a horizon line beyond which looms a cavernous sky. Is the subject of the photograph the twinned corner vacant properties owned (most likely reclaimed) by the City of New York (according to the accompanying parcel information)? Or is it the micronarrative spanning two photographs that illustrates a man encountering his photographer and promptly going about his business that is created by their consecutive appearance in the collection—a narrative essentially authored by the archive? In either case, what remains important about these narratives—however inconsequential or humdrum—is that they offer a sense of a continuity of life in the Bronx that is absent in other more metonymic images on offer in popular culture. Even the mere presence of this body moving confidently through the space of the city—and also moving within the archive, from image to image—complicates the narratives of total desolation that characterized the Bronx of this era.

The irrepressibility of narrative's emergence in photographs, witnessed in Douglas Huebler's "failed" attempts to remove any "interest" from his photographs, in Ruscha's Sunset Strip, or within these tax photographs, is, perhaps, interesting yet perhaps also not unique. That we as viewers can and do read what Shannon calls "intriguing dynamics" that may be self-evident or entirely imposed in photographs that were created with hardly a care for either intrigue or dynamism might seem a rather pedestrian point. What is distinctive, or at the very least important, about the impulse toward narrativizing, contextualizing, and even allegorizing that the Bronx set of tax photographs provokes is that those narratives witnessed in these frames can and should be characterized as "narratives of differentiation." That is, among their most important characteristics and value (here, *not* in the economic sense though, of course, they counted for that too) is their individuality, their specificity, their difference when

compared to the popular "image" of the burning and ruined Bronx, so often represented by a single building, abandoned or aflame. Consider, again, the two photographs of 164 Brown Place and Brook Avenue. That we can follow a man walking down a city street, and indeed, from image to image, suggests both a testament to and a continuity of life that other synecdochic images of Bronx ruin prevent—and which this archive resists, photograph by photograph.

A triptych erupts along East 159 Street. A group of children of assorted ages—walking, standing, perhaps even posing—line the street, their forms echoed in the progression from right to left, from photograph to photograph, by a row of painted bollards. The three photographs, ostensibly of the vacant lot behind the bollards, are numbered by block (2381) and lot (34, 35, and 36, respectively), but they might as well be still images taken from a film. Some of the children confront the camera and return its gaze; others have better things to do. Most are in T-shirts, strolling about on what appears to be a mild, overcast day. At 131 Alexander Avenue (Block 2309, Lot 28), two more children, short of stature and hooded against the cold—for the project spanned not just years but of course seasons as well—stand near the open trunk of a sedan facing away from the camera, perhaps ignorant of its presence, as they admire the graffiti that adorns the corrugated tin fence that protects the property line. Might these two children be caught in the moment before being packed in the backseat of that car by their parents for a drive? Or have they just happened upon this stretch of street as the photographer surreptitiously intrudes on their moment of observation? At 133 Alexander Avenue, fewer impositions of narrative are possible: perhaps wondering at the writers of the graffiti that covers the same tin fence, which now takes on a more imposing air bereft of its youthful admirers. In either case, it is in the difference between these versions of Alexander Avenue, populated and not—a difference that accounts for a host of temporalities from the minute to the seasonal—that we discover the Bronx that has been obscured by the figure of urban ruin, while at the same time recognizing that the impulse to see these spaces in the contexts of those that have come before it is as innocent as it is inevitable.

If single figures so disrupt the mood and method of the photographs, then what havoc might a crowd wreak? A photograph taken on a corner of Third Avenue (Block 2294, Lot 1), one of the South Bronx's busiest thoroughfares, demonstrates the "power of the people"—or, rather, the simple power of presence. There are almost twenty figures captured in this extraordinarily busy frame, and almost every one of them is angled off

Third Avenue. Department of Finance, Bronx 1980s Tax Photographs,
1983–1988, dof_2_02294_0001.
Courtesy NYC Municipal Archives.

on seemingly different vectors. Few, if any at all, seem to take notice of the
photographer's presence, so occupied with the doings of their day are the
people walking to and fro at this stolen moment of midday, discernible by
the lack of length to their shadows. There is not one simple narrative
here but many, perhaps merely gestured at yet still competing for atten-
tion. Upon whom or what should one fix one's attention? Certainly not
upon the commercial structure that occasioned the photograph itself,
visible in the upper left of the frame. The photograph—as if it needed
more—is lent a hefty dynamism by the bold white diagonals of the painted
crosswalk emerging from the lower left corner of the frame. At the very
least, the photograph gives the lie to the idea that the South Bronx was
an unpopulated wasteland; in fact, one could easily have confused this
busy corner of the Bronx's Third Avenue with any that lined Manhattan's
without prior notice. It is evidence of and a testament to the life that main-
tained itself even amid the ruin that affected pockets of the city, some-
times just a neighborhood away.

Compare the Third Avenue photograph with that of 425 East 159th
Street (Block 2381, Lot 29). Seemingly a community center of some kind,

the brown brick structure's street-level open portico is full of people, both beneath its overhang and spilling out onto the sidewalk. It is a solitary moment in the life of a neighborhood, yet the narrative suggested by the photograph here seems slightly more self-contained than that of the Third Avenue photo, if only because most of the "action" seems tied to the actual—and intended—focal point of the photograph. In discussing the boundary marker photographs of Arthur Schott, Robin Kelsey argues that such boundary views "ostensibly subordinated iconicity to indexicality. That is, mimesis, including the careful delineation of foreground features and the representation of distance as a proportional diminution, officially served only to define a point on the earth. . . . What counted was not the subject matter of the views but the viewing positions and the vectors they defined."[34] The same might be said of the tax photographs; that is, in the eyes of the municipality, what mattered was a clear and informative view of the property to be documented—not whatever else may have appeared within the photograph's frame.

But it is photographs like that taken on 1121 Nelson Avenue (Block 2514, Lot 75) that complicate the pretensions of the photographic archive toward operating within a strictly defined documentary scheme that is productive of a singular purpose. Just right of center, and diminished somewhat by the imposing structure of the tall and narrow house at 1121 Nelson, are two figures, captured while in the moment of shaking hands. It is an instance, and indeed an instant, at which we might marvel: how, in a collection of thousands of images, do we arrive at this particular moment in time—not a second before, and not one after—and at this particular photograph, which exemplifies both the allusive and the reportorial potency of this archive as a whole? At a base level, the photograph conveys to its original viewer—the tax assessor—exactly what it needs to: site, condition, and the subject's relation to adjacent properties. But here, as in countless other examples, there are at least two narratives present in each photograph: the ongoing tale of the documentary project itself—each photograph a testament to its continuing vitality and another indexical mark toward its completion—and the instant narratives that either play out within individual photographs or are linked through persons, proximities, patterns, or the grander narrative of the borough's plight. We can't know whether the photographer meant to capture this exact instant, but at the same time, we can't ignore its symbolic import as a record of a moment of exchange between two borough residents, and one that metaphorically stands in for the exchange value that the photograph possesses as

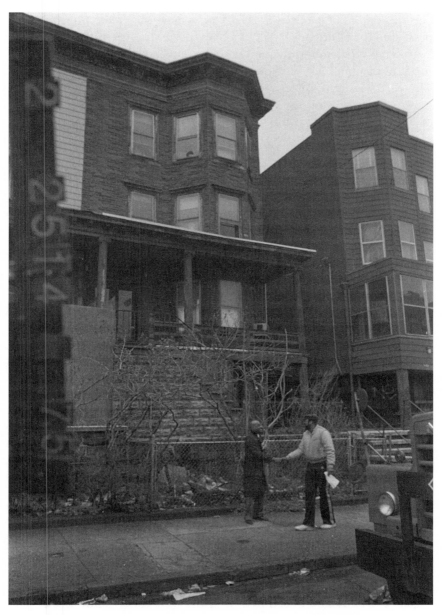

1121 Nelson Avenue. Department of Finance, Bronx 1980s Tax Photographs, 1983–1988, dof_2_02514_0075.

Courtesy NYC Municipal Archives.

part of a record of property value. There is more than mere "information" present in the photograph of 1121 Nelson Avenue, just as there are more "subjects," more subtle and unintentional aesthetic effects, and more histories hidden and left in plain sight in the rest of the archive's holdings. These photographs, replete with vital and meaningful "excesses" such as these, cast doubt not just on what exactly constitutes each photograph's subject matter but also on how we ought to read archival photographs in general against the narratives and contexts of their creation, both of which invariably crowd the photograph's frame with more than we are prepared to see.

## The Logic of the Lot

"Destroyed," the writer Wolfgang Schivelbusch writes of the cultural and intellectual life of post–World War II Berlin, "[the city] presented itself to the observer in two forms."[35] One "was vertical: the ruins projecting upward."[36] The second, however, was entirely horizontal: "the open plain, the field, or, as was occasionally said after 1945, the steppe that had resulted from the destruction."[37] The Bronx that appears in the 1980s tax photos, too, contained both. There were, on one hand, the buildings—the nominal focus of the photographs, which, again, could be understood as a building census—populated, or empty, still viable or bricked shut, the evidence of life or a testament to its degradation or absence. Then there were the vacant lots. Crumbled bricks and decaying wood lined the steppes of the Bronx, massed piles of refuse suggested rolling hills, abandoned cars died slow deaths by the scavenger's hand on these lunar landscapes. Nature began to retake the urban with creeping grasses and invasive ailanthus. Often photographs were more suggestive of scientific surveys of rock outcroppings or palisades than a census of a city's streets.[38] In a relentless parade of building facades, access to the horizon might seem rare. However, it is less infrequently seen than one might think, especially in the Bronx collection. There was, quite simply, just more open space: a different kind of prairie to roam, a different manner of wilderness to navigate. To the viewer perusing the archive, these photos might even be visually welcome—a respite from the claustrophobia induced by the rigid pictorial conventions that present face after face of Bronx buildings—that is, if they weren't also evidence of devastation on a grand scale, evidence of where things, places, and people used to be. In many ways, it is not the abandoned building

but instead the empty lot—the common and most visible open scarring of the surface of the Bronx built environment—that lends the collection its most chilling air of sublimity.

Titled, in effect, by the block and lot signs superimposed over each picture, these were often images of absent buildings—"addresses" in name only for they addressed nothing. The tax photographs linked image to integer, vision to value, coordinates on a map to a view of what that location looked like at a moment in time. However, in the case of many such images, there was in essence "no there there." Whether depicting an open lot or an abandoned building, these photographs contained references with no subject. The indexical here mocked the iconic with what seemed a form of grotesque numeracy.[39] These were spaces that were tied to a coordinate plane—the grid of the city map—whose identity was determined by that geographic index, yet their assumed identity as perhaps a residential home, apartment, or commercial building was belied by the absence evidenced in the very same photograph. This sense of disruption is then followed by one of bewilderment, which—again—bears a relation to the narratives inescapably embedded within these photographs. In his discussion of C. C. Jones's photographs of the 1866 Charleston, South Carolina, earthquake, Robin Kelsey observes that rather than recording the standard fare of "collapsed buildings and piles of rubble," Jones registers Charleston's destruction by revealing instead minor cracks and displacements in standing structures as much as he depicts the more conventional detritus of disaster.[40] Often within the same image, Jones would capture destruction abutting still solid—though imperiled—structures, leaving the "narrative of earthquakes" to remain somewhat "inscrutable," in Kelsey's words, to the wondering viewer.[41] The Bronx photos of rubble-strewn lots, too, possess a quality of inscrutability, intensified by the knowledge that the means of disaster that befell these neighborhoods was far from as "natural" as an earthquake—though disaster's ends appeared just as catastrophic before the tax photographers lenses.

As concepts within the space and logic of the archive, the photographs of empty lots often loosely recall the artist Robert Smithson's theory and series of "non-sites," described in the eponymous essay "A Provisional Theory of Non-Sites":

> By drawing a diagram, a ground plan of a house, a street plan to the location of a site, or a topographic map, one draws a "logical two dimensional picture." A 'logical picture' differs from a natural or realistic picture in that it rarely looks like the thing it stands for. It is a two *dimensional analogy or*

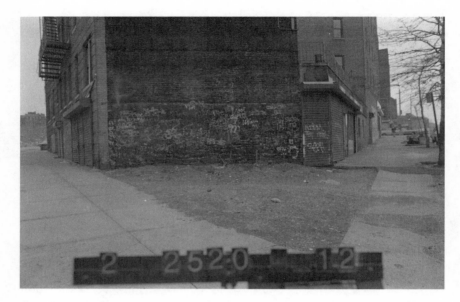

E. L. Grant Highway. Department of Finance, Bronx 1980s Tax Photographs, 1983–1988, dof_2_02520_0012.

Courtesy NYC Municipal Archives.

> *metaphor*—A is Z. *The Non-Site (an indoor earthwork)* is a three dimensional logical picture that is *abstract,* yet it *represents* an actual site in N.J. (The Pine Barrens Plains).[42]

The archival photograph, such as that of the E. L. Grant Highway (Block 2520, Lot 12), is a two-dimensional, realistic picture in that, following Smithson's description, it looks exactly like the thing it stands for—his "non-site"—yet the block and lot notation inscribed by the title card within the photograph complicates the photograph's reading. Though not three-dimensional like Smithson's museum-installed earthwork non-sites, the photograph of this open triangular lot—like many of the vacant lots throughout the collections—is *both* representational *and* abstract. It refers to the actual site in the Bronx, yet the textual accompaniment that delineates its block and lot and which links it to the geographic grid of the city is what imposes the abstraction of space—here numbered and catalogued—where perhaps a structure once stood. If the actual Bronx lot is both "site" and "non-site" in their most literal senses, its representation in the form of the photograph—more in tune with Smithson's con-

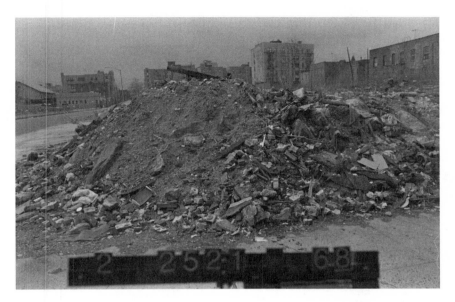

1305 Nelson Avenue. Department of Finance, Bronx 1980s Tax Photographs, 1983–1988, dof_2_02521_0068.
Courtesy NYC Municipal Archives.

ception of the "non-site"—is perhaps a step further removed from reality.[43] Both photograph and triangular plot are, then, "non-sites" of a sort.

Another example of a lot photograph, of 1305 Nelson Avenue (Block 2521, Lot 68), marks a coordinate on the map, but the actual space to which the photograph refers is rife with dissolution—a massive pile of rubble, mere pieces of the place it used to be—its broken rocks and dirt referents to other sites and images of ruin rather than to any structure that may have occupied that space. The empty lot's prominent place within the archive suggests that, even in this kind of building census, it was not the facade but the space of the lot itself that was the true focus of the photograph; its center point, rather than the reliable middle story of, say, an apartment building, was uncentered by—and indeed, as uncertain as—the environment that it depicted.

Different registers of trauma echo constantly throughout these images: the appearance of reference information with seemingly no referents, structures designed as homes and shelters that can no longer provide such comforts, and that of places whose only link to their "place" on the city map remains their address, logged in the city's ledger books but whose presence

in the environment was perhaps more spectral than steadfast. Thus, these photographs might also be thought of as indexes of memory that were soon to be erased by demolition or further decay. In a way, though the photographs of empty lots and piles of refuse are only abstract notions of addresses, the archive manages to reinvest these trash heaps and barren plains with an identity that they surely lacked to those walking right by them. How else might we know 1305 Nelson Avenue without its accompanying tax photograph? How could we distinguish its pieces and particles from those of the adjacent property? And though the photographs are resolutely linked to the ordering logic of the city's grid, given structure by pictorial convention, and are the result of a tertiary, more abstract logic of assessment and valuation, their visual content contests both forms of order and management. Rather, more often the pictures suggest a world outside logic—one governed instead by disorder and made all the more apparent, and absurd, by the indexical address markers included within their frames. Confronted time and again in the archive with a directional code made almost indecipherable by the image of ruin that accompanies it, we as viewers are constantly left to imagine what there once stood.

1161 Webster Avenue. Department of Finance, Bronx 1980s Tax Photographs, 1983–1988, dof_2_02426_0082.

Courtesy NYC Municipal Archives.

Never entirely a ruin, the Bronx was also hardly composed of a single manner of building type, despite the near-symbolic prevalence of the six-story tenement structure in our shared public catalogue of images of the Bronx of this era. A photograph like that of 1161 Webster Avenue (Block 2426, Lot 82) underscores exactly this point. Focused generally on the commercial structure just to the left of center of the composition, the photograph depicts an orderly collision of masses, receding rectilinear lines, and a rare glimpse of the horizon that recalls, again, Hal Foster's description of Ed Ruscha's Sunset Strip photos as "real estate *tout court*," which, in turn reminds one of the tax photographs' raison d'être. The photograph is its own crowded microcatalogue of structural types, architectural styles, and building uses. Animated by the bright white diagonal lines of the crosswalk that recede into the frame away from the viewer and then draw the eye toward both the left and the right, building facades stretch upward at an angle to the viewer, low-slung brick-and-mortar commercial structures giving way to more typical five- or six-story tenement structures just beyond, and looming in the distance in the top left corner of the frame stands a modernist monolith of a residential apartment building. Packed full of rectangular solids that seemingly replicate from left to right in increasingly smaller sizes, the photograph's composition suggests its own kind of geometric modernism—the intimate amalgam of shapes and colors against a neutral blue sky almost suggests photomontage—which mimics that which can be found, like the massive concrete slab in the photo's upper left, occasionally towering over Bronx streets. Indeed, many photographs of similarly outsized structures poorly scaled to the character of their surrounding streets suggest their own form of threat and intimidation. Sheer, poured-concrete facades fit more for a city wall's battlements rather than residential apartments continually crop up while one searches through the archive, confronting the viewer as directly as they must have confronted the pedestrian and neighborhood resident, perhaps proving that abandoned buildings were not alone in effecting an air of menace within the Bronx built environment.

Although many of the photographs communicate similar tensions, by articulating either a sense of uncomfortable urban density or its opposite—an uncanny emptiness—mobility and movement throughout the borough, as both a reality and a concept, is not entirely foreclosed. Not only does the viewer's action of scrolling through the archive's files simulate, even reproduce, the original motion of the tax assessors by tracing their photographic path along the coordinate plane of the city's property

1387 University Avenue. Department of Finance, Bronx 1980s Tax Photographs, 1983–1988, dof_2_02533_0029.

Courtesy NYC Municipal Archives.

map, but the photographs themselves capture and represent that mobility in the form of modes of intercity transportation and various routes of exchange and egress for both residents and visitors.

A photograph from the promontory at 1387 University Avenue recalls the dizzying, spectacular combination of riotously interlocking bridges, cloverleafed highways, and aqueducts in much of the work of painter Rackstraw Downes (who also painted this vista from a similar point of view), yet here with lush green filling the photographic foreground and the river just visible in the middle distance. Downes himself writes of his own painting in a journal entry, and the description of his work illustrates the spectacular vision contained within the tax photo of 1387 University eerily well: "The subject in a way is a vantage point: the Washington Bridge as a lookout point, a belvedere, onto countless elements that make up city life. It's the panoramic point of view as a Whitman, where the individual life counts for little, but the collective life is an extraordinary meal of endless courses, rich."[44] The photograph depicts not merely these many vital arterial connections between the borough and its neighbor, Manhattan, but also the beginning of the Cross Bronx Expressway in the form of the

Alexander Hamilton Bridge—Robert Moses's infamous road blasted through the Bronx that many claim hastened the borough's collapse—whose form spans the center of the frame. From its elevated vantage point, the photograph lifts the viewer from the earthbound confines of the city street, and the profusion of flora in the foreground performs the double service of intensifying our sense of ascendance or even levitation above the ground, while providing an organic, almost pastoral frame for the wild concatenation of transport systems and city forms in the distance. With its suggestion of river crossings and flood tides down below, of the competing currents of water and people in and out of each borough crossing each other at angles, the photograph manages to be, perhaps, even more Whitmanesque than Downes's painting from a similar view. Within the context of the archive, it offers a distinctive if not quite entirely unique perspective. Transportation, whether in the form of an elevated train (as in the elegantly swooping curve captured in the photograph of 1932 Bryant Avenue in whose form is suggested the rapidity of that manner of transit) or the stretches of highways that ring and divide the borough (as dramatically seen in a photograph of the underside of a utility ramp for the Major Deegan Expressway, its gentle curve mirroring that in the 1932 Bryant Avenue shot), is both a thematic and concrete link between the Bronx and the rest of the city, and the archive's holdings testify to the fact that even despite the desolation that affected much of the borough, the Bronx was hardly a "lost" part of the city. Like the lines of exchange and transit catalogued in the tax photographs—which served the purpose of achieving a kind of equalization of assessment across the municipality, balancing Bronx lots with Brooklyn ones, Queens blocks with Manhattan's relentless grid—the archive itself is a document of the ties that bind a city together.

Time can feel infinitely elastic while it is spent scrolling down city streets in the tax photo collection. One can linger on a single image or block for minutes, or cycle past entire neighborhoods in seconds—a luxury afforded us by technology, even that of the outmoded laser disc. Yet the images themselves possess their own temporality—their own sense of duration and of time's passing—that can be witnessed not merely by the time of day and subtle changes in the quality of light but also by the change of season. Between 1262 Nelson Avenue (Lot 15) and 1260 Nelson Avenue (Lot 14), we see perhaps the clearest juxtaposition of seasonal patterns—an "archival summer and winter," respectively—in adjoining shots: one landscape that appears bathed in bright sunlight and the next covered in

103

what appears to be a fresh snowfall. The photographs are evidence of certain discontinuities in the logic of the archive's organization; or, at the very least, these shots of adjoining properties taken in what seems to be two very different seasons are demonstrative of the photographers' perhaps haphazard photographic practices. Similarly, throughout the collection, we find photographs whose subjects are fully golden hues of what appears to be the photographic "magic hour" that are "immediately" (the word is highlighted here because it is an immediacy imposed by the organization and sequencing of archival notation, and not how the photographs were originally taken) followed by snow-covered scenes that together suggest an unlikely "before and after" tableau. If, as Hal Foster suggests, the archive is founded on disaster or its threat, we might even look at the elasticity of temporality that the Bronx archive both allows and enforces in still another way: as offering a method of resistance to the kinds of environmental entropy that are depicted in its images. Though all photographic images are subject to degradation—even digital images, when read, edited, and saved multiple times, suffer a slight loss of compression—the very existence of the archive and each image within it plays a part in the preservation of these thousands of moments in the Bronx's history, no matter how degraded the subjects within them might appear.

## My Egypt: Jerome Liebling and the City of Man

Over and over again in the archive one encounters an undestroyed house amid a devastated environment—a version of George Bellows's lone tenement, standing where almost all else has fallen away. The tax photograph of 168 Brown Place is striking for many of the same reasons as the photograph of 458 East 136th Street with which this chapter began: the dramatic distance captured between foreground and background; the bold, elementary forms that the buildings strike against the sky; and for the simple fact that in both photographs, the nominal "address" pictured no longer exists in the shape of a standing building. Even despite this curiosity, in the photo of 168 Brown, the eye is drawn instead to the angled two-toned brick wall of the adjacent property. Of all the two-toned exposed brick walls in in all the Bronx, this very building wall was also photographed by the photographer Jerome Liebling in 1977.

Jerome Liebling was born in New York City in 1924 and attended Brooklyn College before leaving in 1942 to serve in the US Army Signal Corps in Europe and North Africa during World War II.[45] He resumed

168 Brown Place. Department of Finance, Bronx 1980s Tax Photographs, 1983–1988, dof_2_02263_0016.
Courtesy NYC Municipal Archives.

his studies at Brooklyn College in 1946, majoring in photography and studying design under Walter Rosenblum and Ad Reinhardt. Liebling himself notes that while there, he "really absorbed the formalism of Bauhaus training," which he considered "strong" in his future work.[46] This was perhaps no surprise, as Gyorgy Kepes and Serge Chamayeff, formerly members of the New Bauhaus circle of László Moholy-Nagy in Chicago, were teacher and chair of the department of design, respectively, at Brooklyn College during the time of Liebling's tenure as a student.[47] It was Rosenblum, a former president of the famous Photo League, who encouraged his documentary work. Indeed Liebling himself joined the Photo League in 1947, where he studied with Paul Strand and other major talents of the late 1930s and 1940s, producing the kinds of persuasive social documents that the League was then known for. While in New York, Liebling also studied motion picture production at the New School for Social Research and also worked as a documentary filmmaker. At the age of twenty-five, he was invited to join the faculty at the University of Minnesota, where he worked closely with photographer Allen Downs and John Szarkowski, who was then staff photographer at the Walker Art Center in Minneapolis and

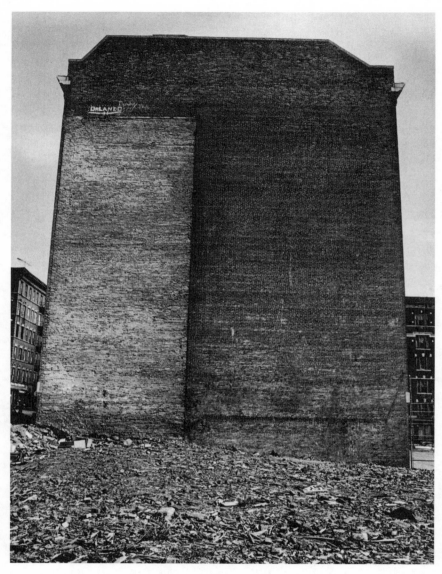

Jerome Liebling, *Orlando Building, South Bronx, New York City*, 1977.
Courtesy of Jerome Liebling Photography LLC.

later would go on to be Edward Steichen's handpicked successor as photography curator at the Museum of Modern Art. Thus there was both a strong sense of Bauhaus structure and design and an equally powerful commitment to social documentary in Liebling's photographic education, both of which he would retain in his later years.

In a meditation upon Liebling's death in 2012 printed in the *Massachusetts Review* in June of that year, Alan Trachtenberg, who was a graduate student in American studies in Minneapolis while Liebling was there, writes that Liebling's Minnesota years of his "great black-and-white pictures" were

> a time of extraordinary personal growth that included discovery of such local signs of the real as grain elevators, stockyards, skid row; old stone downtown buildings falling under the contractor's ball, giving off silent shrieks of pain as if they were human bodies—also the hidden life of slaughterhouses, flophouses, houses of care for the blind and emotionally crippled, and not least, the morgue with its veiled cadavers.[48]

In Minnesota, Liebling freelanced by taking photographs of politicians and political life in and around the city and state, but he also pursued his independent projects that chronicled different aspects of the urban environment, influenced by his upbringing in New York City, where he felt the same tensions and problems were to him "more apparent and exposed."[49] His work both in the stockyards of St. Paul and on Minneapolis's skid row is in many ways characteristic of what would come later in the South Bronx, as he there developed and demonstrated a deep interest in what Trachtenberg called "the city of man . . . the ideal always unsettled and challenged by realities on the street."[50] Of his slaughterhouse photographs, Liebling noted in an interview, "You recognized that you were surrounded by life that was just leaving you as you watched it," and claimed as the general message of his skid row series: "America is not the rosy flow. I mean the gold is not on the streets, it's a hard life for a great many people."[51] His circa 1961 photograph *Destruction of the Metropolitan Building* presents the beautifully rusticated facade of the former North West Guaranty Building as hauntingly disfigured, its upper stories removed in the process of demolition, leaving half its face visible in the photograph and what is left pockmarked with broken windows.[52] In a crumbling building, Liebling manages to capture both felt sentiments: the physical, tactile viscera of stone and broken glass, still majestic yet its destruction imminent, and the lives that once animated the structure, evacuated from view.

The forms in the photograph that Liebling titled *Orlando Building*—after the name scrawled on the building's upper right corner (also visible in the tax photo)—are even more elemental: the facade of the apartment building is given monumental treatment as it is seemingly perched at the top of a cresting hill of rubble. So thrust forward in the frame is the sheer, rough, cliff-like face of the facade that the building's mass seems to dwarf that of the two buildings visible on either side of it, crowned on three sides by an open sky above. The photograph illustrates the prime differences in the treatment of subject matter, of composition, of process, of skill, and of many other variables between the work of the anonymous tax assessor photographers and that of a professional photographer in Liebling. The tax photo can only deal with its subject—the empty lot at 168 Brown Place—both at a distance from the center of the street and at a severe angle due to the photographic conventions imposed to ensure a kind of equality and universality of presentation to the collection.

Yet, as we have seen in many of the tax photographs, other objects emerge as perhaps more interesting subjects than the nominal focus of the photograph, thereby imbuing the collection's images with an import and style that were almost entirely unintended, and perhaps even accidental. Liebling, however, is interested explicitly in the bare brick wall and is able to make it the clear focus of his magnificent composition; seeing as his mobility is not hampered by any photographic convention, he is able to draw nearer to his subject—in fact, he is more than likely standing *in* the empty lot at 168 Brown Place in order to take his shot.

There is a remarkable sensitivity shown here for both texture and tone: the chaos of the detritus below gives way to the subtle differences in shading of the brick wall, itself both regular and irregular as the bricks, lined in courses, bear various degrees of weathering to the camera, while the neutral sky above intensifies the starkness of the composition as a whole. The photograph's gesture is as monumental as it is timeless, suggesting Schivelbusch's "field of antique greatness." And much like one lone tenement reminding of another years before it, Liebling's composition seems consciously in conversation with similar evocations of a modern monuments—the American Precisionist painter Charles Demuth's *My Egypt* comes to mind.

Indeed, the suggestion of an ancient monumentality in Liebling's photograph was not lost on Estelle Jussim, whose essay on his photography appeared in a 1978 Liebling monograph: "One view of the side of an apartment house around which everything else has been torn down is as handsome as any Maxime du Camp picture of Egyptian monuments

during the mid-19th Century."[53] Demuth's own famous awestruck rendering of a Lancaster, Pennsylvania, grain elevator as a totemic symbol of America's industrial landscape, of course, bears its allusions to antiquity in its very title. Demuth's titling of this work, painted in 1927, just five years after the discovery of the tomb of Tutankhamun, may have been inspired by, or a playfully ironic mocking of, the American taste at the time for anything and everything Egyptian.[54] (As a matter of happenstance, the famous world exhibition tour of that same Egyptian king's artifacts, *The Treasures of Tutankhamun,* ran in the United States from November 17, 1976, through April 15, 1979, thus spanning the time that Liebling took his photograph.) Ancient allusions aside, the geometric similarities between Liebling's photograph and Demuth's painting are startling.

Most apparent are the visual rhymes between the central cylindrical forms of the grain elevator in Demuth's painting that find echoes in the light- and darker-toned areas of Liebling's brick wall. Set atop each form in both images is yet another point of affinity: in Liebling's photograph, the upper story of the structure meets the sky in what from this angle looks a trapezoidal form; in Demuth's painting, the housing for either the bucket elevator or the pneumatic conveyor rests atop the elevator's two silos, its shed roof sloped on both sides at roughly analogous angles to the apartment building's upper geometry. The buildings pushed toward the sides and into the backgrounds of each composition seem to meet the central structures at similar heights, leaving comparative areas of sky above. Demuth's dramatic diagonal force lines—cubist shafts of sunlight (particularly the broadest one that meets the picture plane at center bottom)—find correspondence in the asymmetrical advance of rubble toward the viewer in Liebling's photograph.

Though by virtue of its low-angled point of view, Liebling's photo lends the structure that is its subject an air of grandeur that, as we have seen, calls upon an ancient visual vocabulary of monumentality, there is hardly a trace of the celebratory reverence with which Demuth treats his hometown's grain elevators. Liebling's vision is purposefully staid, sober, and even despite the composition's emphasized flatness, he presents the viewer with a varied and rugged textural field in a series of juxtaposed planes. Texture plays much less of a part in Demuth's Precisionist vision; its geometries are rather smoothed over and pleasingly primal. Although Demuth's rendition of his central columnar forms recall the gargantuan columns of many an Egyptian tomb, it is Liebling's photograph that is more deeply reminiscent of a funerary monument.

Liebling himself would have been sensitive to any criticism that suggested he found anything celebratory in such ruin. Indeed, Jussim notes that Liebling felt "guilty because he made some of [his South Bronx] pictures 'too pretty.'"[55] Rather than a pursuit of pure form or some lofty aesthetic ideal, Liebling's South Bronx pictures, supported by a Guggenheim fellowship, sought merely to represent an environment—and occasionally its people—that revealed the most when it was stripped down to its very least. In an epigraph to the South Bronx project's appearance in the *Massachusetts Review*, Lewis Mumford wrote:

> Buildings and streets, bricks and rubble and trash, tell us even more about the inner life of the community than about its daily life. Liebling's photographic revelations of this life open our eyes, not to a series of local disasters, in the Bronx or in Bushwick, in Detroit or Chicago, but to equally sinister urban destructions that have been going on all over the world from Warsaw and Rotterdam to London and Berlin. The empty spaces tell us more about the lives people have led than the solid walls that remain. Now that the ground has been cleared, even of decent durable buildings, we know the worst.[56]

In photographs like *South Bronx, N.Y. 1977*, it is rather the interest in capturing a kind of truth—the "inner life of the community," in Mumford's words—that is as timeless and universal as the allusions made by the forms and figures captured within them. Indeed, Liebling's photography—and that of other "fine art" photographers of the Bronx of this era—performs a critical intervention. Occupying the space between the documentary figure of the "archive" (here exemplified by the tax photography of the municipality) and that of the history of art (the *Lone Tenements* and *My Egypts* recalled by these and other ruins), Liebling's photography forms the hinge between these two traditions that crucially allows both to be seen alongside each other—a kind of Rosetta Stone of visual language and allusion that permits translation of information between the documentary mode and that of fine art—while simultaneously demanding that neither be ignored for or privileged over the other.

Liebling treats his buildings-as-subjects with the care that another photographer might treat a body. His South Bronx photographs consistently demonstrate this interest in physicality and the body—whether human or architectural—and, more often than not, he uses his camera to illustrate the interaction between these bodies and how one conditions, or is conditioned by, the other. Neighborhood denizens are depicted in physical

congress with their environment: children of gradually increasing size sit side by side on the steps of an abandoned building; a man in a white tank top displays his lean, sinewy physique by gripping both sides of a door-jamb, his arms wide open in less a sign of welcome than a kind of confidently disinterested intimidation. There are elements of portraiture here, but these photographs are just as much if not more documents of lives lived within a particular built environment; what's more, they importantly document exactly how lives were lived within what was often a seemingly inhospitable place. An abandoned building becomes an impromptu bench; an entryway becomes a stage for an exhibition, a casual show of strength. Neither the body nor the building is privileged in these photographs; what is instead depicted is the sometimes intimate relationship that can exist between beings and their built environment. Here is the "inner life of the community" that Mumford describes, but out in its streets—the interiority of life that is, of course by necessity, so impossible to achieve in the Bronx tax photographs, externalized and revealed and captured by an eye sensitive to the relationship between a community and its environment.

These photos show Liebling as an "empassioned documentarian . . . of starkly ravaged urban environments" who is as sensitive to and reverent of the wounded physicality of a building as he is that of dead or dying animals in some of his slaughterhouse photographs.[57] An early 1970s black-and-white series of photographs of cadavers taken in a New York morgue attest to Liebling's interest in death and life and the "cycle of birth, growth, decay, and new life."[58]

It is that interest in clinically documenting the processes of life and death—whether a body on an autopsy table or a freestanding building about to fall victim to the wrecking ball—that allows us to return our gaze to the Manhattan tax photograph. Whereas Liebling's photo depicts a single shock of bright light illuminating a deserted and silent—perhaps even mute, as the sealed building suggests—city street in the dead of night, the tax photograph reveals not only a seemingly pleasant daytime sky above but also an open-for-business establishment at street level.[59] Both photographs, however, share a similar ethic of scientific precision, of careful documentation and straightforward presentation of structure and form. The tax photograph achieves this quality by way of the photographic assessment criteria by which its photographers operated. Liebling's composition retains elements of the Bauhaus tradition within which he was first trained: simplicity, pure form, logical presentation. Both photographs—as has already been observed about the tax photographs as a

111

body of work—offer Becheresque typological qualities in their respective compositions of the same facade. If not quite Precisionist in his process and aims, Liebling reveals a kind of precision in his documentary interests and in his presentation of ruined facades like this and the South Bronx side wall seen earlier. Of his photography, Trachtenberg writes: "His vision, organic and inclusive, took in everything alive and some things dead; they brought the dead to life as it were . . . a dimension of grim truths integral to his vision of *civitas* as an enduring value."[60]

It is the Roman idea of *civitas* as seen by Trachtenberg in Liebling's photography, a word that suggests both the collective body of the citizenry and what binds them together, that allows us to return once again to a consideration of not merely a municipality's photography project but also one that was designed with serving that municipality—that citizenry—more equitably. We have seen how Liebling—a professional photographer, a practitioner of "fine art" certainly, though also a committed social documentarian—uses his photography, both to gesture at history and art history, and to capture difficult and painful elements of the present out of his sense of a social mission.

Yet, the Bronx tax photographs possess this allusive capacity as well. As much as we can see Charles Demuth in Liebling, so too can we see him in the photograph of 168 Brown Place; if we can liken the care for detail and texture and slight shifts of tone, light, and shadow that is revealed in Liebling's *Orlando Building* to the riot of textural and tonal shifts present in Timothy O'Sullivan's famous survey photographs of ruins in the Canyon de Chelly, so too can we see similar elements in the municipal tax photographs—even if they were taken with no such referents in mind. Indeed, Liebling himself "agree[d] that great photography can be anonymous, that preoccupation with style, unique individual style instantly recognized as belonging to this or that great master, can sometimes interfere with the necessity of making certain kinds of pictures that are just as important as the 'art' pictures."[61] Liebling, however, spoke from the position of one who felt that his photography necessarily had a political and social dimension to it—perhaps providing a step toward the redemption of humanity in whatever small or large ways it could. By his standard, representative examples from the anonymous Bronx tax photograph archive could almost certainly be considered "great photography" whether or not they possessed artistic intentions. Yet, how might the same collection compare to the work of a different photographer who termed his own series of photographs of Bronx ruins a "hard-art project"?

## Personal Days: Ray Mortenson in the South Bronx

In 1982, when Ray Mortenson first began taking photographs in the South Bronx, he was working as an electrician. To arrive at his destination he would take the 5 train to the Bronx, avoiding the 4, because the neighborhoods along the 5 "had been so gutted and burned out during the 1970s that whole blocks were completely abandoned, meaning fewer chances of stumbling into a mugger or a drug deal." He, in fact, composed a rhyme to remind himself how to proceed at the subway station: "Take the 5, stay alive. Take the 4, dead for sure."[62] Though a couplet not worthy of the man whose lyrics the Museum of the City of New York borrowed for the title of Mortenson's 2008 exhibition there—*Broken Glass*, the opening words of the first verse rapped by the Furious Five's Melle Mel on the hip-hop classic "The Message"—it offers a brutal reminder of the dangers, perceived and real, that the image of the South Bronx suggested at the time.[63]

Taken between 1982 and 1984, Mortenson's photographs illustrate the breadth and depth of the destruction that affected large swaths of the borough—the neighborhoods of Mott Haven, Morrisania, and Tremont most directly—by situating the viewer at various points within the urban landscape. Whether perched atop tenement roofs, peering down into airshafts, or having scaled a tall apartment building's height to gaze across whole blocks from above, Mortenson's photographs offer a rare panoramic sense of the physical geography of the Bronx, yet he does not limit his vision to merely the grand view. Perhaps his greatest photographic intervention into documentation of South Bronx ruins is, alternatively, microcosmic: the even rarer still access that he provides viewers to the interiors of abandoned structures and, to read this care and interest for small detail even more broadly, to interiority itself. What Mortenson's photographs offer us is a way inside—yet another manner of viewing Mumford's "inner life of the community" and the personal, accumulated, even accreted, levels of history visible on the surfaces of a neighborhood's interior walls, floors, tables, and chairs. What emerges, then, is an image of an entire landscape that feels somehow startlingly complete, if even from only a comparatively small selection of photographs. Though they occasionally bear resemblance to the municipal tax photos of the Bronx, they offer in miniature an intimate view of the borough that some of the many thousands in the archive simply can't provide.

In an untitled photograph noted with the date "30 January 1984," Mortenson reveals in one grand gesture toward the horizon both the

enormity of his chosen landscape and the crisis that was then affecting it. Framed between two arms of a tall brick apartment building as the viewer's eye proceeds out along the rooftops are a few shorter tenements and, oriented at the photograph's center, a seemingly abandoned triangular building—a metonymic representative for the hundreds of potentially similar buildings just beyond it. The borough stretches out for acres into the distance, disappearing into a haze near the top of the frame, with the viewer finding it impossible to tell how many of the countless apartment buildings in view are similarly abandoned or still inhabited. It is exactly the kind of view that appears so rarely throughout the Bronx tax photo collection, and if so, largely by either accident or providential placement (as with the photograph from 1387 University Avenue). It provides a different manner of orientation from the archive's block and lot title cards, one that is perhaps less geographic and more spatial, less technical and more relational. And whereas the Bronx archive sounds its notes of alarm at the scale of devastation one by one, building by building, photograph by photograph, Mortenson's composition is almost immediately cacophonic, while suggesting a threat of replication: one abandoned building seemingly begets the next, exponentially so on and so forth, into the distance. Geometric rigidity—from the sharply articulated brick building arms that enforce a dizzying, canyonesque window through which to view the rest of the scene—seems to dissipate and become more formless the farther one progresses toward the horizon. Mortenson's photograph takes a surveyor's view, casting a grand cartographic eye across the Bronx's urban landscape from a single point of view; the Bronx tax photgraph archive casts the same cartographic eye, but its sweeping vision rather results from the agglomeration of many thousands of viewpoints.[64] What Mortenson offers the viewer is at the same time liberating and depressing: an airy relief from street-level goings-on, yet what is visible from his photographic aerie sinks the heart with the seemingly limitless boundaries of abandonment and ruin.

Mortenson's immediately iconic image of half a home brings to mind many allusions, both to other images and to the work of other artists, and to a viewer of the Bronx tax photos, it would seem utterly familiar if it weren't so perfectly composed in the center of its frame. In fact, the photograph is more reminiscent of Bernd and Hilla Becher's typological studies. One could certainly imagine a series of similarly perfectly balanced compositions of Bronx ruins—which the Bronx archive approaches but never quite achieves due to the subtle variations in position, time of day, season,

114

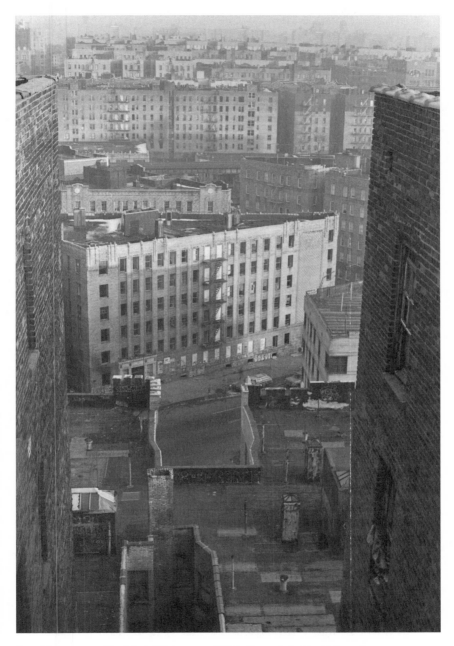

Ray Mortenson, *Untitled, 30 January 1984*. Copyright Ray Mortenson.

Ray Mortenson, *Untitled, 1984.* Copyright Ray Mortenson.
Courtesy L. Parker Stephenson Photographs, NYC.

and other factors even despite the photographic program imposed upon its photographers—of this type produced by the German couple as well. Yet the image, rich with metaphors of broken homes that border on the literal, also recalls one of the signature works of the artist Gordon Matta-Clark—his *Splitting* of 1974, which consisted of a house in Englewood, New Jersey, that Matta-Clark cut in half with an assortment of power saws. Mortenson, in fact, acknowledges having been in thrall to the work of artists like Matta-Clark and Robert Smithson, both artists who explored urban decay and entropy in much of their work, Matta-Clark—of course, as we have seen in Chapter 2—having walked these same Bronx streets a decade before Mortenson to find the structural canvases for his art of building cuts.

Yet here, as opposed to in many of his other photographs of the Bronx which we will examine, Mortenson offers us a single exterior view of the building's facade, flat to the photographic plane, suggesting a kind of symmetry that proves impossible once the viewer understands this seemingly

charming structure to be only half of what it once was. Indeed, it could pass for a freestanding row house if not for the jagged left edge of the building's facade, which reveals, unsteadily, a triangular pediment shorn almost exactly down from its apex to the street below. The photograph presents itself without comment, merely evidence of an unknown and unsettling event that has left an extraordinary artifact, memorable for the presence of both regularity and catastrophe within the same structure and the same image. Matta-Clark obsessively documented his bifurcation of the Englewood house in many photographs, in essays, and on film—it was as much the process as final product that was on offer for the viewer of his artwork. The gerund form of his given title suggests as much. However, Mortenson's photograph—untitled (except for its date), and taciturn in its visual regimentation—offers little else than the opportunity to speculate as to the proximate cause of such an astonishing image. His interest in the built environment is here and elsewhere indeed "purely physical," and in the aftereffects of whatever rupture caused a once dense urban landscape to look like "excavated Pompeii or Dresden after the firebombs."[65] There is, then, a similar strain of "scientific" vision, perhaps akin to that which we have seen in some of Liebling's photography: a restrained logic of presentation, a mute serenity that is often contradicted by the distress produced in the viewer by the depicted scene.[66]

Mortenson's debt to Smithson manifests itself partly in his desire to photograph ruins in the first place, just as Smithson had done in the late 1960s around his birthplace in his famous 1967 essay "A Tour of the Monuments of Passaic, New Jersey." Indeed, Mortenson's first forays into the photographing of ruins took place in the swamps and industrial wastelands of the Meadowlands in New Jersey—not at all distant from Smithson's hometown. As a child growing up in Delaware, Mortenson spent a great deal of time walking alone through forests and fields, and the artist thought of the bizarre nexus of industry and nature present in the Meadowlands and, later, the deserted streets of the Bronx in much the same way.[67] Mortenson's earlier photographic work *Meadowland: A Photographic Survey of the Industrial Landscape of North Eastern New Jersey* fits comfortably within the mode of the *New Topographics* exhibition of January 1975, a landmark show in American landscape photography curated by William Jenkins at the George Eastman Museum in Rochester, New York, which included the work of Robert Adams, Lewis Baltz, Bernd and Hilla Becher, and Stephen Shore, among others. Jenkins, in his introduction to the catalogue, mentioned Ed Ruscha—whose work has here

already been examined in context with both the archive and serial photography in an urban setting—as one of the inspirations for the exhibition and the photographers it featured.[68] His Meadowlands pictures appeared in an exhibition titled *The New American Pastoral,* also organized at the George Eastman House in Rochester, which a 1990 *New York Times* review saw as "a successor" to the *New Topographics* exhibition in that both reflected "photographers' attempts to devise a documentary style able to call attention to environmental issues that defy conventional description."[69] Indeed, one could describe Mortenson's approach to his Bronx photographs in much the same way. His interest in the environment, whether urban or industrial-pastoral (or however one might describe the Meadowlands), often takes the form of a profound sensitivity to texture and particularly to how that texture is affected or hastened by decay.

Two photographs of Bronx apartment interiors help illustrate Mortenson's ethic. The first, *Untitled (19 October 1983),* depicts a chair just to the left of center in a darkened interior space, a natural light source likely emanating from a window to the right, just out of frame. The floor is littered with countless paint chips and peeled plaster; indeed, it seems that we are intruding on the slow dissolution of the room as the walls and ceiling disintegrate, piece by peeling piece. There is a sense of lives formerly lived here, manifested centrally in the figure of a chair that perhaps once provided comfort, but the photograph begs the question, how long ago? Days? Weeks? Perhaps even years? The rate of decay is eternally at issue in Mortenson's photographs, especially when one considers that such interiors—some abandoned, some still occupied—were constantly under threat of fire, more often than not from arson. Could this peeled and chipped plaster and paint be the result of the room withstanding the heat of a nearby fire? Or is it the registered effect of the tremors caused by a nearby building demolition? Or, finally, is it merely the result of abandonment and neglect, time taking its toll upon a room, perhaps an entire building that was left to rot? Mortenson offers us no clues; his interest is in the representation of time—indeed, of entropy, as both Smithson and Matta-Clark would be—as it manifests itself in tangible fragments and shavings. Unaccompanied by title or artist's statement, the works are offered as a sober consideration of form, structure, and the ruination of such, yet they seem also to possess an elastic idea of duration: the images suggest environments both frozen in time and on the verge of collapse.[70] There is a sense of excavation or uncovering in photographs like this—the sense

118

that, perhaps like at Pompeii, so cataclysmic was the interrupting act that caused this devastation that the residents barely had time to flee. We can gaze at the imagined existence that the fossilized objects in the frame suggest—a vision itself complicated by the troubling idea that, in reality, these "ruins" are perhaps only weeks or months old. These wounds to the fabric of the city are more recent and hardly healed. And, as Mortenson's travels revealed, it required only the price of a subway token to see them.

The photographs in Danny Lyon's *The Destruction of Lower Manhattan,* to which Mortenson's Bronx work bears a great deal of similarity, was offered in part by Lyon as documentation of a neighborhood soon to make way for the World Trade Center; Mortenson's work is, too, a form of documentation, yet, as Sean Corcoran observes in Mortenson's catalogue essay, this is part and parcel of photography's dual nature. One can sense in *Untitled (19 October 1983* a darkening that can be read as perhaps the sun setting on this scene and, by extension, the evacuated life of this building. Yet, this is as much an implication as can be made or, at least, as much as the photographer is willing to make.

By locating himself within the interiors of abandoned Bronx buildings, within the borough's deserted living rooms and burned-out bedrooms, Mortenson creates a greater degree of intimacy—whether perceived or imagined wholly—between the viewer and the past lives now gone from between these walls. Whereas from a Bronx rooftop Mortenson suggests that such ruin might endlessly replicate even beyond the limits of vision, here it is presented as somewhat more self-contained—a microcosm of what lies beyond these walls. The arms of the chair in Mortenson's photograph are open and gently bathed in light; it is almost as if we have been invited inside a home, and purposefully given nowhere to sit. The photograph simultaneously enforces this same sense of reception and repulsion: we are admitted to these once-inhabited interiors by virtue of Mortenson's camera, yet we are disturbed by the condition in which we find them. Rather than confronting the building's potentially intimidating mass at street level, as much of the Bronx tax photography does, we as viewers are given access to spaces—perhaps even dangerous ones, due either to structural instability or other kinds of physical danger—that would be rarely seen by the public. Mortenson himself noted that he would walk through many buildings which seemed to have been so recently abandoned that coats still hung on the backs of closet doors, or furniture—like the chair in this particular photograph—still adorned otherwise empty rooms. As such, the effect created by Mortenson's photographs is both unsettling

Ray Mortenson, *Untitled (19 October 1983)*. Copyright Ray Mortenson.

Courtesy L. Parker Stephenson Photographs, NYC.

Ray Mortenson, *Untitled (17 February 1984)*. Copyright Ray Mortenson.

Courtesy L. Parker Stephenson Photographs, NYC.

and strangely touching: there is an ethic of intimacy to these abandoned places that reveal traces of those lives that have been lived, but they can bring us only so close.

*Untitled (17 February 1984)* locates the viewer at the top of an apartment stairwell, looking down at a small sea of rubble that has collected on the landing below. The view, though perhaps less dizzying than one of Mortenson's rooftop reveries, is still precipitous: the strong crossing diagonals of the stairwell banisters on the left side of the frame draw the viewer's eye sharply downward as the camera seems precariously perched atop the stairs themselves. Momentarily distracting the eye from the cluttered remains of walls, floors, ceilings, and former inhabitants' possessions is a shock of fanciful floral wallpaper, parts of which have already peeled from the wall, visible in the upper-right-hand portion of the frame. The wallpaper functions here both as a visual register of the remnants of human life and as evidence of the process of decay. Again, it engages—perhaps even more directly—with the work and interests of Matta-Clark and Smithson. Matta-Clark's photographic documentation of his own interventions in Bronx buildings, many of which capture similarly precarious views down, up, and through floors, ceilings, and walls, are precursors to Mortenson's sharpened angle of vision here, just as his early 1970s forays into these same Bronx neighborhoods in search of an urban "canvas" upon which to work were for Mortenson in the first place.

The floral pattern in Mortenson's photograph recalls some of the "samples" of floor and ceiling taken from a Bronx building for one of Matta-Clark's sculptural fragments, *Bronx Floors,* and could almost be seen as a gesture on the photographer's part to Matta-Clark, with whose work Mortenson was more than familiar. And in the debris that has collected in pools of larger and smaller fragments of rock, wood, and other building material, we might see suggested a relationship to Smithson's depositional model of time, yet here one that is radically abstracted and telescoped from the generational and geological models that Smithson explored in works like *Spiral Jetty* and elsewhere.[71]

The ruin in Mortenson's photographs is both recent and therefore significant to the viewer as evidence of devastating physical, economic, and sociopolitical trauma, yet if left untouched perhaps would acquire the "patina" of more familiar, and more distant, representations of time past. Mortenson's photographs depict ruin in the process of becoming; this is their special quality. Whether within the space of a minute, or ten, exploded into infinity, or at the second of photographic interruption, we

are presented with a vision of urban decay that is both immediate and timeless, hastened and laconic, full of the possibility of reversal or doomed to lie dormant for an age.

## World Enough and Time

Where does the visual memory of a city reside? Within the photographic archive and its ambitious program that gestures toward a relentless totality of vision? Or within the idiosyncratic artistic visions of those who represent it from a personal perspective? As we've seen, the distinction between these two approaches in photographing the Bronx built environment of the 1980s—a place what was once, and often still lingers on in our memory as, a symbol of urban crisis—bear more significant similarities than differences. Taken together, they offer a nuanced and powerful visual understanding, certainly of that built environment but also of the city's imperiled social and political moment, and the municipality's attempted response to balance one of the many inequities of the era. So, too, do the two projects offer understanding of the heights of representation and the depth of societal breakdown; of the elasticity of both the archive and fine art to represent subjects with occasionally remarkable intricacy; and, finally, of factuality, of disaster and resistance, and of the irrepressibility and inevitability of narrative—of which there is much to both modes.

Photography is a kind of drawing with light, yet it is also selection, quotation, and citation. The particular "drawings" seen in this chapter, whether executed by municipal functionaries or trained specialists of the art form, are not only portraits of a city but also illuminated visions of a painful moment in that city's history. They are, too, documents produced by a municipal body that were testament to a fiduciary responsibility of "center" to "periphery" that was, in evidence, in the process of being abdicated. Documentary photography, then, in the case of Liebling, Mortenson, and the Bronx tax photo archive, is defined by the capture and the inscription of a multitude of narratives—those intended and unintended, historical and romantic, present and past—that are continually written on, and written over, a city's built environment. These stories are left to us to read and revive by looking, and then looking again—or photographing and photographing again—as each act momentarily dispels the illusion that time stops with the click of the shutter.

# 4

## A GLOBAL BRONX

An unwritten rule of life and art is that the best parties end up being those to which one discovers they've been invited, seemingly by mistake. In the summer of 1982, the alternative art gallery Fashion Moda—established in 1978 in the heart of one of the South Bronx's busiest commercial districts by the Viennese émigré Stefan Eins—opened three "stores" as installations at the seventh Documenta exhibition of contemporary art in Kassel, Germany. The stores were stocked with artist-generated multiples (small sculptures, posters, T-shirts, and the like) priced from 50 cents to $200—a gesture at an affordable brand of egalitarianism reminiscent of Eins's earlier experiments in SoHo, circa 1972, selling what he called "low income multiples." Invited to the exhibition by Documenta's artistic director, Rudi Fuchs, and curated by Eins and artist Jenny Holzer, the Fashion Moda stores sold work created by approximately forty artists, including Tom Otterness, Kiki Smith, Keith Haring, and Holzer herself.[1] Known alternatively as "A Museum of Science, Art, Technology, Innovation, and Fantasy," Fashion Moda averred a pluralistic underlying philosophy that "art can be created and appreciated by anyone, trained and untrained, middle class and poor, known and unknown, anywhere," as disclosed in some of its earliest promotional literature.[2] Such a philosophy—essential to the relationship that Fashion Moda forged with its South Bronx home outside the Manhattan gallery circuit, and which was reflected in many of the artist-generated multiples available at Documenta—encountered in its exportation overseas a kind of test, an interrogation of its principles. The outcome of that test suggested that though the pluralism of Eins's project helped lay the groundwork for a global embrace of some of its artists—particularly its graffiti writers—it was rather also Fashion Moda's South Bronx site of "anywhere" that proved to be as portable, and as multiplicable, as the art it sold.

To many of Fashion Moda's artists, Kassel must have seemed a long way from Fashion Moda's storefront at 2803 Third Avenue—incidentally, about a mile and a half south of where Gordon Matta-Clark made his building cuts for *Bronx Floors* ten years earlier—but by many critical accounts, the gallery made itself at home overseas almost immediately. The art historian Benjamin Buchloh described the assembled "artists' tchatchkis and souvenirs" as a "petty-commodity program" and, for this very reason, deemed Fashion Moda "one of the few courageous curatorial choices" of the exhibition. Buchloh saw the Fashion Moda Stores' wares as cleverly exposing the high-market commodity status of other art objects on view by contrast with its South Bronx–centric kitsch.[3] As art historian and theorist Douglas Crimp describes in his 1984 article "The Art of Exhibition," some of the stationery on sale at the Fashion Moda stores featured quotes sampled by the artist Louise Lawler from what was, by then, an already roundly mocked invitation-cum-press-release written by the artistic director Fuchs, which had been circulated to invited artists like Eins and Holzer the previous fall.[4] Like Buchloh's review, Crimp's essay—a canonical work within the field of curatorial studies as well as a chronicle of the reception of Fashion Moda's Documenta 7 installation—advanced the notion that a "store" selling such simple, portable products and reproductions had the effect of acknowledging the commodity status of all of Documenta's displayed artworks. The Fashion Moda stores might be seen as "courageous" and egalitarian, as opposed to merely a capitulation to capital, however small in scale. Thus, in the critical estimation, the status of objects like Lawler's stationery multiples not only stood in symbolic opposition to much of the art on display at Documenta, but their playful subversion of Fuchs's curatorial ideology was also quite literally written all over their surfaces. Crimp, in turn, borrows Lawler's impish gesture and begins his essay with a critique of Fuchs's inaugural curatorial move: namely, the press release.

Here is how that press release begins: "How can I describe the exhibition to you: the exhibition which floats in my mind like a star?"[5] Despite his professed rhetorical helplessness at putting words to the waking reverie he describes, Fuchs proceeds to do just that, sketching for his reader "an encounter in the forest of art" in which "great minds of different character and tradition" can discover their "high, common language."[6] From there, the prose gets no less purple. What Fuchs argued for most broadly in his press release was a kind of elevated experience, a restoration of the autonomy of the art object, which was to be encountered in only the most

rarefied air. Fuchs's vision for the exhibition suggested a more literal definition of lofty: soaring, without grounding in social reality or physical space of any kind beyond that provided for by the hallowed halls and cosmopolitan curatorial spheres of the international art exhibition space.[7] It was a vision that seemed to argue for an abstract notion of placelessness while retaining a particular sense of the specifics of site, locating itself within the familiar confines of the walls and atria of the Orangerie and Fridericianum at Kassel. Fuchs continued: "Art just is not a spectacle; it is almost a devotional object. Art and the artist, with their different ideas and dreams, need a space of their own; a space which should not be defined by society or by architecture, but which art at first must define for itself."[8] For Fuchs, this "space of their own" had less to do with contemporary artistic and critical prerogatives of societal responsibility, environmental or experimental artistic practices, or reflections on the particularities and politics of built space than with a sublimated exchange of disembodied intensities. Perhaps the great minds of different character and tradition were meant to encounter each other, floating freely, buoyed up by the hot air of his statement. Whatever the intention, Fuchs's press release thus articulated an artistic program that seemed to clash with the Fashion Moda stores' more egalitarian visions of the plurality of creativity, antiexclusivity, and antielitism.

Whether one prefers the rootless, cosmopolitan, "placeless" exhibition space and attendant art of Fuchs—and his desire for a purity of aesthetic experience—or a space and an art rooted in historical materiality and political commentary, as Crimp describes, both conflicting critical and curatorial positions, whether lofty or grounded, are based in a logic of site specificity. Crimp situates his review of the exhibition within the American social and material realities that gave inspiration to much of the art sold by Fashion Moda in Germany—the interrelated housing and homeless crises that were all too visible on New York streets—as well as the historical materialities of Kassel, heavily damaged by bombing raids during World War II, as they interacted with Fashion Moda's Documenta contributions.[9] Fashion Moda's willful exportation of its curatorial philosophy and aesthetic practice (as exemplified by the work of its exhibiting artists) beyond its municipal and national borders provides for us an occasion to reflect upon how Fashion Moda operated within its American context of the South Bronx, which was then considered, in the words of Eins, "the worst ghetto in the USA."[10] In relocating temporarily to a foreign site, Fashion Moda not only situated itself between the set of historical and

material realities that Crimp describes but also—whether unintentionally or not—served as a symbolic emissary of the already symbolic South Bronx abroad.

One wonders, then, what did this South Bronx, as exemplified by the T-shirts and riotously colored posters of the Fashion Moda stores, look like to Documenta audiences that had never been there? Was the space between the imagined and the real Bronx erased with the purchase of a Holzer "Truism" on a T-shirt? And what of the art objects themselves, many made with highly specific local references, now brought to bear upon a global art marketplace? Fashion Moda's Documenta moment contained within it implications for rethinking art historical concepts of site specificity—for instance, what do art objects made within one specific, yet highly symbolic, locational context mean when viewed outside of those specific, symbolic contexts—but this particular instance also allows us to consider how "The Bronx" as site and symbol was received and understood in a global marketplace: here, the art market, and in the embodied, commodified form of the art object. If Fashion Moda's participation in Documenta 7 marked the time when, in the words of the *New York Times,* a "South Bronx collective went international," then we might also understand this same moment to be a time when the South Bronx itself—freighted with meaning as worldwide symbol and real site of urban ruin—went global.[11]

Can we view the whole Bronx—as sign, as signifier, and the reality of its streets—as a site? Can that site be rendered or otherwise captured—even immortalized—and then made transportable as a commodity for exchange? And what happens when not only the artistic object, or the gallery that offers it for sale, but the very site itself—the South Bronx—becomes unmoored from its geographic location? More broadly, what happens when specific sites of artistic practice lose their specificity and instead come to register as neither site nor what Robert Smithson termed "non-site"? Or when the legibility of socially engaged practice becomes blurred by romanticized reception and representation?[12] If the South Bronx existed as both place and idea in the minds of the artists who represented it; if it was place and idea in the minds of audiences who received Fashion Moda's artworks with varying contextual understanding; if it was place and idea even in the minds of those who truly called the Bronx home, then we might also say that Fashion Moda's critical and curatorial practice, in its American and European contexts, operated—like the Bronx itself—at the level of site and symbol. As an international exemplar for urban ruin and civic neglect, perhaps to the chagrin of Rudi Fuchs and Stefan Eins alike,

the South Bronx could be both place and as placeless as Fuchs intended the art of Documenta to be.

Miwon Kwon's foundational genealogy of site specificity develops three models or paradigms of site-specific art practice, each of which correlates to its own conception of site: "phenomenological," "institutional," and "discursive," the third of which has historically offered the broadest—and perhaps most contested—notion of site specificity.[13] In this third, discursive paradigm, site need not be an actual, physical place but rather a "discursively determined site that is delineated as a field of knowledge, intellectual exchange, or cultural debate," thereby opening up seemingly endless possibilities for artists to engage a genre of literature, the fiber-optic infrastructure of the internet, or, perhaps for our purposes, a discourse of symbols as a site. The "discursive" site, and particularly the brand of "community-based site specificity" that Kwon has theorized—where the "site" is essentially the ever-ambiguous and impossible-to-define notion of "community"—might seem to encompass both Fuchs's cosmopolitan groundlessness and Crimp's materialist version of Fashion Moda's South Bronx rootedness.[14] However, the peculiar identity, and infamy, of the Bronx as it existed at that time, what we might call "symbolic" site specificity, suggests a hybrid and eminently transportable model of site-specific art practice, where Fashion Moda engaged the symbolic Bronx—its ruins, its rubble, its wounded yet world-renowned reputation—as much as it did wildly unstable notions of "community," society, or politics. In this formulation, it is the collective idea of what the "South Bronx" meant, how it was perceived and imagined, and what it resembled that "float[ed]" in the minds of all who engaged with Fashion Moda, either willfully or unintentionally, as Fuchs mused, "like a star."[15]

Within the brief yet influential history of Fashion Moda we might see inscribed its own radically condensed "genealogy" of site specificity: from a practice that was formally determined or defined by its environmental context, to one that can and does play as provocation in a multiplicity of sites and surrounds. Fashion Moda's hybrid model exists as both unmoored from material terrain yet bound to the historical, cultural, and social specificities of the Bronx. Within the story of one gallery's invitation to an international exhibition are embedded questions about cultural exportation; about interpretation across transnational networks of exchange; about collective assumptions about the definition of community; and how Fashion Moda's example, in turn, refashions our sense of the possibilities of each.

## A South Bronx Hall of Fame

For many who lived outside its borders, and even for many who lived within them, the South Bronx seemed to represent a place that had already become "unhinged" from its geographic site, to use Kwon's term, and functioned more as a floating signifier—a symbol of "despair, of oppression, or of devastation." Bronx iconography was both infamous and international, as the Italian art critic Francesca Alinovi confirmed in a visit to the borough: "People write about it everywhere in Italy in the papers, scouring the seamiest suburbs of Italian cities in search of any as sordid and derelict as New York's ill-famed quarter. . . . The Bronx, depressing heart of New York State, and perhaps of the entire United States, may be considered the symbol of today's disintegration of the big city and of ultra-modern urban degradation."[16] It had become, in the words of Luis Cancel, executive director of the Bronx Museum of the Arts and himself a Bronx native, "a side show, a backdrop for symbolic political initiatives," which also threatened to obscure those parts which were still viable and vibrant.[17] Politicians like Ronald Reagan and Jimmy Carter did not visit the "South Bronx" as much as they did the site of the nation's shorthand for urban ruin, which, to them, might as well have been anywhere—except that, to Bronx residents, that site was nowhere else but home. For them, it remained a site that had, irretrievably, already become symbol as well. In this way, the site specificity of artwork produced within or responding to the Bronx built environment and its related social conditions is not so easily categorized, even according to Kwon's useful taxonomy. This disjuncture—or commingling—of site and symbol was well understood in countless journalistic accounts of building abandonment and arson, but it was best exemplified by one *New York Times* article from 1980 that provocatively asked its readers to "consider *South Bronx* itself, a term the whole country now regards as generic as well as geographic."[18] Thus, to Americans and to the rest of the world, the ruins of the Bronx were axiomatic—a matter of course, a means for relating to ruin elsewhere and in their own communities, as well as a very real place that they might hope never to visit.

The symbolism that President Carter sought on Charlotte Street was not lost on one particular New York transplant, however: a Viennese émigré to Manhattan's SoHo, Stefan Eins. Yet what Eins saw in Charlotte Street, for all its salability as an archetype of urban decay, was not merely symbol but also a very real site within which to situate a gallery. Eins credited seeing a 1977 photograph of Carter "jumping over a fence" during his

famous visit to Charlotte Street as the moment in which Eins "discovered" the Bronx and—impulsively, simultaneously—decided to open his new gallery space there.[19] The built environment of the South Bronx was central to the identity of the art space; indeed, it was written into one of its first and most public statements in a 1981 issue of *Artforum,* where the gallery introduces itself by way of its geographic location: "Fashion Moda is located at 2803 Third Avenue in the business district of the South Bronx, an area of severe urban devastation."[20] In a 1998 letter written to the program director of the Andy Warhol Foundation for the Visual Arts, Eins writes retrospectively of his understanding of Fashion Moda's relationship to its site, as well as his initial decision to leave SoHo for the Bronx: "The then barren South Bronx—at one time considered the worst ghetto in the nation—provided a perfect breeding ground for unfettered expressions of creativity without the commercial pressures of the marketplace and a destroyed urban landscape with open lots and abandoned buildings waiting to be used in exciting, innovative, and challenging ways."[21] Thus, we see Eins here simultaneously trading upon the idea of the South Bronx that existed by reputation, manifest in familiar narrative tropes of ruin and devastation, while the brick-and-mortar storefront that was Fashion Moda concretely attested to Eins's commitment to something beyond mere notoriety or infamy. Eins's vision of Fashion Moda was a redemptive one; he sought to mobilize the built environment of the Bronx toward generating artistic practices and products from within. It remains unclear, however, exactly how aware Eins was of how similarly generative such sites were to more sensational, surrealistic, and less generous fantasies from without.

One of Fashion Moda's central interventions in the art world of New York City during the late 1970s and 1980s lay in its reinscription of the real estate dealer's favorite dictum: relocation, relocation, relocation.[22] The gallery was instrumental in establishing a hybrid meeting space for the burgeoning graffiti and hip-hop scene in the Bronx that lay outside what Eins believed to be the elitist strictures of the SoHo art world.[23] He knew this downtown world well, having previously established a storefront space in the neighborhood at Three Mercer Street in the early 1970s, which was part studio and part exhibition and performance space. It was here that he first experimented with the idea of selling artist-conceived knickknacks and multiples under the aegis of what he called the "Three Mercer Store."[24] According to Eins, the inspiration for Three Mercer had to do with its close proximity to a business district, the Canal Street shopping area. Eins replicated this strategy by locating Fashion Moda not far from

130

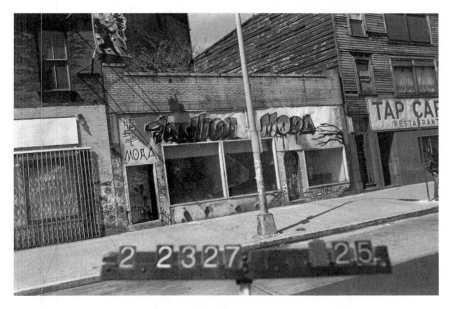

2803 Third Avenue. Department of Finance, Bronx 1980s Tax Photographs, 1983–1988, dof_2_02327_0025.
Courtesy NYC Municipal Archives.

149th Street, also known as "the Hub," one of the Bronx's busiest business districts, and just a short drive from the thickly symbolic Charlotte Street of Carter and Reagan.[25] In both cases, Eins's choice to locate his spaces near shopping districts where the art object might be seen proximate to retail commodities suggested that he viewed his store's multiples and other wares as a kind of commodity as well. In a 1980 interview in *REALLIFE Magazine,* Eins again engages with the Bronx within this symbolic register, here speaking to the particular allure that the South Bronx held and what brought him there: "I think it important to include as many people as possible, preferably from very different sub-cultural levels," Eins says, underscoring his democratic and pluralistic ideals for art practice. "The South Bronx had a special attraction," he continues, "because it had a bad reputation in Manhattan, so I thought it might be a good spot to do it in."[26] Journalist and critic Francesca Alinovi understood Fashion Moda's Bronx location to be central to its vitality: "The context of the art is as important as the artistic activity. It is the context which gives sematic meaning to the artwork. Or rather, it is the relation between the

work and its context which creates new circuits of semantic energy."[27] As a new and unique site for cultural exchange, Fashion Moda facilitated creativity outside the traditional bounds of the marketplace and displayed works from *both* local and downtown artists that responded directly to the devastated urban landscapes that were only blocks away. In doing so, Fashion Moda operated within established frameworks for site-specific art, yet many of its artists—especially those who benefited from the gallery's influential support of graffiti—offered new models of site-specific work that made ingenious use of both transport networks and the urban built environment in redefining what site specificity could mean.

It is important here to reckon with how Eins—and others—imagined his own relationship to the place in which he chose to start his new gallery. In a review for the *Village Voice,* Carrie Rickey sketches the opposing critical positions regarding Fashion Moda at the time: apologists argued for the positive effect it had for both downtown artists and South Bronx residents, whereas critics insisted it reeked of "'downward mobility' . . . a radical chic equivalent of noblesse oblige."[28] The artist Tim Rollins, who exhibited at Fashion Moda with his group, K.O.S., offered praise on record for the gallery's program but also voiced similar reservations about what he saw as a "patronizing, missionary model" in terms of how Eins viewed the gallery's relationship to its community.[29] Alinovi put this very question to Eins in an interview, asking him whether he understood how an outsider might look at his move to a "depressed area like the South Bronx" as emerging from a "populist and missionary outlook."[30] Eins disagreed. He maintained that he was interested in making contact with the residential community and local artists, but not for humanitarian and populist reasons, "simply because we'd like to challenge the prejudice that art should be for an elite and that only someone who's been to school can understand it."[31] Eins continued, in a vein that might have maddened the highly formalistic Fuchs, "Art isn't a question of educational background, it's a vitality, it's a way of looking at things. A way which doesn't really need to be realized at a formal level. Art means working in any place with any means. Creation and art can happen anywhere."[32]

Joe Lewis, an African American poet and musician who joined Fashion Moda as codirector (along with William Scott) soon after its founding, offers a different reading of Eins's motives for starting the galley: "I was with him the day he found the space [for Fashion Moda, a burned-out former Salvation Army storefront]. The idea was just to get the alternative space out of downtown Manhattan. Stefan will tell you that Fashion

Moda was about art, science, and technology, and I say that Fashion Moda was about creating a place for underserved populations."[33] One can read Eins's relocation from SoHo as a cynical gesture of urban colonialism, or one can take the lapsed Austrian theologian at his evangelical word. What can be said with certainty, however, is that by choosing to locate his gallery in the Bronx—in the near-immediate wake of the 1977 blackout (which Eins suggests indirectly provided the ruined storefront for the gallery by way of the accounts of looting that briefly seized the city during those hours)—Eins committed himself to engaging with a place and an idea when many others in Manhattan might have preferred to ignore its existence entirely.[34] By most accounts of Eins's intentions, he was too idealistically naive and too utopian to merit serious accusations of base cultural tourism; however, one can, of course, be naive and casually essentialist, sometimes in the same breath. Eins admits that, after having established the gallery, he "[knew] now that it's different from what I thought it was."[35] Such an acknowledgment testifies to the disjuncture between the South Bronx as an imagined place and the South Bronx as a site of experience. Eins's admission—suggestive of the "downtown stereotype"—gestures at the complexities, objectifications, and misidentifications of symbol and site that make our understandings of what he understood his subject position to be in relation to the Bronx as place and as idea difficult to discern. Yet it is also this instability, this slipperiness between site and symbol, that allowed for artworks produced within the South Bronx—and much of the art displayed at Fashion Moda—to make plastic use of this hybrid condition to create works that engage just as fitfully with both the material and the symbolic realms, not merely engaging with their native contexts but, once removed, enforcing their own contexts upon foreign shores, thereby creating new meaning.

The Bronx's hybridity of site and symbol—and the portability of both those ideas and the art produced in relation to them—was not lost on the directors of Fashion Moda. Both Eins and Lewis took pains on various occasions to establish that Fashion Moda—despite displaying its Bronx bona fides as proudly as one would a badge in some of their promotional material—was "not a South Bronx institution" but rather "just happens to have its first manifestation in the South Bronx," and preferring to "deal on an international scale."[36] Eins and Lewis's desire to maintain their pretensions toward international and universal engagement is persistent and even admirable in their early interviews, but such a stance is often destabilized by the centrality of the South Bronx to their project as both site and symbol.

133

As much as either Eins or Lewis might make claims to the contrary, the extent to which Fashion Moda desired to shape, and be shaped by, the complex interplay between competing ideas and realities of the Bronx is evident in their articulations of its establishment. Of this, Lewis notes:

> I came to the South Bronx initially because I got a studio space from the Berg Corporation, which is one of the largest minority owned chemical corporations in America. . . . I also saw the need for something to reflect the attitudes, the aesthetic, political, and moral values of the downtown scene in a so-called depressed area. I say so-called because culturally this is a very rich place for aesthetic ideas—music, art, fashion.[37]

Lewis's anecdotal origin story for his involvement with Fashion Moda suggests that he imagined not merely a producer-consumer relationship between Fashion Moda's South Bronx site (as well as his own artistic practice) and New York's artistic hub, but also an interchange of "attitudes," aesthetics, and related values from the "downtown scene." We might thus begin to reconcile the seeming contradiction of imbricating the identity of the gallery in place-based, community-based, and environmentally based practices, and looking beyond the borders of the Bronx for additional engagements. Indeed, Eins imagined Fashion Moda's relationship to that "downtown scene" as a dialectical one. As he explains in decrying the early critical reception of the gallery's project, "All this coverage I get in those white elitist magazines doesn't really get the gist of what's happening here, of what Fashion Moda is about. It feeds back to SoHo."[38] This interchange between sites was reflected in the gallery's programming: Eins at once commissioned local graffiti writers like Chris "Daze" Ellis and John "Crash" Matos to paint their storefront signage at Fashion Moda; he also extended invitations to downtown artists like Jenny Holzer, Keith Haring, Christy Rupp, and John and Charlie Ahearn to make and show work uptown in the Bronx. Regarding Eins's desired interchange between art world downtowns and uptowns, we can read such relationships in two ways. At first glance, Eins's enforced dialectic reads as an attempted inversion of the familiar relationship between center and periphery. But we might also read the gallery's keen understanding of and engagement with its South Bronx location as a method of conceptualizing the idea of the "South Bronx" as a unit of exchange and therefore as a "site" writ large—and one that could then be as portable as the art displayed both in its storefront and along local, national, and international networks of exchange.

Much of that art—John Ahearn's face castings of local community residents, or John Fekner's painted textual interventions (one of which served as backdrop for yet another presidential visit to Charlotte Street, Ronald Reagan's in 1980)—was specific, or at least responsive, to the conditions of the South Bronx environment that helped generate it. Ahearn's life-cast work, best exemplified by his 1981 show with Rigoberto Torres at Fashion Moda titled "South Bronx Hall of Fame," was enormously popular in its site-specific, street-side iterations leading up to that show—busts and nearly full-figure casts of local residents hung as murals on the sides of Bronx buildings. Ahearn's later work, however, was more infamously unsuccessful in his commissioned—and later voluntarily removed—project for the New York City Department of Cultural Affairs, which consisted of three bronze sculptures, also of local residents, placed on pediments adjacent to the NYPD's Forty-Fourth Precinct on Jerome Avenue. The unfortunate saga, which unfolded within the context of early 1990s debates about multiculturalism and identity politics, formed the subject of writer Jane Kramer's New Yorker article "Whose Art Is It?" (later published as a book by the same name).[39]

That incident crystallized the fierce debates surrounding site-specific work and issues of representation of communities of color by those who might or might not be a part of those communities, as well as the broader question of what constitutes community membership in the first place. Ahearn's early work at Fashion Moda, however, produced more harmonic rather than discordant notes: his partnership with the then seventeen-year-old high school student Torres was born out of the teen seeing Ahearn's work and recognizing a relationship with his uncle's Bronx statuary company, which produced religious figures for local botanica shops.[40] Indeed, Ahearn's "South Bronx Hall of Fame" show, whose audience featured many of the African American and Latinx subjects cast by the artist for his painted, lifelike mascarilla (or face mask) statuary, had the effect of transforming the storefront art space into a reliquary for still-living saints for all the community to see.

Ahearn's castings were crucial for providing Fashion Moda an early—and deep—connection with its surrounding communities and area. Among the most famous example of site-specific work sponsored by Fashion Moda was Justen (Houston) Ladda's The Thing, a three-dimensional image of the Marvel Comics figure painted on the walls and over the seats of an abandoned auditorium in a South Bronx public school. Ladda's work was even position-specific in the sense that the cohesiveness of the image, and its

three-dimensionality, could only be discerned from one vantage point, rendering it fragmented or distorted from any other angle.[41]

The brands of site-specific art on view at, and facilitated by, Fashion Moda in the South Bronx were essential to its concept, and unique site-specific artistic practices like graffiti bring into focus the productive peculiarities of the modes of site specificity that took root at Fashion Moda—and which took off, so to speak, to elsewhere. Fashion Moda facilitated art practices that called attention to its site—the nearby devastated urban landscapes of the Bronx and the equally devastating social realities attendant to its environment—yet also managed to transcend the more phenomenological strictures of site-specific work.

In this way, the same frameworks of exchange that characterized Fashion Moda's relationship to the downtown New York art world are replicated, also, in the South Bronx gallery's relationship to the international art market—and to Documenta 7. But thinking internationally, counterintuitively, brings us back to a consideration of the Bronx itself: if the South Bronx was already, in the words of the *New York Times,* "another country" to many Americans by the time of Fashion Moda's establishment, I would argue that we can describe the gallery's engagement with what appeared to be a grotesque, "foreign" figure—alien in both its physical and symbolic form to Americans as a part of America, and alien, in some ways, to itself—as constituting a dialectic model of site specificity.[42] We might think such a dialectical model alongside Smithson's concept of the "dialectical landscape" that argues against "one-sided" views of landscape and advocates instead for understanding of landscape as an ongoing historical and temporal process, and a dialectic that sees things, as Smithson understood Frederick Law Olmsted's Central Park, as "a manifold of relations, not as isolated objects."[43] In this formulation, the ever-shifting concept of the "South Bronx" itself—whether physical or symbolic, imagined or real—is a site that "can no longer be seen as 'a thing-in-itself,' but rather as a process of ongoing relationships existing in a physical region."[44] In opening three Fashion Moda stores at Documenta 7, this concept of "South Bronx as site" would itself be exported as part of the international exhibition.

## Internationally Known, Locally Respected

It seems ironic that Fashion Moda, an exhibition space that was so intimately tied to and defined by the realities of place at its South Bronx home,

Fashion Moda, Documenta 7 sign, 1982.
Courtesy Gallery 98.

found, in art historian Sally Webster's estimation, the fullest realization of its concept in Europe, at Documenta 7.[45] When visitors arrived at the Kassel exhibition, they would have discovered out on the lawn in front of the Orangerie in the palatial Fridericianum's English garden what *Artforum* critic Richard Flood described as a "funny little four-room structure" that had been left over after a horticulture show.[46] That structure housed part of the Fashion Moda store, either in homage to the gallery's adaptive reuse of its South Bronx storefront space or perhaps out of a desire to relegate Eins and Holzer's collection of wares to the periphery of the exhibition. In any case, both the Fashion Moda store's seemingly ramshackle structure and the merchandise inside—considering the stately grounds and structures that surrounded them—provided even greater contrast to the grand, totalizing gestures of the exhibition as a whole.

Nevertheless, the South Bronx, with its manifold relations, identities, and material and symbolic properties, came to Kassel with Fashion Moda in 1982. Yet the gallery initially bore little of this complexity in its outward presentation. In comparison to Fuchs's letter, Fashion Moda's own May 1982 press release announcing its participation in Documenta is a model of practicality and directness:

> Jenny Holzer and Stefan Eins have organized a . . . Fashion Moda Store for Documenta 7 in Kassel West Germany (June 19th to September). . . . A wide variety of style—a Fashion Moda trademark—will be represented. Items in the store will include small sculpture, posters, knick-nacks and fashion items. Graffiti from the subways are represented as well as work on nuclear biology. Prices range from 50 cents to $200. (This effort relates to Claes

Oldenburg's Store, the Fluxus, Stefan Eins' 3 Mercer Store, the stores orga-
nized by Collaborative Projects including the one at the Times Square Show.)[47]

This earnest, broad statement rather thinly masks some of the artistic influences that are present in Eins's artistic philosophy, and by extension that of Fashion Moda. Rarely is the gallery as specific about the expansive—and indeed, international—inspirations for its own artistic directions, here naming Oldenburg, who also showed sculpture at Documenta, and, perhaps most interestingly, the Fluxus as artistic kin. German Fluxus Joseph Beuys debuted his own site-specific, community-based work at Documenta 7, *7000 Oaks*, which invited citizens of Kassel to plant seven thousand trees throughout the city, each accompanied by a basalt stone.[48] Given these international, and particularly European, spheres of influential artistic practice—and given Eins's own European background—we might understand Fashion Moda's global pretensions as not merely a desire for international relevance but reflected in the very roots of its artistic philosophy. And if not quite its heart, the representative essence of those universal pretensions was borne on the very sleeves of the T-shirts that they sold at Documenta in the form of their multilingual logo, printed in English, German, Russian, and Spanish. Far from a breach of character, Fashion Moda's international intentionality was laid bare in the pages of *Artforum* more than a year before Documenta 7 in its January 1981 issue:

> Fashion Moda is located at 2803 Third Avenue in the business district of the South Bronx, an area of severe urban devastation. Above the door a local graffiti artist has drawn our logo which always appears in English, Chinese, Spanish and Russian to reflect both our local and international objectives. Fashion Moda has been around forever, but as of the summer, 1978, it finally had an address. Fashion Moda is impossible to define because by definition we have no definition.[49]

Eins testifies to the centrality of location to the mission of Fashion Moda, while going so far as to suggest, in a gesture approaching mysticism, that Fashion Moda had always existed, as if some primordial spirit rendered itself manifest at its Bronx address. More broadly, "site" here as understood by the gallery has become the very arena within which geography, language, reputation, narrative, and even a kind of spiritualism are engaged, and—given the slipperiness of these relations with regard to the real and imagined "South Bronx"—such engagement happens at the level of both the material and the symbolic. Thus, in the same way that Eins asserts that Fashion Moda has "been around forever," in this written in-

vocation of itself as entity, the gallery implicitly acknowledges its conceptualization of the South Bronx as commingled site and symbol—and something as mystical (or, at least, mystified) as some of Fuchs's free-floating, starry visions but also as physical as a hand-drawn sign. As we've seen, in Eins's own dissimulations regarding his artistic influences, we might detect more of a dialectical relationship with cosmopolitan, international sources and its temporary European site.[50] If such a dialectic encourages us to see Fashion Moda's engagement with the South Bronx as "a manifold of relations," in Smithson's terms—historical, physical, spiritual, symbolic, or mythic—then we might view the role of Fashion Moda's stores in Kassel as negotiating between these competing and at times contradictory understandings, and not always comfortably, with regard to how those images or identities were deployed.[51]

If Fashion Moda's particular relationship with its South Bronx site exists in part within a dialectic between the material and the symbolic, between the built environment and the way that environment is represented and imagined, then we might also accept that the "products" of Fashion Moda—the art objects that take on the "manifold of relations" of the South Bronx by association—exist within a similar dialectic as well. The cheaply reproduced multiples that so delighted Buchloh at Documenta for their open acknowledgment of the dual status of the art object as bearing both auratic and commodity value then ought to bear the same dialectical relationship to the mostly cosmopolitan clientele at hand and to the international exhibition of which they were a part. If part of that auratic value of Fashion Moda's objects was bound up with the symbolic, even mythic, signifiers of the South Bronx, then we might also say that Fashion Moda highlighted, displayed, sold, and traded upon that value as it did with any of its playfully commodified art at Documenta. It is the exportation and display of these petty commodities outside of their native South Bronx home that allow us to see how Fashion Moda invests its particular version of "site-and-symbol" with the potential for commodified exchange. That is, in selling its Bronx-born boutique wares at Documenta's international exhibition, Fashion Moda managed to sell the very concept of site specificity itself.

What, exactly, did the two "store owners" Eins and Holzer have on sale? Louise Lawler excerpted Rudi Fuchs's invitation letter and printed those short passages on sheets of stationery. Selections from Holzer's *Inflammatory Essays* series were reproduced on colored paper and available in packets of twenty, and statements from her *Truisms* series ("ABUSE OF POWER COMES AS NO SURPRISE") were silkscreened on T-shirts.

Indeed, T-shirts were among the most popular items, featuring designs by John Fekner ("DANGER LIVE ARTISTS"), Keith Haring, Kenny Scharf, David Wells, and Christy Rupp, whose images of an attacking rat—last seen plastered around New York City during the garbage strike of 1979—stood out from the set. Mike Glier's "White Male Power" lithograph series depicted the smug or sneering faces of white men under which appear anonymous labels such as "Tycoon" or "Key C.I.A. Official." Following Rupp's indelible silkscreened images, most of the art on offer demonstrated social or political consciousness: David Wells's drawing of a stag floating downriver past a ruined cityscape—which echoed plywood silhouettes he had placed around "the Hub" near Fashion Moda—stirred both apocalyptic and poetic sensibilities while gesturing toward decaying neighborhoods near the gallery's American home.[52]

More curious were Marc Blane's *Glass Wine Bottles,* which had appeared previously in New York at the "Times Square Show" organized by Collaborative Projects (Colab). Using discarded pint-sized green glass Thunderbird wine bottles, Blane inserted into them singed black-and-white photographs of abandoned and decaying South Bronx buildings. Not only were Blane's bottles "archaeological artifacts of an often forgotten present," as David Craven described them in *Arts Magazine,* but, as objects found in the vacant lots of the South Bronx and elsewhere, they both embodied and quite literally encapsulated the ruin that was often in evidence there.[53] These were allusive, though ambiguous objects, as they paid homage to ruined Bronx streets and buildings, while suggestively entombing these images in what may be described as an alcoholic "amber," creating keepsakes of memories that may have charmed their Documenta audience but for a viewer born in New York or the Bronx may have represented painful visions best forgotten.

As Richard Flood wrote of Fashion Moda's Documenta installation as a whole, "What was most remarkable about the project was the provocatively encapsulated view it gave of an immediate, specific New York sensibility—a sensibility that mixes black and Hispanic influences with street politics, club-scene theatrics, and consumer-culture savvy."[54] But what remains unclear is how international audiences processed these images. What "South Bronx" did they see? Some saw artful squalor, reflected in Francesca Alinovi's musings: "The Bronx is the most romantic place in New York. Its romanticism no longer stems from literary and fantastic images, but from the naked reality of a civilization that has gone beyond history, beyond itself."[55] Or were some able to look beyond the power-

fully symbolic and see the struggles of real residents of the South Bronx? They may have worn a part of the Bronx home in the form of a T-shirt, but was the "South Bronx" seen as any more or less than a brand? To Documenta audiences, the South Bronx *was* "another country" and thus was even harder to understand outside of the symbolic register.[56] Like journalistic and literary accounts of South Bronx ruin, the visual art that was made in response to—or even in protest against—such conditions also oscillated between the symbolic and the historical.[57]

After all, Fashion Moda appeared, much like the Bronx itself to those who did not live there, to be as much a concept as it was an actual place. Indeed, Eins reminded countless reporters of his refusal to be considered anything less. That is, to be considered an "alternative art space" was, to him, a fate worse than death: "Fashion Moda is not an alternative space . . . it is not an alternative to anything; it is something in itself—an

Fashion Moda, Documenta 7, Holzer & Eins, 1982 (T-shirt, front).
Courtesy Gallery 98.

141

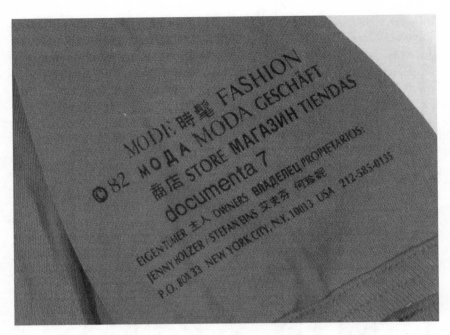

Fashion Moda, Documenta 7, Holzer & Eins, 1982 (T-shirt, detail).
Courtesy Gallery 98.

international cultural concept."[58] Fashion Moda's stubborn insistence on remaining undefinable—and the tendency of its codirectors to dissimulate their influences and to occasionally disclaim a local identity in favor of an international one—can be seen as problematic but also, in the tradition of the do-it-yourself aesthetic, the height of ambition. In some ways, that desire to remain undefinable is also among the most honest compliments it could have paid to the Bronx, given the borough's own similarly illegible, contradictory, and ever-shifting identity. By refusing to define itself, Fashion Moda perhaps saved itself from the fate of paternalistically defining the borough that it served.

The unstable figure of the South Bronx of this era finds perhaps its closest analogue in Kwon's text in a richly evocative phrase that appears in her conclusion (and is given, therefore, relatively little exposition): "the phantom of a site."[59] Such a term conjures notions of hauntings and of a "no-man's-land" that seem appropriate, yet which still do much to mask the fact that the Bronx was not populated by ghosts but by men, women,

and children for whom that "no-man's-land" was home. And it was that home, that site, that phantom, that Fashion Moda inevitably brought, along with its wares, to Documenta: a multilayered notion of site made transnational in a manner that would find explicit rhetorical fulfillment in works like Francesc Torres's 1988 video installation *Belchite/South Bronx: A Trans-Cultural and Trans-Historical Landscape,* which juxtaposed the ruins of the abandoned town of Belchite (largely destroyed in the Spanish Civil War) with the ruined buildings of the Bronx's urban landscape, and which suggested not only a borderless kinship between sites, bound in both the physical and the symbolic registers, but also that sites like these are hardly "no man's" but rather ours with which to reckon and repair.[60]

## Coda: Graffiti Art Success for America

Somewhat ironically, what put Fashion Moda "on the map," according to Joe Lewis—what truly made it truly "global"—was graffiti.[61] Graffiti provided the central catalogue image for Fashion Moda's international debut at Documenta: a facsimile of a print produced by John "Crash" Matos.[62] Graffiti made the gallery mobile in ways that the touring of Fashion Moda shows to other cities could not (Lewis traveled to shows in Atlanta, New Orleans, and San Francisco and the greater Bay Area) and brought its forms and styles—and, importantly, its artists' names—beyond the Bronx's borders.[63] The "Graffiti Art Success for America" show of October 1980, curated by Eins and John "Crash" Matos a full two years before Documenta 7, was enormously influential in establishing graffiti within art world circles and featured graffiti writers already legendary outside of the gallery setting like Fab 5 Freddy, Futura 2000, Lady Pink, Lee Quiñones, and Zephyr, among others. *Wild Style,* the seminal 1982 film directed by Charlie Ahearn (twin brother to John Ahearn), which brought not only graffiti but also hip-hop culture to the world, opened about a month before Documenta 7 closed.[64] However, it was in the nature of the work itself—a particular brand of site-specific work, on walls and on trains that toured the city—that lent it its brilliantly transgressive, and physically transportive, nature. Graffiti, already an art form that mobilized transportation networks (in the form of the city's subways) as art material, canvas, and distribution channel since the early 1970s, was a synergistic match for Fashion Moda, which then became a conduit of exchange to even more rarefied quarters of the city and, importantly, to similar corners of the art market. Writers of graffiti realized then, as

perhaps many "street artists" do today, that they did not necessarily need the support of that art market, via the gallery system, to survive. They appropriated their own networks of distribution.

"Wildstyle," as critic and scholar Hua Hsu describes it, the "dense and beautiful" style of "overlapping, interweaving letters and words threatening to riot," was the form of lettering after which Ahearn named his film. "Utterly indecipherable to the untrained eye," it also made perfect sense to the artists and writers who produced it.[65] In the famous words of Claes Oldenburg upon seeing graffiti trains slide into subway stations, "At first it seems anarchical—makes you wonder if the subways are not working properly. Then you get used to it. The city is like a newspaper anyway, so it's natural to see writing all over the place."[66] And given its often indecipherable letter forms—at least to the untrained eye—it was an ideal art form for what was, to many outsiders, an illegible site.[67] It unified and resolved symbol with site in ways that few other art forms that engaged the South Bronx could. And, in making the "illegibility" of life in the South Bronx legible, it did so mainly—and importantly—for those to whom it mattered most: those who called the South Bronx home.

Partly by luck—hip-hop and graffiti had begun to coalesce as related movements in the Bronx before Eins's arrival—but also partly by his own earnest belief in the power of universal creativity and populist art, Eins's Fashion Moda emerged at a time, and in a place, that allowed it to shine brightly, though briefly, as one of the South Bronx's cultural lodestars. Perhaps Fashion Moda evades categorization within our conceptions of site specificity because it was so intimately of, and made *by*, a place that itself defied geographic boundaries. Fashion Moda reached far beyond the borders of the Bronx to places that many of its young artists might never have dreamed they could.

This is the sentiment that lay at the heart of almost any young Bronxite or New Yorker who picked up a spray can or a marker: wanting to be a part of something, and wanting that something to be bigger than oneself. Growing one's own space in what the world imagined was an inhospitable place, street by street, car by car, train yard by train yard. Broadening one's audience by broadening their minds—piece by masterpiece—of what is possible, of where it is possible. Expanding one's sphere to encompass worlds: five blocks becomes fifteen blocks which becomes another borough. From "all city" to all cities. Writing in languages secret and sacred, making your mark where it might carry you further than any place you've ever been.

# 5

In the February 24, 1986, issue of the *New Republic,* the (since-disgraced) literary editor, Leon Wieseltier, recounted an exchange between the novelists Saul Bellow and Günter Grass (also since-disgraced, but for different reasons) at the 1986 International PEN Congress.[1] Bellow, in offering "his appraisal of the American dream" during a talk at the congress's afternoon session, praised the United States for, as Wieseltier describes, "having made its citizens physically and materially secure, thereby freeing them for their spiritual and cultural development."[2] At the start of the question-and-answer period, Grass rose and challenged Bellow on his estimation of the state of American society by asking the following:

> I have a question. When you explain that democracy gave people in this country not only freedom, but also shelter and food, I think, "Where am I?" Three years ago, I was in the South Bronx. I would like to hear the echo of your words in the South Bronx. And I can tell of other places in the United States where people don't have shelter, don't have food, or the possibility to live in the freedom you have or some have in this country. Perhaps I misunderstood what you explained.[3]

In response to Grass's statement, Wieseltier notes (while including himself in this group) that "some of those in attendance groaned at still another instance of moral tourism."[4] Clearly unenamored of Grass's invocation of the South Bronx's plight, Wieseltier takes this documented instance of literary disagreement as inspiration for the spinning of what he calls "A Fable": namely, Grass's trip "three years ago" to Charlotte Street in the South Bronx, as imagined by Wieseltier.

With tongue firmly in cheek, Wieseltier invents Grass's Bronx grand tour, as sponsored by Manhattan's Goethe House (now known as the Goethe-Institut New York) and accompanied by one of its employees, the

pointedly named "Zeitblom."[5] The tone is both jaunty and sneering throughout: "Offended by the rough manner in which the conservatives and anticommunists and chauvinists and cold warriors of the American media have treated the man into whose hands German language and literature have fallen for safekeeping, Zeitblom has agreed to tell the story."[6] Wieseltier turns the literary knife at every turn, skewering what he perceives as Grass's pretentiousness and presumptuousness in wielding the suffering of the Bronx as, if not quite his own, at least a useful prod with which to poke at America's ideas of itself:

> They talked of Werther and Wilhelm, of the centuries of young German men of sensibility for whom Charlotte was the very name of first love. . . . They agreed that the cab was transporting them across whole cultures, into a new zone of thought and feeling that only $1.75 at the Triboro Bridge and largeness of soul qualified them to enter.[7]

It should be noted that there is, of course, no little pretension and presumption in even imagining such a fable—and one that attempts to puncture what it imagines as the enormous self-regard of its subject in a mode that suggests the healthy self-regard of its author—to begin with, and surely only for the delectation of a select band of literati. But we will discuss this a bit later.

Wieseltier's duo arrive at Charlotte Street's iconic ruins, and Grass is struck by the sight of them:

> He told Zeitblom that it was 40 years since he had seen so many burned and gutted structures. This time America was making war on itself, he reflected, and he considered the meaning of a system of aggression so perfect that bombing from the air was made obsolete by the willingness of men and women to destroy their cities themselves.[8]

Here, Wieseltier presents his reader with not merely the ruins of Charlotte Street themselves but also the visitor confronting them, as if their existence required confirmation, the bearing of witness from without. Here, also, in Grass's reflection one hears shades of Senator Daniel Patrick Moynihan's suggestion that Bronx residents themselves—who "didn't want or need housing, or they wouldn't burn it down"—were largely to blame for the dire state of their environment.[9]

Wieseltier's Grass becomes lost in a reverie: "Then Grass observed the Potemkin flowerpots that the authorities had painted and posted over the wounds in the facades that used to be windows. By now he had the sen-

sation of being in the presence of a logic."[10] It is perhaps the logic of perception that Wieseltier's character sees here, of which for the Occupied Look's trompe l'oeil window decals, deception and theatricality played as important a role as preservation and camouflage. "Potemkin" though they might be, Grass's choice of appellation only accounts for an "audience" of outsiders; that is, it assumes that such contrivances are designed only for those passing by, leaving out the potential benefits to morale, to self-perception, and certainly to safety that, as we have seen, the decals offered to many Bronx residents.

Grass is "struck by the contrast between the desolation of the place and its noise," which to him was "proof of unvanquished life."[11] The character's sympathies here are not misplaced, even if Wieseltier delivers them with faux earnestness; areas of the Bronx remained vibrant and lived in throughout the 1970s and 1980s, and even the area around Charlotte Street was not totally deserted. Life did persist in the South Bronx as evidenced and visually documented by the Department of Finance and by photographers like Jerome Liebling and Ray Mortenson, all throughout its environmental devastation. Wieseltier, however, does not allow his Grass even this brief moment of dignified clarity, as he immediately forces an encounter between Grass and the youth of the Bronx:

> Observing the fierce physical response of the young blacks to the rhythms of their portable tape players, "ghetto blasters," he'd heard them called: would that it were so! . . . He wanted to touch, to smell, to taste, all the great American negations around him. Above all, perhaps, to taste: to penetrate into the very pantry of the American underclass.[12]

All of it—the potential encounter, the unsubtle, anthropological air to the description, the clumsy attempts at urban taxonomy—is pure satire. (Whether it is effective satire is a different question, and one that will be taken up later in this chapter.) Here, it is race that primarily confounds both character and author, unwittingly illustrating the social and economic inequities that exist between ethnic subjects and their white observers on tour with each graceless depiction of the Bronx "underclass." Upon provoking a young black man by approaching him too closely, Grass elicits a pointed verbal response, and the story reaches perhaps its comedic zenith, or its vulgar nadir, depending on your point of view:

> It pained Zeitblom to hear the heir of Thomas Mann referred to as a "motherfucker." Grass, however, accepted the compliment. He felt that he had been addressed as an equal. Moreover he had always thought of himself a little

147

like that. *Ein geistlicher* motherfucker: an exciting literary concept, and the perfect name for his ambition. Maybe there was an essay in it.[13]

Wieseltier ends Grass's journey of self-reflection to the South Bronx by describing how the experience "changed" him: "Here he was, at last, in the South Bronx, one of capitalism's cruelest failures, and his heart was not broken. He was stimulated, rather; he would return from his few hours on Charlotte Street . . . with material, with fresh ideas about the relationship between suffering and ribaldry."[14] For Wieseltier, it is the use of the figure of the South Bronx for Grass's own "convenient" purposes of argumentation that so irks the former *New Republic* editor. Yet, the fact that either Wieseltier or Grass employed that fraught figure at all, whether it was couched within a fictional narrative or a moment of authorial grandstanding in front of a pride of literary lions, is testament to the power of the Bronx's self-perpetuating legend.[15] But why exactly did Grass's invocation of the South Bronx in challenging Bellow's view of American life provoke such savage satire? Leaving aside any preexisting personal animus for Grass on Wieseltier's part, what was it about the use of this example that was worthy of such an imaginative rebuke, itself set within the very environment whose employment caused such offense?

Part of what inspired Bellow's original comments—to which Grass felt the need to respond—was the theme of alienation to which many of the PEN Congress's authors spoke. Exiled writers from four countries addressed their own sense of alienation: as the *New York Times* noted:

> Comments ranged from a description by Vassily Aksyonov, the exiled Russian poet, of how the exiled author feels when he is deprived of his home, culture, and language, to a description by Manilo Argueta, a Salvadoran writer, of what it is like for Central American writers to ask questions of life and death when they are regularly faced with "the very real possibility of death."[16]

It was to this line of thinking that Bellow responded, describing alienation as something to which American writers sometimes "have a fatuous attachment."[17] In failing to see the brands of alienation that might deeply mark and trouble American writers—Toni Morrison, for example, spoke of never in her life feeling "as though [she] were an American"—Bellow tempted fate with his grandiloquent pronouncements, and Grass was more than happy to oblige him with a comparable response.[18]

It was more the manner in which Grass critiqued Bellow's position— essentially offering to give Bellow, and by extension all Americans, a lesson

in and tour of parts of his and their own country—that so riled Wiesel-tier. Yet, in context, perhaps this wasn't such a bad idea. Wieseltier's fable, in skewering what he imagined as the pompous foreigner, Grass, censuring a nation at which he had formerly directed passionate critiques, makes use of the same worn and familiar tropes of ruin in imagining the South Bronx landscape through which his invented Grass travels. Though he imagines a trip through the South Bronx for Grass, one wonders if Wie-seltier, or Grass, or Bellow had actually paid the South Bronx a visit during the worst of its years. It will by now perhaps have dawned upon any reader—of literature concerning the Bronx, or otherwise—that the spec-tacle of three successful, white, male literary figures performatively searching, and finding, moral high ground by degrees loftier than the man previous regarding attitudes toward the South Bronx, and some of the most vulnerable communities of color in America, provides no little en-tertainment. However, it hardly helps us to understand better the relation-ship between the on-the-ground realities and the popular symbol of the South Bronx that offered such a ready and evocative example to all that it could be so deployed to score moral points at literary conferences and within the pages of political magazines.

The nameless narrator at the end of Ralph Ellison's 1952 classic, *In-visible Man,* offers the enigmatic question, "Who knows but that, on the lower frequencies, I speak for you?" from his subterranean Harlem hole, as its concluding line. Though Ellison himself did not, as far as can be determined, attend this infamous edition of the PEN Congress (and thereby missed his old Tivoli, New York, roommate, Bellow, drawing Grass's ire), the parting shot of Ellison's novel has always seemed an elegant construc-tion delivered with intimations of a threat—and one that remains ever-green in considerations of the relationship between voice and agency. As we have just seen, although many authors would invoke the familiar tropes of the South Bronx to various ends, speak the names of its infamous streets for good or ill, and otherwise employ its powerful imagery, who spoke for, and on, its lower frequencies? Who, then, spoke for the South Bronx?

## The Unwritten Borough?

Though the literary history of the Bronx is quite rich—writers as varied as Edgar Allan Poe, Sholom Aleichem, James Baldwin, and Nicholasa Mohr either wrote about the Bronx or once called it home—fiction about the South Bronx of the 1970s and 1980s is less abundant than that lineage

might suggest. Yes, the Harlem Renaissance poet, playwright, and novelist Countee Cullen published his first poem while a student at the Bronx's DeWitt Clinton High School; and James Baldwin's *The Fire Next Time* represents his time at the very same high school; and Nicholasa Mohr's *El Bronx Remembered: A Novella and Stories* depicted the Puerto Rican immigrant and first-generation experience in New York. However, while these writers' poems, stories, and essays are testament to the many difficulties that black and brown residents of New York encountered from the 1920s through the 1950s, they do so in the time before the Bronx became a signal trope of urban devastation. And with regard to African American and Latinx literatures, there have no doubt been generations of bards of Harlem, El Barrio (or Spanish Harlem), Washington Heights, and the Lower East Side. Alongside the aforementioned Ellison and Baldwin (whose Bronx reflections were limited to his high school years) stand Piri Thomas, Julia Alvarez, the poetry of Willie Perdomo, Claude Brown's *Manchild in the Promised Land*—too many to name here, all deeply associated with their respective New York sites and settings, and with various, often recently immigrated, communities of color. Such authors have all been central to the formation of their city-bound, neighborhood-specific literary canons, while literature that imagines the Bronx of the 1980s— by then, infamous and iconic, and seemingly ripe for fictional evocation— remained comparatively slim.

Much of the energy that might have been poured into a robust canon of South Bronx fiction likely went toward capturing the lived experience of the South Bronx in music and lyric in the myriad forms and styles of hip-hop—whether sung, spoken, painted, or danced—which is undoubtedly the South Bronx's greatest cultural invention. The intricate, novelistic narratives and baroque self-mythologizing that characterized much of early hip-hop produced in and around the South Bronx perhaps obviated the need or impulse to render their worlds in a medium that, to the ingenious and innovative Bronx youth who birthed not only a genre but an entire way of being out of whole cloth, must have seemed rather conventional. After all, as Bronx graffiti artists—most of whom pointedly referred to themselves as writers—would no doubt tell you, graffiti *was* Bronx literature, and a populist form at that, which hardly required an agent or a publishing contract to reach an audience. Many of hip-hop's earliest representations, whether musical, visual, gestural, or filmic were as much—if not more—about disseminating images and ideas of their own devising, via alternative networks, as they were about self-mythologizing.

There is a "South Bronx canon," so to speak, but it is one that exists largely though these alternative forms of narrative, poetic, musical, gestural, and visual representations. Perhaps it was something to do with the surreality of this era of South Bronx ruin that sublimated the traditional desire to capture the moment in fiction, and that sublimated desire emerged elsewhere. Or maybe it was just the irrepressible, ingenious style of Bronx youth that produced these alternate, hybrid, and durable modes. Hip-hop was, and is, the Bronx's social novel for the ages. But that doesn't mean a few writers didn't try their hand at writing one as well.

The Bronx literature that does exist, however, is of a more traditional sort and is represented mainly in the form of autobiography and memoir— with Allen Jones's *The Rat That Got Away* and Geoffrey Canada's *Fist Stick Knife Gun: A Personal History of Violence* as some of the more notable examples of work by such memoirists of color. One subgenre of what might already be described as a cottage industry of Bronx memoirs that remained popular for a time might be best described as the "nostalgic white ethnic memoir," often the product of an author who grew up in one of the Bronx's many ethnic enclaves in the early part of the twentieth century and moved away during its middle part, only to look back wistfully—and painfully—on what "the old neighborhood" had become.[19] Books like Jerome Charyn's *Bronx Boy: A Memoir* and Avery Corman's *The Old Neighborhood* typify this genre, whose coming-of-age narratives are populated with the signifiers of a particular, bygone New York: the carefree consumption of endless egg creams, and games of stickball and Ringolevio run long into the gloaming.[20] The brand of historical fiction by Bronx-born E. L. Doctorow, exemplified by gangster-epic-cum-bildungsroman, *Billy Bathgate,* occupies a middle ground between the white ethnic memoir mode and fiction, placing historical figures like the German-Jewish-American gangster Dutch Schultz alongside Doctorow's fictional characters. Even *Bathgate,* which appeared in 1989 when the South Bronx was well in the throes of its infamy, harkened back to an earlier time, with Doctorow reimagining a Prohibition era Bronx populated by Italian American and Jewish American gangsters rather than setting a novel contemporaneously in the—now browner, blacker, and burned-out—borough of his birth. Why, for a place that had been so thoroughly *represented* in journalistic accounts, photography, visual art, and other media, did so few authors write Bronx fiction?

With regard to South Bronx writing, rather than engage with the borough as it appeared to the world, some authors were attracted to earnest

tales of how they narrowly escaped their own childhoods and the worst aspects of their declining neighborhoods; or, in the face of a newly unfamiliar South Bronx, by virtue of demographics and environmental destruction, writers offered paeans to lost—and usually white ethnic—urban enclaves. It seemed as if something about the reality of the South Bronx— or perhaps its surreality—presented a problem that could not be solved by fiction. Memoir flourished, perhaps, because for so many writers of color, simply being alive to tell the tale and bear witness to their lived Bronx experience sufficed. There was no need to imagine what, for them, had been an unimaginable reality. And whereas fiction writers may have found it difficult to escape the narrative tropes of South Bronx ruin that, by the late 1980s, were so familiar to Americans and to the world— certainly Grass and Wieseltier did—autobiographers were more at home in their own memories and wielded those descriptions of setting more comfortably, if no less wincingly. Fiction, for South Bronx writers, did not provide a freedom from fact, since the fact of the South Bronx often exceeded that of which the imagination was capable.

There were, however, a handful of writers who did try their hand at rendering the South Bronx of this era in fiction. Among these examples, three authorial models emerged: that produced by the native and current South Bronxite; fiction in the mode of the aforementioned nostalgic white ethnic; and the work imagined by the outsider-looking-in. Three authors here represent those modes: South Bronx native Abraham Rodriguez, whose debut 1992 short-story collection, *The Boy without a Flag: Tales of the South Bronx,* offered an unsentimental portrait of Bronx youth amid the ruins; Belmont native and now Bronxville, New York, resident Don DeLillo's 1997 novel *Underworld,* with significant portions of its sprawling narrative sited in the South Bronx; and Virginia-to-New-York transplant Tom Wolfe's best-selling 1987 satire *The Bonfire of the Vanities,* a version of Thackeray's nineteenth-century society-spanning *Vanity Fair* set in 1980s New York City. Of the three, Wolfe was most instrumental in contributing to the image of the South Bronx in the collective imagination, as apart from early critical acclaim for *The Boy without a Flag* and an American Book Award for his first novel, *Spidertown,* in 1993, Rodriguez has largely maintained a low profile in critical and certainly popular conversations. DeLillo, despite his place of birth, is hardly thought of as a "Bronx writer," and even fans of *Underworld* might be hard-pressed to remember that much of its narrative depicts the South Bronx in ruin. At first glance, these authors make for an unlikely trio through which to

consider literary representations of the Bronx. Yet despite Tom Wolfe's pretensions with *Bonfire* toward writing a grand social novel in the style of Émile Zola or Honoré de Balzac, it would be Rodriguez whom *New York* magazine would later dub "the Balzac of the South Bronx" upon publication of his first novel in 1993.[21] Balzac was one of Rodriguez's literary heroes as well. Moreover, in rereading DeLillo and Wolfe together (as they will be read here), both authors of best-selling, kaleidoscopic, maximalist works of fiction from the 1980s and 1990s, we see that *The Bonfire of the Vanities* and *Underworld* share much more than simply the ruined Bronx as setting, yet they have rarely been considered together as signal works in the context of literature and the environment in particular, and within and against literary history more broadly.[22] The authors produced novels of such grandiosity that each work seemingly required manifestoes or paratexts to either introduce or explain them—both of which are also examined here. Wolfe and DeLillo demonstrate the difficulties in rendering a South Bronx that evades familiar tropes and stereotypes to varying degrees, yet each author also finds different solutions for—and success with—depicting the inextricable processes that produced the Bronx's problems.

Rodriguez, despite also being a native son of the Bronx, encountered his own struggles in the wake of publishing his first short-story collection, and not merely problems of representation regarding his South Bronx Nuyorican community but also of identity. His real-life example demonstrates, in part, many of the same impediments encountered by Ellison's nameless narrator in *Invisible Man:* representing the brutal realities of a community doesn't always guarantee the approval of that community, and speaking for the South Bronx *from* the South Bronx hardly guarantees being heard, or, at least in the way that you'd want to be.

If there are three modes of authorship regarding Bronx literature—the outsider, the nostalgist, and the native—then we might also define three paradigms of how those authors understand the Bronx in relation to the world. Wolfe's *Bonfire* portrays a paranoia of connection on the part of the monied districts of the city to its poorest, where that connection is tacitly acknowledged but feared and often ignored. Rendered at a reporter's remove, Wolfe casts this paranoid vision of the Bronx in a form that he imagines as social realist, but given its deeply satirical nature, relies more on the gothic mood and mode in its portrait of the Bronx. DeLillo's *Underworld* revels in the processes, accreted histories, and manifold networks of exchange made possible by Cold War–era capitalism that, in

part, occasioned South Bronx ruins. For DeLillo, the story of the Bronx and the story of America in the late twentieth century are all part of the same historical and narrative fabric. A lapsed Bronxite himself, DeLillo's vision of the Bronx, though, is offered largely through the scrim of the surreal, from the perspective of those nostalgic for a past—obscured by Bronx ruin—that is now difficult to see. And with nary a hint of nostalgia, the native and then-resident Rodriguez depicts his South Bronx in an urban realist mode that attempted to represent the perspectives of those who lived in its ruined neighborhoods while avoiding many of the familiar narrative tropes already common to the portrayals of such distressed areas. That this native son was not always successful—in the minds of fellow residents and readers, often his toughest critics—suggests the difficulty, perhaps impossibility, of the task of representing that Bronx to the satisfaction of all in any medium. In contradistinction to Wolfe and DeLillo's models of geographic connection, Rodriguez's fiction supplies a sobering third option: that despite the many infrastructural, economic, and historical linkages that bind the South Bronx to New York and the world, in the minds of his native characters the South Bronx is, in fact, a place and a land apart.

## "Where Hell and History Overlap": Infrastructure, Information, and Identity

*Underworld,* the 1997 novel by Don DeLillo, concludes its 827-page, half-century-spanning narrative in two places at once: in the ruins of the Bronx, and on the internet. The novel's final scenes describe the miraculous appearance of the vision of a murdered Bronx girl on a South Bronx billboard. This phenomenon draws hundreds of penitents and curious onlookers to a traffic island in the placard's shadow. Two nuns, Sisters Grace and Edgar, from a nearby Bronx neighborhood also bear witness to the apparition—either a trick of light and shadow or the residue of previous advertisements—leaving each woman in contrasting states: Grace in disbelief, Edgar in awe. One of the two dies soon after. But, in a novel so deeply concerned with contemplating worlds beneath and beyond our own, DeLillo grants Edgar a final triumph over death: she passes into new life in the hyperlinked geography of the web. She is reborn as a historical figure on a website chronicling similar miraculous tales to be discovered by another character's teenage son. Sister Edgar's vision, that "miracle in the Bronx" witnessed by her in real time, and endlessly searchable in a

virtual landscape of archived information, serves as the novel's node of linkage between the physical ruins and human tragedies of the Bronx and their digital representations. The distance between these real and representational encounters is bridged by the structure and engineering of a digital network, driving home for the final time a point DeLillo spends much of the novel elaborately underscoring: "Everything is connected."[23]

The same technologically adept teenager who finds the web-based version of this fantastical tale confesses to his father, who happens to be a Bronx native, feeling a sense of shyness and guilt at the dissonance between "all that suffering and faith and openness of emotion, transpiring in the Bronx," and the distanced, mediated representation that he's found. The boy, in DeLillo's narration, has always regarded the place where his father was born and raised as "part of the American gulag, a place so distant from his experience that those who've emerged can't possibly be willing to spend a moment in a room with someone like him." It is a touching moment of expressed inadequacy on the part of the young man, who feels both the weight of his father's history and the tragic mythology of the Bronx on his shoulders, yet also somehow unworthy of expressions of empathy with those histories. Perhaps indulging a native Bronxite's penchant for (self-)mythologizing, the boy's father responds, "What better place for the study of wonders."[24]

This same southernmost part of the Bronx is, conversely, a beginning of sorts for bond trader Sherman McCoy, the main character of Wolfe's *The Bonfire of the Vanities*. It is, however, only the beginning of his end. As Sherman drives his Mercedes coupe eastbound over the arc of the Triborough Bridge with his mistress beside him in the passenger seat, he experiences a Gatsby-esque moment of pride and longing while gazing over the roiling waters of the East River and Hell Gate toward Manhattan's crowded mass of towers. "There it was, the Rome, the Paris, the London of the twentieth century, the city of ambition, the dense magnetic rock, the irresistible destination of all those who insist on being where things are happening—and he was among the victors!"[25] So enraptured in this moment of reverie is Sherman that he misses the exit for Manhattan and takes an unexpected trip to the South Bronx, continuing on Interstate 278 toward the Bruckner Expressway and a fatal encounter with two Bronx youths after a disorienting drive in search of the way back to Manhattan. Sherman's costly navigational error in *Bonfire* occurs along what is essentially the same arterial highway as does Sister Edgar's magical vision in *Underworld,* if only for a little rejiggering of roadway

nomenclature by the city and state departments of transportation. This South Bronx environment—what DeLillo terms "the bottommost Bronx," and what Wolfe's protagonist deems "the goddamn jungle"—forms a crucial hinge point in each novel's labyrinthine narratives. Everything is connected, indeed.

In *Bonfire,* the structures and systems that appear impregnable or comfortably secure are, for many of its characters, rendered vulnerable. In *Underworld,* those structures and systems are dissected and reassembled in a cartographic skein of connections that suggest grander, concealed architectures that give shape to a half century of Cold War history. Wolfe uses both the figure and the landscape of the South Bronx to repeatedly puncture the ruling class's idea of insulation—from nonwhite populations, from the working class and working poor, and from zip codes located outside the island of Manhattan—which Sherman subscribes to in *Bonfire,* while DeLillo explodes entirely the idea of insulation in *Underworld,* weaving connections using multiple strands and across many landscapes in order to reveal the myriad, metaphysical, and even mythological relationships of the ruined Bronx to the city, and the city to the larger world.

According to critical consensus, *Underworld* is thought of—due to its "neurotically webbed" nature—as a novel in the paranoid style par excellence, though critics differ as to whether such a style makes for great fiction.[26] *Bonfire* is often read by critics primarily as a satirical novel of race and class whose main contributions were Wolfe's own brand of social taxonomy and new vocabulary for the popular culture lexicon. Though DeLillo is often thought of as the paranoiac's paranoiac, it is actually *Bonfire* that might be better thought of as a novel of paranoia—indeed, a racial paranoia of connection to many "underworlds" that threaten the insulation of the wealthy classes. In some ways, it is Bronx native DeLillo who fulfills Wolfe's desire to have written a book of ambitious scale that captures New York as "*the* Western city of the second half of the twentieth century," along the way, successfully rendering its ethnic characters' dialogue with greater warmth and naturalism than either author had by then (or since) achieved.[27] But far from entirely paranoiac, there remains with DeLillo a serenity in knowing first that the world may be headed unavoidably toward ruin—a confidence, if not exactly delectation, in entropy—and, second, exactly the road upon which we will arrive there. To that end, DeLillo's detailed formal rendering of the city's built environment is central to establishing and maintaining the many linkages feared so deeply by many of *Bonfire*'s characters and exposed so rhap-

sodically throughout the entirety of *Underworld*. Whether one prefers the baroque flourishes of Wolfe or the slow-building neurosis common to DeLillo's fiction—or whether one finds, as a matter of taste, both entirely disposable—what distinguished their fictional South Bronxes is that DeLillo's rendering takes care to gesture toward the systemic, economic, and social processes that drove the South Bronx to ruin. While Wolfe understands what deindustrialization, suburbanization, white flight, "planned shrinkage," and the effects of systemic racism have wrought, apart from a brief glimpse or two, one has to search to find those forces at work in his fiction.

The guiding themes of insulation and connection that both animate and divide the narratives of these novels, and which Rodriguez leaves behind for a more circumscribed version of linkage to the outside world, run deeper than mere manufacture and development of plot and place. Much of Wolfe's and DeLillo's fiction, and especially *Bonfire* and *Underworld,* can trace its origin point to historical fact: more pointedly, to reporting and other forms of journalistic work and primary sources— whether visual or literary, mere headline, news snippet, or an entire series of filings on any particular topical beat. DeLillo famously traces the inspiration for *Underworld* to being "struck . . . with the force of revelation" upon seeing the front page of the October 4, 1951, edition of the *New York Times,* which "symmetrically matched" headlines and column inches for two stories: the New York Giants winning the pennant by defeating the Brooklyn Dodgers on Bobby Thomson's ninth-inning home run, and an announcement of the Soviets' second atomic bomb test in two years, a juxtaposition of events that made the author "feel the power of history."[28] Wolfe's source material for what he called his "big realistic novel" of "New York, high and low" was, famously, his own reporting in Manhattan and the Bronx—the nature and performance of which Wolfe suggested might form an example for all novelists working in the second half of the twentieth century in his 1989 essay "Stalking the Billion-Footed Beast."[29]

Journalism provides, in some ways for DeLillo and almost entirely for Wolfe, a formal and methodological framework that structures their approach to generating plot and description, yet each seeks different outcomes. DeLillo looks to fact and journalism in an attempt to align the grand and often terrible movements of history—to see them all at once— as one might the crowded frame of Pieter Bruegel the Elder's *The Triumph of Death,* which appears, reprinted in the torn-out pages of *Time* magazine,

in the novel's prologue. Wolfe's method of reporting-then-fictionalizing is calculated to reproduce a brand of realism that captures the cultural zeitgeist—to "get it right," as it were—through accumulation of period detail, and it occasions a curious development. While his fictional characters rarely rise above the level of caricature, Wolfe's descriptions of the city's built environment, and his considerations of urban space in many forms—whether satirical, spectacular, or exaggerated—can be shown to reveal the extent to which space itself can become not only "Othered" but also stereotyped: case in point here, the mythological specter of the South Bronx, which had by then become the international standard for urban crisis and ruin. Wolfe's descriptive style—within the passages that explicitly address and illustrate that built environment which are examined here—bears elements of both the grotesque and the uncanny which, as aesthetic categories, were characteristic not merely of fiction but also of "fact." More unsettling than each disquieting visage of the Bronx, drawing equally upon the uncanny and the grotesque, was how that image was already mirrored in the era's journalism as well.

If DeLillo's *Underworld* refers in part to a place where "hell and history overlap," as writer Luc Sante suggests, then *Bonfire*'s narrative, perhaps best described by one of its own characters as telling a "tale from the lower depths," does too. Wolfe and DeLillo attempt to render, in whole or in part, a comprehensive vision of New York City that, at certain points within each author's novel, might also stand for America at large. Akin to that metonymic relationship, the Bronx served as the nation's "pure archetype" of urban ruin, unrest, and inner-city decay, which had by then manifested throughout many cities across the country, large and small.[30] It then seems significant that the authors of two of the signal works of fiction of these successive decades felt obligated to deal explicitly with the South Bronx's decimated environment within their pages, reckoning with both its image and the reality of its streets, and the aftereffects years hence. Crucial to the narrative of both texts is the darkness and repression represented by the South Bronx that they imagine, which was necessary to animate such sprawling works. It's not merely a measure of happenstance that Wolfe's and DeLillo's novels are linked by the general geographic location of developments significant to their narratives, but also that these sites themselves are linked even more directly along the same extended stretch of South Bronx roadway.

What this opportune linkage reveals is that both authors explicitly and implicitly explore the city by way of its physical infrastructure and inter-

linked municipal systems, imagining for their readers how those infrastructures are used to organize, divide, or obscure human activity and its social and environmental consequences. Each novel replicates and reflects, for better or worse, theoretical, political, and popular conceptions of the Bronx built environment, of municipal infrastructures and relative access to and through built spaces, and of the individual's relationship to their environment, each within their respective eras. Ultimately, these novels tell a still larger tale about how literature receives and repurposes images of ruined environments for varying ends; what relationship those accepted images bear toward the histories behind them; and how the themes of connection and juxtaposition—central to both works (and in a different way to Rodriguez's short and long fiction as well, as seen in the last part of this chapter)—structure not only the formal architectures of each novel but also the historical understanding of the sites and spaces in which they locate much of their narratives. *Bonfire* and *Underworld* cross paths, so to speak—expressways, to be specific—in the same southern swath of the Bronx, so it is perhaps then natural that part of the analysis of each that follows should examine the episodes sited by their authors in these spaces.

## Crossing Hell Gate: "Stalking" the "Beast" in "King of the Jungle"

May I be forgiven if I take as my text the sixth page of the fourth chapter of *The Bonfire of the Vanities*? It would only be appropriate, as—with this very line—Tom Wolfe does exactly that in the lede of his *Harper's* essay, "Stalking the Billion-Footed Beast," subtitled "A Literary Manifesto for the New Social Novel." In his essay, Wolfe firmly establishes the centrality of the built environment to his conception of *Bonfire* as "a novel *of the city* in the sense that Balzac and Zola had written *of Paris* and Dickens and Thackeray had written novels *of London,* with the city always in the foreground, exerting relentless pressure on the souls of its inhabitants."[31] His vision for this "new social novel"—best exemplified, in his opinion, by *Bonfire* itself—is one that he believes is capacious enough to encompass the many social realities at play, and at odds, in a city as large as New York:

> The past three decades have been decades of tremendous and at times convulsive social change, especially in large cities, and the tide of the fourth wave of immigration has made the picture seem all the more chaotic, random, and discontinuous, to use the literary clichés of the recent past. The economy with

159

which realistic fiction can bring the many currents of a city together in a single, fairly simple story was something that I eventually found exhilarating.[32]

Wolfe's essay—read here briefly alongside *Bonfire* because Wolfe does so himself—is essentially a spirited, though ultimately loose critique of the postmodernist novel, and one that, since its publication, has been roundly criticized by scholars and fellow fiction writers alike. Brock Clarke takes Wolfe's essay to task in a 2006 essay in the *Virginia Quarterly Review* by extension: he reads Wolfe's essay as the progenitor to a then-recent *New York Times Book Review* essay by Rachel Donadio that decrees the "death of the novel"—a development that Clarke characterizes as happening anew seemingly every six months.

Wolfe's clarion call, essentially, was for authors to employ the techniques and training of journalism—reporting, mainly—in attempting to most fully capture the entirety of the historical moment in their fiction. Clarke understands that in his fiction, Wolfe "does want to capture his complicated subjects, to stand for them, to be the final word on them." However, "the problem is, his subjects (class, race, regional identity, municipal and national politics) are complicated, and as such refuse to be captured, unless, of course you make them less complicated."[33]

Few have been more savage in their judgment of Wolfe's reductionist tendencies in books like *Bonfire* than scholar Liam Kennedy. Kennedy characterizes *Bonfire* as a novel "which strikingly promotes the discourse of decline in its singular effort to reproduce the totalizing vision of the classic realist novel as the most adequate form of literary response to the complexities of urban change at the end of the twentieth century."[34] And in this endeavor, he believes it is a considerable failure. Kennedy writes, "Far from representing the diverse social realities of a polyglot metropolis, he constructs a narrative of two cities—represented by the black Bronx and white Wall Street/Park Avenue—and focalizes all the action through the consciousness of the white protagonists."[35] This sentiment is shared by many critics of the novel, and Wolfe's own admissions in his essay regarding his desire to write about "New York, high and low" reveal the Manichaeism inherent in such a structure.

Critics of Wolfe's treatment of race and ethnicity as it is mapped over the built environment of New York have noted in particular the reductive nature with which he first identifies, then opposes, the spaces of monied Manhattan and the bestial Bronx as Manhattan's Other, best exemplified in the novel itself in the tabloid journalist Peter Fallow's piece about

Sherman's ensuing trial titled "A Tale of Two Cities."[36] Such critiques are not so poorly placed. Rather than demonstrating knowledge of, or suggesting interiority to, the inner life of Bronx neighborhoods, Wolfe's engagement with the image of the Bronx, however evocative, reflects more the Gothic grotesque of its surface appearances. Much like his consideration of modernist and postmodernist architecture in 1981's *From Bauhaus to Our House,* it is concerned with both literal and figurative facades. Yet, whether merely outlined in quick, light pencil sketches or slathered on a canvas in broad brushstrokes, Wolfe's employment of the image of the Bronx tells its own tale, about how such images can become "all-conquering"—lasting, self-perpetuating, and forever ingrained into the mind of the culture. And a significant part of the power of Wolfe's imagery relied upon the simple fact that few of his readers had ever been to the Bronx, nor, due to its reputation, would they ever venture there if not entirely by mistake, as Sherman did. For these readers, their conception of the Bronx—only reinforced by Wolfe's work—had already been rendered in indelible ink. It is a particular trick of cultural history that Wolfe's generalizations regarding the Bronx and its inhabitants were, in actuality, hardly novel; they were merely the result of received "wisdom," and they reflected the popular perception of the Bronx at the time. Wolfe's employment of these Bronx-centric tropes of ruination helps establish both the preexisting history and the cultural reach of the Bronx's urban legend, long before Wolfe graced the borough with a glimpse of his customary white suit and spats.

Though Wolfe's own forays into architectural history and criticism remain largely superficial, some of the architectural writing and theory of both Peter Eisenman and Anthony Vidler proves useful in illuminating some of Wolfe's imagery. When read alongside Wolfe's novel, Eisenman's and Vidler's related explorations of the aesthetic categories of the grotesque (in Eisenman's 1988 essay "En Terror Firma: In Trails of Grotextes") and the uncanny (in Vidler's 1990 essay "Theorizing the Unhomely" and 1992 book, *The Architectural Uncanny*), respectively, provide new spatial understandings of Wolfe's more Gothic evocations of the Bronx landscape and of how that landscape was understood by Americans and the world at large.

*New York* magazine deemed the best-selling *Bonfire* "a sort of Rosetta stone, a reference source for deciphering the eighties," noting that "you can hardly discuss any aspect of life in New York [in 1988] without someone's invoking the book."[37] If this is true, then we might be entitled to ask of the book what meanings it broadcast not only to other New

Yorkers but also to other parts of the country and the world. We might also ask how Wolfe's characterizations and visions of the city—alongside more straightforwardly journalistic accounts—play to those "outside the bubble" of Manhattan.

Wolfe begins his literary manifesto in the same place that this chapter's consideration of Wolfe's novel begins: on the Triborough Bridge. Again, there one finds Sherman McCoy admiring the wealth and importance of Manhattan as reflected in its verticality while mistakenly heading toward a fatal confrontation with the South Bronx, its landscape, and two of its residents. *Bonfire*'s Bronx is, as Kennedy observes, "often figured as underworld or labyrinth," throughout its narrative, "come to represent the psychological space into which Sherman 'falls.'"[38] Nowhere is this more apparent in the novel than in its provocatively titled fourth chapter, "King of the Jungle."

Momentarily reveling in the certainty of his elevated position in the world, as a successful Wall Street bond trader with a Park Avenue apartment, a wife, child, a mistress, and an expensive car, Sherman finds his confidence almost immediately shaken upon realization of the navigational lapse that will take him farther away from his destination in the Upper East Side of Manhattan. It's perhaps ironic that the aggregate monumentality of Manhattan can best be seen from without—from its surrounding boroughs—yet for Sherman, even the thought of actually entering what he would consider these exterior spaces produces "a vague smoky abysmal uneasiness" within him. The feeling is merely an intimation of the powerful sense of dislocation and geographic disorientation that will subsume Sherman during his unscheduled visit to the Bronx. Yet it is also illustrative of a fraught and problematic sense of connection, here primarily visual, between "center" and "periphery," Manhattan and its outer boroughs.

Even to a native New Yorker today, the Bronx can seem a land apart. A place immediately distinguished by nomenclature, its definite article hints at some grand but distant history. Yet, its apparent distance from the popular image of skyscraping New York reflected the very real social and geographic isolation of its residents due to a host of factors that could be traced as far back as the 1940s and 1950s but truly began to affect the physical environments of its neighborhoods—and their perception by outsiders—in the late 1960s. The ghettoization of recently arrived black and Latinx populations to the Bronx, the exodus of middle-class families, rampant joblessness, and inadequate access to education left residents of the Bronx locked into their neighborhoods with little or no meaningful out-

side contact or countervailing influences.[39] With the exception of a few city landmarks, the Bronx was hardly a destination on the minds of anyone who wasn't already a resident. Wolfe narrates his character's entrance into the borough as such:

> The Bronx . . . He had been born and raised in New York and took a manly pride in knowing the city. *I know the city.* But in fact his familiarity with the Bronx, over the course of his thirty-eight years, was derived from five or six trips to the Bronx Zoo, two to the Botanical Gardens, and perhaps a dozen trips to Yankee Stadium, the last one in 1977 for a World Series game.[40]

Wolfe's reference to the 1977 World Series between the Los Angeles Dodgers and the hometown New York Yankees here is a glancing one, though also precisely calculated. It is the first intimation of the painful, then-recent city history upon which Wolfe draws to create what is for Sherman a frightening digression through the borough.

As we now know, there is no doubt that a school burned on live television for all the nation to see that evening, nor is there any doubt that the Bronx was struck by an epidemic of fires during the 1970s. By the end of the decade, some six hundred thousand New Yorkers had lost their homes and around two thousand people had lost their lives as a result of the fires.[41] But as we know, Howard Cosell never said, "Ladies and gentlemen, the Bronx is burning." Wolfe, through his protagonist, trades here and not for the last time on the real and imagined reputation of the Bronx—its urban legend as lionized on one famous October night—in aligning Sherman with an infamous para-historical event that has ascended to the level of myth. It's a particularly rich example of fiction drawing upon a half-truth that has, over time, become accepted as whole, and one that however indirectly reminds us in retrospect that the Bronx suffered for almost a decade before the nation noticed the ruin visited upon its largest city almost daily in 1977. In Wolfe's account, Sherman encounters a South Bronx that had been "burning" on and off for ten years hence.

"King of the Jungle" is perhaps the novel's most complex set piece: bracingly plotted, its environments and the characters' movements through them evocatively detailed, yet equally problematic with regard to the scope of its social and racial imagination. The chapter thus serves as an excellent example of the manner in which Wolfe foregrounds both place and the legend of the "wild Bronx"—hence the chapter's title. The concept of directionality—and the legibility of the Bronx itself—is portrayed here as

chaotic and inscrutable at best. The logic of the city's grid seemingly disintegrates into cartographic enigma, leaving Sherman and his mistress, Maria, lost and subject to repeated confrontations with the increasingly uncanny landscape. What begins as familiar ("He did know that the Bronx had numbered streets, which were a continuation of Manhattan's") soon becomes the equivalent of a hellscape on earth ("The tide of red taillights flowed on ahead of them, and now they bothered him. In the darkness, amid this red swarm, he couldn't get his bearings. His sense of direction was slipping away. . . . His entire stock of landmarks was gone, left behind").[42] Gradually, the more typical trappings of wealth and status— their clothes, their car—are either stripped from Wolfe's lost characters during this extended episode or turned wholly against them, exposing them as vulnerable marks in this unfamiliar land. However, in stripping down and puncturing these material forms of insulation specifically within a locale then so emblematic of ruin, Wolfe's chapter also reveals both how deeply the concept of insulation was already written and drawn into the city's built environment, and also how contingent one's sense of insulation truly is.

From Sherman's very first vocal utterance of the words "The Bronx" (in response to Maria's question as to where their missed exit has taken them), Wolfe begins to seed his prose with notes of unease that are made manifest in even the smallest environmental details: a "long gash" marks the side of the Triborough Bridge toll both through which Sherman's Mercedes passes. Seemingly evidence of some violent act, Wolfe notes of the aftermath of that slash, "The gully was corroding."[43] Aptly, having traversed the narrow tidal strait in the East River known as "Hell Gate" while on the bridge, Sherman's "fall" first takes the form of a literal descending down where, as the reader sees through his eyes, outlandish grotesqueries abound:

> All at once there was no more ramp, no more clean cordoned expressway. He was at ground level. It was as if he had fallen into a junkyard. He seemed to be underneath the expressway. In the blackness he could make out a cyclone fence over on the left . . . something caught in it . . . A woman's head!

It was not—rather, Wolfe head-fakes and offers an image that does not involve human dismemberment but something that is no less macabre: "No, it was a chair with three legs and a burnt seat with the charred stuffing hanging out in great wads, rammed halfway through a cyclone fence."[44]

By now, the idea of the highway as an ordered system of arterial linkage binding the boroughs together begins to fall away in a very real sense. Sherman and Maria have exited from the Bruckner Expressway, the elevated road that even today towers directly over Bruckner Boulevard, placing that neighboring East Bronx avenue forever in its shadow.[45]

Designed, in effect, with drivers like Sherman and Maria in mind, shuttling between Manhattan and weekend homes in New England or Westchester County, the Bruckner Expressway had the perhaps unintended effect of making what remained beneath it an afterthought—mere scenery either to be glimpsed while traveling at around fifty miles per hour or to be ignored entirely. Sherman and Maria, and all commuters like them, were never meant to have to see the Bronx as they did "at ground level" when they took their wrong turn off the "clean cordoned expressway." Like the Cross Bronx Expressway before it, the Bruckner Expressway became a "vantage point for motorists to survey the 1970s urban crisis" for "Manhattanites and suburbanites who had never ventured out of their cars in the Bronx."[46] To wit, one *New York Times* article described the abandoned buildings that lined the Cross Bronx and Major Deegan Expressways as standing "like rotten teeth."[47]

Before the construction of the elevated highway, Bruckner Boulevard had paralleled the New York, New Haven and Hartford Railroad, and—as part of the state and federal arterial systems—was eventually linked by developer Robert Moses to the Bronx River Parkway, Bronx River Expressway, and New England Thruway in the north and, by the time Sherman and Maria encounter it, the Triborough Bridge in the south.[48] Ironically, the construction of the elevated highway (opened in 1973) was intended as an improvement designed with the intention of making it "possible to travel without interruption between Manhattan and Queens and the arterial highway and parkway systems of the Bronx and Westchester," thereby bypassing the bisected neighborhoods of Hunts Point and Longwood, wherein Sherman's fatal encounter occurs.[49] Whether he meant it or not, in imagining and locating the novel's crucial event in this particular space within the city, on this particular stretch of highway and its attendant roads, Wolfe had internalized and reproduced in fiction both the intended and unintended consequences of decades of city planning ideas. To the Manhattan-bound commuter from Connecticut in the late 1980s, these expressways traversed what might as well have been a foreign nation's zones of conflict. Such was the Bronx to those who beheld it from above: a place to pass through and, in doing so, pass over.

In order to understand New York's expressway projects, scholar Ray Bromley suggests that we consider the city from the viewpoint of a trucker. "To most truckers," he observes, "Manhattan Island is an obstacle 13 miles long."[50] Manhattan separates mainland America from Brooklyn, Queens, and Long Island, and New Jersey from Connecticut and places north and east of it. The Bronx, just east of Manhattan, also lies squarely within much of this intermediate space. Once the George Washington Bridge was constructed (and opened in 1931) to address the concerns of motorists and business owners about Manhattan's congestion and difficulty of access, it was as if "a giant cannon pointed directly at northern Manhattan and the South Bronx," the dense urban areas that had to be traversed to reach New England and Long Island.[51] Traffic was, in the eyes of master builder Robert Moses, what urban agglomerations were created both by and for; these individual highway segments—the Bruckner, Cross Bronx, and others—were seen by transportation planners merely as "parts of existing and future regional and national systems."[52] What the city sees as individual expressways while within its border, the nation views as integral links to an interstate highway system. Millions of Americans and foreign visitors who drove these roads thought little of the extant neighborhoods through which they cut; hardly anyone thought of the Bronx until it "became visible" from these same roads as a ruin so dire New York City used federal highway funds to decorate the windows of abandoned buildings that lined them with trompe l'oeil vinyl decals depicting shutters and flowers.[53]

In this way, these municipal arteries of transport in part occasioned—according to those critics who lay the Bronx's descent largely at Robert Moses's feet—Bronx's ruination and became sites from which to observe its aftermath.[54] Unquestionably mechanisms of transport, connection, and linkage, these expressways—especially when traversing ruined Bronx neighborhoods—also became, in effect, methods of insulation from the grim realities taking place just beyond their boundary lanes. "King of the Jungle" enacts Wolfe's dramatization of the incremental removal of the privileged class's layers of insulation, of which the city's infrastructure is merely one—though a largely unperceived one at that. In this way, Sherman's "descent" from the expressway is thus into a land that, for all intents and purposes, did not exist to those who did not live in the Bronx but merely accepted it as background to their daily commute if they saw it at all—that is, until conditions there made such invisibility impossible. In turn, what Wolfe's fiction makes visible to New Yorkers like Sherman is what the infrastructural figure of the municipal highway made visible: the Bronx, in ruin.

What lay beneath the elevated expressway was confusing on its face as a collection of service roads, exit and entrance ramps, cross streets, supporting columns, and fencing, and Wolfe hardly needed to dress up such a collection of intersecting, interstitial spaces, yet his employment of gothic horror flourishes like an imagined, decapitated head heightens and cheapens the tension of the scene. The city itself is already ample source for Sherman's agitation:

> To his left are four or five lanes of traffic, down here underneath the expressway, two going north, two going south, and another one beyond them, cars and trucks barreling in both directions—there's no way he can cut across that traffic . . . So he keeps going . . . Another opening in the wall coming up . . . Same situation! . . . He begins to feel trapped here in the gloom beneath the expressway.[55]

Knowledge and expertise can function as a kind of protective bulwark against doubt and disorientation; Wolfe's chapter uses the uniqueness of its setting to dismantle those bulwarks and expose its characters to an environment that is, despite being part of their same city, unfamiliar to them. Here, the Bronx built environment is productive of a kind of bewilderment that is, counterintuitively, quite legible: unfamiliarity, at a speed and within a space whose lines of transport are hopelessly convoluted, is completely understandable. What readers, imagining themselves in the same situation, adrift in an area unknown to them, could not share Sherman's frustration and growing unease?

Where Wolfe often loses his reader's sympathies, where the familiarities of a universal situation like getting lost in a strange setting are made narrower, is also where race emerges, often closely. After a few more minutes of aimless, anxious driving, Wolfe's characters find themselves in a more densely populated area where they encounter people "out in the street . . . dark, but they look Latin . . . Puerto Ricans?" for the first time.[56] Wolfe's casual references to possible ethnicities take a different tone when these nameless, faceless characters fulfill all the beastly connotations that the chapter's title implies as some of them scream at each other, crawl about "on the street on all fours," or grapple "like Sumo wrestlers . . . staggering, weaving . . . worn out." Gothic horror is played first for terror and then for laughter, yet when the figure of Wolfe's hyperbole is human rather than environmental, its effect broaches the irredeemable. A woman "[leans] over with her hands on her knees, laughing and swinging her head around in a big circle" with two men "laughing at her," all while Wolfe

orchestrates a characteristically onomatopoetic bass line for them to dance to: "*thung thung thung thung thung.*" A more stereotypical urban "jungle" than this would be hard to imagine.[57]

Wolfe is more effective as an author when he maintains sharp focus on illustrating the built environment and its effect upon his characters. Again, his narration sings when called upon to render an environment devoid of familiar landmarks and any sense of cardinal direction. "Over this way a subway entrance . . . Over there low buildings, shops . . . Great Chinese Takeout . . . He couldn't tell which street went due west . . . *That* one—the likeliest—he turned that way . . ."[58] The ellipses, used almost to excess throughout the chapter, here and elsewhere function effectively as the space between images—linguistic gestures for Sherman's turning of his head from left to right—and the thoughts that they engender, and they are one of Wolfe's most effective formal tools. What becomes most terrifying for Wolfe's characters is not just the total loss of their bearings while in the Bronx but a seeming eradication of the city's governing logics, which should not be overlooked as crucial—and comforting—concepts that underlie any city dweller's sense of assurance: "There was a street sign, but the names of the streets were no longer parallel to the streets themselves. East Something seemed to be . . . in that direction . . . So he took that street, but it quickly merged with a narrow side street and ran between some low buildings."[59] They might as well have been lost on another planet; very soon, they seem as if they are.

If Wolfe's human grotesques fail to affect the reader deeply or convincingly beyond the level of simple—and simplistic—caricature, the power and acuity of the environmental grotesques encountered in this fourth chapter do much toward redeeming at least some of the stains on his authorial reputation caused elsewhere by what appears clumsy satire. While not quite entirely southern in the style of, say, Flannery O'Connor, one might call the native Virginian Wolfe's nightmarish rendering of the environment that his characters soon discover before themselves a brand of "South Bronx Gothic." Streets and curbs and sidewalks and light poles lined the streets and nothing else. "The eerie grid of a city" was spread out before Sherman, "lit by the chemical yellow of the street lamps." Traces of "rubble and slag" were everywhere. The earth "looked like concrete, except that it rolled down this way . . . and up that way . . . the hills and dales of the Bronx . . . reduced to asphalt, concrete, and cinders . . . in a ghastly yellow gloaming."[60]

What use is satire when straightforward description approaches the gothic with little embellishment? When does the urban built environment

cease to be seen as orderly and "natural" and become something else, as something less than natural and potentially haunted or, at the very least, haunting? Far from providing concrete answers to these questions, Wolfe might have found it amusing, being an amateur architecture critic himself, that contemporaneous critical architectural writing on the related concepts of the uncanny and the grotesque registers, in its redefinition of these aesthetic categories within the architectural realm, novel ways of understanding how Wolfe—and the world—looked at the Bronx.

### Varieties of the Uncanny: Wolfe's "Geographic Gothic"

In the essay "En Terror Firma," published in the inaugural volume of the *Pratt Journal of Architecture* in 1990, just a year after *Bonfire,* architect Peter Eisenman develops and explores the concept of the grotesque, which, like the uncanny, can be considered a component of the sublime. Yet for Eisenman the architectural sublime deals with "qualities of the airy, qualities which resist physical occupation," while the architectural grotesque deals with "real substance, with the manifestation of the uncertain in the physical."[61] Eisenman's grotesque is a "condition of the uncertain, the unspeakable, the unnatural" and "introduces the idea of the ugly, the deformed, the supposedly unnatural as an always present in the beautiful."[62] These characteristics of the grotesque, visible everywhere in the horror-inducing landscape that Wolfe illustrates, is for Eisenman what is repressed, unacknowledged, or ignored in considerations of the contemporary sublime. And as Wolfe continually asserts in this chapter, the very environment of the South Bronx hardly exists in the minds of New Yorkers like Sherman and Maria as any real, physical space—that is, until they are forced to confront it directly. What the "ugly . . . deformed" environmental grotesques that Wolfe's characters continually encounter bring into focus is not merely an authorial flair for urban Gothic imagery but the idea that the Bronx itself was, in a sense, New York's geographic repressed—the once familiar, now forgotten.

Part of a larger study of the architectural uncanny from the eighteenth century to the present, the architectural historian Anthony Vidler's essay "Theorizing the Unhomely" suggests three ways in which we might think through Wolfe's imagery in relation to the neighborhoods he represented in his fiction. As described by Freud, and as followed in a psychoanalytic model by Vidler, the uncanny is the "rediscovery of something familiar which has been previously repressed; it is the uneasy feeling of

the presence of an absence."[63] It is a concept that perhaps naturally translates to an architectural framework as the German word for the uncanny—*unheimlich*—literally translates to "unhomely," thereby rooting it by etymology and usage in the domestic sphere.[64] First figured at the human scale, Vidler observes a common theme with regard to the uncanny as articulated in architecture: the human body in fragments. "On an obvious level," he writes, "architecture has provided the site for endless explorations of haunting, doubling, dismembering, and other terrors in literature and art."[65] It is this "body in disintegration" that is present throughout Wolfe's chapter, whether manifested in a hallucinated disembodied head or in buildings whose "bodies" were broken down, decayed, or still decomposing. The environment is in utter disarray; all comforting landmarks of the urban are either absent or in the process of being rendered into the mere fragments of their constituent parts. At points throughout his drive, Sherman mistakes trash receptacles for dead bodies curled up beside the road and passes beneath crumbling tenements seemingly on the verge of collapse. Both serve as examples of a unique manner of body horror—and one that understands a close metaphorical relationship between buildings and the human body—that characterize significant elements of the uncanny in architecture.

The uncanny can also be witnessed at the scale of the social "as a dominant constituent of modern estrangement and alienation," which in *Bonfire* often manifests itself in the geographic, economic, and psychological insulation of the wealthy classes away from the poorer residents of the city.[66] A third notion of the uncanny against which we might consider Wolfe's Bronx is what Vidler calls the "spatial uncanny"—a broad category that can include houses "haunted" with any number of terrors or the spatial derangement of the senses that can, and does, seem to occur in the "ghastly yellow gloaming" in which Sherman and Maria find themselves. In either of the two cases, it is the defamiliarization of once-familiar space that is the hallmark of the uncanny—and also an apt description of what befalls Wolfe's characters once they reach what seems the epicenter of Bronx ruin.

Though it is difficult to map with any degree of precision where in the Bronx Wolfe's characters encounter this barren wasteland, the images and their description bear much resemblance to the area around Charlotte Street in the South Bronx, which in the late 1970s and early 1980s became what the *New York Times* called the foremost "national symbol of the physical ruin that follows the sharp industrial decline of older Amer-

ican cities."[67] For Manhattanites—Wolfe among them—these images depicted a city that looked wholly unlike their own, even though its scenes were replicated as near as Brownsville or Bedford-Stuyvesant in Brooklyn. To those living downtown, these pictures of the Bronx, whether they featured presidents or not, might as well have been beamed in from a contemporaneous Beirut. The fact and realization that they weren't images from another war-torn nation but simply from uptown marked for New Yorkers and Americans at large a kind of journalistic *punctum,* to borrow Roland Barthes's term.[68] Images of ruined Charlotte Street and the surrounding area returned the repressed, in a sense, and effected a rupture in America's conception of its urban centers and, in turn, laid waste to the idea that this was something that could only take place elsewhere.

Wolfe's description of the Bronx here undoubtedly borrows from the teeming archive of images, journalistic accounts, and suggestive cultural resonance of the South Bronx—certainly of the well-known specter of Charlotte Street. He explicitly marshals the images in his fiction and in this chapter by systematically puncturing Sherman's insulated vision of what his native New York City looks like, wrong turn after wrong turn. His description of the vast open terrain encountered by Sherman and Maria is calculated to produce shock and horror in his readers, yet as article upon article upon news broadcast suggests, Wolfe's formal work here is hardly a work of exaggeration. This merely reflected the portrait of the South Bronx that was regularly broadcast to the world. Yet, this also stands out as a strangely touching, if haunting, passage since it lacks the haughty, mocking tone Wolfe takes with his subjects throughout almost the entirety of the rest of the novel. It is as if the gravity of the images and the direness of the historical moment itself have, through sheer force of their immediacy, interrupted and disturbed Wolfe's cavalier authorial mien. The preening authorial voice of *From Bauhaus to Our House* is gone, perhaps chastened by the state of the South Bronx. Any perceived sincerity of these passages hardly absolves Wolfe of sundry problematic authorial abuses regarding racial and ethnic caricatures throughout the novel. A few pages later, in expressing Maria's terror and fervent desire to escape their predicament, Wolfe suggests, "Human existence had but one purpose: to get out of the Bronx."[69] Yet, these passages are evidence of a voice and tone that Wolfe rarely entertains, if he allows it to escape at all in his fiction. This seemingly solemnified Wolfe continues, intricately illustrating Sherman's journey: "There was a lone building, the last one . . . It was on the corner . . . three or four stories high . . . It looked as if it were

ready to keel over at any moment. . . . Sherman had lost track of the grid pattern altogether. It no longer looked like New York. It looked like some small decaying New England city."[70]

What might a "geographic gothic" look like? Perhaps this. Whereas in earlier passages in "King of the Jungle" Wolfe heightened the tension by amplifying the grotesquerie of his images one after the next, here the authorial action is one of removal—a formal stripping down of detail that mirrors the un-building of the particular locality being described. What pervades this latest description of the environment is a sense of loss: not only the loss of cardinal directionality and a casual familiarity with one's hometown city's streets but also the absence of urban logic itself with regard to recognizable urban forms. Wolfe's brief comparison of the Bronx to a "decaying New England city"—perhaps a shuttered Massachusetts mill town like Fall River or Lowell—suggests that the author is aware of forces such as deindustrialization and the conversion of New York's economy from manufacturing to the service and financial industries— perhaps initiated by folks like Sherman McCoy—but brief acknowledgments of those forces like this are welcome, though few and far between. Vidler's "spatial uncanny" manifests itself here in the ambiguity and sense of defamiliarization produced by the environment. That is, the only thing more terrifying than being surrounded by terrible forms is, for Sherman, not knowing what one is surrounded by at all. After all, it is the regularizing pattern of the grid that gives structure and organization to many a city—and famously to Manhattan, by virtue of the 1811 Commissioner's Plan—and with that structure comes a kind of metropolitan poise, born of the ease of navigation that the grid provides. All such poise is lost here, and with it—as Sherman wonders to himself—the sense that this place was or could ever be a part of "New York" at all. Any sense of connection or linkage between center and periphery by infrastructural means—streets, highways—or the more abstract city planning method that overlay them in the form of the mapped grid is, in this scene, obscured under cover of night. Here, at the geographic heart of Wolfe's evocation of the South Bronx, the physical destruction of the environment is echoed by a scale-model disintegration of its cartographic analogue. Both territory and map come to ruin.

It's hardly a surprise that Wolfe demonstrates not only skill but also sincerity in his descriptions of the built environment. A first-rate observer, which is also to say a first-rate reporter, Wolfe has an eye for nuance, for manner, for presentation, and for almost every brand of detail is well es-

tablished. As the journalist Bill Moyers once noted, "Wolfe has eyes like blotters, soaking up what others look at but do not see, and like the 19th century novelists who are his literary heroes, he is first and foremost a reporter of the life around him."[71] Wolfe has described himself as "a status theorist," drawing as much from the German sociologist Max Weber as he does from Balzac, his literary idol.[72] In *Bonfire*, he channels a Spanish brain physiologist, José M. R. Delgado, in elucidating a philosophy that seems to align with the idea that identity is primarily derived from the status group, and that that group, in turn, is directly influenced by its environments: "For nearly three millennia, Western philosophers had viewed the self as something unique, something encased inside each person's skull, so to speak. Not so, said Delgado. Each person is a transitory composite of materials borrowed from the environment."[73] Wolfe (as we will see later with DeLillo) also subscribes to the view that, as DeLillo puts it, "everything is real estate," that is, we are all products of our own geographies.

Despite the fact that corporeal metaphors were often used to describe the "death" of buildings and of neighborhoods, inversely ascribing the decay and ruin of a particular environment to its people—whether or not they have been "made" by it—is more often than not a poisoned idea. That said, Wolfe's facility with capturing physical externalities translates well to the evocation of built environments; his observational gifts effect a more natural—and less essentialist—identification with architecture, material objects, and symbols than they do with people.

Moreover, Wolfe's representations of physical ruin were no more overwrought than attempts by the journalism of the era to capture those same scenes on its broadsheet or magazine pages. A 1973 *New York Times* article about the construction of a new complex of apartment buildings in view of Bronx ruins began:

> In the South Bronx, they call the complex of once-elegant brick apartment buildings on Bryant Avenue the DMZ. The five buildings and their central courtyard look as if they had been blasted with cannon and burned over with napalm. All but a few windows are fire-blackened and vacant. Junkies haunt the reeking, ruined hallways. Most of the courtyard is occupied by a three-foot-high pile of garbage spilling from paper bags.[74]

A 1983 issue of *People* magazine provided all the inspiration Wolfe might need for Sherman's venture north in an article about South Bronx blight that seems to revel in the grotesque:

Gazing at all the scenery along New York City's Cross-Bronx Expressway, many motorists feel an intense need to communicate with the Almighty: They utter a quick prayer that their steel-belted radials will hold air for at least a few more miles. The landscape that inspires such terror is called the South Bronx, and it has been, for a decade, a national symbol of poverty, arson, and urban decay. From the expressway, the scene resembles nothing so much as the final footage of The Day After. Rows of high-rise apartment buildings stand gutted and burned.[75]

Longwood, one of the South Bronx neighborhoods through which Sherman and Maria likely pass, had, according to Orlando Marin, the chairman of Bronx Community Board 2, "an almost post-apocalyptic character."[76] In 1981, Marin recalled that when a young woman asked him to pick her up at her home on Kelly Street, she warned him, "When you get off the train you have to walk in the middle of the street; there are no lights, or sidewalks, the buildings are abandoned, and someone might drag you into a building and do something to you."[77] Neither were other city officials shy in resorting to evocative metaphors that recall the uncanny's notion of bodily disintegration when discussing abandonment as witnessed in the South Bronx: "Abandoned buildings are like cancer," said Frank Dell'Aira, an assistant commissioner of the Department of Housing Preservation and Development. "They spread from one to the other and that's how whole neighborhoods are lost."[78] There was, as evidenced, at this time a common language rich in metaphor that was associated with urban ruin, and both the media and the public were not only conversant in it but also indulgent in deploying it. When it came to the Bronx, images of the uncanny and the grotesque were hardly tools limited to the creative arsenals of the fiction writer or the visual artist. That common language of ruin, which had filtered into those nominally more "objective" sources of journalism and reportage, spoke of a deeper common understanding of ruin in the urban environment.

Wolfe's commitment to his own vision of realism born of reporting and research—and here, to his desire to write a novel of the city, of "New York, high and low"—is, in the end, most often what gets in the way of writing good fiction. One could say that, in desiring to evoke Balzac in his own fiction, the New Journalist Wolfe fell into the trap of the Gothic in rendering the South Bronx and ended up conjuring Horace Walpole.[79] Said another way, it is Wolfe's training as a journalist that, in the opinion of Brock Clarke, limits his ability to effectively inhabit characters and sensitively render environments and individuals that are in most ways

different from himself. Wolfe argues in his essay that "the future of the fiction novel would be in highly detailed realism based on reporting."[80] Clarke counters that though it might be true that "nonfiction profits by approaching its subjects directly . . . [this] is not true of fiction," which requires, in the difficult process of creating believable characters within their historical moment, a good deal more than just the kind of reported observations that make for excellent nonfiction.[81] What works for Wolfe atmospherically—his evocation of the South Bronx, its structures, systems, and its streets, drawn almost directly from journalistic accounts of the state of each—fails when rounded personalities need detailed rendering in his fiction. To write a novel of the city—a novel about New York in the late twentieth century—requires more than just looking at the high and the low, especially when that novel's pitch has been so finely calibrated to the middlebrow. To write such a novel requires the understanding that uneven development manifests itself in society and the city—and, when represented properly, in fiction—unevenly. That is, it is not simply a question of looking high and low, but rather of revealing the many links between them that captures a city in full.

## Prodigal Son: Don DeLillo and the Study of Wonders

In chapter 8 of Don DeLillo's *Underworld*, the South Bronx of the 1980s receives a different set of unexpected guests who've traveled from much farther away than the Upper East Side of Manhattan. A tour bus toting a sign that reads "South Bronx Surreal" in the destination window and carrying about thirty Europeans pulls up across the street from a derelict tenement. Two nuns—Sisters Grace and Edgar, whom the reader has just encountered—sit watching the scene in a van parked just down the street. As the Europeans file off the bus and onto the sidewalk in front of boarded shops and closed factories with cameras slung over their shoulders, Sister Grace—aghast—shouts: "It's not surreal. It's real, it's real. Your bus is surreal. You're surreal." And a few beats later: "Brussels is surreal. Milan is surreal. This is real. The Bronx is real."[82] The moment registers Grace's shock and anger, but it's also one that offers a sense of wonder: surreal were the seemingly lunar landscapes of ruin found at points throughout the Bronx to be sure, but so too was the idea of Europeans come to visit such modern urban ruins, often found in the midst of still-viable communities. Surreal was the incursion of those come to gawk at the economic, infrastructural, and social breakdown of communities as a marquee

175

feature of their holiday travel. Surreal was the fact that even in 2013, such an idea would still have purchase: a company calling itself "Real Bronx Tours" was forced to cease operations in May 2013 after it had conducted tours through the South Bronx, advertised as giving visitors "a ride through a real New York City 'GHETTO.'"[83]

Grace's impassioned argument has embedded within it a question: What defines the reality or surreality of an image or place whose character and quality are so extraordinary—and extraordinarily raw and, perhaps, "real"—that it approaches the dreamlike? It is a question to which the novel offers answers in its narrative's repeated visitations and confrontations with the South Bronx landscape. Simply by way of the manner in which Grace orders her understandings of the real, and by the international provenance of the Bronx's visitors, we can see a subtle shift from the way that, say, Wolfe's novel deals with the relationship between the Bronx and its surrounds, between center and periphery, and between New York and the world. Rather than mere outland, the undiscovered country of urban wilderness and gothic horrors that Wolfe's characters encounter, DeLillo suggests that the Bronx must be understood, as Thomas Heise argues in his book *Urban Underworlds*, "within the context of global economic transformations."[84] Attendant to that, we must understand the novel of the city not only as representing "high and low" and spaces of poverty and wealth—which, as Heise observes, "historically . . . have been intertwined and interdependent, falling and rising in lockstep with each other"—but also within and intricately connected to global contexts of infrastructural systems, sprawling metropolitan geographies, and newly emergent and rapidly diminishing economies.[85] The figure of the South Bronx as center of an urban crisis is, in turn, crucial to the novel's imagination and illustration of this networked world that marks a shift in the portrayal of an urban metropolis from *Bonfire*'s dominant trope of insulation to one of dynamic connection in *Underworld*. In a viewpoint akin to the artist Robert Smithson's geological understanding of history as a kind of sediment that accretes over time, DeLillo suggests that we might see modern urban histories in the "landscape of vacant lots filled with years of stratified deposits—the age of house garbage, the age of construction debris and vandalized car bodies, the age of moldering mobster parts."[86] In this way, *Underworld* links the geology of South Bronx urban ruin to the geographies of uneven development and its many manifestations and representations across the globe.

Like Wolfe, DeLillo wrote an explanatory essay of sorts to accompany the publication of *Underworld*—part manifesto and part research

memoir—precisely about how and why he weaves those strands of history together in his fiction. Published in the *New York Times Book Review* in 1997, "The Power of History"—like Wolfe's *Harper's* essay "Stalking the Billion-Footed Beast"—espouses a theory of fiction and the novel by articulating in part how he constructed his own. For DeLillo, histories equally personal and political serve as the inspiration for powerful fiction. "Fiction will always examine the small anonymous corners of human experience," he writes.

> But there is also the magnetic force of public events and the people behind them. There is something in the novel itself . . . that suggests a matching of odd-couple appetites—the solitary writer and the public figure at the teeming center of events. The writer wants to see inside the human works, down to dreams and routine rambling thoughts, in order to locate the neural strands that link him to men and women who shape history.[87]

*Underworld*'s vision encompasses both the literal corners of experience beside which piles of rubble sit on South Bronx streets and the systemic and historical processes that have led to and flow from such moments and environments. DeLillo continues, "In *Underworld,* I searched out the word-related pleasures of memory. The smatter language of old street games and the rhythms of a thousand street-corner conversations, adolescent and raw. The quirky language of baseball and the glossy adspeak of Madison Avenue."[88] The book is the work of a Bronx native, whose perspective—both as a youth and as an adult returned to the Bronx of his birth—can be seen in every narrative brush with the borough: "And what rich rude tang in the Italian-American vulgate, all those unspellable dialect words and derivations of the lost Bronx, and what stealthy pleasure to work out spellings, and how surely this range of small personal recollection served to quicken and enlarge the language that ensued."[89] In *Underworld,* DeLillo recovers the voice—the thoughts, feelings, and diverse and expansive subjectivities—of the Bronx, suggesting that the pain and pleasure felt in and about the borough by some of his characters are, ultimately for DeLillo, personal.

Though it is not the first time we encounter Bronx streets in the novel, chapter 8 of the book's second part, "Elegy for Left Hand Alone," is the reader's earliest sustained confrontation with their reality—or surreality, however one chooses to understand it. Long before Sister Grace faces off against the clutch of curious Europeans, we begin that day soon after dawn with Sister Edgar, in veil and habit and sitting in the passenger seat

of a van that was headed "down past the monster concrete expressway into the lost streets, a squander of burnt-out buildings and unclaimed souls."[90] As with *Bonfire* and as is often the case with representations and evocations of the Bronx of this era, the figure of the expressway—whether that of Robert Moses's Cross Bronx Expressway, or the linked highways of the Bruckner and Major Deegan—literally looms quite large over the action, though here it remains unidentified. It is a reminder of how these elevated roads became the primary vantage points from which motorists could view the decay of the Bronx below them. Once the sisters arrive at their destination, the area known as "the Wall," partly for a graffiti facade that memorializes dead neighborhood children as angels and partly for "the general sense of exclusion"—the scene that is set also recalls that described by Wolfe: "Weeds and trees grew amid the dumped objects. There were dog packs, sightings of hawks and owls." City workers arrived periodically "to excavate the site and they stood warily by the great earth machines, the pumpkin-mudded backhoes and dozers, like infantrymen huddled near advancing tanks." Trash abounded. There were "networks of vermin, craters choked with plumbing fixtures and sheetrock," and "hillocks of slashed tires laced with thriving vine." Gunfire "sang at sunset," its sound ricocheting off the walls of demolished buildings.[91]

The prose delights in a mosaic of images of the landscape, vocabularies of municipal infrastructures, encounters with wild beasts, and bizarre unions of the organic and the unrecyclable that encapsulate the idea of the Bronx as less a fixed place to live and more an ongoing process of waste, wilderness, and ruin. DeLillo systematizes even this visible destruction in imagining "networks of vermin" coursing through the vacant lots and detailing the city's Sisyphean efforts to arrest or at least structure the environmental collapse at hand. Demolition was an important tool in the municipality's limited arsenal in its attempt to clear acres of abandoned and collapsing buildings in the South Bronx for future development. A 1983 report of the South Bronx Development Organization noted that there were approximately two thousand "dangerous, abandoned buildings" that still "scar[red]" the landscape while hundreds of acres were buried under a "thick cover" of rubble and debris. "Dynamic compaction"—which sounds like something that DeLillo would surely have invented in his fiction, were it not an extant method of ground clearing—was introduced to the South Bronx by the Port Authority. The process involved "pounding rubble into a consistency comparable to that of virgin earth rather than hauling from empty lots," which provides an image perhaps

even more evocative than DeLillo's mass excavations while grounding that image in documented reality.[92] These excavations and the powerful machineries that carry them out gesture at archaeological processes that uncover material histories embedded in the ruins—the physical residue of lives and communities lost to abandonment, arson, and the gradual deterioration of the built environment. These "underhistories," in turn, allude to the many other kinds of waste—nuclear, toxic—that are buried and uncovered throughout the novel, primarily by DeLillo's protagonist "waste broker" Nick Shay. Here, DeLillo unsubtly militarizes the machinery's appearance and violent action in his description, which, for a landscape often colloquially referred to as a "no-man's-land" is perhaps all too apt. The two women look out across these fields and see entire periods of decay and entropy as reclassified by the symbols of ruin: ages of garbage, construction debris, and abandoned cars as if they were minor categories of geological time, visible in layered deposits. The potency of the images themselves, laden with the weight of material history that is both sacred and junk, eternal and ephemeral, seems to transform the prose itself, effecting a hybrid language whose terms are unique to the landscape. Hillocks of tires and craters of sheetrock suggest that any degree of South Bronx surrealism—or its opposite, as argued by Sister Grace—might simply be a question of perspective. In either case, DeLillo's descriptions suggest a deeper reckoning, a fascination, a communion as it were, with Bronx ruin rather than Wolfe's fearful, distanced view.

Even so, DeLillo's sustained engagement with the real and the surreal of the South Bronx occasionally, and interestingly, aligns some of his formal and imagistic experiments with Wolfe's gothic flourishes when illustrating his characters' visit to the Bronx. On a mission to visit former legendary graffitist-turned-unofficial-neighborhood-sage Ismael "Moonman 157" Muñoz, DeLillo's nuns run a grotesque gauntlet while climbing the stairs to Munoz's apartment, encountering "a prostitute whose silicone breasts had leaked, ruptured and finally exploded," as well as a "man who'd cut his eyeball out of its socket because it contained a satanic symbol, a five-pointed star . . . severed the connecting tendons with a knife . . . finally flushing the eye down the communal toilet outside his cubbyhole."[93] It is as if the temptation to imagine the horrors of hell—or the underworld, so to speak—visited upon the streets of New York is too great for either author, and especially for DeLillo, who after all begins his novel by planting the image of Bruegel's apocalyptic painting *The Triumph of Death* deep within the reader's mind in the prologue. The memorial

179

graffiti Wall itself can be thought of in direct relation to Bruegel's painting, a comparison DeLillo underscores in a bit of local folklore regarding this particularly unforgiving landscape: "People in the Wall liked to say, When hell fills up, the dead will walk the streets."[94] Ghastly horrors, these, to be sure, and but a few of the visual manifestations of societal breakdown in the Bronx offered by DeLillo; however, what distinguishes the two authors' employment of the specter of the grotesque in their fiction lies in part in how their characters experience that exposure to situational terrors. DeLillo's characters do not engage merely with the intimidating spaces that they encounter—it is important to note here that they travel to this part of the South Bronx out of their own volition to perform community service—but with its residents as well, handing out food and conversing with those with whom they've built regular, if tenuous, relationships. DeLillo, in a sense, earns his employment of grotesque images in representing Bronx dysfunction, both because he writes from a place of personal understanding of the Bronx's fall from the days of his youth and out of a sensitivity to the experiences of those who continued to inhabit its neighborhoods long after he left.

That DeLillo fully imagines diverse subjectivities for his Bronx-bound characters is evidenced in part by the relationship between Sisters Grace and Edgar. Grace is the young firebrand: passionate, and first out of the van and "into the breach"—the troubled neighborhoods in which they perform their service. Edgar is of an older generation, more reserved, comfortable, possessed of herself. To wit, when Grace shouts her displeasure at the European disaster tourists outside Ismael Muñoz's building, DeLillo reveals to the reader that Sister Edgar holds a different view. "She thought she understood the tourists," he writes of Edgar. "You travel somewhere not for museums and sunsets but for ruins, bombed-out terrain, for the moss-grown memory of torture and war."[95] They are lines seemingly written in the familiar, all-knowing, all-seeing internal voice in which many of DeLillo's characters seem to speak, yet they reflect a particular—and particularly mature—understanding of the relationship between the real and the surreal, and also between ruin and reality. Edgar's view of the ruin's attraction for the tourist signals an expansive understanding of ruins as sources of both wonder and shame, repellant in many cases, and romantic in others.

The urban designer and theorist Kevin Lynch investigated ideas and understandings of ruin and waste during the time when the South Bronx was considered the "pure archetype" of a "declining area," which was of

course also around the time DeLillo's fictional nuns visited its neighbor-hoods. In his posthumously completed 1990 book, *Wasting Away,* Lynch explores the role of waste processes and decay in the natural world and in urban spaces, paying particular attention to the ways that people con-ceive of waste in their surrounding environments and how it affects their daily lives.[96] In 1981, Lynch conducted twenty-one interviews about waste in order "to obtain a better understanding of common feelings and prac-tices." The interviews wound about a range of topics: definitions, memo-ries, daily practice, loss and abandonment, the nature of wasted life and wasted time, irretrievable waste, feelings about ruins, reuse, and the sight of destruction, and more. Though his sample size was extraordinarily small and idiosyncratic, the responses to questions about notions of waste and ruin, and about various representations of both in culture, are worth spending some time with, in view of *Underworld's* fascination with the same issues. Asked about "declining areas," respondents brought to mind two distinct images: "decaying, low-income inner city" zones like the South Bronx, or rural areas of childhood, perhaps lost to development. The former evoked "a sense of fear and decay, the latter a sense of nos-talgia for something gone." That image of the "inner city" was, for Lynch's respondents, a very familiar one, "whether or not they have ever lived in such a place." Their attempts at description deemed such areas "dirty, wasted, decaying, crime-ridden, racially-torn, prone to fires, failed, broken in spirit."[97]

The respondents were also asked about their perception of ruins and abandoned places, and here the results are particularly evocative when laid alongside DeLillo's own internal discourse on ruin and reality in his novel. People tend to make a sharp distinction between a ruin and an abandoned place. "The first is something old, romantic, and disconnected from their own lives." These are places of fascination, repositories of memory—perhaps ancient, perhaps painful—and they are rarely con-nected with ideas of waste for, as Lynch writes, "the passage of time has burned away the discomfort; the remoteness in space and time drains them of any emotion but curiosity."[98] In these responses, and in Lynch's words, we can read elements of DeLillo's conception of what might draw a for-eigner to the ruins of the South Bronx: the desire for a reckoning with loss, or a managed confrontation with danger or the not-unrelated sub-lime. Yet, Bronx ruins are distinguished on these grounds primarily by the metric of time or, more accurately, the absence of distance. New ruins are, for many, hardly ruins at all. As Lynch observes, "Emotional distance

is the key to a definition of a ruin."[99] What the South Bronx seemed to many was less a ruin than an "abandoned place"—Lynch's second figure of a waste space. Respondents to Lynch's questions deemed abandoned places "ending[s]," "something discarded." Of the South Bronx in particular, one suggested: "A feeling of something sick. It's crazy seeing the apartments in cross-section—toilets, mirrors, people once doing things, all sliced in half!"[100] Yet, as with DeLillo's Sister Edgar, there is perhaps a middle ground. One perspective offered:

> We are *taught* that ruins are beautiful, and the South Bronx is not. The latter is an abandonment that could have been otherwise. We see what is not there—an indictment of our time, something we wish we could change but are impotent to accomplish. The Parthenon would not be as impressive if next to it there were another one still functioning.[101]

It is a complicated, conflicted statement, full of both indictment and acceptance, yet its understanding of the uncomfortable allure of ruin is just as sophisticated as Edgar's, and perhaps as willing to admit the pain and pleasure of confronting it.

If DeLillo seems accepting of, or perhaps indulgent toward, the imagery of ruin and abandonment, it is because—perhaps even more so than Wolfe—he understood that the language and iconography of urban crisis they related to the South Bronx were already part of the common tongue and palette of American culture. We might say that DeLillo's understanding here is Sister Edgar's writ large: he knows that in the era of the late Cold War which he here depicts, the sublime and the surreal are not merely part of the culture, but have come to resemble reality, if not manifest themselves entirely within it. Moreover, much of DeLillo's fiction is almost painfully focused on revealing both the intricate connections and the annihilating power of late capitalism in the Cold War era, and that there would be no South Bronx—no extant urban ruin within a few miles of what was then arguably the financial capital of the world—without sufficient, and terrible, forces to create it. The scholar Philip Nel writes intelligently about DeLillo's relationship to avant-garde art and literature as evidenced in his fiction, arguing that DeLillo turns to the "ambivalent legacy" of Dada and surrealism because "they are uniquely suited to revealing the ideological underpinnings of the Cold War period. To put this another way, he turns to the historical avant-garde because the emotional attitude of the Cold War era is surreal."[102] Nel suggests that we can see the relationship between the styles and repertoire of surrealist images—

182

represented through characters at different points by the work of fictional visual artists Klara Sax and the Fluxus "garbage guerrilla" artist Detweiler—and reality in DeLillo's juxtaposition of Bruegel's *The Triumph of Death* and J. Edgar Hoover's deep and abiding sense of paranoia mixed with fascination regarding atomic annihilation in the novel's prologue.[103] Yet we can extend this relationship to DeLillo's treatment of the South Bronx landscape, which, as we have seen in the novel, approaches the kind of apocalyptic imagery present in Bruegel's painting. While watching subway riders pour forth from beneath the streets escaping a subway fire, Sister Edgar recalls a trip to Rome from her youth, prowling

> the catacombs and church basements and this is what she thought as the riders came up to the street, how she'd stood in a subterranean chapel in a Capuchin church and could not take her eyes off the skeletons stacked there . . . and she remembered thinking vindictively that these are the dead who will come out of the earth to lash and cudgel the living . . . death, yes, triumphant.[104]

This is the famous Capuchin Church in Rome that had so fascinated Nathaniel Hawthorne in *The Marble Faun;* later, Mark Twain, in *Innocents Abroad,* imagined it as both a tribute to and a harbinger of death. If, as the writer Brian Dillon suggests, the modern ruin, "the specter of Cold War dread . . . is in fact always, inevitably, a ruin of the future," then we might think of DeLillo's South Bronx as a presentiment of that future ruin—the postapocalyptic present feared by all and which haunts the novel's characters as they experience its intricately networked Cold War history.[105] Of all possible futures to be had in the shadow of the bomb, the streets of the South Bronx offered an example of a potentially traumatic one, but one that was not only already part of our world but inextricably bound both to history and to global processes, systems, and infrastructures far beyond its borders, and to other processes—like systemic racism and municipal neglect—that were decidedly more local. After all, if this could happen in New York City—a "global city"—then it could happen anywhere.

*Underworld*'s "controlling metaphor," as a *New York Times* review deemed it and as many literary scholars have since expanded upon, has to do with waste—with "chemical and nuclear toxins, as well as the more mundane trash our ravenous, bulimic society recycles."[106] With regard to the Bronx built environment, waste and the many means of accumulating, transporting, diverting, avoiding, or eliminating it are among the novel's

most concrete and effective methods of illustrating how interdependent are spaces of affluence and spaces of ruin both in New York and throughout the world. Urban geographers like David Harvey have long chronicled patterns of consumption in New York City and understood it as both a material object and a cultural and ideological symbol, both of which in globalized economies can be easily transported far and wide across the planet.[107] In the material sense, the globalization of garbage, or what Julie Sze discusses as the "unyoking of New York City from its previous spatial limits," in turn reflects "the intensification of processes of deterritorialization," which Sze defines as the "removal of a city from its physical limits of production and consumption, signifying a transition from previous spatial practices."[108] DeLillo's central character (and, for the lapsed Catholic schoolboy DeLillo, essentially his stand-in), Nick Shay, twice reflects upon waste in the ideological or philosophical sense: first, at the word's etymological roots ("Waste is an interesting word, that you can trace through Old English and Old Norse back to the Latin, finding such derivatives as empty, void, vanish and devastate") and, near the novel's end, that "waste is the secret history, the underhistory," which we attempt to repress or deny but which invariably pushes its way to the surface.[109]

In DeLillo's South Bronx, that waste lies already exposed, the evidence of open wounds across its vacant lots and notched on the facades of its abandoned buildings. In one of DeLillo's most haunting images, Sister Grace describes her fruitless chase of the feral, doomed girl Esmeralda through the Wall until Grace became distracted by "actual bats—like the only flying mammals on earth" that came "swirling out of a crater filled with red bag waste. Hospital waste, laboratory waste . . . [d]ead white mice by the hundreds with stiff flat bodies . . . amputated limbs after the doctor saws them off."[110] Cast in the role of open dump, the Bronx landscape can be clearly connected with what was then truly New York's official trash heap, Staten Island's Fresh Kills landfill—known for "its rancid odors, air pollution, and leakages of garbage and toxic leachate into the surrounding ground and water"—just a few miles south.[111] Fresh Kills (as mentioned in Chapter 2, once the site of a Gordon Matta-Clark film) opened in 1948 as a temporary waste station and, despite its temporary status, grew to cover 2,200 acres, or three and a half times the size of Central Park—then the largest landfill in the world. One of DeLillo's characters calls it the "King Kong of American garbage mounds," and the author sites a scene early in the narrative at the landfill.

With the towers of the World Trade Center visible in the distance, a character named Brian Glassic gazes upon "three thousand acres of mountained garbage, contoured and road-graded, with bulldozers pushing waves of refuse onto the active face," all of which employed "bridges, tunnels, scows, tugs, graving docks, container ships, all the great works of transport, trade and linkage . . . directed in the end to this culminating structure."[112] In a way, that waste stream does not end but instead finds continuance in the Bronx, where Ismael Muñoz and his crew of informal salvage workers scavenge "under bridges and viaducts" and for abandoned cars, following the Bronx River, "a major dump site for stolen, joyridden, semistripped, gas-siphoned and pariah-dog vehicles" to be brought to a scrap-metal operation in far-off Brooklyn where "forty or fifty cannibalized cars" sat in what DeLillo terms "a junkworld sculpture park—cars bashed and bullet-cratered, hoodless, doorless and rust-ulcered, charred cars, upside-down cars, cars with dead bodies wrapped in shower curtains, rats ascratch in the glove compartments."[113] The character of Ismael Muñoz himself—"a graffiti master, a legend of spray paint" who "marked subway cars all over the city, his signature running on every line"—is a conduit for this sense of shadow connection. In Muñoz, DeLillo gestures at the notion that graffiti constituted a gestural, performative, urgent—and largely unacknowledged—archive of Bronx writing. Like the young graffiti writers of Fashion Moda (discussed in Chapter 4) and those interviewed by Norman Mailer in Mervyn Kurlansky and Jon Naar's photo book, *The Faith of Graffiti,* the name "Moonman 157" rings out across the city, employing its built-in and binding networks of subway lines and cars to broadcast—and to affirm—his existence. The voice in which Mailer writes of his young interviewees in 1974 is one that could easily be mistaken for DeLillo's:

> You hit your name and maybe something in the whole scheme of the system gives a death rattle. For now your name is over their name, over the subway manufacturer, the Transit Authority, the city administration. Your presence is on their presence, your alias hangs over their scene. There is a pleasurable sense of depth to the elusiveness of meaning.[114]

Between the Bronx, Brooklyn, Fresh Kills, and beyond, DeLillo maps for the reader dumps both formal and informal, lines of transport and exchange that negotiate between the geographic and the topographic, and by virtue of those interrelations, he suggests that the boundaries between

spaces of wealth and spaces of waste are more porous than a character like Sherman McCoy would like to believe—if they exist at all.

The point at which Edgar, Grace, Ismael Muñoz, and Esmeralda—the murdered girl whose miraculous appearance on a billboard serves as a form of urban beatitude—converge is, naturally, at a transportation hub of sorts in the South Bronx at the end of the novel. Bridges, entrance ramps, traffic islands, expressways, boulevards, and commuter train tracks crowd the scene from which crowds gathered to witness the vision stare at the advertising sign scaffolded high above the nearby riverbank. As a Metro-North train rolls slowly toward the drawbridge, casting its headlights across the billboard and causing a young girl's face to appear at its dimmest part, Grace plays doubter to Edgar's true believer. "It's just the undersheet," Grace says. "A technical flaw that causes the image underneath, the image from the papered-over ad to show through the current ad. . . . When sufficient light shines on the current ad, it causes the image beneath to show through." In some ways, the scene and Grace's words play as grand metaphor for DeLillo's evocation of the Bronx. Just beneath the surface, the image of the Bronx broadcast to the nation at large of a ghost town, abandoned and emptied of life, is—like the image of Esmeralda for Edgar and the watching crowd—another image that acts as "a verifying force . . . a figure from a universal church with sacraments and secret bank accounts and a fabulous art collection."[115] DeLillo's portrait of his native borough, of his native city, is always cognizant of the fact that the city is both icon and territory, both a literal, haunting ghost story told to urbanists and to children everywhere, and a real place, constantly imagined, but within which people not only reside but share. Within DeLillo's conception of the Bronx in *Underworld,* on every page and in every likeness of street, facade, and profile, "there is the sense of someone living in the image, an animating spirit—less a tender second of life, less than half a second and the spot is dark again."[116]

Wolfe constructs his idea of New York as an essentially binary proposition: New York, "high and low." For him and his characters, there is Manhattan and there is elsewhere, and the South Bronx is Wolfe's elsewhere—the mapmaker's terra incognita, either shaded in as an afterthought or filled with fanciful monsters—that is everywhere else but New York's central island. DeLillo's New York does not merely contain multitudes so much as it attempts to illustrate what might bind them—the city and the nation, together—and, by extension, to history. The former gestures at that idea of connection; the latter exults in it. Perhaps para-

doxically, the final lesson of each novel remains the same: whether New York is "two cities" in one author's conception, or a multiverse of layered cities one upon the next in the other's, by virtue of the systems, arteries, and infrastructures that bind it, it is one *shared* city—a development that Wolfe or his characters might willfully repress, and one that DeLillo imagines as organic. That is, in *Underworld,* the paradigmatic postmodernist DeLillo is revealed in part to desire the restoration of some essential, natal relationship to place, thus effecting a literary homecoming of one of the Bronx's prodigal sons.

## "The Balzac of the South Bronx": Abraham Rodriguez Jr.'s *Native Son*

When journalists from the *New York Times* came to the Bronx to interview Abraham Rodriguez, they asked him to take them to a crack house. Or, at the very least, they asked to see something *like* a crack house. Rodriguez, understanding that this might be a bad idea, informed the reporter and the photographer who had joined him that this might be dangerous. Nevertheless, he took them to a location that he thought might suit the occasion, underneath the Westchester Avenue El. The photographer began taking pictures and, in no time at all, the inevitable happened. To hear Rodriguez tell it, all of a sudden, "This big man comes out and says, 'What are you doing in front of here?' I told the [photographer], 'Listen, this is dangerous, let's get out of [here], because I live in the community and you're putting me in a bad place.'" The photographer insisted on taking one more picture. That picture ended up being the one that accompanied the *Times* profile of Rodriguez ("They [chose] a picture where I look grim," said the author), but it did not come without a cost. When the photographer was trying to pull out from under the El as he headed home, a 4×4 vehicle smashed into the front of his vehicle. "You are so stupid and so dense," said Rodriguez about the desires of the *Times* team, "That's [the drug dealer] way of saying *Don't come back here! Go away!*" When they returned to Rodriguez's house, he told the journalist, "If anybody in my family gets hurt because of you, I'm going to teach you a lot about journalistic integrity."[117]

The anecdote, which Rodriguez recounts in an interview with the Puerto Rican book critic Carmen Dolores Hernandez, is illustrative of what audiences either expected or desired from the South Bronx by the early 1990s: crime, drugs, the threat or promise of danger, and, in the

person of Rodriguez, someone who could tell them all about it—a translator of sorts, who could help the Bronx make sense to them, perhaps so they never had to visit themselves. The *Times* profile of Rodriguez tried its hardest to lean into the experience that its writer and photographer had with a dramatic lede: "The street was filthy and slatted with the shadows of elevated train tracks. In this dark corner of the South Bronx, even Abraham Rodriguez Jr. was not entirely at ease as he pointed out a forgotten storefront, the model for a crack house in his novel, *Spidertown*."[118] Indulging in what by then were already familiar Bronx tropes—and perhaps trying to channel the authorial voice of his subject—the *Times*' characterization demonstrates that the journalistic view of the South Bronx, as evidenced by the examples discussed earlier in this chapter, had not changed much by the early 1990s. To be fair, as readers of Rodriguez's fiction might believe, the South Bronx had not changed much by then either. "This world," Rodriguez told his interviewer, "is a ripoff," where young Puerto Ricans can feel "as empty and abandoned as the crumbling building" that Rodriguez stood before on that day, right before being shooed away by its annoyed, threatening inhabitants.

This metaphorical construction, a creation partly that of Rodriguez and partly of the journalist, highlights the dilemma that faced both fiction and nonfiction writers regarding the South Bronx. How does one avoid stereotyping a place and its people? This is a question that all artists, fiction writers or otherwise, surely face, but it becomes more pointed when they are faced with representing so overdetermined a space. When does a row of abandoned buildings in the Bronx become too clichéd for description? And what happens when that row of abandoned buildings is on your street? That is, what happens when other writers' imagined surreality is simply your reality? These questions were urgent enough already for those who had the privilege to call somewhere else home. For a writer like Rodriguez, who was asked time and again not merely about the role of representing his Puerto Rican American community in fiction but also about whether he was speaking *for* them, the related question of *how* that Bronx would be represented—relentlessly bleak, or with hope on the horizon—one would imagine finding answers to these questions would be paramount.

For his part, Rodriguez seemed to care less than one might have thought—or, at least, such was the impression he put forth to the press. In the wake of *The Boy without a Flag* and *Spidertown,* released in successive years in 1991 and 1992, Rodriguez was sensitive to becoming a

darling of the literary media, such as it was, and to being labeled as "the good boy who came out of the South Bronx."[119] It was not only sensitivity toward how his literary persona—a bookish Puerto Rican ingenue who skewed more punk than hip-hop, but could write comfortably in corner boy dialect—was being sold to the public, but also how the South Bronx itself was being used "to sell books" that displeased him. Upon the release of *Spidertown*, all of the major television networks sought him out for interviews, companies contacted him to gauge his interest in various partnerships or promotions, and Rodriguez—to the chagrin of his publisher, Hyperion—turned down most, if not all, of these offers. The rights to the novel were bought by Columbia Pictures, and the director Robert Rodriguez was briefly attached to the project—and, consequently, the director spent some time with the author in the South Bronx—but nothing much developed beyond that initial interest. To hear the author tell it, "I told them there are certain things I don't want to do and the primary thing I don't want to do is to become a pimp for the South Bronx."[120] For Rodriguez, being typecast into the role of social uplifter—depending on who was doing the typecasting—was an uncomfortable process and, not unlike Ellison's nameless *Invisible Man* narrator thrust into the Harlem street corner soapbox spotlight, he preferred to define that role himself rather than have it imposed, if he accepted it at all.

Writing about the South Bronx was as much a question of form and style as it was one of authorial identity and representation. Metaphors for ruin abounded in journalism and fiction, from the stereotypical, to the gothic, to the surreal. Many of these were surely unavoidable, but the line between accurately rendering a harsh neighborhood and its personalities, and relentlessly—breathlessly—indulging in the grisliest aspects of that neighborhood was thin. Rodriguez, who drew both praise and criticism from fellow Puerto Rican authors and advocates for focusing on the hopelessness encountered by many in the Bronx, was sensitive to such criticism, but at the same time, he could only write what he knew, or at least what he saw around him. One fellow writer quoted in the article, Ed Vega, offered, "It is incumbent on an artist to point out not only the horrible aspects of life but to be true to the reality. The thing that draws attention is the harsher aspects of Puerto Rican life, when the reality is that many people escape the South Bronx, escape the ghetto."[121] It was often that reality, however common or rare, that did not get as much attention, either in the press or in other representations of the South Bronx. Rodriguez himself was conscious of this criticism, and of how both he and his fiction

operated within the literary marketplace: "I want to show the whole Bronx, not just the crack dealers, the pimps and 14-year-old prostitutes. But it sells."[122] Such knowledge, however, did not make the work of writing any easier. Not wanting to be seen as pimping for the South Bronx, all the while understanding that pimping sells: herein lies but one version of the paradox of representation facing literary artists charged with writing the South Bronx. Fictionalizing the Bronx was no less precarious for one of its own born-and-bred residents than it was for writers like DeLillo and Wolfe. A few scenes from Rodriguez's short-story collection and novel help illustrate the difficulties encountered, and how a native son like Rodriguez navigates such perilous waters.

*The Boy without a Flag,* a collection of seven short stories, a few of which clearly borrow from Rodriguez's youth, wears its heart on its author's cut sleeves, tacking its own road between fiction and memoir in offering an earnest evocation of what it meant to grow up in the Bronx of this era. Its opening story, from which the title of the book is taken, is its most autobiographical, telling the tale of a boy—a loosely fictionalized Rodriguez—who out of deference to his Puerto Rican nationalist father refuses to salute the American flag during a school assembly. But it's in the book's second story, "No More War Games," that Rodriguez experiments with how to render the Bronx built environment in a way that reveals the lived experience of his characters as a function of that environment. A brief coming-of-age tale told over the course of an afternoon's "war games" between two Puerto Rican American girls and their boy tormentors in an empty lot and adjacent abandoned buildings, the story is a simple meditation on the role of violence, sexuality, gender roles, and the loss of youthful innocence—which also manages somehow to be one of Rodriguez's sweetest, even despite its slightly sour ending, in a book where sweet moments are few and far between.

The story begins with Nilsa, the preteen protagonist, daring to show mastery over the Bronx's ruins, standing "skillfully balanced on the rubble in her plastic sandals." It's not merely a physical mastery but also a budding feminine one: "She had to start thinking about dressing like a young woman." Such an assertion of her youthful self within her environment places her in minor danger—after all, though the sandals were "adorable," they were also not "really made to walk on rubble"—but it is illustrative of the courage and daring that she demonstrates throughout the story.[123] The two girls converse as they assemble a small arsenal of sticks and rocks, in preparation for the boys' attack, which apparently has been preor-

dained. The empty lot around which they prowl is described as others have been by many a fiction writer or journalist: the yard brims with "shattered glass and the odor of raw decay," as this "desert of garbage teemed with half-demolished tenements and mountains of bricks." Nature reclaimed the urban as "swaying lanes of tall grass" cut through the field, "growing wild and uncut" while "tiny paths sliced through the walls of gently undulating leaves."[124] While the descriptions are evocative, they are also familiar Bronx tropes. However, what begins to distinguish Rodriguez's employment of the images of Bronx ruin is how the author ties them, and this lot in particular, explicitly to character and to identity. Nilsa uses this "pre-battle" stroll to reflect not merely upon her looming puberty (she was turning twelve that week) but also upon this environment as a reflection—even a symbol—of her youth. "She had always been happy here," Rodriguez writes. "It had always been fun to hang out in yards, explore gutted buildings, play war games."[125] While Rodriguez does not exactly humanize the ruin that Nilsa has held dear, he offers a glimpse of how even such an unforgiving environment could have meaning. Moreover, by defining that meaning in the terms of childhood memories, of the innocence of play, of happiness and exploration, Rodriguez manages to invert the common understanding of such spaces as hostile, barren, and threatening. They, too, are the repositories of memory. In the grand tradition of Bronx youths making do with what little they are given—of which hip-hop is only one, but certainly the most prominent example of this impulse and talent—ruins are made into the sites of childhood idylls and stages of play.

It takes the entrance of the antagonist boys, who begin to throw rocks at the girls from a third-floor window of a neighboring abandoned building, to break Nilsa's reverie and reintroduce a threat to a situation that had heretofore been peaceful. Nilsa bravely seeks refuge in the same building the boys are bombing from, leaving the younger Maria behind. An intrepid soul, Nilsa runs through the building's hallways and apartments, being careful to step over "ugly beams that hung down from the torn walls." She eventually finds a Bacardi bottle "full of murky water" to use in retaliation, and stealthily outflanks the boys, all the while feeling like "some animal of prey, maybe a hero soldier in a war movie, only this was better, because she was a girl, a lioness, or cheetah-ess, or whatever."[126] She eventually corners one of her antagonists and demands a kiss from her new "prisoner," under pain of torture (an arm twist). When he hesitates and offers a response to the question as to whether he thinks she is

pretty that disappoints her—"It had been more than he wanted to say and less than she wanted to hear"—she is crushed, and resolves to leave these playful childhood pursuits in the rubble fields behind her, reluctantly taking on those that result in "get[ting] boyfriends."

In the story's final lines, the valence of these empty lots changes for Nilsa, but not because of reasons stereotypically associated with urban ruins. "The whole place looked and smelled different," Nilsa thinks. Something was "gone forever," but she didn't know what. What she did know was that "running around in empty lots was no longer enough."[127] Perhaps now that ruin would simply *be* a ruin to Rodriguez's young protagonist, having not only been previously a site for Nilsa's imagination and adventurous spirit to run free, but now also the quite literal site of her "ruined" play for a most innocent of intimacies. If not exactly a "safe space," Nilsa's empty lot had been a space made, by her and her friends, safe for fantasy and wonder, while to most of the rest of the world, it—and images of similar lots—conveyed danger and the unknown. Though this was a stage set for play, it was play of a particularly violent sort: "war games" that pit girls against boys, in an environment where any implement, rock, brick, or broken bottle was a potential weapon. However, in Rodriguez's rendering, it is not the violence of the space or of the "war game" itself that causes Nilsa to leave her childhood behind and, in so doing, reject her tomboyish impulses for those imposed by more conventional gender norms ("painting her nails and getting the right color lipstick").[128] Rather, it's the casual, unintentional violence of other children that prompts her change.

All is fair, it seems, in love and war games, but Rodriguez invests this awkward and painful encounter with much more than just the daily mortifications of youthful interactions. It's a slight, clever inversion which suggests that spaces like these—ones that the world imagines to be full of horrors of one kind or another—can also be made sites of diversion or delight as much as they can be sites of trauma as well. Implicit in that suggestion is the notion that it takes *people*, perhaps even a shy, careless boy, to inflict that trauma, rather than it being inherent in the land or the neighborhood, while understanding that such human-inflicted trauma possesses the power to change—almost immediately—one's relationship to the space around them. Other similarly crafty reinscriptions of the way that the Bronx built environment had heretofore been presented in Bronx literature exist within Rodriguez's short-story collection, but his novel *Spidertown* offers some of the most poignant and precise representational motifs that help bring the Bronx visions of DeLillo and Wolfe into even sharper focus.

*Spidertown,* set in the late 1980s, is a crime-novel-as-bildungsroman, told from the perspective of a sixteen-and-a-half-year-old drug runner named Miguel. Thus, it might be seen alongside the work of writers like Richard Price—another Bronx-born son who imagined his own coming-of-age tale in the white ethnic enclaves of the Bronx of the early 1960s. *Spidertown* is also, according to scholar Paul Allatson, a portrait of a Bronx "characterized by social collapse, the informal economy based on crack, racialized antagonisms, violence, poverty, and posse staking of *barrio* streets."[129] This would seem to indicate that the novel's subject matter engages many of the typical tropes associated with the Bronx of this era, and to a large extent it does. But it is Allatson's description of Rodriguez's vision of the Bronx as "a warring contact zone, an inner-city island, cordoned off from the surrounding city" that most interests me.[130]

Such a description ought not suggest, in my estimation, that Rodriguez subscribes to the typical characterization of the Bronx as a "no-man's-land," nor does such a vision willfully ignore the processes of deindustrialization, white flight, and rampant structural racism that contributed to the collapse of social and municipal order in the borough. What Rodriguez's vision distills to the reader is that, for all intents and purposes, very little of that was visible on the ground—in a way that could be easily articulated or imagined—to a character like Miguel. Though Miguel may acutely *feel* the effects of each and every one of those processes daily, his vision of the world is limited by, and to, the boundaries of the borough—even the smaller neighborhoods—that he frequents. In many ways, Rodriguez draws this as an even deeper tragedy: though South Bronx residents may be able to see out into the wider world and engage with it through popular culture, the idea that one's favorite band or actor is part of the *same* world as that of the South Bronx is, to some of the novel's characters, almost unimaginable. As Allatson observes of the novel's characters, "Their world is bounded and rarely extends beyond the South Bronx. These spatial limits are reinforced by imaginative limits."[131] In this way, we might understand Rodriguez's novel as examining not simply what that South Bronx looks like *from the South Bronx* but—more interestingly—what the South Bronx thinks of when it imagines the rest of New York and the rest of the world, even if that vision is remarkably constrained. That is, for as much as authors and artists have thought about what the South Bronx looks like, and how it should be represented, few have given thought or voice to how the South Bronx looked out at the world around it.

Near the end of the novel, as Miguel is in the hospital, recovering from two gunshot wounds, he is visited a few times by a Latinx policeman, Sanchez, who is seeking to turn the drug runner into an informant in a case against the drug kingpin, Spider. Sanchez manages to gain Miguel's trust, partly by simply *not* being white but also by conversing with him as two sons of the Bronx—albeit from different generations—rather than threatening him or interrogating him into submission. Sanchez gives Miguel a book, and though this particular volume is certainly a heavy-handed gesture, it also makes perfect sense as a gift for a South Bronx boy who seemed, at first glance, to be a product of environmental determinism: a new copy of Richard Wright's *Native Son*.[132] In *Spidertown*'s final few paragraphs, Miguel thanks Sanchez for the gifted novel, noting, "It was dope."[133] The detective turns excited literary critic at Miguel's clipped enthusiasm: "What I like about him is his ability to present us with the case of a young man who was born into a situation that he couldn't change. He couldn't help what he did. He just didn't know any better, and there was no one to teach him."[134] Miguel, who throughout the novel is shown to be a voracious reader and consumer of popular culture with an amusing talent for malapropisms (he makes reference Nurse Ratched from Ken Kesey's *One Flew over the Cuckoo's Nest* as "Nurse Rat Shit"), both is and is not a Bronx-born Bigger Thomas.[135] Like Bigger, his ambitions, for most of the narrative, are greatly circumscribed by his environment, but by novel's end, Miguel realizes that leaving his life as a drug runner may be the only possibility to unite the world he encounters in the fiction and culture that he loves to his own world and, perhaps, transcend that circumscription. It is Sanchez, in part, who teaches him so, by literally giving him the example of Bigger Thomas from which to learn.

By novel's end, it seems as if Wright and his most famous novel might be just as apt a comparison to Rodriguez as Ellison's. Though Miguel does firmly unlatch his future from that of his drug kingpin benefactor, choosing individual agency over the uncertain identity of being a cog in the wheel of a criminal enterprise, he seems less interested in a future speaking for Nuyoricans everywhere—as Ellison's narrator suggests he might for the black community—than he does in simply securing safe passage from an untenable situation and a hostile environment. It is, in actuality, the Spider character who performs more of the novel's acts of "speechifying," damning the typical version of the American Dream for the—perverted, yet more perversely within reach—version that he and his drug-dealing

operation offered young black and Latinx youth. In doing so, and in offering Bronx youth like Miguel an alternative vision of success in America—one that circumvented the invisibility imposed by the "mundane, humdrum WHITE world where [they] felt like [they] didn't even register on the scale"—Spider offered his workers the illusion of self-determination and of a kind of mastery unavailable to them anywhere else.[136] To wit, Rodriguez drives home this point with a rewriting of the most famous phrase from Wolfe's *Bonfire* (itself ripped from a bit of 1980s pop culture)—which also acts as a subtle rejoinder to Wolfe's novel: "Spider had made [Miguel] feel as if he was a master of his own universe."[137] "Masters of the universe" is how Sherman McCoy referred to himself and his Wall Street bond trader brethren, and it's no coincidence that Rodriguez invokes the same phrase (referencing the same 1980s cartoon and series of action figures) to gesture at how close to (or how far from) a character like Miguel was to Wolfe's character's invocation of the term. Though Sherman understands his mastery to extend even to the domains to which he would never hope to visit—the South Bronx in particular—to Miguel, the South Bronx and the rest of New York were different universes altogether, each capable of wildly divergent forms of mastery, and rarely—not never—shall the twain ever meet.

Much like Wright, who drew some reproach from African American critics that books like *Native Son* and his autobiography, *Black Boy,* were "unrepresentative" and gave a bleak view of black culture, Rodriguez experienced the same with regard to his portrayals of Latinx communities in New York. Speaking of *Spidertown,* Rodriguez offered, "Some people see it as a bleak message, some people see it as a message of hope. For me it's my way of expressing my feelings about things."[138] He professed a different model than Ellison of speaking "on the lower frequencies": "I'm not really saying anything about the community or the South Bronx, except that it's a lousy place to live."[139] As African American literature scholar George Hutchinson has noted of Wright's response to black critics—like Ellison—who took Wright to task for an environmental determinism in which *Spidertown* seems to share, Wright's writing came "from a visceral need to wring meaning out of deadlocking tensions and was thus a key to survival."[140] Wright himself replied to Ellison's criticisms, and it is a response with which one can imagine Rodriguez agreeing: "I don't mean to say that I think that environment makes consciousness . . . but I do say that I felt and still feel that the environment supplies

the instrumentalities through which the organism expresses itself, and if that environment is warped . . . the mode and manner of behavior will be affected toward deadlocking tensions."[141] Rodriguez's writing seems to emerge from the same needs as Wright's and is arrayed at the same goals as his own protagonist Miguel: survival, and a need to express these narrative tensions. Perhaps, in the end, Rodriguez lived up to the grandiloquence of the title "The Balzac of the Bronx." It's likely that many Bronx writers of both graffiti and rhymes from hip-hop's golden age would assert what they saw as more righteous claims to that crown. Perhaps more accurately, Rodriguez might better be thought of as a realist who took neither Wolfe's fear of the apocalypse, nor DeLillo's embrace of the apocalypse, to heart in his fiction, but rather attempted something more difficult: to write not merely a largely unwritten place from the perspective of one who remained, but a place that was, to a certain extent, unwritable—at least by conventional, fictional means.

But by way of ensuring Miguel's survival, at both the outset and the close of the novel, Rodriguez finds a poignant image that serves as a highly practical relic for his main character of Miguel—and one that has already served as a fitting subject and motif for this book: the city's Occupied Look window decals. Miguel acquires this artifact in an afternoon's rummaging around an empty lot, where he found "a framed metal sheet, the kind they use to board up windows on abandoned buildings facing the expressway. It had shutters and a flowerpot on a fake sill painted right on it."[142] Miguel takes his prize home and uses it as decoration—as a painting, hung on his bedroom wall—thereby emptying out the object of its primary use value of "fooling the eye" on a city street, while replacing it with another, more personal function: an impromptu safe, wherein behind its false front he hides the considerable cash proceeds from his drug running. But the object, despite the fact that its facade is remade to contain a different, monetary secret—still brings Miguel no pleasure: "When he stared at the fake windowsill with the fake shutters and the fake potted petunias he felt waves of depression washing over him."[143] Here, Rodriguez demonstrates a delightful narrative facility with one of the signal icons of the South Bronx of this era, and arguably the text's most inventive image. To make an informal implement of a tool of the municipality, to further aestheticize an object that itself only claimed to offer an ersatz aesthetics, and to repurpose the forgotten as essential not only exhibits Rodriguez at his most impish but also expresses the same ingenious spirit as the Bronx youth who imagined the elements that would eventually become what we

know as hip-hop and then made them real. It performs a similar playful, revelatory gesture to much of Gordon Matta-Clark's work (as discussed in Chapter 2) and demonstrates the iconicity of these strange aesthetic trompe l'oeil objects to even those who lived with them—not just to those who encountered them in passing. It is also a rather brilliant instance of a well-worn trope—much like the South Bronx itself, in Rodriguez's work—quite literally being opened and revealed to contain more than meets the eye.

# 6

To have style is, in a sense, to be boring. To have style, or even to be linked with something so grand as "a" style means that you are so committed to a particular routine or set of practices that these methods and manners define you, often to a point where they can be identified or even replicated by others. Style is the product of rigorous devotion to certain principles, such that this consistency eventually becomes associated with elegance, sophistication, or some other form of fashionable or even avant-garde air. Stylistic commitment is almost unimaginative in its rote dedication, even if the resulting outward appearances suggest wild inspiration or tasteful restraint. If you think there is a right way and a wrong way to dress oneself, if you have ideas about how language should be used, and if you have preferences, say, for one century's or one country's construction of furniture over another's, then it's likely that you are familiar with, or perhaps even have, style. The historian Richard Hofstadter identified particular streams of American political discourse as having a style—in his words, a paranoid "style of mind"—but also a particular mode of expression that trades on conspiracy, fear, suspicion, and intimations of apocalypse and is, in its own way, boring in its commitment to those frantic modes. "Style," for Hofstadter, had "more to do with the way in which ideas are believed and advocated than with the truth or falsity of their content."[1]

The more suggestive and elastic potential of style that Hofstadter envisions is one that I'm particularly interested in with regard to the ways that New York in the 1970s and 1980s—and particularly the Bronx—was portrayed in the literature and film of that period. After all, it was the Bronx of this era that birthed, as Tricia Rose once described, "a style nobody can deal with," in the form of hip-hop and its myriad cultural forms and figures.[2] The films of the Bronx have style too. And, sure, they might

even be said to possess "a" style, and not merely in the form of variations on a title—the hip-hop classics "Wild Style" and "Style Wars" being primary examples of such. The vision of New York that was reflected in cinema of that era was, euphemistically, dystopian, or perhaps more accurately, postapocalyptic. For a time, it was a style that many sought to avoid, that is, until small groups of black and brown teenagers made it the stylistic lingua franca of successive generations of American youth. Films like John Carpenter's *Escape from New York* and Walter Hill's *The Warriors* imagined a New York that was in many ways beyond civilization, perhaps taking literally the famous New York *Daily News* headline "FORD TO CITY: DROP DEAD" characterizing President Ford's refusal to spare the city from bankruptcy with federal dollars in the fiscal crisis of 1975. This imagined New York was elastic enough to support opportunistic rip-offs of films like *The Warriors;* case in point, *1990 The Bronx Warriors,* an Italian production featuring Blaxploitation-era star Fred Williamson and the actor Vic Morrow (in his final completed role before his untimely death on the set of John Landis's *Twilight Zone: The Movie*). The 1982 sci-fi *Mad Max*–inspired drama essentially combined the plots of Carpenter's and Hill's films, and managed to shoot half of its footage on location in the Bronx.[3] Even the low-budget schlock horror studio Troma Entertainment, producer of the 1984 cult classic *The Toxic Avenger,* produced a sub–Martin Scorsese–level crime drama, 1990's *Emperor of the Bronx.* (The film led with the tagline, "His Bronx cheer is a bullet in the nose," and suggested its own comparison to the director of *Goodfellas*— also released in 1990—in its promotional material, observing that *"Emperor of the Bronx* is the gritty crime story Martin Scorsese wishes he made.")[4] The threat of death was seemingly everywhere leveled squarely at dwellers of urban centers during that period, but nowhere as cleverly or as strangely as in two prime examples of this "paranoid style" of South Bronx film, namely director Daniel Petrie's 1981 film *Fort Apache, The Bronx* and Michael Wadleigh's 1981 horror film *Wolfen,* itself based on the 1978 novel *The Wolfen* by Whitley Streiber.

In the opening scene of *Fort Apache, The Bronx,* a drug-addled street hustler played by 1970s blaxploitation-era icon Pam Grier staggers across Wilkins Avenue toward the window of a parked NYPD squad car, makes sultry conversation with two patrolmen seated inside, and—without warning, remorse, or established motive—shoots both officers multiple times from point-black range.[5] The sequence of events is as stunning as it is inexplicable, though such an act would seem to prepare any viewer of

cinematic genre fare for a typical—and perhaps more temperate—police procedural to emerge from this chilling initiating event. Yet, as critic David Denby observed in his contemporaneous review of the film, the opposite was true: "The brazenness of her crime—and its utter pointlessness—sets the tone for the whole movie."[6] After committing this double murder, Grier's character climbs over a pile of rubble in the middle distance—the closest landform in a field full of bricks, trash, and other detritus—and disappears. Then, as if echoing a *National Geographic* nature documentary—or perhaps a western wilderness reminiscent of the 1948 John Ford and John Wayne *Fort Apache* that inspired the nickname Bronx cops gave to their own Forty-First Precinct station house—scavengers emerge.[7] Though here, the scavengers are distressingly human rather than animal—most are children, actually—at first peeking warily from the surrounding abandoned buildings, then swiftly stripping the dead bodies of valuables. The film's politics—indeed, the portrait that it offers of the Bronx's residents as a whole—are muddled enough here and throughout the film to suggest that any distinctions between human and animal were not ones that the film's makers were either careful or skillful enough to draw.

As opening scenes to Hollywood films starring screen legends like Paul Newman go, *Fort Apache, The Bronx*'s is quite the gruesome tableau. However, rather than simple shock at a barbarism imputed to the Bronx—and its people—that approaches the automatic, we are also left with disbelief and confusion at the aimlessness, indifference, and hollow cruelty exhibited here. This is a world for which there is not only no consequence to action, but also no motivation or desire beyond sheer, random, malevolent impulse. If the scene is meant to illustrate some fundamental illogic at play in the Bronx's urban landscape, it fails once the audience realizes that the film has little interest in exploring that illogic with its characters in any ways that manifest outside of violence, cruelty, or self-harm. The one note of consequence for students of Bronx history—which only the most careful viewer might discover in the end credits, since the character is never addressed by name, nor is the audience ever privy to her backstory or motivation—is that the film's free-floating avatar of gratuitous death, Pam Grier's prostitute, is named Charlotte.

Charlotte is also the name of the Bronx street just a short block away upon which Charlotte, the sex worker, clumsily struts on her way to committing double homicide. Charlotte, the street—like Grier's character—is never acknowledged by name in the film either, apart from the aforementioned indirect, end-credit reveal, but such elisions suggest that the film-

makers thought neither place nor person was important enough to iden-
tify. Charlotte Street, of course, is also where President Jimmy Carter
strode during his surprise visit to the South Bronx on October 5, 1977,
thereby enshrining the area as *the* symbol of urban blight in America.
What was once a vibrant neighborhood in the 1920s, 1930s, and 1940s,
well appointed with brick apartment houses with embossed tin and granite
cornices carved by some of the Italian immigrant stonemasons who lived
in many of its apartments, had become by the late 1960s and early 1970s
largely abandoned if not almost entirely disappeared. By 1977, so thor-
ough were the demolition and destruction of abandoned buildings that
Charlotte Street itself could scarcely be called a "street"—as distinct from
the empty lots of ruins surrounding it on both sides—except as a place
on a Bronx map.[8] If the South Bronx was, for a time, America's "inner
city," then Charlotte Street was its Main Street, its Broadway—the "Great
Blight Way" of a New York tabloid headline writer's dream. And, as if a
visit from a sitting president was not enough, in the mere four years be-
tween Carter's and Grier's respective walks in and around the area, Char-
lotte Street welcomed visitor after visitor, some more esteemed—and more
welcome—than others. But, as was the case with Carter's original visita-
tion, almost all were drawn there by the power of its symbolic, iconic
status as stand-in for the urban neglect and building abandonment that
then affected many other cities nationwide.

Soon after Carter's visit, Charlotte Street quickly became what the
*Washington Post* called a "backdrop de rigueur" for those who were ear-
nestly interested in understanding the problems made visible on the
morning of Carter's South Bronx sortie.[9] The *New York Times* editorial-
ized that a visit to the South Bronx was "as crucial to the understanding
of American urban life as a visit to Auschwitz is to understanding Na-
zism."[10] Mother Theresa visited the first mission established in New York
of her Missionaries of Charity order—opened in the South Bronx's Mott
Haven neighborhood in 1971—a few months after Carter's visit. The
urban planning department of Hunter College gave tours of Charlotte
Street on alternating Saturdays for eight dollars apiece.[11] It was also a ruin
luster's paradise. European tourists took chartered bus tours of the Bronx
that stopped at Charlotte Street's fields of rubble on their way to the Bronx
Zoo, unknowingly echoing Alexis de Tocqueville's mid-nineteenth-century
encounters with ruins in the state of New York.[12] (Tocqueville, both dis-
mayed and fascinated at encountering an abandoned woodland cabin on
an islet in the New World of northern New York exclaims, "Are ruins,

then, already here?")[13] A nine-member delegation from the Soviet Union "trudged around the rubble of Charlotte Street" led by Democratic New York City councilman Gilberto Gerena-Valentin, who—in a marvelous piece of political theater worthy of the dystopic mise-en-scène, and while still in the midst of the Cold War—petitioned the Soviet government for $5 billion in foreign aid "to rebuild the South Bronx." ("It seems like it was bombed," one delegate apparently whispered in Russian to another.)[14] And when the fifteen-acre area around Charlotte Street saw little improvement despite Carter's promises of federal aid, it is where Ted Kennedy and Ronald Reagan visited in March and August 1980, respectively, during their campaigns for the presidency. What gave Charlotte Street such powerful symbolic resonance was not merely that so many came to see its urban ruin for themselves but rather that such acts of witnessing—often public, and often publicized—further dramatized the area as and ready-made stage set for photography and other forms of intimate image-making, while also offering a stark and haunting arena ripe for performances both political and social, empathetic and callous.

In this chapter, we will consider how a patch of land the size of four to six city blocks briefly came to define the visual—particularly, the filmic—representation of a city to the world.[15] Despite the fact that many Americans—and many New Yorkers—might have found it difficult at the time to locate Charlotte Street anywhere on a map of the city, the images of vast fields of detritus and trash surrounded by abandoned tenements remained fixed in the minds of Americans and the world. In this way, Charlotte Street's presence in the minds of those who encountered its images managed to be, at once, spectral and yet geographically situated. Images of the site encapsulated, to those situated elsewhere, whatever ideas one had not simply about the Bronx in miniature but also about 1980s New York, and about urban America at large. Charlotte Street was, by the early 1980s, already rich with historical narrative—a potent, material metaphor that was as inscrutable as it was legible as a shorthand for urban dystopia. As much a site of layered legends and mythologies as it was filled with literal layers of a city's and a neighborhood's history, it was only a matter of time before Hollywood, too, came calling.

It might have seemed natural, in the wake of these accreted strata of history and metaphor, for the makers of Fort Apache, The Bronx to name "Charlotte" as the film's embodied harbinger of doom. Indeed, the very fact that the nickname for the Forty-First Precinct that gave the title to Petrie's 1981 film is likely derived from the 1948 movie that both lionizes

and punctures some of the myths of the American West is further testament to how history and mythology are inextricably intertwined at various sites throughout the South Bronx. And whether made casually or intentionally, the decision to locate the savagery and chaos illustrated by Grier's character within a black female body is representative of how the film portrays the black and Latinx populations of the South Bronx as a whole. Such portrayals, which ranged from indifferent to irresponsible, sparked historic protest against the film from these communities, both in the Bronx and beyond. In this way, and in that opening scene, the audience is meant to understand "Charlotte" at once as the pointedly raced, barbarous, and characteristic product of her environment, *and* as the murderous, phantasmal personification of that environment—as if Charlotte Street itself reached out a hand to pull the trigger.

As it was on the morning that Jimmy Carter trod upon its abandoned, empty building lots where crowded, thriving apartments once stood, Charlotte Street was—as the Brooklyn Bridge was to Alan Trachtenberg's classic interdisciplinary historical work—both "fact and symbol" of American urban ruin. And as both *Fort Apache, The Bronx* and *Wolfen* demonstrate, Charlotte Street remained both a place—not simply New York City brought low in the eyes of the nation, but the emblem of the South Bronx, a name that by the early 1980s rang out far beyond the city limits—and an idea that transcended those city limits via networks of visual representation. But this image of urban desolation was integral to, indeed, inextricable from, its power as an idea. Charlotte Street served as a stereotypical signifier whose eeriness was derived from its seeming emptiness, a vacuum that could be invested with alternate possibilities and, often, divergent politics: paranoia by some, or the presence of a racialized threat by others. From whatever perspective such images constituted, as Trachtenberg writes of representations of the Brooklyn Bridge, "a vehicle for the emotions—rather powerful emotions—concerning the city and modern civilization."[16] Charlotte Street embodied the physical manifestations of catastrophic disinvestment, governmental neglect, and building abandonment, forces that were then reshaping urban America for generations to come. But as these two filmic representations show, Charlotte Street was also so potent a vehicle for the imagination—familiar yet foreign to a viewing public dumbfounded by the scale of the destruction—that realistic, graphic representation was inadequate to express the full spectrum of the site's symbolic resonance in film, in courts of law, and throughout many realms of culture. Herein, we discover how werewolves

and wayward, drugged-up hustlers with bloodthirsty hearts became filmic avatars of the South Bronx.

## Welcome to the Jungle: The South Bronx Strikes Back

For a film that drew such organized and vehement protest from Puerto Rican and African American audiences for its portrayals of Bronx residents that its producers felt compelled to insert an apologetic title card before its opening credits, it seems unnecessary and perhaps even cruel to observe that *Fort Apache, The Bronx* strikes discordant thematic chords with even the first few notes of its score. Written by Jonathan Tunick, the prolific composer, musical director, and arranger of many of Stephen Sondheim's most acclaimed shows, the film's opening cue is a useful distillation of the broader disjuncture between how the film purports to treat its subject and its setting, and how the film actually understands them. That is, the film imagines itself as looking at the Bronx with a frank, unflinching eye, when most evidence suggests that that same eye has objectified all it has seen.

Tunick's number fades in as the camera pans left in a long shot over the low tenements of the Bronx with Manhattan off in the hazy background. A smooth bassline groove strolls beneath syncopated conga drum claps and the synthesizing rasps of a guiro. One might read these as apt and clever musical themes that acknowledge both the Afro-Latinx and African American background and musical cultures of many South Bronx residents.[17] What's more, such a muscular groove would hardly seem out of place in a *policier*—exactly the type of genre fare that *Fort Apache, The Bronx* imagined itself to be—and the litheness of the bassline would not have been out of place in any Pam Grier grindhouse classic of the previous decade. However, whatever goodwill is earned by Tunick's composition is extinguished by the faintly orientalist clarinet melody that intrudes upon the scene, which suggests a stereotyped South Asian "snake charmer" ditty more than it does the South Bronx. Notwithstanding even this unfortunate, and perhaps unwitting, conflation of disparate cultural signifiers into a kind of musical Global South, the "othering" effect that this overlaid melody has upon the composition itself is startling: what was, before, a lissome combination of conga, guiro, and bassline is transformed into a ghastly musical masquerade in which each individual instrument becomes conspicuous for its simple connotation of "alien" rather than sounding a mellifluous whole. Rather, we are made to assume by the accompanying music that the physical space that we as an audience are

entering—announced by the seemingly scrawled-by-hand onscreen title
text reading, "FORT APACHE THE BRONX"—is one that is simulta-
neously an urban "jungle" in all of the xenophobic senses of the word,
and also *not* many things: not welcoming of outsiders, not predomi-
nantly white, and not, to certain Americans, an America they are wont
to recognize.

Genre fare like *Fort Apache, The Bronx* might at least offer, in its ideal
form, a lean, sharp script that is strongly plotted, with a moral or ethical
quandary for its central character to overcome, and a sense of place that
doesn't just set the film's mood but becomes a crucial character all its own.
With Charlotte Street and the rest of the South Bronx as a shooting loca-
tion, the film had such an evocative setting, yet the its opening scene fea-
turing Pam Grier's brazen cop-killing hustler is, case in point, how to
squander that opportunity. From there, the film's plot departs in multiple
directions, resulting in drastic shifts of tone that demonstrate only how
little the film's makers understood the social situation within which they
chose to set their film. The film's press kit does its best to frame the nar-
rative in familiar terms, selling the film on the basis of its star, Paul
Newman, who

> plays a cop—but he's still the nonconformist of his great early screen roles.
> The actor gives one of his most commanding performances as Murphy, a
> veteran police officer who faces a crisis of conscience that pits him against
> his colleagues and endangers his career. Nicknamed Fort Apache, the 41st po-
> lice precinct in New York City's South Bronx is an embattled outpost in a
> violent and devastated 40-block area which has the city's highest crime rate.[18]

The setting is made secondary to the film's star, and yet is still illustrative
of the filmmakers' cardinal (but certainly not final) sin: accepting the
premise of the dubious nickname given to the real-life precinct by the
NYPD officers who worked there as a basis for their narrative. In this
way, and despite the filmmakers' many avowals of their liberal bona fides
and best intentions, the implicit opposition between "civilization" and
"savage"—which John Ford's original film managed to blur—would, here,
prove impossible to overcome.

But try, it did, to overcome such a problematic trope, while employing
many other well-worn tropes along the way:

> Paul Newman's Patrolman Murphy is an 18-year veteran of the precinct,
> twice busted from sergeant. Although willing to use force when necessary,
> Murphy is known as a humane man whose sharp sense of humor and

understanding of the community's problems have helped to defuse many potential explosive situations. . . . Danny Aiello is Morgan, a tired cop who's spent too many long years in the violent streets surrounding Fort Apache. Rachel Ticotin is Murphy's girlfriend, a Puerto Rican [nurse] treating others but filled with too much pain of her own. Pam Grier is a prostitute whose drug addiction leads to her tragic degeneration. The harsh realities of the South Bronx draw the cops who work there and the men and women who live there into a common battle for survival.[19]

Even despite the phalanx of stock characters assembled here, pulpy *policiers* such as this have operated, and succeeded, with less. But given how the balance of the plot is given over entirely to the film's white characters and their negotiation of the difficult conditions of the South Bronx— to say absolutely nothing of the portrait painted of the film's nonwhite characters, who are depicted as causing, rather than suffering from, most of those conditions—such limited focus demonstrates how muddled and misdirected any messages that the filmmakers cared to make about the Bronx would be from the outset. The press kit's summary continues:

> A series of murders, including those of two 41st precinct officers, has put the men of Fort Apache on edge. These murders, and the overly-casual operation of the precinct, arouse the ire of the newly-appointed commander, Captain Connolly (Edward Asner). His determination to find the killer, straighten out his men and somehow control the community outside the doors of the fort brings him into conflict with Murphy (Paul Newman), a laconic cop who doubts that Connolly's rigid methods will produce results. Murphy's bittersweet relationship with a young Puerto Rican nurse (Rachel Ticotin) is a needed relief from the petty thieves, junkies, prostitutes, and crazies he and his patrol car partner Corelli (Ken Wahl) must deal with each day. When Murphy sees a fellow officer deliberately kill an innocent Puerto Rican boy during a street riot, he faces a moral crisis—one that forces him to judge his own code of ethics, his effectiveness as a cop and his worth as a human being.[20]

Again, as a premise to a police procedural, this may seem a bit hackneyed, and the portraits drawn of Rachel Ticotin's nurse character and the neighborhood "crazies" don't seem at all generous, but it's certainly not the worst story treatment one can imagine. However, given the fact that the film takes pains in its promotional material to wear its interest in social issues as a badge on its sleeve—partly in response to the community protests that its script would later engender—the fact that it centers its narrative upon Newman's Irish-American-cop-as-white-savior to a black and Latinx neighborhood that the rest of the film itself illustrates

has good reason for distrusting the police is, perhaps, not the most co-herent way to achieve the filmmakers' stated goal of "call[ing] attention to the problem of urban blight."[21] But what compounds these errors is the filmmakers' decision to locate the film within the particular space and place of the South Bronx—and, importantly, not a South Bronx of near science fiction, as some later films would imagine it—as opposed to some-where, almost anywhere, else.

Employing the geographic specificity of the South Bronx as a central feature of the production called for an awareness and an empathetic intelligence that the filmmakers were not willing or able to offer. Had they dreamed up a fictional city with all of the same challenges as the South Bronx—a "South Gotham," perhaps, or even a "South Central Metropolis"—there might have been less expectation upon the production to do right by its adopted setting and, more important, the communities that called that setting home. But rather than do this, the filmmakers maintained that their portrayal of the Bronx was sincere and accurate, and even articulated a social mission that underlay the film which, as the protests attest to, did not bear itself out in its final form: "We're hoping that by showing the conditions of the South Bronx as they actually exist," Newman said in the film's press kit, "audiences will be shocked and demand action to have these conditions improved. We hope the film will be the positive catalyst needed to start a nation-wide effort to rebuild the inner cities and better the lives of their inhabitants."[22] Though Newman and the film's producers may have believed that they showed the Bronx, "as [it] actually exist[ed]," the film revealed that, as the *Wall Street Journal* observed, its makers "brought their cameras to the South Bronx without knowing what they wanted to say."[23] And what they did end up saying was, to many, better left unsaid.

After all, this is the kind of film where the sole positively portrayed Puerto Rican character, Rachel Ticotin's nurse (also Newman's love in-terest), is purposefully sold a "hot bag" of uncut heroin by two Puerto Rican drug dealers (one of whom is played by playwright, actor, and co-founder of the Nuyorican Poets Café, Miguel Piñero). After injecting some of its contents, she overdoses, alone, on the street, only to die in the very hospital in which she works. It's the kind of film that plays for laughs a suicidal trans woman calling for talk show host Tom Snyder while threat-ening to jump off a roof, using the same scene to set up Newman's char-acter and his partner (Ken Wahl)—who save the jumper—as benevolent cops who understand an otherwise unknowable community, even when

their bosses don't. (That unknowability carried with it a deep irony to some audiences because, of course, such a community could certainly be better known if the local police spoke Spanish, which none in the film attempt to do.) It's the kind of film where those bosses cast the police's relationship to their community in the starkest terms: "This isn't a police station. It's a fort in hostile territory, you understand?" And it's the kind of film where even Newman's beleaguered "nonconformist" cop turns in his badge near the end, suggesting that even he can't help "these people" anymore, noting, "I feel as burned-out as those buildings down on Charlotte Street."

Critics noted such shortcomings of imagination upon the film's release, but these were not the only grounds on which *Fort Apache, The Bronx* was found wanting. David Denby, demonstrating his own familiarity with the iconicity of the South Bronx's landscape in 1981, observed that director Daniel Petrie, "working in one of the most frightening urban landscapes in the world, fails to produce a single memorable image."[24] (It is somewhat ironic, in light of Denby's criticism, that Petrie's director of photography was director Stanley Kubrick's favored DP John Alcott, who had won an Academy Award for cinematography for 1975's gloriously painterly *Barry Lyndon,* and worked with Kubrick—who grew up and went to high school in the Bronx of the 1940s—on *2001: A Space Odyssey, A Clockwork Orange,* and *The Shining.*) Critic Joy Gould Boyum was particularly sensitive to the tonally haphazard, somewhat random and brutal series of events that make up the film's plot:

> The film has the feel of a whole season's TV series compressed into a two-hour slot. Everything is interrupted, rarely resumed and never ever completely resolved. What is potentially of considerable significance is given equal weight and stress with that which is trifling. Such a sweeping vision almost by its very nature ends up as shallow, never revealing causes (deprivation, neglect, racism) but focusing only on effects (muggings, murder and mayhem). And effects, of course, are precisely what bigots never see beyond.[25]

Besides the fact that the film seems to understand the Bronx already as a lost cause, and its people beyond saving, it is the very structure of the film that enforces a trivialization of even that limited understanding. And it is emblematic of the distractingly confused politics of the film that systematic societal ills are made opaque in the film's vision, while the manifestations of those ills—those that are more easily tallied on a criminal record or in police statistics—initiate and inspire the action. Such mis-

leading and muddled politics were to be expected, however: *Fort Apache, The Bronx* merely replicated, on-screen, the attitudes of many of the politicians and much of the American populace who looked upon the Bronx from afar. It is, and has always been, easier to see crime, drug use, and civic unrest in American cities—not just the Bronx—as characteristic of and endemic to those places and the people who occupy them than it is to understand such problems as the aftereffects of the broad systematic causes that produce them.

If Charlotte Street was the literal ground upon which liberals and conservatives met—exemplified by Jimmy Carter's and Ronald Reagan's well-documented visits—then it was also the place where liberal and conservative policies and points of view crossed paths and became summarily jumbled, in some cases beyond comprehension. (Of course Carter, as an evangelical liberal who, in visiting Charlotte Street, symbolically accepted the erosion of the New Deal order, was already transforming liberalism in ways large and small. And Reagan's brand of conservatism was, already at the time of his own Charlotte Street visit, more apocalyptic than classic.)

On April 7, 1980, Paul Newman stood on a rocky outcropping in an empty lot in the South Bronx, the by-now-familiar dramatic backdrop of abandoned buildings behind him, surrounded by reporters who (according to journalist Richard Goldstein of the *Village Voice*) had been bused in by the film's producers, and addressed charges that his film was little more than a racist exploitation of Puerto Ricans, African Americans, and the South Bronx at large.[26] "I've lived here, I've talked to these people," Newman asserted, having interrupted a day of filming for this impromptu press conference with a makeup bruise still painted on his brow. "I was in Alabama long before Bill Kunstler was in Chicago."[27] In one fell swoop, Newman invoked both his liberal bona fides and the name of attorney, civil rights activist, and famed defender of the Chicago Seven in 1969–1970, William Kunstler.

A little over a week before Newman's rubble-side chat, the Committee Against Fort Apache (CAFA)—a loose coalition of ten minority groups— had filed a libel action claiming that the film portrays South Bronx residents "totally as outcasts," according to José Rivera, a member of the committee, and their place of residence as a hopeless urban jungle.[28] The group had engaged Kunstler as their lead counsel for the lawsuit, which accused the filmmakers of providing "ideological justification for the neglect of the South Bronx by the rest of society" and encouraging "police violence and judicial inequality toward the plaintiffs and the classes

they represent." The terms of the suit promised a billion dollars in damages if *Fort Apache, The Bronx* was released against the wishes of the community.[29]

Newman, for his part, was upset. Copies of the *Fort Apache, The Bronx* screenplay had been shared with various community groups already wary about the kind of portrayal they were in for, having been aware of Tom Walker's 1972 memoir, which also had "Fort Apache" in its title. Newman was dismayed at how the script had been interpreted by those groups and by the press in particular, which he claimed had misrepresented the script to the public. "It is not a racist picture. It is tough on Puerto Ricans, blacks, and the neighborhood," Newman said, echoing much of what would later be a part of the publicity push for the film, "but the two villains are Irish cops who throw a Puerto Rican off of a roof."[30] For Newman, in order to make a "realistic" film about the Bronx, the film could not feature "Puerto Rican doctors and bankers" because the film was about the police, who dealt with crime in the streets, and the figures in the film were involved with that. He went on to observe that there was neither a hospital nor a high school in the Forty-First Precinct and seemed to suggest that those opposing the film might better occupy their time protesting on behalf of these issues.[31] "They're the whores," Newman said of the protesters to the *Los Angeles Times* in February 1981, closer to the movie's premiere. "Maybe they're looking for a political base, or to call attention to themselves in the community."[32]

Such impolitic language from Newman, not merely a self-professed liberal but a lifelong Democrat with a documented history of political activism, might seem out of character for someone who later was the chief investor in purchasing the progressive left-wing publication the *Nation* in 1995 (Newman had, after all, landed proudly on Richard Nixon's "enemies list" when it was discovered in 1973). Depending on one's point of view, it was either ironic or tragic that Carter's fact-finding-cum-photo-opportunistic visit to the South Bronx to witness Charlotte Street's ruin firsthand would be followed only three years later by Newman's own vacant-lot press conference, which seemed to serve a purpose almost antithetical to Carter's: to defend Newman's right to "tell it like it is," even if that telling was to Bronx residents themselves. But Newman was hardly the lone liberal taking this curious position. David Susskind and Daniel Petrie, producer and director, respectively, of *Fort Apache, The Bronx*— as well as the filmic adaptation of Lorraine Hansberry's 1959 play, *A Raisin in the Sun*—also had what passed for impeccable liberal bona fides

in Hollywood and were similarly astonished as Newman was that they, as "good" liberals, were being singled out for accusations of cultural insensitivity by community protests. ("My entire public and private life has been concerned with man's inhumanity to man," wrote Susskind in his brief answering the CAFA lawsuit.)[33] As a 1981 review of *Fort Apache, The Bronx* in Los Angeles's short-lived *KIIS The Newspaper* noted, the film was proof of "how hard it [was] these days to tell liberals from conservatives."[34] How is it that these supposed bastions of radical progressivism could be so tone-deaf in defending what amounted to reactionary portrayals of the Bronx and its communities, or in even understanding why they might be perceived as problematic in the first place? How, then, do those radical progressives find it so easy to claim victimhood from victims of oppression—that, from their perspective, it is rather the newfound sensitivities of minority groups that threaten the free artistic expression and freedom of speech of screenwriters and filmmakers to create as they wish?

Goldstein attributes the reactionary turn exemplified by films like *Fort Apache, The Bronx,* in part, to what amounts to a kind of proto-Reaganism, a growing sense among what he calls "disenchanted liberals" that "only a charismatic cop"—or actor, present or former, for that matter—could save America, and particularly its urban centers, from crime and municipal decay.[35] (Implicit in that sentiment was the notion that saving America might also require saving it *from* urban centers like the Bronx.) In *Fort Apache, The Bronx,* this takes the form of the familiar "white savior" trope, where only Newman's beaten-down, though principled, realist cop can navigate the moral morass of the South Bronx. "This myth," Goldstein writes, "used to be the personal property of men like John Wayne"—whose Kirby York character Newman updates in the 1980s version of *Fort Apache*—"but now that the Duke is gone, Paul Newman, who once deemed himself soulful enough for Tennessee Williams, looks strong enough for John Ford."[36] It is a peculiar version of the idea of the political or military strongman, to be sure—Newman is hardly Charles Bronson's murderous urban vigilante from the *Death Wish* series of films—but Goldstein offers a deeper reading of the particular feeling of liberal disenchantment that may lurk behind such films as *Fort Apache, The Bronx:* that of white male liberals toward the minorities they once championed. "As a group," Goldstein writes, "these men perceive ingratitude on the part of blacks, women, and gays; and feel threatened by the growth of minority chauvinism. . . . Suddenly, it's sissy stuff to hide your bloodlust and your bigotry. Suddenly it's clear that the job these assholes

are after is yours."[37] *Fort Apache, The Bronx* was released into a world that had already heard Reagan's campaign sloganeering to "Let's make America great again"—an idea that, to critic Carrie Rickey, only meant "Let's stop feeling guilty about racism, let's get the white power elite confident again."[38] One certainly hears echoes of this disappointment—or even shock—at how those to whom Newman had imagined his film might help bring national attention had the audacity to claim their own agency in how they were to be portrayed. In the years before debates about "political correctness" erupted from academia out into the larger cultural conversation in the late 1980s and the 1990s, one can see strains of some of the political—and personal—animus that informed those debates in the discourse about *Fort Apache, The Bronx,* except here it is self-professed liberals, rather than conservatives, employing the idea that the increasingly more vocal "sensitivities" of minority groups were an impediment to freedoms of speech and expression.

What Goldstein and Rickey describe here are two distinct, though related, forms of paranoia. The latter form, as articulated by Rickey, is perhaps more familiar to modern eyes: paranoia born out of a nativist sentiment that capitalizes on a feeling of dispossession, and a sense that somehow, somewhere, some inchoate American qualities have been eroded or lost. These inchoate qualities are, more often than not, quite easily definable, and most of them have to do with whiteness and one's proximity to or distance from it. The former style of paranoia is more slippery in the sense that it, too, has nativism at its core, but it is a particular brand of nativism that has been produced via a proximity to peoples and cultures that can demonstrate historical and systemic dispossession and oppression, and emerges *only after* having helped, in some way, address those systemic and historical issues.[39] As Goldstein would have it, after having spent the 1960s advocating on behalf of the civil rights movement and other minority groups, by the 1980s, for the makers of *Fort Apache, The Bronx,* the natives, as it were, were getting not only a bit *too* restless but also ungrateful.

Such confused political sentiments on the part of those producing cultural artifacts weren't specific to those involved with *Fort Apache, The Bronx,* nor were various community responses to art and entertainment that was ostensibly meant to represent those communities in this era. Rather, the response to 1981's *Fort Apache* emerged during a period in which minority communities increasingly made their voices heard in speaking back to what they saw as insensitive, demeaning, or stereotypical

portrayals of them in the media. A few days after Paul Newman stood near rubble-strewn Charlotte Street to speak in defense of his film, the Chinese American community in San Francisco protested the filming of *Charlie Chan and the Curse of the Dragon Queen* on the eve of the commencement of location shooting in Chinatown. Eliza Chan, a representative of the group Chinese for Affirmative Action, observed that the Chan character, played by British actor Peter Ustinov, "belittle[d]" Asians by "reciting fortune cookie inserts" in "chop suey English," referring to the screenplay's notation that many characters would communicate in pidgin English.[40] And perhaps most famously, in the summer of the previous year, queer organizations protested the William Friedkin–directed Al Pacino vehicle *Cruising,* in which the actor portrays an undercover policeman investigating a serial killer of gay men, set in the subculture of New York City's waterfront leather bars. The shooting of the film was consistently disrupted, rallies were organized, boycotts discussed, all culminating in a midsummer's march and sit-in on Greenwich Village's Sheridan Square. Along with these notable uprisings, the protests against *Fort Apache, The Bronx* were at the forefront of demanding fair representation in film and other media—especially in Hollywood, which, as the *Washington Post* observed, since the days of D. W. Griffith, had projected "powerfully stereotyped majority perceptions of immigrants, blacks, Hispanics, Jews, and other humans in the American Melting Pot."[41]

Such newfound power on the part of underrepresented communities— to speak back to the tired tropes and stereotypes that had been perpetuated in film and the media for years—was often met with derision or dismissal in the public sphere. A 1971 *Time* article deemed the decade "The Age of Touchiness" and, in doing so, presented a playbook of talking points (now almost as well worn as the stereotypes they argue are wholly inoffensive) for how "feeling oppressed" has become a "national sport" and how "touchy minorities" and their hypersensitivity and propensity to overreaction have, seemingly, taken away whatever fun existed in essentializing people by race, religion, or sexual preference.[42] This relatively early salvo in the then-still-to-come culture wars over "political correctness" was echoed throughout conservative outlets in the press, and there was much hand-wringing—regarding *Fort Apache* and other films—over Hollywood's formerly silenced subjects of color, creed, or ethnicity increasingly having a say in how their image was to be perpetuated on-screen and elsewhere. The CAFA was instrumental in navigating this contested media landscape, and the group established a long-lasting framework for

building and sustaining organized protests through the electronic and print media that remains a model for such efforts even today.

The producers of *Fort Apache* may have thought that they were simply making an "honest" picture that was "tough" on many different communities. Among the many things that they underestimated was exactly how "tough" life was for residents of the place they chose to film. The *Fort Apache* production walked into a South Bronx whose residents had very little trust in the police force that was ostensibly there to protect them, due to a spate of incidents of police brutality involving black and Latinx members of the community in the months before filming began. And despite the fact that Time-Life's financiers and producers invested a great deal of resources in public relations in local New York publications to help grease the wheels of production—going so far as to hire "super flack" publicist Bobby Zarem, who was responsible for the "I Love New York" campaign—they were met almost at every step by the vastly underfunded but committed forces of the CAFA. Though the CAFA was not able to alter the *Fort Apache* script in the ways that it had hoped, or prevent the release of the film, the group was enormously successful in terms of drawing national attention to its cause. Sizable demonstrations and protests forced one New York theater to close the movie, and the film's opening was delayed in Philadelphia and Jersey City. Locals also protested the opening of the film in Hollywood, Miami, Boston, Albuquerque, and Rochester.

Among the many points on the protest platform—as articulated by longtime community activist Richie Perez—the CAFA organizers and protesters realized three goals in particular that would have the most lasting effects on representations of communities of color in the future: (1) to "educate the community about the effects of media stereotyping and show the links to the overall situation we face, the deterioration of our living conditions, and the rise of racism and police brutality"; (2) to "build higher levels of unity between the Puerto Rican and black communities through common struggle"; and (3) to "develop our communities' ability to use the media."[43] Kunstler, who had brought suit for libel against Time-Life Films on behalf of the CAFA—which was later dismissed—articulated its plan:

> The point is that you have to use the courts anyway you can. Maybe we didn't get the script changes, and we haven't stopped the movie. But look at what we did get. Eight stories in the *New York Post*, seven stories in the *New York Times*, four stories in the *Village Voice*, and a lot of TV and radio time.[44]

Put on the defensive, Time-Life Films went so far as to have phony "pro–Fort Apache" counterprotesters appear at the State Supreme Court in downtown Manhattan carrying signs with messages such as "*Fort Apache* brings awareness of South Bronx conditions for government funding" and "Don't mix our people's progress with communist political advancement." The "protesters" were students from Alfred E. Smith High School in the Bronx who apparently were to be paid for their appearance, but when they arrived at Foley Square, there was no one there to do so, so they attempted to find the publicist Zarem—who denied hiring them to the press—for their fair share. That Time-Life allegedly went to such lengths to discredit the CAFA protesters is a testament to their efficacy.[45] The CAFA's argument was poignantly summed up in one of its own press releases: "We oppose this film in the name of our parents. They built our communities. *Fort Apache* says they built *nothing* except a garbage dump, a zoo full of wild maniacs."[46] Their work demonstrated not only that the producers of *Fort Apache, The Bronx* did not know what they were getting into when they chose to put this film into production, on location in the Bronx but that, as Perez notes, the CAFA was both prescient and responsive to a time in American politics where—as we have seen—it seemed as if many American liberals, in either word or deed, were "embracing the solutions of the reactionary Right" and increasingly using places like the Bronx as "scapegoats for the nation's economic and social failures."[47]

In truth, it was not surprising that by the early 1980s, self-described liberals fell into reactionary, Reaganite conceptions of urban ruin like *Fort Apache, The Bronx*. The film upon which the reimagined *Fort Apache* was based—Ford's original—featured John Wayne, an actor after whom the recently elected Reagan imagined himself. It was, after all, Reagan's political recasting of the South Bronx and all places like it as unworthy of governmental care or aid that characterized the erosion of the New Deal order and of post-Civil Rights liberalism in this era. What was, however, surprising about this loose genealogy of *Fort Apache* films and memoirs was not merely that Ford's 1948 version is the more powerfully imaginative and richly complex rendering of history, ideology, and myth, but also that there existed still yet another, unrealized retelling of this tale that, in its own way, captured many of the essential ironies of the period and of the players involved.

## The *Fort Apache* That Wasn't: Ring Lardner Jr.
## and the Road Not Taken

*Fort Apache, The Bronx* was purported to be "suggested by the real-life experiences of former New York City police officers Tom Mulhearn and Pete Tessitore," who were themselves assigned to the Forty-First Precinct from 1964 to 1968. As screenwriter Heywood Gould tells it, an agent approached him to write the script based on Mulhearn's and Tessitore's recollections at some point in the early 1970s. He wrote the first draft of the movie in 1973 and sold it for $1,250. But it wasn't until around 1978 that producer David Susskind, who had read the script back in 1973 and liked it, finally had the financing to make the film.[48] But just as Mulhearn and Tessitore weren't the only cops assigned to the Forty-First Precinct, they also were not the only policemen with a desire to tell their tale to a wider audience. Tom Walker served as commander of the "Four-one" from May 1971 until August 1972. Based on his experiences, he wrote a memoir, published in 1976, entitled *Fort Apache: Life and Death in New York City's Most Violent Precinct*. Despite the similar titles, Walker's book was not acknowledged by the filmmakers as having inspired their work. (Walker would later sue Petrie, Gould, and the makers of *Fort Apache, The Bronx* for copyright infringement, among other allegations, and it would prove to be a lawsuit that would have great import, both to the reception of the film and to legal precedent.) That memoir was, however, the basis for a script for what was likely a made-for-television, feature-length version of "Fort Apache" (which never made it to production) written by the journalist and screenwriter Ring Lardner Jr.—who was, apart from being the son of the well-known journalist and humorist, most famous for being blacklisted by the Hollywood film studios for refusing to answer the questions of the House Un-American Activities Committee (HUAC) during the "Red Scare" of the 1940s and 1950s.[49]

Lardner's outline (and accompanying script), dates to 1976—soon after the release of Walker's memoir—and hews close to its source, depicting in its opening pages the arrival of the "Tom Walker" character to his new command at the "Fort Apache" precinct.[50] To summarize Lardner's detailed story outline in broad strokes, Walker's character learns of his promotion to lieutenant and his assignment to the Forty-First Precinct early on, and from his arrival to the Bronx and the precinct itself, the audience witnesses his first day on the job: from learning from his captain that his two functions ought to be to "guard the fort and keep the natives on the

216

reservation," to dealing with an attack on the precinct by the local citizens in response to an incident of police brutality that injured a young boy, to finally witnessing a Bronx tenement being consumed by flames due to an act of arson. Petrie's *Fort Apache, The Bronx* featured just as many narrative threads as does Lardner's script—some followed to completion, others left hanging—and, as Boyum keenly observed in her review, it merely had a two-hour run time in which to do so and suffered because of that narrative crowding. The result is as confusing as it is trivializing and dangerously reductive: such simplistic and stereotyped renderings can only reinforce prejudice and other harmful preconceptions.[51]

Despite the fact that Lardner's televisual script (in whatever form it eventually took) was never realized, it is worth meditating on as a point of comparison to the finished, filmic product from the screenwriter Gould and director Petrie. It's clear from Lardner's notes and papers regarding his proposed "Fort Apache" TV film that he set out not merely to adapt Tom Walker's book for the screen but also to more fully explore the relationship between the Forty-First Precinct's deeply problematic nickname and the 1948 John Ford original, *Fort Apache*. In truth, neither Walker's book, nor Lardner's script, nor Petrie's film makes explicit reference to Ford's film; for them, the name already existed as a displaced signifier, having been bestowed upon the precinct by some of the police officers who worked there at some point in the late 1960s. But even before Walker's book, the name had achieved some notoriety on a March 4, 1973, airing of NBC's half-hour newsmagazine show *NY Illustrated,* entitled "Saturday Night at Fort Apache," which chronicled a cinema verité–styled evening at the Forty-First Precinct. The voice-over introduction to the program establishes that despite police officials' attempts to discourage it, the officers who worked there persisted in using the name "because it expresses their sense that they are surrounded by violence."[52] "Fort Apache" was then, as it remains even today, a metaphor for a place of shelter amid hostile action, but it is a metaphor that both was—and is—explicitly raced.[53]

Whether the officers who popularized the "Fort Apache" name for their precinct were fans of Ford's film, we might never know for sure, but certainly the layered mythologies that are examined in the film (of the American West, of heroism, and of outdated notions about civilization and savagery) are also present in the nickname, even if it was used as a mere signifier of a brand of siege mentality—an updated "us versus them" for the twentieth-century city.[54] The Bronx's "Fort Apache," like many racial epithets, is almost admirable for its display of a grammarian's

economy of intolerance: with but a colorful, pop culture–inflected phrase, wielders of the name could disparagingly refer to whole populations of people without calling them out by name and, in doing so, signal a desired difference from those people who, in comparison to them, were primitive, inherently vicious, or beyond hope. Ironically, as one of the first "pro-Indian" westerns, Ford's *Fort Apache* offers a respectful portrait of Native American populations, as well as immense complexity with each successive viewing—the kind of depth and sensitivity that is lacking both in Petrie and Gould's Bronx-centric version and certainly in the reductive coining of a nickname that imagines a predominantly white police force as American soldiers occupying a fort in territory peopled by communities of color.[55] Lardner's unrealized script is by no means as richly shaded in grays as is Ford's film, but the evidence of his grappling with the existence of the 1948 original in the construction of his adaptation of Walker's memoir demonstrates his attempt to reckon, albeit imperfectly, with the conflicted and often critical portrait of American expansionism offered by *Fort Apache*. In truth, though it may have directly or indirectly inspired the station house's nickname, Ford's *Fort Apache* was terrible source material for literary or filmic adaptation to the situation in the Bronx, precisely because it undermined typical notions of heroism: if anything, representatives of the US government were the true savages, as Ford would have it. Leaving aside, then, the fact that it made poor sense to take at face value the equation of police as American army, and Bronx residents as hostile oppositional force, some of Lardner's script notes are instructive:

> The police (army) consider themselves to be the law in a primitive stretch of territory, preventing insurrection . . . maintaining civil order and dispensing rough justice. . . . The populace (Indians) see the territory as thinly occupied by a foreign invader whose very uniform is a symbol of oppression. . . . The fort is the symbol and the practical stronghold of the invader—hence, the ultimate target of the resistance. . . . The only significant departure from the *Fort Apache* parallel is the great number of assaults and depredations against the native population itself by natives. It is they who suffer not only in the everyday crime wave, but also in destruction from pitched battles. . . . Police have little understanding or sympathy with the inhabitants. Inhabitants regard police as the main enemy—except where a temporary aim is to be served by using them against a temporary, lesser enemy.[56]

In Ford's *Fort Apache,* the most important conflict in the film is not the one that takes place between the US Army and the Apache warriors but rather, as critic Dave Kehr observes, an internal—and philosophical—

conflict within the community that is formed at the military outpost it-self. Henry Fonda plays Lt. Col. Owen Thursday, a racist, all-too-rigid, West Point–educated officer sent out West to command Fort Apache, where he displays nothing but contempt toward the Apache, whom he sees as "breech-clad savages." John Wayne plays Capt. Kirby York, a com-paratively enlightened westerner who understands the landscape and has more respect for its people. This same dynamic finds its way into both Lardner's television script and *Fort Apache, The Bronx,* as Newman's "nonconformist" cop fulfills the Wayne character arc, and Ed Asner's dra-conian commander is meant to evoke Fonda's stubborn Owen Thursday. However, it's significant how in *Fort Apache, The Bronx,* this interper-sonal and political conflict is but one of countless threads that are estab-lished, dropped, picked up, and lost amid the din of so many competing and ultimately confusing plotlines that leave the viewer to assume that the Bronx itself—much like any satisfying resolution to the film—is a lost cause. Though Lardner's first draft of the script is by no means enlight-ened when it comes to portraying the "native" populations of the Bronx, his script notes betray that his understanding of the way that the local police could be perceived as a "foreign invader" or even as the "main enemy"—largely due to their lack of "understanding or empathy with the inhabitants"—was slightly more sophisticated in theory than Petrie and Gould's film, if not always in practice.[57]

In fact, there is evidence that Lardner's script received copious produc-tion notes from development executives who demanded better represen-tation and portrayal of the black and Latinx characters in the proposed show. Upon reading Lardner's draft, Malcolm Stuart, the vice president of program development for Charles Fried Productions (which was de-veloping the project), saw the need to "relieve in some small way the other-wise completely bleak picture of a mass of people wildly striking out," suggesting that his script painted just as ungenerous a portrait of the Bronx population as Petrie and Gould's realized project would. Stuart advised Lardner, "It should be clear that they are not all simply ripping-off each other, hurting each other, and attacking the Fort," in an attempt to draw a more balanced portrayal of such populations, but other notes reeked of a lingering paternalism and condescension: "Let at least one of the natives be a somewhat articulate spokesman for the oppressed group. Through him we will learn more about the natives, and indeed he may represent some slight hope for eventual improvement." Subsequent memos to Lardner from Stuart also took issue with the episodic nature of the script, decrying

the lack of emergence of a central story that the audience must care about "at the heart of the piece (and also at the heart of Tom [Walker's memoir])," thus echoing Joy Gould Boyum's later criticisms of Petrie and Gould's film.[58] But Stuart's notes on the problems of Lardner's script signal the deeper issues at play in adapting Walker's memoir for the screen, and—more broadly—in crafting fictions about a place like Charlotte Street or the South Bronx at all.

These deeper issues are perhaps seen most clearly by examining one of the tales told, many likely apocryphal, about how the Forty-First Precinct got the name "Fort Apache." As Walker tells it (on the dust jacket and in the prologue of his book):

> Late one night, a mob, angered by the arrest of a black man accused of killing a junkie, attacked the Forty-first Precinct station house on Simpson Street in the South Bronx. As bricks crashed through the windows and the crowd started to break down the barricaded door, a voice on the lieutenant's neglected telephone could be heard crying, "Hello, hello?" A volley was fired over the heads of the mob and they began to retreat. "This is headquarters," yelled the voice on the phone. "What the hell is going on there?" The lieutenant screamed back, "What the hell do you think is going on? This is Fort Apache and we're under attack." Fort Apache—the name stuck.[59]

In the first chapter of his memoir, Walker rounds out this anecdote in greater detail. He reflects upon how the officers at the Forty-First Precinct looked at their jobs in light of their understanding of their surrounding environment, noting that such men considered the assignment a kind of exile or punishment:

> The Department has never fully understood what the Four-one does to a man, and the men knew this. It was this knowledge that drew them closer together. Their isolation gave them a special identity and sense of pride. That, I learned, was why the men in the muster room had laughed when Lieutenant Clitter called the precinct, "Fort Apache." They were outcasts at the last outpost.[60]

In writing his memoir, Walker could not help but cast himself and, by extension, the officers serving at the "Four-one" as protagonists. On one hand, this is simply the nature of autobiography. To Walker's credit, throughout the whole of his book, he demonstrates an interest in better understanding the black and Puerto Rican populations that the precinct polices. His experience is his experience, and it is conveyed in a matter-of-fact, reportorial, and—notably—highly episodic style, which is reflected

in Lardner's adaptation for television. However, what Walker's book often lacks—as do Lardner's draft script and Petrie and Gould's 1981 film—is a deeper curiosity about what led to the initial "arrest of a black man accused of killing a junkie," rather than a romanticizing of that same incident as the birth of a catchy nickname. Such errant focus—ignoring the underlying tragedy that gives rise to a metaphor which ultimately diminishes that tragedy and makes it seem commonplace—is a microcosm of the broader issue at hand. The fiction and fantasy inherent in the very idea of the Bronx's "Fort Apache" had become more an object of fascination to some than the reality that inspired it. Such deep fascination with the frontier fictions of Ford's film—repurposed in the Bronx to describe what, with Charlotte Street's broad fields of rubble, were seen as an urban frontier of sorts—also performs the ingenious task of reading the actual victims of social and municipal calamity as victimizers, while the perpetrators of that clever inversion cast themselves as martyrs for the cause. To put this phenomenon in the oft-quoted—though, here, updated—terms of another of John Ford's classic westerns, *The Man Who Shot Liberty Valance*, this is the Bronx: when the legend becomes fact, print the legend.[61]

The notion that a mob angered by the arrest of a black man can become mere background detail toward the adorning of a legendary nickname, per Walker's anecdote, is emblematic of why so many attempts at telling this same story failed. Police brutality, systemic racism, joblessness, and poverty may well be background detail to some, but any telling of the story of the South Bronx that reduces a nearly unparalleled concentration of such powerful societal issues and forces in a single place to trivial detail reveals exactly how out of its depth that telling is. The faults in that telling are shared, to varying degrees, by Walker's memoir, Lardner's script, and Petrie and Gould's film. But these attempts at telling the story of the South Bronx should not be seen merely as failures by virtue of how myopic or sociologically unenlightened they may be—few if any realist works of popular art could satisfy all of its critics in a case such as this—but as failures of narrative as well. What Walker, Lardner, and Petrie and Gould didn't seem to understand—but perhaps Ford did—was that the least interesting thing about any "Fort Apache" story was the "fort" itself and the police officers who worked there. How rich can a narrative be if it ignores the truly compelling stories, and people, that linger at its periphery? As the critic Carrie Rickey observes, projects like *Fort Apache, The Bronx* and its ilk fail on multiple levels because "their assumptions are all inverted: their makers think the saga of white men among struggling people

of color is heroic; rather, it's the struggles to which heroism should be ascribed."[62] Even despite all of this, movies like Petrie's *Fort Apache, The Bronx* paradoxically—frustratingly—remain interesting to our modern sensibilities, precisely because it is almost stunning to watch white men so clumsily project themselves into the landscape and, thereby, into history. Newman's well-meaning cop can't hear how offensive it is to identify with Bronx ruins when he exclaims that he feels as "burned out as those buildings on Charlotte Street" because he understands this as an act of empathy. The very fact that one of the central figures of the Nuyorican poetry movement was relegated to playing a one-dimensional bit part as a drug dealer in a movie that would be protested by the Puerto Rican community is but one of the film's many deep ironies.

Indeed, the stories of the cops who worked at "Fort Apache" pale in comparison even to those that surround the parallel film and television projects about it, all of which sought to tell their own version of the tale of this area—and era—of the South Bronx. A few questions remain: both Tom Walker's memoir (on which Lardner's script was based) and Petrie and Gould's film (allegedly based on the accounts of former police officers Mulhearn and Tessitore) are episodic and share some similar sequences and plot points. Was this merely coincidence? Or perhaps something more suspicious? And why did Lardner's script never go into production? The first few questions will be taken up soon in this chapter, but evidence that answers, in part, the final question is found in Lardner's production notes and correspondence on the project.

Though it is tempting to entertain theories of a few lingering Hollywood McCarthyites maintaining Lardner's "Hollywood Ten" blacklisting long after the rest of the industry had welcomed him into the fold again, the answers are likely more mundane. We have already seen how Lardner's script received notes from production executive Malcolm Stuart regarding the imbalanced portrayals of the black and Puerto Rican residents of the Bronx depicted on the show. Stuart's last note to Lardner in the same October 6, 1976, memo makes clear to him that the Standards and Practices Department at NBC was already concerned about how violent and unrelentingly bleak Lardner's script already appeared: "Please keep in mind as you write the script that NBC's department of Standards and Practices is concerned about how far the outline seems to indicate we will go in 'telling it like it is.'"[63] Stuart continues, "Somehow we must do the kind of film we all want without offending the sensibilities of everyone. NBC will simply not accept all the violence presently indicated." As noted

previously, concerns about the short shrift given to alternate plotlines featuring characters of color—and a privileging of the Walker character's experience at the precinct at all others' expense—are the subject of subsequent critical memos. Though the actual reasons for not proceeding with the production could be myriad, it seems significant that the very reasons for which Lardner's *Fort Apache, The Bronx* would draw public opprobrium even before its premiere were among the reasons his script never made it to the screen.

John Ford's *Fort Apache* was conceived, as film critic J. Hoberman notes, in early 1947, well before HUAC began to ask its questions of Ring Lardner Jr. and the rest of Hollywood, and it premiered in April 1948 "in a season of crisis."[64] At the time, Lardner and Ronald Reagan were both veterans of the Hollywood of the 1940s, though from markedly different sides of the political aisle, and in light of what the future held for each man, it is hard to ignore the heavy ironies inherent to Lardner's failed attempt in the late 1970s at reimagining—for an American audience soon to elect the other man as president—Ford's *Fort Apache,* a film in which the younger Reagan surely would have loved to act. Ford's film, which "manifest[ed] a new fascination with the post-atomic southwestern landscape," opened in New York on June 25, 1948, which, as Hoberman observes, was one day after the Soviet blockade of Berlin created a "beleaguered Western fort in the midst of hostile Red territory."[65] Petrie's *Fort Apache, The Bronx* began shooting in the winter of 1980—certainly a season of fiscal and social crisis in New York City history—on location, on Charlotte Street and elsewhere in the South Bronx, and it opened in theaters in February 1981. As we have seen, director Petrie's *Fort Apache* manifested its own fascination with a seemingly postapocalyptic urban landscape, and it reimagined Ford's western fort as the NYPD's "Four-one" Precinct—an outpost in the midst of what it perceived to be hostile territory where the hostiles were not "Red," but rather brown and black, and the police, the occupying force.

It is both eerie and, perhaps, uncomfortably fitting that a film—which would later inspire a real-life nickname that would be imposed by the police upon their own station house and, to some extent, an entire neighborhood—would also see so many of the moods and manias of an earlier era echoed by a film doubly inspired by it more than thirty years later. But even despite the many similarities, the world into which *Fort Apache, The Bronx* emerged was one in which, though the "Western fort" of Berlin still stood sentry against the Soviets in the last decade of

the Cold War, the same oppositional metaphor was mobilized, rather, on the American home front—and this time, along racial lines, against some of the nation's own people. Ford's largely sympathetic portrait of the Native American Apache avoided such racist portrayals and, in doing so, viewed the US Army as aggressors. Cast as modern savages in almost entirely unsympathetic terms, it would be left to the Puerto Rican and African American communities of the 1980s Bronx not simply to object publicly to their representation in Fort Apache, The Bronx but also to marshal that opposition into effective protest. But Fort Apache, The Bronx was not the only Hollywood production that dared to shoot on location at the site of one of the most recognizable sets of urban ruins in the world.

## Charlotte's Web: Irony and Invention and Werewolves

Wolfen, a supernatural, semi-werewolf thriller directed by Michael Wadleigh and released in July 1981—just a few months after Fort Apache's February release—was also shot on location in the Charlotte Street area.[66] However, rather than invoke the symbol of Charlotte Street via personification, as did Fort Apache, Wolfen's producers quite literally inhabited the symbol and concept of urban ruin by constructing their own urban ruin—in the form of a decaying, burned-out Gothic church—at the Charlotte Street site. The irony of an invented ruin—rendered with all attendant accoutrements of studio-fashioned rubble shipped in, in the midst of what was otherwise very real ruin—was but one of many delicious, if depressing, ironies of the film's production design. What these ironies cast in sharp relief, however, was that the Bronx had already been a stage set of sorts upon which anyone—liberal or conservative—could imagine fantasies of crime, postapocalypse, or surreal horror. With the dual South Bronx–based productions of Fort Apache, The Bronx and Wolfen, Hollywood merely acknowledged what the world had already understood Charlotte Street's representational identity to be: a studio backdrop.

Each film accomplished this curious production of spatial and visual understanding in idiosyncratic, and not wholly positive, ways. Fort Apache, The Bronx was, almost from its first days of shooting in March 1980, beset on all sides by organized demonstrations and protests decrying the film's portrayal of racial minorities and of the Bronx itself, and by lawsuits from a host of different parties with a variety of claims—from libel, to copyright infringement, to breach of contract. As Fort Apache's opening scene demonstrates, the film itself is rife with depictions of South Bronx

residents that range from reductive to downright racist, all of which certainly contributed to the nation's repository of visual and spatial understandings of Charlotte Street. But it is arguably the response to the film, in the form of the protests and the lawsuits, that helps us best understand Charlotte Street's significance—or what the scholar William Gleason calls "cultural real estate"—as both physical site and narrative trope during this era and beyond.[67]

*Wolfen* literalizes many of the nation's urban fantasies about the South Bronx, and about urban America at large, and builds an actual monument to them, a temple—or, at least, a ruined church—to house the specters believed to haunt America's city streets during the 1970s and 1980s. It locates that temple, with deliberation and intent, at what the English architect and writer Michael Webb describes as "the heart of the worst urban desolation in America," and in doing so transformed a place that had been a visual shorthand for ruin and urban America in peril into the equivalent of a Hollywood soundstage.[68] In the parlance of Hollywood, Charlotte Street was not merely its own stand-in in *Wolfen;* it played itself—and a stylized, theatrical version of that self. One film uses the degeneration of Charlotte Street as a livable neighborhood to indict the largely African American and Latinx populations who live in the South Bronx with a similar—though racialized—degeneracy, and thus imputes upon those same populations the ruin in which they have been forced to live. Another sees these Bronx streetscapes as an indictment of the political, societal, and capitalist structures that have allowed such desolation to occur in the center of perhaps American's greatest city.

*Wolfen,* in both book and film form, is about a breed of intelligent wolves that stalk the more forgotten spaces of our cities. It may, then, seem fairly ridiculous to consider any strain of paranoia that does not directly involve fear of being disemboweled by a highly evolved predator of the human race. But, as with any vaguely supernatural tale, the suspension of disbelief is essential to any enjoyment of the narrative. And, as with almost any nightmares, what's most interesting about them is less the physical threat that any specter might present than what that specter might, indeed, reveal about the dreamer.

Three strains of paranoia are present across *Wolfen*'s various texts. The first kind, apparent more so in Streiber's novel than in the film, is a kind of class paranoia—but here the kind of class or racial anxiety exemplified by, say, Tom Buchanan in *The Great Gatsby* takes the form of a species anxiety, where human beings are under threat of displacement from

the top of the food chain by a hyperintelligent and more vicious species. The second, more prevalent in the film version of *Wolfen*, takes the form of a spatial paranoia that, given the urban context of New York City, manifests primarily as a concern over real estate and the various kinds of urban renewal projects whose self-professed charge was both to define and to "clear" slums, there and in urban centers nationwide. The last brand of paranoiac style shared between these works and some of the other period texts is one that most often takes the form of the surrealistic vision, the occasionally grotesque image, and—as was often the case with the Bronx of this era—the most patently unbelievable aspects of reality.

In an article delineating what he terms "the urban gothic," scholar Seymour Rudin suggests, "The horrors that once stalked the castle of Otranto or Dracula's lair in Transylvania . . . are now to be found and feared in the South Bronx."[69] And it is the South Bronx, Rudin writes, "and its equivalents in other American cities, and analogous wastelands abroad—the Liverpool slums . . . or the blighted London areas stalked by the American werewolf in John Landis' film—that have become the settings for the antihuman activities of the ancient horrors, settings that not only shelter the horrors but sometimes generate them, or their descendants."[70] But what seems to terrify most of the characters about the monsters in Whitley Streiber's novel is not merely the fact that they have taken root in what the journalist Sidney Schanberg once called "a household synonym for abandonment, hellish crime, devastation, terminal urban disease and in the visual imagery of some of its quarters, saturation bombing."[71] Rather, it is the fact that these beings were stronger, faster, healthier, and smarter than the humans on which they occasionally feasted. The Wolfen—the titular monsters, in Streiber's imagination—are members of what he calls "canis lupus sapiens," an intelligent species that evolved from the canine branch of mammals but seemingly with a primate's more evolved brain. That species has, in the lore of the novel, lived quietly in conjunction with human society for all the millennia of human existence, distributed about the world in family groups or packs, and possessing a deep sense of order and family. And, as a matter of course, they kill and eat human beings.

The novel focuses on one six-member family pack that lives in an abandoned building in the South Bronx, where they attempt to mask their existence by hunting only those whom they understand the human world seems to care for the least: the poor, the weak, the aged, and the ill, who were then too much in evidence in their surrounding neighborhoods. That existence is threatened when a few of the werewolves impul-

sively kill two police officers in a junkyard, which draws the attention of the city and two detectives who, for the rest of the novel, attempt to prove the wolves' existence while being hunted by them. It's quite a thrilling read, and this description hardly does it justice.

More exhilarating, however, is how we can read, in sometimes hilarious ways, the novel's imagination of this "topsy-turvy" world where humans might no longer rule the roost as a species. Indeed, at instance upon instance throughout the novel, it seems as if the *Wolfen* world's carefully constructed "racial" calculus is threatened with upset. Lines like "All of history has been living in a dream, and suddenly we're about to discover reality. It's an extraordinary moment." Or: "Man has always confronted nature by beating it down. This would require something new—the werewolf would have to be accepted. He wasn't likely to submit to a beating."[72] And most glaringly: "Did they have civil rights, duties, obligations? The very question was absurd. Despite their intelligent nature there would be no place for them in human society."[73]

With regard to the particular style of paranoia here employed, the earlier reference to *The Great Gatsby* was not careless: one recalls the moment in the novel when, while driving over the Queensboro Bridge, Nick Carraway sees a limousine, "driven by a white chauffer, in which sat three modish negroes, two bucks and a girl," and thinks to himself, "Anything can happen now that we've slid over this bridge, anything at all."[74] Within these anxious lines run modes of paranoid expression and fears of dispossession—both of which very much stand at the heart of Hofstadter's articulation of the "paranoid style." Yet where the paranoid style of *Wolfen,* the novel, departs slightly from Hofstadter's vision is in how this threat to the status quo can be read as a kind of racial paranoia, where the racial calculus of the novel's main characters is destabilized by this "supernatural" intelligent force looking to revenge itself upon mankind— the lycans finally come home to roost, so to speak.

The novel's main character, Detective George Wilson, is a Bronx native who returns to the now-ruined neighborhood of his youth to investigate the murders, and it is through him that the reader experiences the strain of spatial paranoia that Streiber's book describes, and from which the film liberally samples. Wilson is also the novel's Marshall Berman and Don DeLillo, rolled into one. This would mean that he is both a cosmopolitan Marxist intellectual and part paranoid—a contradiction in terms by Hofstadter's definition—as well as fitting firmly within the model (established in Chapter 5) of the returned "nostalgic white ethnic" who

marvels at what the old neighborhood has become. This is the paranoia of what white flight hath wrought, when one of its escapees return to be confronted with what he left behind. Part shock, part awe, and part white guilt, Wilson's return "home" establishes a crucial and often overlooked character detail that, here, makes poignant his encounter with the newly estranged urban landscapes of his youth, even as Streiber treads deeply familiar ground in his descriptions of the area: "They made their way through the devastated streets of the 41st Precinct, past the vacant brick-strewn lots, the empty buildings, the burned, abandoned ruins, the stripped cars, the dismal, blowing garbage in the streets."[75] And later: "Every time I'm up here this place looks worse."[76] Streiber rounds out the scene by making the motif explicit: "Wilson was in the neighborhood of his child-hood, looking at the ruins of where he had been a boy. 'It was a pretty good place then, not the greatest, but it sure wasn't like this. Jesus.'" Streiber locates the character of Wilson in the selfsame area as *Fort Apache, The Bronx*—namely, "Fort Apache"—the neighborhood of the Forty-First Pre-cinct, a place where "just another couple of rotting junkie corpses and a poor old man" would be seen as "about the score for the South Bronx."[77]

*Wolfen,* the film, begins in destruction. A groundbreaking ceremony for a new luxury housing development in the South Bronx assaults the audience with the sounds of demolition. The project is helmed by the brash scion of New York City's power elite, a wealthy real estate developer with political aspirations named Christopher Van Der Veer. Any similarities to real-life figures who approximate the character are more than likely in-tentional. That night, after a cocaine-fueled limousine ride to Battery Park, Van Der Veer, his wife, and their bodyguard are found brutally murdered near a (wholly invented for the movie) monument to the Van Der Veer family near Castle Garden. Van Deer Veer's corporate interests around the globe steer the investigation toward intentional terrorism; the police sus-pect a political assassination. Suspects—and red herrings—abound: a group not unlike the Weather Underground, a Baader-Meinhof-adjacent terrorist cell named Götterdämmerung, and American Indian Movement–affiliated construction workers (with a Leonard Peltier–like leader) are all placed under surveillance. Then, bodies showing the marks of the same vicious modus operandi are discovered in the rubble of Charlotte Street's wide expanse. The film's protagonists—a disheveled cop (played by Al-bert Finney), an expert on the psychology of terrorism (played by Diane Venora), and an eccentric coroner (played by Gregory Hines)—are left to make the connection between the city's most powerful forces and what

was then symbolically its most destitute terrain. It's an astonishing drama, and the press release for *Wolfen* is no less breathless:

> *Wolfen,* an Orion Pictures release through Warner Bros., starring Albert Finney, is an extraordinary tale of terror set in the urban milieu of contemporary New York City. The forces of modern-day police technology and 20th century psychological research are pitted against the instinctual cunning and intelligence of an alien being who has been robbed of its ecological niche. Drawing on contemporary ecological theory and ancient American Indian folklore, *Wolfen* presents audiences with a frightening, mystifying vision of a city helpless in the face of an unknown menace.[78]

But what could be taken for a stone's soup of thematic elements, hastily thrown together (there is a longer history—too long for this chapter—of how *Wolfen*'s director, Michael Wadleigh, who also directed the famed 1970 *Woodstock* documentary, sued to take his name off of the theatrical version of the film in a dispute over having final cut) is, for critic Carrie Rickey, a "serious symphony" that takes "three parallel themes of alienation—from home, community, and body—and intertwines them into a helix of despair."[79]

For me, it's part of the film's bizarre and uneven genius that it takes such a historically and culturally fraught site and space—already identified with decay, and often talked about with a vocabulary that suggested a kind of epidemical spread of that ruin beyond that site—and transforms it into the locus and lair for a horror that does indeed leave the Bronx to wreak havoc elsewhere. *Wolfen* offers its viewer tense DeLillovian postmodern avant-gardism (as witnessed in *Underworld* in Chapter 5) as seen through the camera of a director like John Carpenter. It's essential not to lose sight of the fact that this existential threat to humanity is produced in response to the threat of real estate development and coming gentrification as seen in some of the film's first frames. The film ends in the gilded and gaudily mirrored penthouse apartment of the movie's real estate developer with the detective played by Albert Finney—having reached some sort of spiritual accord with the wolves upon the moment of death—destroying the scale model of the housing development planned for the Charlotte Street area, thereby saving himself from a violent murder. In doing so, he also saves the Bronx from an urban renewal project that threatened the wolves' home. It is, quite literally, a heavy-handed finish, but at least the film makes the greater majority of its politics clear. In most of the films of this era that exploit New York as the paragon of urban

crisis, such sites and spaces are used as mere backdrop and mise-en-scène; *Wolfen* charges that space—and its residents—with a means to strike back.

The final and perhaps most diffuse category of paranoia in *Wolfen*'s two texts is that of the surreal. The ruined, burned-out church on 172nd and Seabury at the heart of the actual Charlotte Street where the wolves make their home was the product of an imaginative set designer. As the film's press kit reads:

> It was in the South Bronx, a devastated ghetto area that resembles post-war Berlin and is referred to as Dresden in the script, that production designer Paul Sylbert was called upon to erect a burnt-out church which serves as the lair of the Wolfen. The single largest set ever built for a New York film, the church took four months and several hundred thousand dollars to construct. Working with his assistant, Dave Chapman, Sylbert created an eerie, decaying Gothic structure that rises out of the rubble of one of the city's most depressed areas.[80]

A November 3, 1979, *New York Times* article describes in detail the construction of this fake ruin—a structure that recalls the efforts of the city to mask its abandoned buildings with trompe l'oeil. The article does not fail to notice the irony that this was "a major construction effort of the kind Charlotte Street has been unable to obtain in real life," as the federally backed promises of revitalization that President Carter made on his 1977 visit never materialized.[81] In one of the more comical examples of art imitating, and then entirely supplanting, life, shipments of rubble were brought in for scenic effects, but all of the actual garbage that had been accumulating at the site for years was removed. "There is no location like it in the world," said producer Rupert Hitzig, noting that the film company had finally found the "homogenized environment" it was looking for in Charlotte Street.[82] The production fenced off the area and built the new ruin almost as high as some of the abandoned and gutted apartment buildings that surrounded the rubble fields. The Bronx had already been in the minds of many the imagined stage set for Americans and urban dwellers worldwide against which to play their fantasies of terror, neo-western, or action film. Now it became its own studio backlot. If there was, as HUD secretary Patricia Harris described in her memo to Jimmy Carter, a "final stage," an "end product of a process of decline and decay," perhaps this was it—the ne plus ultra of the fact and symbol of the South Bronx.[83] The preference for the symbolic Charlotte Street, the symbolic Bronx, had by this point far outstripped any pretense for its realistic repre-

sentation. When Hollywood needed a ruin, shooting a movie in the midst of the most infamous site of urban ruin in American was not enough. It simply designed its own.

In a sense, *Wolfen,* the film, succeeds where other apocalyptic New York films fail—or simply settle for exploitative spectacle, rather than reaching for the spectacular—because it offers up a kind of honesty in its presentation. After all, what was Charlotte Street if not a visual icon, an immediately recognizable signifier of the failings of late capitalism? We, of course, know that it was much more than this, and that Charlotte Street was not the whole of the Bronx, but in a peculiar way, building a fake ruin at its heart was an acknowledgment of the way that images of Charlotte Street were used as visual implements, tools for politicians with which to construct platforms and make promises, or fodder for columnists to decry the death of the American city, and that the end of civilization was nigh. Why not engage the fantasy already inherent in the space and cast it as the natural habitat of the species here to revenge itself—and nature—upon those who threaten it? The two geographic poles of the film, Charlotte Street and the developer Van Der Veer's penthouse, are, as Carrie Rickey observes, "comparable as extremes of urban sleaze." Van Der Veer's New York, for Rickey, "all climate-controlled, chauffer-driven, heavily-guarded glitz—makes the alfresco, rubble-strewn Bronx look positively virtuous and alive."[84] In this way, the true barbarities of our civilization shield their kind in gilded, glass towers from the chaos that they themselves create.

These two films, *Wolfen* and *Fort Apache, The Bronx,* are emblematic of the ways that Charlotte Street—and, by extension, the Bronx and similarly distressed urban areas, like Watts in Los Angeles or Chicago's South Side—was often imagined in the cultural conversation by those beyond its borders. Yet the significance of Charlotte Street and the representations of it offered by these films do more than merely provide us with sensationalistic or supernatural renderings of a fraught site of struggle in the city. As William Gleason, scholar of literature and environment, has written, "Cultural real estate can matter as deeply as the physical kind—indeed . . . they are often inextricably linked."[85] Charlotte Street's "cultural real estate"—in the form of the narratives spun out of, and around it—was, indeed, inextricably linked to its physical site, and these two filmic representations of Charlotte Street allow us to see three interrelated manifestations of this linkage. Images of Charlotte Street, whether fictional or historical, populated a dense visual web of cinematic, televisual, and

231

journalistic representations that traveled along their respective networks of communication. This web of representations—wielded by conservatives and liberals alike, sometimes to unexpectedly similar ends—came to define not simply the whole of the Bronx but, for many, what urban ruin in America looked like. Paul Newman himself attested to the power and usefulness of the metaphor of the South Bronx when he noted, in promotional material for *Fort Apache, The Bronx,* "There's a South Bronx in every major city."[86] In Newman's formulation, Watts was a South Bronx; the South Side was a South Bronx; Detroit, a South Bronx too. Seen this way—and during this historical moment—Charlotte Street in particular became a repository for the paranoid urban fantasies of the nation and, in some cases, for the world at large. As *Wolfen* and *Fort Apache* demonstrate, the historical and physical Charlotte Street site was integral to the production of the representational, fictional, and filmic Charlotte Street. What these films also reveal, however, is the extent to which the amalgamated production of history and fantasy that was Charlotte Street—"a paradigm of a ghetto," according to the *Washington Post*—helped, in turn, to produce an abstracted, and pointedly raced, vision of American urban

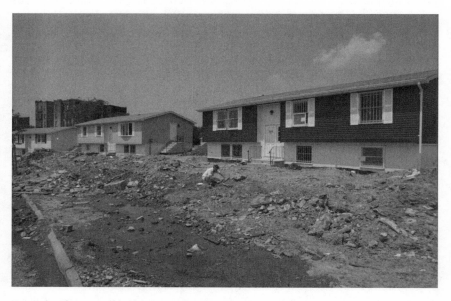

Street-level views of bungalows, single-family homes, and four-story attached brick face buildings (being renovated). HPD Photo, hpd_1984_109_7.
Courtesy NYC Municipal Archives.

life that did not always resemble the actual map or the territory that inspired it.[87] These two films are not linked just by their shared site but also by what inextricably linked ideas and forces lay, metaphorically, beneath the rubble: race and real estate, venture capital and the forces of urban renewal, representation and identity, liberalism and conservatism—and the paranoia that feeds the tension between each.

If you visit Charlotte Street today, you will be confronted—perhaps confounded—by a different source of urban wonder: a pocket of split-level ranch homes in the midst of what *Fort Apache, The Bronx* suggested was an "urban jungle" of six-story tenement buildings. On a winter's night in 1983, just a few years after Charlotte Street served as the untamed urban prairie for one film and the home of murderous supernatural beasts for another, the first two entries in ninety-tract Charlotte Gardens went on the market, offered for the subsidized price of $49,500.[88] More than five hundred people applied in the first three weeks. As of 2009, fewer than a dozen homes out of the ninety-two that were constructed have ever been sold.[89] From working-class ethnic enclave, to iconic urban legend, to a kind of Afro-Latinx Levittown, Charlotte Street contained not merely multitudes, but also retained the capacity to inspire a more modern, cognitively dissonant brand of paranoia than that engendered by any film: that of the suburban.

## The Inevitability of Ruin: A Jurisprudential Coda

In a world and a time when real ruin is insufficient for the tastes of Hollywood producers, and a facsimile must be invented in its midst, it became easy to view everything as a kind of fiction. After all, the madcap surreality of *Wolfen* posited ancient supernatural beings as making their rightful home in the Bronx—and this was a more believable and generous portrait of the Bronx than the gritty "realism" of *Fort Apache, The Bronx*. And these fictions, undergirded by the deep ironies that emerged from these representations of ruin, at times shaded into the farcical.

The CAFA lawsuit was not be the only case of an aggrieved party petitioning the courts to police the cinema. The controversies surrounding *Fort Apache, The Bronx* would also produce a hallmark case in the history of copyright infringement that tangentially defined, in legal amber, how one could or could not depict the South Bronx—or, indeed, any place like it—in a realistic work. Ironically, Tom Walker, the former police officer who wrote the first *Fort Apache* memoir, was the one to file suit.

In 1983, Walker sued Time-Life films, the producers David Susskind, Gill Champion, and Martin Richards, and the screenwriter, Heywood Gould, in federal court, alleging copyright infringement, unfair competition, deceptive trade practices, and breach of a fiduciary and confidential relationship, after an earlier complaint—filed in 1980 before the film was released—was thrown out for lack of subject matter jurisdiction. Among Walker's many assertions, he claims that in late 1971 or early 1972, while he was still employed as a lieutenant at the Forty-First Precinct, Gould—who then worked as a newspaper reporter—visited the Forty-First Precinct to write a story about the arson problem in the area. Walker claimed that he offered to show Gould a copy of the manuscript of his *Fort Apache* memoir, with the provision that Gould could not take notes. Gould agreed, although Walker claimed that when he returned later he caught Gould doing just that. Walker also claimed that a few weeks after Gould's visit his manuscript disappeared from his locker in the station house. Gould claimed that he never even met Walker and that he didn't visit the precinct until after the publication of the Walker's memoir. The producers, for their part, claimed that an idea for the film originated in the late 1960s or early 1970s after they watched news reports of the Bronx's escalating crime rate. The defendants later conceded that they did, indeed, have access to Walker's unpublished manuscript, but even so, the court held that no reasonable observer could find substantial similarity between the two works, and the case was dismissed. Walker appealed the decision and lost again a few years later. Ultimately, both courts held not only that the two projects were not substantially similar but that a majority of the material that Walker claimed the producers copied from his manuscript was not protectable under law.[90]

The case turned on a particular legal doctrine introduced to copyright law in 1942 by California Federal District Court judge Leon Rene Yankwich called *scènes à faire*. This French term of art, which describes scenes that necessarily result from a scene or setting, likely owes its own origin to the nineteenth-century drama critic Francisque Sarcey, who used the phrase to mean an "obligatory scene"—one that the public has been "permitted to foresee and to desire from the progress of the action, and such a scene can never be omitted without a consequent dissatisfaction."[91] Yankwich introduced the phrase into a case, *Cain v. Universal Pictures Co.*, where the crime fiction writer James M. Cain sued the director, the screenwriter, and the studio of the 1939 motion picture *When Tomorrow Comes*, claiming that a sequence from the film infringed upon a similar

scene from his 1937 novel, *Serenade*. Yankwich found that the details from events—in both works, a couple takes shelter from a storm in a church—such as playing the piano, prayer, and hunger, were inherent in the situation itself, and it was "inevitable" that incidents like these "should force themselves upon the writer in developing the theme." Although since Yankwich's introduction of the concept to copyright law, courts have not precisely defined *scènes à faire,* the doctrine has two major strands. The first is that there are scenes that "must" be included in a given context because identical situations call for identical scenes. The second is that certain scenes are considered standard or "stock"—customary, or expected, for the situation or nature of the setting.[92]

Another way to understand *scènes à faire* is to imagine a genre film—your run-of-the-mill detective story, for instance—and what story elements you might need to tell the tale effectively: a hard-drinking private eye, a femme fatale, a byzantine plot with many twists, trench coats, fedoras, informants who turn on their employers, briefcases full of cash or jewels, and a panoply of underworld characters. Essentially, any incidents, characters, or settings that, as a practical matter, would be indispensable or standard in the treatment of a given topic are not protectable by copyright. Walker claimed that similar accounts in *Fort Apache, The Bronx* and his book described the disarming of threatening individuals and the poor morale of disgruntled officers. Judge David N. Edelstein of the US District Court in Manhattan wrote, "In any account based on experiences in a poverty stricken, crime-ridden environment, depictions of bribery, prostitution, purse-snatching and neighborhood hostility to law enforcers are inevitable." Additionally, copyright protection, as Edelstein's opinion states, does not extend to "historical or contemporary facts, material traceable to common sources or in the public domain, and *scènes à faire.*" Chief Judge Feinberg of the US Court of Appeals, Second Circuit, on appeal, agreed: "Elements such as drunks, prostitutes, vermin and derelict cars would appear in any realistic work about the work of policemen in the South Bronx. These similarities therefore are unprotectable as *scènes à faire,* that is, scenes that necessarily result from the choice of a setting or situation."[93]

What Feinberg's opinion described as the "violence and urban decay" of the Forty-First Precinct was, by the time of the decision and by rule of law, assumed, presupposed, and a matter of course. South Bronx ruin—and certain representations of it in film and literature—was, at least to the Southern District of New York and the Court of Appeals, Second Circuit,

as Yankwich wrote in *Cain v. Universal Pictures,* "inevitable." Even with regard to the glorious exaggerations and science fictional elements of *Wolfen,* both Streiber's novel and the film ingeniously argue for and perform their own version of *scènes à faire* doctrine: to some of their characters, the fact that the South Bronx is a setting for grisly, supernatural murders committed by intelligent wolves is, to their eyes, inevitable.

*Walker v. Time Life Inc.* is still good law and has been cited almost two thousand times.

In 1982, when the Latin jazz innovator Jerry González chose the name of his band—on stage, during a performance in Europe—he didn't even give his band the opportunity to weigh in. But his choice did not emerge out of the ether: Fort Apache. González was, of course, referencing both the name that Bronx cops—"with a cowboys and Indians mentality toward law enforcement"—gave to their station house and the Hollywood movie *Fort Apache, The Bronx,* which extended the name, and the offense, to the whole of the borough.[1] Within that cast-off gesture lay both a sense of civic pride and a keen sense of irony, but also a bold act of cultural reappropriation—or radical reclamation—that was just as revolutionary as the jazz that González and his band were playing. It's a gesture that is representative of the same spirit that inspired young black and brown folk in the Bronx to take what little was given to them and use exactly that lack to invent a whole musical genre, artistic form, and self-sustaining cultural economy that, in many ways, drives much of popular culture today.

It also speaks to the very gesture and argument of this book, but about this, I will let González's brother Andy explain. Responding to an interviewer's question regarding who named his and his brother's band Fort Apache, the younger González brother stated: "We wanted to show that art still comes out of Fort Apache. That's why we named the band 'Fort Apache Band' . . . there were all kinds of artists living there."[2] Though *Urban Legends* falls short of discussing "all kinds" of artists, its aims were, and are, aligned with those of the Fort Apache Band, as articulated by Andy González: showing that art can, and does, emerge from an imperiled environment—and one so ceaselessly imaged, rendered, and imagined—in a way that echoes the utopian visions of Fashion Moda's Stefan Eins. At the same time, native Bronx artists like González were also charged with navigating the field of preconceptions, prejudices, and

symbolic schemas—this book's idea of "urban legends"—imposed upon those who hail from such overdetermined places.

Indeed, as both Andy González and scholar José E. Cruz tell it, the campaign organized by Puerto Rican and African American community leaders against *Fort Apache, The Bronx* (discussed in Chapter 6) led directly to the formation of the Fort Apache Band. Though the brothers' childhood were certainly musical ones—their father sang in a series of local Latin bands—and they had the privilege of simply growing up in an era in which they could consume as much jazz and Afro-Latin music as they could handle, from Mongo Santamaria to Lee Morgan to John Coltrane to Machito, it was Puerto Rican American politics around which the members of the Fort Apache Band eventually coalesced. According to Francisco Reyes II, who took photos of the band's early performances, the core group of Fort Apache was composed of members of percussionist Manny Oquendo's group Libre, with alternating participants, but with the central trio of Oquendo and the González brothers. That ensemble quickly became recognized as the official band of the Committee Against Fort Apache (CAFA)—the coalition of groups organized to oppose the film, as recounted in Chapter 6—and the musicians "performed in school auditoriums and at street rallies where CAFA organizers were mobilizing communities to disrupt the production of Newman's film."[3]

The Fort Apache Band made its official debut in 1982 with *The River Is Deep*, a recording of a concert in Berlin, and went on to record seven albums around a generally standard configuration of congas, trumpet, sax, bass, and piano. Jerry González—who died in a house fire in Madrid, Spain, in the fall of 2018—was the genius behind it all, a virtuosic multi-instrumental talent who, along with his brother and a series of inspired musicians from both the Latin and jazz worlds, not so much merged Afro-Cuban rhythms and jazz as illustrated how these two forms were always already in conversation. Of a touring group established in González's later years, Jerry González y el Comando de la Clave, jazz critic Nate Chinen writes, "Concert footage of the band shows the degree of its cultural synthesis—and the extent to which González holds it all together."[4] "Cultural synthesis"—the product of a diverse array of environmental and aesthetic influences, at a particular and contingent moment in Bronx history—is, indeed, what artists like González exemplified in their work, and it is a similar strain of cultural synthesis about that historical moment that this book has endeavored to illustrate.

As an amalgamation of neighborhoods, peoples, languages, cultures, and influences, the South Bronx defined synthesis in the 1970s and 1980s,

even as pockets of its built environment threatened to collapse. While sifting and scrolling through archives both physical and digital, it is gestures like that of the Fort Apache Band—reclaiming a name, a territory, an image, a way of being, and making it their own in a way that appealed to the rest of the world—that consistently emerged. One such discovery materialized late in my research.

A photograph in the New York City Municipal Archives, in the Housing Preservation and Development Collection, depicts a street-level view of an abandoned two-story building at 110–113 Northern Boulevard in Queens. The building features "Occupied Look" decorative decals over its sealed doors and windows; indeed, the photograph is meant to document these seal-ups for HPD's records. When we considered the Occupied Look decals in Chapter 2, we understood them as banal, curious—and to some, useful—objects of municipal art, meant to be perceived at speed. Upon closer examination, however, the seal-up for the building's front door is unlike any other decal I have ever seen.

Rather than a suggestion of French doors, closed shutters, or a crudely lined simulacrum of a door, we find renderings of two finely appointed African American men, garbed in what we might today describe as streetwear, standing in the doorway, outfits perfectly befitting the era and year, 1983, in which the photograph was taken. The man on the right is decked out in full head-to-toe Adidas, the brand's identifiable three stripes running along his sleek tracksuit sleeve and along the sides of his shell-toed sneakers. The man on the left sports a pair of Puma sneakers with fat laces and form-fitting jeans accentuated by a prominent belt buckle. His manner is relaxed: he appears in profile, leaning against the door-jamb, hands in pockets. The Adidas fashion plate, on the other hand, confronts us directly: one hand is by his side, the other extended toward us, as if he is underscoring a point he has just made, casually accentuating the climax of a story he has been in the midst of telling. Both men wear futuristic sunglasses, all angles and flash and—in more ways than one—impenetrable cool. What appears to be a hand-rolled, cone-like cigarette of some kind hangs rakishly from the mouth of one of the men. Sentries of the stoop, they are rendered in the pop-comic figural style favored by graffiti writers of the era, but they are scaled to human size. They, too, seem designed to "fool the eye"—perhaps in a different way, attracting, or deflecting, different audiences. But the effect that they have, when viewed next to the city's window decals beside them, is to make those simplistically sketched shutters and flower pots appear even more cartoonish than

Street-level view of an abandoned two-story building with decorative seals on the window, HPD Photo, HPD_1983_066_1.

Courtesy NYC Municipal Archives.

they already may be. When HPD chief Anthony Gliedman commissioned the department's window decals, versions featuring these gentlemen were likely not an option—not, at least, as far as I have been able to find in my research.

The gesture here recalls that of the graffiti writers highlighted by Marshall Berman in his 1999 essay "Views from the Burning Bridge": "Bronx graffitists, violently banned from the subways, found a new life covering broken buildings with enormous inscriptions: 'This is a decal,' 'This is a fake,' 'This is a ruin.'"[5] From the looks of the HPD image, this may very well be a figural iteration of those indelible acts of urban commentary.[6] However, while the inscriptions that so delight Berman were meant to disrupt the city's efforts to line the abandoned buildings along the Cross Bronx Expressway with peaceful domestic scenes, this intervention is scaled to street level. This rendering's portrayal of two stylish black bodies at rest, nonchalantly taking in the scene, subverts the anodyne versions of domesticity imposed upon similar buildings across the city. I am endlessly amused by imagining the potential experience of passersby whose racial calculus would be immediately upset upon confronting these two figures, and heart-

ened by imagining the same for those for whom encountering them might produce a moment of joy, however fleeting. I dream of an alternate history in which decals like these adorned buildings across the city in the 1980s—a thought that is nearly as beguiling as imagining the present day that such an alternate history might have engendered. Of all the photographs included in this book, I find this one to be among the most resonant. I can only speculate as to who might have created this piece of guerrilla still life, but it is that very act of speculation that continually fills me with awe and admiration for this visual testament to life behind the ruined facade. The gesture that the artist makes toward the surrounding urban environment with these two figures is as casual as it is radical, and the work offers exactly the kind of engagement with that environment that I remain interested in today. The rendering suggests, "This may be fake, but it's OUR fake." The fake fronts offered by the city, largely evacuated of life, are here appropriated and repurposed to attest to the lives of those who call these communities home. Fake life, as this photograph proves, need not be bland or boring. It can, as this work is, be sly and clever, and at the same time represent the messy realities of urban life better, even, than some more faithful representations. Real, we might say, recognizes "real."

This book began with a series of questions about the South Bronx, its image, its place and time in the world, and the legacy of its legend. Looking at the South Bronx today, with modern eyes and particularly through digital media designed to better capture and explore the images of a city, may very well bring us both new answers to those questions and new lines of inquiry about the relationships between representation, reputation, and the urban narratives that eventually become enshrined as legend.

Consider the near ubiquity of Google Street View, a technology launched in 2007 in Google Maps and Google Earth that offers 360-degree panoramic views of streets and locations on all seven continents. In order to compile these panoramas, the Google Street View team must, much like the Department of Finance's tax assessor photographers, drive or walk around the globe in order to photograph the locations shown on Street View, later matching each image to its geographic location on the map and then stitching the photographs together to create seamless transitions from image to image. Street View's precursors reach as far back as the New York City tax photograph projects of the 1930s and 1940s, but they share a more direct relationship to the updated version of that project in the 1980s, which currently also resides on the website of the New York

City Municipal Archives in searchable form. The similarities between the two projects do not end there. Street View "mapped" both the difficult—witness the notoriously labyrinthine streets and *sotoportegi* (alleys that pass beneath buildings) of Venice that have been photographed by Google "Trekkers" (ambulating employees with 360-degree cameras strapped to their backs or to boats)—and the archaic: the ruins of Pompeii have been viewable and navigable since 2010. And like Google Street View, the 1980s images of New York City are viewable, if not quite as "navigable" as Google's algorithmically stitched photographs are easily searchable online through the New York City Municipal Archives website. However, through the use of elastic and still-developing Geographic Information Systems technology, it may be possible to create a useful map of these images that approaches if not quite the panoramic scale of Google Street View, at least a more coherent and complete image of 1980s New York—and of the singular landscape of the Bronx—at one of the most fascinating, most troubling, and most contingent times in its history.

Yet, like many new technologies, Street View is not without its perils and pitfalls, and neither has it always offered the fantasy of "total representation" that was the purported goal of the tax photographs and many of the projects taken on by some of the conceptual photographers examined in this book.[7] As we have seen with the South Bronx, not only can a neighborhood's myth and legend obscure the lived realities of its residents, but the negative stereotypes acquired by certain areas can translate into harmful identities than can impact an area's residential self-image. Consider, briefly, the case of Moyross, one of the most deprived public housing council estates in Limerick City, Ireland. Moyross is a place the Irish mass media have long stigmatized as a site of "violence perpetrated by criminal gangs and general social disorder."[8] In 2010, Google Street View mapped almost thirty-five thousand miles of Irish villages, towns, and cities, yet areas of Limerick—including Moyross—were omitted. As sociologists Eoin Devereaux and colleagues relate in their study "At the Edge: Media Constructions of a Stigmatised Irish Housing Estate," the only images of Moyross were taken from the other side of a wall in the nearby middle-class estate of Caherdavin. Google's explanation for the omissions was the extraordinarily vague comment "for operational reasons." More important were the arguments lodged by local politicians who suggested that such omissions "could give the impression that estates like Moyross are 'no-go' areas. Indeed, a former mayor of Limerick City, Councillor John Gilligan, said that Google were 'doing this out of prejudice, based

on reports they have of the area. It is entirely irresponsible of them. . . . Companies will link into this.'"[9] As the authors of the study conclude:

> If, as is claimed by the local councilors, multi-national companies are being influenced by "reports they have of the area" to such an extent that they will not even send their employees into the estate in a car to take photographs, then the uncritical reproduction of stigmatized/pathologized images of Moyross in the media, as highlighted by this research, has very serious implications for the immediate and long-term future of the estate.[10]

These debates should sound familiar. Indeed, I have included this example to highlight the fact that questions regarding the potency of a negative public image of a particular built environment did not, of course, begin with the South Bronx, and neither did they end there with the borough's social and physical revitalization by the early 2000s. The image of a city in the public eye is hardly just a superficial concern: as we have seen in the South Bronx, and as the researchers of the Moyross study have indicated, the subjective reputation of a neighborhood bears an important relationship to the objective conditions experienced by its residents. "Reputation," they write, "is a social construction," and even changing the physical infrastructure and environment of a place, whether it be a single council estate or an entire collection of neighborhoods, "may not be sufficient to alter those aspects of the residents' lived experiences which are influenced by the reputation of the estate if that reputation is not also addressed."[11] Certainly anywhere that the trope of self-making has been so central to the guiding myths of a nation throughout its history ought to take care to protect the modern self-image of its cities, its towns, and its people going forward.

How, then, to make sense of Google Street View, which apes the vernacular, systematic style of the municipal photographers of New York City in the 1940s and 1980s, but updated for the digital age? Unlike the tax photograph project, Google operates without the same obligation to any particular municipality—for purposes of tax assessment, or for the assessment of building conditions, for example—which allows, as with Moyross, for legitimate critique of the company's perceived privileging and ignoring of certain places and populations via simple tweak of its powerful algorithms. Perhaps the work of the photographer Doug Rickard offers the beginnings of an answer to these questions. Rickard's photography borrows elements both from the vernacular, municipal style and directly from the work of Google Street View. Rickard's work, collected in the

photo book *A New American Picture,* appropriates images from Google Street View's massive image archive, most often selecting images that depict "the unseen and overlooked roads of America, bleak places that are forgotten, economically devastated, and often abandoned." Rickard himself cites the photographs in the Farm Security Administration archive (immediate precursors to the municipal photo projects of the 1940s) as an inspiration, seeing Google Street View's photographs as "parallels or continuations of that work." In the course of performing his own work, he "visited many of the same streets and small towns that Evans and Shahn and the others had documented during the Depression."[12]

The only thing that we might be certain of as images of the city emerge in the digital age—both as historical documents of their era, stored in the unstable archive of the internet, and as ever-evolving testaments to the rapid change of our physical environments—is a profound uncertainty about the utility and the capacity of these new technologies to represent our reality any better than those that have come before them. Can one photograph, one film, one work of art portray a particular place without perpetrating the mythical or stereotypical image of that place any better in 2020 than in 1980, or in 1940 for that matter? Or does something like Google Maps, rather, flatten all space, demystifying it, and evacuating it of any aura or uniqueness: the South Bronx is to South Beach is to South Bend, all mere searchable places on a map? And finally, does the idea—or fantasy—of "total representation" maintain the same allure it may have had for the New York City Department of Finance with such comprehensive digital mapping technologies on hand, even when those technologies and algorithms have proven to be insufficient in ways that adversely affect many of the communities captured by those representations?

## BX, Stand Up

In the autumn of 2015, the Bronx burned again, if only for an evening. A pop-up art show in the South Bronx two nights before Halloween called "Macabre Suite" featured fires burning in trash cans and a sculpture fashioned from bullet-riddled cars. Guests of the party posted photos to social media with the hashtag #thebronxisburning. The party was organized by a private real estate firm in Manhattan that plans to build a $400-million-plus residential and retail complex on a stretch of industrial waterfront on the Harlem River. Melissa Mark-Viverito, a Democrat who represents the area and was then the city council speaker, criticized the

"woefully out-of-touch developers" for putting on such a show: "The South Bronx deserves respect—not a tasteless party that reduces Mott Haven and Port Morris to a sad caricature of urban blight."[13] Both the risible insensitivity and justified outrage on offer here made it difficult to see an essential point: such events, no matter how thoughtless, no matter how outdated the stereotypes relied upon might be, are exercises in de-mystification. A party like "Macabre Suite" is designed to bring those who never would have set a willing foot in the Bronx beyond Yankee Stadium—the Sherman McCoys of the world—to the borough and dem-onstrate to them what a real estate developer might describe as the "po-tential" that lies in places like the South Bronx. Trash fires and abandoned cars are here made mere accoutrements to a sales pitch, defanged of all menace, emptied of threat. In the wake of its most difficult days in the 1970s and 1980s, the Bronx—as this book has tried to illustrate—has been hard to "see" clearly beneath the layers of myth, stereotype, and urban legend stoked by its many representations throughout popular cul-ture. That one of the Bronx's originating myths—Cosell's apocryphal "Bronx is burning" call—would later be used to drum up investment in luxury real estate development offers an irony so astonishing that surely not even the bombastic sports broadcaster could have imagined what this quite literally legendary quote could trigger.

The Bronx of today has largely grown beyond these iconic remnants of its past. A visit to the suburban enclave of Charlotte Gardens in the early 1990s would have confirmed this—and, now, a walk through a Mott Haven or Port Morris that now supports subway-tiled coffee shops pulling shots of espresso, art galleries, and locally owned stores selling Bronx-branded merchandise offers an entirely new definition of "urban renewal." A clothing line like Bronx Native, which takes as its central icon and logo the familiar visage of an abandoned building, aims to reclaim "the lone tenement" and reinvest it with a sense of pride, in the manner of Jerry González reinvesting "Fort Apache" with new meaning.[14] The specter of the 1970s and 1980s lingers, but it is now the shadow of gentrification that is creeping northward from Manhattan.

Parties in poor taste pale in comparison to the threat of displacement. Out of New York City's fifty-nine community districts, the Bronx is home to six of the top ten community districts facing the biggest threats of dis-placement in the city.[15] Out of these, Community Board 5, which covers the University Heights and Fordham neighborhoods of the borough—where I grew up—faces the biggest threat of displacement in New York

City.[16] And for the past year, I have watched outside of my living room window as a pair of twenty-five-story luxury towers rise just south of Metro-North Railroad's Park Avenue bridge. That project sits directly north of the two parcels of land being developed by the real estate firm behind the "Macabre Suite" party. The South Bronx waterfront, once entirely industrial, will soon appear as nearly indistinguishable from the newly built-up shorelines of Williamsburg, Brooklyn, or Long Island City and Astoria, Queens, all of which now feature packed enclaves of steel- and glass-clad residential towers. Once completed, these new, upscale Bronx towers will call the poorest congressional district in the nation home. These neighborhoods were among the first to have had their individual identities swallowed under the sobriquet of the "South Bronx." Now some of these same developers want to rename parts of the South Bronx once again with handles that would be laughable—"SoBro"—if they weren't also painful to set down in print. Port Morris, among the southernmost neighborhoods in the borough and therefore most deserving of the cardinal direction "south" in the South Bronx, suffered its own attempted rebranding as "the Piano District." A billboard—located not at all far away from the billboard where Sisters Grace and Edgar witness the "miracle" of the angel Esmeralda in DeLillo's *Underworld,* and one, like the Occupied Look decals that are designed to be seen by drivers heading to and from Westchester County and Connecticut—advertised the neighborhood as such in 2015. The list of developer-backed purchases seems only to grow as the days go by.

The sight of such development leaves one not at all nostalgic for ruin, but rather bafflement at the way that an event like "Macabre Suite" suggests that I, or any past or future resident of the Bronx, ought to look back wistfully at its most painful signifiers. I stare at the glowing lights of the as yet unfinished luxury high rises reflecting on the Harlem River and wonder what Bronx these new residents will be nostalgic for ten, twenty years hence, when nostalgia was a privilege afforded so few to those who grew up in the Bronx of the 1970s and 1980s.

Almost assured, by this rapid growth, of a markedly different future than its infamous past, how, then, will the South Bronx live on in our memory? Will it live on film, as it did, to varying degrees of exploitation, excess, and lunatic excellence, in the 1980s and 1990s? In a sense it already has. In 2016 the Queens-based film and television production company Silvercup Studios opened up a production facility in the Port Morris section of the South Bronx after purchasing a building for $15 million

246

and investing another $20 million to transform it into four production studios.[17] Now, York Studios is opening a 175,000-square-foot production studio in the Soundview neighborhood—a project that its owners hope draws major production companies as tenants to its campus, given the massive uptick in both demand for and investment in streaming content.[18] So the South Bronx that approximated a studio backlot with the application of the Occupied Look decals to its abandoned buildings now welcomes multimillion-dollar production studios in its midst. In light of *Wolfen*'s ersatz Charlotte Street cathedral, one wonders what imagined ruins might already have been constructed inside these massive, multi-story facilities.

What version of the Bronx will live on in music, even if the metaphorical center of hip-hop has shifted elsewhere in the nation—certainly much farther south than the South Bronx—and continues to do so? Or might the spirit of the Bronx instead take after the work of the actor, dancer, writer, performance artist, and singer Okwui Okpokwasili, whose powerhouse 2014 one-woman show, *Bronx Gothic,* depicts—rather, embodies—the lives of two young, vulnerable black girls growing up in 1980s New York City? It is an interdisciplinary work, incorporating visceral, violent movement with dialogue, sound, and installation art—a synthesis, much like the borough that inspired its creation. Captured in documentary form by the filmmaker Andrew Rossi in a film of the same name, Okpokwasili's performance channels the perspective of Bronx natives—much like the youthful protagonists of Abraham Rodriguez Jr.'s fiction—but gives them corporeal manifestation. *Bronx Gothic* explores, in part, the often fraught dynamic of performing as a black and brown body in pain—often for largely white audiences—without necessarily offering the possibility of transcendence of that pain, which is notion that Rodriguez's fiction asked (and to some critics, didn't sufficiently answer) as well.[19] Okpokwasili was awarded a MacArthur Fellowship in 2018 on the strength of this and other projects, and for what seems to be a promising career of multidisciplinary work.[20]

Or will the South Bronx live on, as urban legend or otherwise, on television, as a historical and cultural curiosity to be discovered by those born tomorrow, found and selected for an evening's entertainment on whatever streaming service—or future technological marvel—comes to rule the roost? Netflix's two-season-long musical television series *The Get Down,* directed by Baz Luhrmann and which premiered in 2016, situated itself in the murky area between mythmaking and historical representation—a

space created, in the Bronx in 1977, by young black and brown people who had the imagination to remake themselves as superhuman. The series reflected the era that it depicted: uneven and uncertain, frantic and fraught, and always open to possibility (that is, until it was canceled at the end of its first season, reportedly after then being the most expensive production in Netflix history, costing over $120 million to make). Despite the fact that it drew deeply upon the rich musical, visual, literary, and cinematic history of the Bronx, it also leaned just as deeply into un-self-consciously romantic evocations of urban ruin, proving how difficult it remains to evade such renderings and how much the idea of the Bronx still floats somewhere between myth and history.

One of my earliest memories involves looking out the backseat window of my parents' car at these strange drawings that filled the windows of some of the buildings that lined the Bruckner Expressway. To a child's eye they looked like slightly bigger versions of the kinds of things that schoolchildren might have drawn when asked by their teacher to draw a house. I note this half-remembered detail (that, in part, inspired this book) to convey that—having grown up listening to, and loving both the music and now global culture that this place spawned, having watched television and films that aim to either faithfully or cartoonishly evoke its streets and avenues—the Bronx has always been to me not merely fact and symbol, but a lived experience. Watching *The Get Down*'s ambitious blend of fiction, fantasy, and fact felt both exhilarating and apropos, but also uncanny and confusing. Real fantasy was conceiving something as earnest and ardent, like Charlie Ahearn's *Wild Style*—one of *The Get Down*'s source texts—and actually pulling it off with a mere fraction of the budget of *The Get Down*. Inventing an entire way of being—of rhyming, of moving, of listening, and of seeing—and watching it become the lingua franca of popular culture is, truly, the stuff of legend. I can't know exactly how other audiences watched *The Get Down,* or what they wanted out of its curious blend of reality and representation, but for those who knew how utterly fantastical the actual fact of the Bronx was during this era, perhaps it was this unresolved tension between fiction and fact that left many viewers unsettled and the series largely unwatched.

"In the rubble fields by Charlotte Street" is hardly a long-lost war poem written in the style of John McCrae's "In Flanders Fields," though the visage of Charlotte Street itself suggested the elegiac mode. Rather, it's the quoted location of a majestic graffiti mural in *The Get Down,* painted by one of the series's central characters. Even after the show's titular crew of

kids risk life and limb in trespassing gang territory in order to see the mural, the show revisits an imagined Charlotte Street—somehow always smoldering with computer-generated smoke—many more times during the first half of the series.

These rubble fields form the show's central and animating set piece. In *The Get Down*'s first episode, Luhrmann borrows an overhead shot (amid clips taken from other films and documentaries of the era) featuring the *Wolfen* ruined cathedral, partly to illustrate the geography of the "rubble fields by Charlotte Street." For the show's protagonist, Ezekiel "Zeke" Figuero, these ruins are—as they were for so many other artists, writers, photographers, thinkers, and builders—alternatively a site of wonder, of disquiet, of danger, and ultimately, of triumph and transcendence. Their recurrence in the plot is no accident. Charlotte Street is at the heart of the show's physical and spiritual terrain because as we know, Charlotte Street defined the image of urban ruin to America and much of the world.

But neither the Bronx, nor Charlotte Street, looks like that anymore. The borough is no longer burning, and hasn't for a long time. These facts are simple, yet significant, and they bear mentioning here. However, many of the structural and economic conditions that caused both the historical and the mythical South Bronx, of course, still exist there, and threaten places and spaces like it elsewhere. We must remain sensitive to the ways that urban legends like the South Bronx—wherever in the world those "South Bronxes" may be found—are simply metaphorical constructions for a host of more complex, contradictory, and troubling social phenomena that can't be explained away in a word or phrase. There are, no doubt, more insidious employments of such specious legends, and we must be wary of their use in the political and societal scapegoating of places and— most importantly—the people who call such places home. It is our duty to understand such problems—beyond the frames and schemes and ready-made narratives already familiar to us. This book has been an extended attempt at such an exercise. The lessons of contemporary representations of the Bronx, like *The Get Down,* are ones that many of the writers and artists who inspired creations like it—and who populated and inspired the writing of this book—never needed to learn about the South Bronx. They, too, were often trapped within the context of the Bronx's urban legends, the most successful of which were able to escape, transcend, or reveal that legend for what it was.

Ruins don't need to smolder all of the time in order to be remembered. Sometimes the world is expressive enough as it is.

## INTRODUCTION

1. Patricia R. Harris to Jimmy Carter, October 1, 1977, Office of Staff Secretary, Presidential Files, Folder 10/4/77, Container 45, Jimmy Carter Library.

2. Ibid.

3. Ibid. Among Harris's suggestions for developing the devastated Boston Road and Charlotte Street area was transforming the site into a park. See Patricia R. Harris to Jimmy Carter, October 7, 1977, Office of Staff Secretary, Presidential Files, Folder 10/12/77, Container 46, Jimmy Carter Library.

4. Memorandum, Tim Kraft to Jimmy Carter, September 30, 1977, Office of Staff Secretary, Presidential Files, Folder 10/4/77, Container 45, Jimmy Carter Library.

5. William Safire, "On Language: In Nine Little Words," *New York Times,* March 26, 1989, 16.

6. Jill Jonnes, *We're Still Here: The Rise, Fall, and Resurrection of the South Bronx* (Boston: Atlantic Monthly Press, 1986), 311–314.

7. Fred Ferretti, "After 70 Years, South Bronx Street Is at a Dead End," *New York Times,* October 21, 1977, 29, 31.

8. Ibid.

9. Robert Schur, "Prescription for the South Bronx," *Nation,* January 21, 1978, 38.

10. David Gonzalez, "Faces in the Rubble," *New York Times,* August 21, 2009, WE1; Jonnes, *We're Still Here,* 316.

11. The philosopher Donald Schön's classic 1979 essay on problem setting and problem solving metaphors (like "urban renewal") establishes an extremely useful framework in understanding the kinds of "urban legends" in which I am interested. See Donald Schön, "Generative Metaphor: A Perspective on Problem-Setting in Social Policy," in *Metaphor and Thought,* 2nd ed., ed. Andrew Ortony (Cambridge: Cambridge University Press, 1993), 137–163.

12. Marshall Berman, "Ruins and Reforms: New York Yesterday and Today," *Dissent,* Fall 1987, 24.

13. Richie Perez, "Committee against Fort Apache: The Bronx Mobilizes against Multinational Media," Media Justice History Project, https://www.media justicehistoryproject.org/archives/82, accessed May 25, 2019.

14. See Greg Tate, *Flyboy in the Buttermilk: Essays on Contemporary America* (New York: Simon and Schuster, 1992), and *Flyboy2: The Greg Tate Reader* (Durham, NC: Duke University Press, 2016); Tricia Rose, *Black Noise: Rap Music and Black Culture in Contemporary America* (Middletown, CT: Wesleyan University Press, 1994); Jeff Chang, *Can't Stop, Won't Stop: A History of the Hip-Hop Generation* (New York: St. Martin's Press, 2005); Dave Tompkins, *How to Wreck a Nice Beach: The Vocoder from World War II to Hip-Hop, the Machine Speaks* (New York: Melville House and Stop Smiling Books, 2010); and Nelson George, *Hip Hop America* (New York: Penguin, 2005).

15. See Alan Trachtenberg, *Brooklyn Bridge: Fact and Symbol* (Chicago: University of Chicago Press, 1965); Marshall Berman, *All That Is Solid Melts into Air* (New York: Verso, 1983); Kim Phillips-Fein, *Fear City: New York's Fiscal Crisis and the Rise of Austerity Politics* (New York: Metropolitan Books, 2017); and Suleiman Osman, *The Invention of Brownstone Brooklyn: Gentrification and the Search for Authenticity in Postwar New York* (Oxford: Oxford University Press, 2011).

16. Lydia Yee and Betti-Sue Hertz, eds., *Urban Mythologies: The Bronx Represented since the 1960s* (New York: Bronx Museum of the Arts, 1999).

17. See Henry Louis Gates, Jr. and Nellie Y. McKay, eds., *The Norton Anthology of African-American Literature*, 2nd ed. (New York: W. W. Norton, 2004).

18. Grace Paley, "Introduction," in Mel Rosenthal, *In the South Bronx of America* (Willimantic, CT: Curbstone Press, 2000), 11.

19. Stephen Jenkins, *The Story of the Bronx: From the Purchase Made by the Dutch from the Indians in 1639 to the Present Day* (New York: Knickerbocker Press, 1912), 3.

### 1. THE LONE TENEMENT

1. For excellent recountings of the decline and subsequent rebirth of the Bronx, see especially (for grassroots political and social histories) Jill Jonnes, *South Bronx Rising: The Rise, Fall, and Resurrection of an American City* (New York: Fordham University Press, 2002), and Alexander von Hoffman, *House by House, Block by Block: The Rebirth of America's Urban Neighborhoods* (Oxford: Oxford University Press, 2004). On urban renewal in the South Bronx, see Lizabeth Cohen, *Saving America's Cities: Ed Logue and the Struggle to Renew Urban America in the Suburban Age* (New York: Farrar, Straus and Giroux, 2019), which considers the benefits and costs of rebuilding American cities through the life and career of urban planner Edward J. Logue, who contributed to major redevelopment projects across the Northeast, including Charlotte Gardens, the community of single-family ranch-style homes that was eventually built on and around Charlotte Street, the infamous locale visited by both Jimmy Carter and Ronald Reagan during the worst of South Bronx ruin. Charlotte Gardens still stands today as a vibrant and—it must be said—quite cognitively dissonant suburban community in the midst of an ultra-urban Bronx that surrounds it.

2. Evelyn Gonzalez, *The Bronx* (New York: Columbia University Press, 2004), 66. "In 1915, 14 census tracts had 100 people per acre, two of which had more than 200 per acre, and one more than 300 per acre. By 1920, there were 15 tracts with more than 100 people to the acre, within which six hovered around 200 to 350 persons per."

3. Ibid., 97.

4. Ibid., 118. The literature on ethnic change in the Bronx is relatively substantial; notable examples include Gonzalez's *The Bronx* but also Lloyd Ultan's *The Northern Borough: A History of the Bronx* (Bronx, NY: Bronx County Historical Society, 2005) and Constance Rosenblum's *Boulevard of Dreams: Heady Times, Heartbreak, and Hope along the Grand Concourse in the Bronx* (New York: New York University Press, 2009).

5. Gonzalez, *The Bronx*, 109.

6. Ibid., 122.

7. Bill Moyers offered the following example of the profitability of such schemes in his 1980 documentary news program "The Fire Next Door": "You can buy a large occupied apartment house in the Bronx for less than a thousand dollars. By taking advantage of the city's three-year tax moratorium, you can collect several thousand a month while paying no taxes; provide heat and services infrequently and only under duress; no maintenance. A few promises will keep the rents coming in until the tenants give up in disgust. Then $200 will buy you a first-class arson job. Federally subsidized fire insurance is required by law. A quick settlement, with few questions, puts you ahead by $70,000 or $80,000." See Mel Rosenthal, *In the South Bronx of America* (Willimantic, CT: Curbstone Press, 2000), 51.

8. Donald Schön, "Generative Metaphor: A Perspective on Problem-Setting in Social Policy," in *Metaphor and Thought,* 2nd ed., ed. Andrew Ortony (Cambridge: Cambridge University Press, 1993), 137–138.

9. Ibid., 144–147.

10. Citizens Budget Commission, *Abandoned Buildings: A Time for Action, February 1970* (New York: Citizens Budget Commission, 1970), 2–3. The Citizens Budget Commission was a "non-partisan civic research organization supported by public contributions." Factors that contributed to, and caused, the incidence and spread of building abandonment were many, varied, and complex, and are, unfortunately, beyond the scope of the argument here. See also Robert Jensen, ed., *Devastation/Resurrection: The South Bronx* (New York: Bronx Museum of the Arts, 1980), for more on the causes of abandonment.

11. Citizens Budget Commission, *Abandoned Buildings,* 2–3.

12. New York City Management Office, "Proposal for the South Bronx: Preliminary Draft (for Discussion), April 11, 1978," New York City Municipal Archives, City Hall Library, M47.95 pfsbpd, Copy 2, introduction and summary.

13. See *Women's City Club of New York: Highlights of Achievements 1915–2008* (New York: Women's City Club of New York, 2010), http://wccny.org.s81086 .gridserver.com/wp-content/uploads/2010/02/WCC-Highlights.pdf.

14. Women's City Club of New York, *With Love and Affection: A Study of Building Abandonment* (New York: Women's City Club of New York, 1977), 1.

15. Ibid., 5.

16. Ibid., 1.

17. Census Bureau and other figures were gleaned from *Meanwhile, in the South Bronx . . . : A Report of the South Bronx Development Organization, Inc.,* ed. Edward Logue (New York: SBDO, 1983), 2.

18. Women's City Club of New York, *With Love and Affection*, 3. "No-man's-land" was a term used perhaps most famously in World War I to describe the area between two enemy trenches most devastated by warfare, carnage, and the artillery's remains.

19. Ibid., 21. A more detailed definition is found in the report's introduction: "An abandoned building is defined as one in which no rents are being collected and no services are being provided by the landlord. City and State laws require that landlords provide certain basic services in their buildings and maintain them in decent, safe, and sanitary condition. Landlords who walk away from their buildings are therefore not complying with the law. There is no legal procedure by which a landlord can abandon a building and through which he might provide the City with advance information of his intention to do so."

20. All understandings and definitions here are indebted to Women's City Club of New York, *With Love and Affection*.

21. Ibid., 2.

22. Ibid., 5.

23. Ibid.

24. Bryant Rollins, "To Most Americans, the South Bronx Would Be Another Country," *New York Times,* May 4, 1975, 216. The article estimates unemployment figures as follows: "In April, when the officially announced national unemployment rate rose to 8.9 per cent over-all, the rate for blacks was 14.6 per cent, for black teenagers 40.2 per cent. The rate for Spanish-speaking persons was about the same as that for blacks." Several nongovernmental agencies put the overall unemployment rate for the 105,000-person labor force in the South Bronx and Hunts Point at around 25 percent. The New York City Manpower Planning Council estimated the rate to be 18 to 20 percent.

25. Ibid.

26. A questionnaire was administered to 163 households, 145 in 26 of the 27 occupied buildings on the study site, and 18 off the site in buildings to which former tenants of 6 of the 11 abandoned buildings had been relocated. Women's City Club of New York, *With Love and Affection*, 22.

27. The report draws its median household number from Paul Niebanck's *Rent Control and the Housing Market in 1968* (New York: Housing and Development Administration, 1970).

28. Women's City Club of New York, *With Love and Affection*, 22.

29. Ibid., 24.

30. Ibid., 25–26.

31. Ibid., 35.

32. Ibid., 39.

33. Ibid., 18.

34. Schön, "Generative Metaphor," 150.

35. Ibid., 138–139.

36. See Lydia Yee, "Photographic Approaches to the South Bronx," in *Urban Mythologies: The Bronx Represented since the 1960s* (New York: Bronx Museum of the Arts, 1999), 10.

37. Joseph P. Fried, *Housing Crisis U.S.A.* (New York: Praeger, 1971), 3.

38. Roger Starr, "Seal of Approval," *New York Times,* June 7, 1982, A18. As noted, Starr was no longer housing commissioner at this time, but he appeared regularly on the *Times* editorial page from 1977 to 1992.

39. An advertisement tagline for Mossberg shotguns in the December 3, 1987, issue of *Newsday* made these lawless frontier associations crystal clear: "The slugster that is making history. Great for the brush or the Bronx." See Rosenthal, *In the South Bronx of America,* 49.

## 2. PERCEPTION IS REALITY

1. New York City Municipal Archives (hereafter NYCMA), Tax Photographs, 1939–1941, Bronx, Block 2621, Lot 43, Roll 3. The photograph is one of 720,000 35mm black-and-white pictures of every house and building in the five boroughs of New York City taken by the Department of Finance for appraising real property for taxation purposes.

2. Municipal Archives records from the 1980s denote that most buildings in the surrounding area, for instance, those that occupy the adjacent lot 2622, were built in or around the year 1910, though no sufficient building date could be found for 960 Third Avenue in these records.

3. Also visible in the immediate foreground is the metal stand that displays the identifying block and lot numbers as well as identifying the borough, again for tax purposes. It is difficult to tell whether the figures in the photograph are engaging with the camera, though given the necessarily constructed nature of the shot, it might be safe to assume that the photographer was not inconspicuous.

4. A visit to the site revealed that the address 970 Boston Road—just north of where 960 Third Avenue would have been—exists and is one of four five- to six-story buildings of a low-income, Section 8 housing complex called Albert Goodman Plaza. Further research demonstrates that the buildings are considered "Unsafe" according to the Department of Buildings Façade Inspection & Safety Program, and are under repair. Ben Coss, KamenTall Architects, P.C., February 23, 2012, http://www.kamentallarchitects.com/team/ben-coss/. In the 1980s Department of Finance tax photograph collection, Block 2621 appears as a fenced-off lot, overgrown and littered with rubble.

5. Gordon Matta-Clark, *Bronx Floor N.Y. 73,* Gordon Matta-Clark Archive (hereafter GMCA), File 3: Quadrille (1A/33.3), ca. 1973. Though part of the series of artworks and photographs most commonly referred to collectively as *Bronx Floors* is occasionally referred to as *Boston Road Floor,* to my knowledge, this is the first instance in which one of the two Bronx buildings that Matta-Clark "dissected" for the piece has been positively identified by its address.

6. See Marshall Berman, *All That Is Solid Melts into Air* (New York: Verso, 1983), 287–349.

7. Sybille Ebert-Schifferer, "Trompe l'Oeil: The Underestimated Trick," in her *Deceptions and Illusions: Five Centuries of Trompe l'Oeil Painting* (Washington, DC: National Gallery of Art, 2002), 17.

8. Lorenzo Bini Smaghi, "Introduction," in *Art and Illusions: Masterpieces of Trompe l'Oeil from Antiquity to the Present Day,* ed. Annamaria Giusti (Firenze: Fondazione Palazzo Strozzi, 2009), 9.

9. Ibid. See also Michael Leja's superb *Looking Askance: Skepticism and American Art from Eakins to Duchamp* (Berkeley: University of California Press, 2004) for more on the viewer's delight in being deceived in nineteenth-century and early twentieth-century American art.

10. For excellent in-depth discussion of the epidemic of arson that struck the Bronx in the 1970s and 1980s, as well as the economic rationales that in part governed the Fire Department's response, see Joe Flood's *The Fires* (New York: Riverhead Books, 2010).

11. Jonathan Soffer, *Ed Koch and the Rebuilding of New York City* (New York: Columbia University Press, 2010), 181.

12. Robert D. McFadden, "City Puts Cheery Face on Crumbling Facades," *New York Times,* October 10, 1980, B1. "Decoration" is not here used facetiously or carelessly; indeed, it is a succinct way of describing what was essentially another form of architectural embellishment—a radically straightforward style of architectural trompe l'oeil painting—but it was also employed by city government officials as another way to describe the program here referred to most often as the "Occupied Look" or as the "decorative seal" program. See NYCMA, Box 175, Memo from Anthony Gliedman to Patti Harris, December 16, 1980.

13. Ibid.

14. NYCMA, Box 175, Letter from Lois Greb to Congressman John M. Murphy, October 10, 1980.

15. NYCMA, Box 175, Letter from Edward I. Koch to Congressman John M. Murphy, December 15, 1980.

16. Ibid.

17. Richard Zacks, Columbia News Service, reprinted in the *Milwaukee Sentinel,* February 28, 1981, p. 14, part 2.

18. Wendy Bellion, *Citizen Spectator: Art, Illusion, and Visual Perception in Early National America* (Chapel Hill: University of North Carolina Press, 2011), 63–64. Bellion discusses these stories in the context of a similarly (likely) apocryphal story regarding George Washington's misperception at the hands of the artist Charles Willson Peale and his *Staircase Group (Portrait of Raphaelle and Titian Ramsay Peale)*.

19. Ibid, 64.

20. See Soffer, *Ed Koch and the Rebuilding of New York City,* 303, and Kurt F. Stone, *The Jews of Capitol Hill: A Compendium of Jewish Congressional Members* (Lanham, MD: Scarecrow Press, 2011), 260.

21. William E. Geist, "Residents Give a Bronx Cheer to Decal Plan," *New York Times,* November 12, 1983, http://www.nytimes.com/1983/11/12/nyregion/residents -give-a-bronx-cheer-to-decal-plan.html.

22. Ibid.

23. Roger Starr, "Seals of Approval," *New York Times,* June 7, 1982, A18. It is, in retrospect, a curious position that Starr here finds himself editorializing on the Occupied Look, as many critics would point to his tenure as commissioner of the Department of Housing Development and Preservation—in particular, his concep-

tion and implementation of the idea of "planned shrinkage," the systematic withdrawal of municipal services to blighted city neighborhoods (either to conserve resources in times of recession or to encourage the exodus of neighborhood populations when the situation became unbearable)—as partly engendering the Bronx's downward spiral.

24. Ibid.

25. Ibid.

26. John Chancellor/Stephen Frazier, "NYC Disguises Abandoned Buildings," *NBC Nightly News,* October 10, 1980, https://archives.nbclearn.com/portal/site/k -12/browse/?cuecard=45249.

27. Robert D. McFadden, "Derelict Tenements in the Bronx to Get Fake Lived-in Look," *New York Times,* November 7, 1983, A1. According to ProPublica, in 1982, after Gliedman, as housing commissioner, declined to grant a $20 million tax abatement for Trump Tower, Gliedman told the New York City police commissioner that he had received a call "threatening his life" over the abatement, according to BuzzFeed. The next day Trump called the FBI, saying he had also received a call with threats to both himself and Gliedman. According to the FBI notes, Trump explained he was "merely passing on this information not only for his own safety but for the safety of Commissioner Gliedman." Gliedman later went to work for Trump. https://www.propublica.org/article/a-short-history-of-threats-received-by-donald -trumps-opponents.

28. Edward I. Koch, "Of Decals and Priorities for the South Bronx," *New York Times,* November 19, 1983, 24. Koch went on to quip, "The *Times* would have put us on the art page and applauded. How easy it is to ridicule. How hard it is to get anything done."

29. Norman Bryson, "Xenia," in *Looking at the Overlooked: Four Essays on Still Life Painting* (Cambridge, MA: Harvard University Press, 1990), 17.

30. See Otto Friedrich, "Marshal Potemkin, Meet Your Fans," *Time,* November 28, 1983; Geist, "Residents Give a Bronx Cheer to Decal Plan"; Bob Greene, "Decals Let New York Put on a Happy Face," *Chicago Tribune,* November 22, 1983, E1; and "Fake Blinds Can't Hide Blight" (editorial), *New York Times,* November 14, 1983. Quoting Friedrich, "Marshal Grigory Potemkin, one of the more artful lovers of Catherine the Great, accomplished many things during his long domination of Russia, but he is best remembered for an illusion. To impress Catherine with the prosperity that he had brought to her subjects, he is said to have built handsome fake villages all along the route of her tour through southern Russia in 1787. Historians doubt this tale, which they blame on malicious court gossip, yet there is something about the idea of 'Potemkin villages' that lingers in the memory as a symbol of political craft" (116).

31. Jack Smith, "Vinylly We're Vindicated, as New York Decal-ifornializes Our Image of Self-Nowhereness," *Los Angeles Times,* December 26, 1983, C1.

32. My understanding here is greatly informed by Bryson's description of German art historian and archaeologist August Mau's "Four Pompeian Styles"— particularly the "Fourth Style," in Bryson, "Xenia," 35–46.

33. Anne Freidberg, *The Virtual Window: From Alberti to Microsoft* (Cambridge, MA: MIT Press, 2006), 1.

34. Hubert Damisch, *The Origin of Perspective* (Cambridge, MA: MIT Press, 1994), 203–214.

35. Geist, "Residents Give a Bronx Cheer to Decal Plan."

36. Bellion, *Citizen Spectator,* 180.

37. Johanna Drucker, "Harnett, Haberle, and Peto: Visuality and Artifice among the Proto-Modern Americans," *Art Bulletin* 74, no. 1 (March 1992): 37–50.

38. For broader contextual reference, see Lisa Phillips, *The American Century: Art and Culture 1950–2000* (New York: Whitney Museum of American Art, 1999), 288; Angela L. Miller et al., *American Encounters: Art, History, and Cultural Identity* (Upper Saddle River, NJ: Pearson Prentice Hall, 2008), 613.

39. Claire Grace, "Christy Rupp," in Helen Anne Molesworth, *This Will Have Been: Art, Love and Politics in the 1980s* (Chicago: Museum of Contemporary Art, 2012), 226; Miller et al., *American Encounters,* 613.

40. See Hal Foster, et al., *Art since 1900: Modernism, Antimodernism, Postmodernism,* vol. 2, *1945 to the Present* (New York: Thames and Hudson, 2004).

41. Gordon Matta-Clark, Letter to Harold Stern, 1971, GMCA, Letters, 1970–74.

42. Indeed, Carol Goodden, Matta-Clark's former partner, noted in an interview, "Gordon was fascinated by garbage and wanted to make it alive again. He was fascinated by the life in death, and vice-versa." Mary Jane Jacob, *Gordon Matta-Clark: A Retrospective* (Chicago: Museum of Contemporary Art, 1985), 39.

43. For more on this seminal show and on "Earth art" in general, see Philip Kaiser and Miwon Kwon's excellent book *Ends of the Earth: Land Art to 1974* (Los Angeles: Museum of Contemporary Art, 2012).

44. Ibid., 35. The photographs, Matta-Clark's first photo piece per se, were first published in Willoughby Sharp and Liza Bear's *Avalanche* magazine in fall 1971 with the caption composed by Matta-Clark: "Jacks: the auto demolition debris zone ripoff imitation neighborhood group action cars abandoned raised propped dismantled and removed 24 hour service."

45. Ibid., 28, 35. Matta-Clark's final contribution to the show was a pig roast staged underneath the bridge in which he handed out five hundred sandwiches to locals. His enthrallment with refuse (and a particular vision of "recycling") was further underscored by his contributions to an untitled show at Pier 18 in July 1971, organized by Willoughby Sharp, where he piled up trash and trees and suspended himself from a rope, upside down, over it, and an earlier exercise in casting glass ingots from a large collection of discarded bottles.

46. Vincent J. Cannato, *The Ungovernable City: John Lindsay and His Struggle to Save New York.* (New York: Basic Books, 2001), 197.

47. Interview with Jane Crawford, "All Work, All Play," in *Laurie Anderson, Trisha Brown, Gordon Matta-Clark: Pioneers of the Downtown Scene, New York, 1970s* (Munich: Prestel/Barbican Art Gallery, 2011), 81.

48. Danny Lyon, *The Destruction of Lower Manhattan* (Toronto: Macmillan, 1969), introduction. Lyon's book consists of seventy-five black-and-white images of historic building facades, vacant lots, demolition crews, and abandoned and decaying interiors, interspersed with descriptive captions and Lyon's own journal

entries chronicling his thoughts on completing the project, which was supported by a grant from the New York State Council on the Arts.

49. Lynne Cooke, "From Site to Non-Site: An Introduction to *Mixed Use, Manhattan,*" in *Mixed Use, Manhattan: Photography and Related Practices, 1970s to the Present,* ed. Lynne Cooke and Douglas Crimp (Cambridge, MA: MIT Press/Museo Nacional Centro de Arte Reina Sofia, Madrid, 2010), 22.

50. GMCA, Unfinished Projects Original Slides & Negatives, no. 35. Two other series, titled "The West: Virginia Valley Mines" and "Towers," depict industrial ruins, abandoned factories, and the like, all in a desert setting. Even Matta-Clark's friends knew to feed his fascination: in 1975, friend Roger Green supplied him with photos from a trip to Berlin that included photos "of the Wall," and of "the Haus Vaterland ruin"—a vast pleasure palace on Potsdamer Platz that was bombed in World War II, burned out in a devastating fire in 1953, and finally demolished in 1976, a year after Green sent Matta Clark the photos. Ibid., GMCA, no, 91.

51. "Interview with Gordon Matta-Clark, Antwerp, September 1977," reprinted from the catalogue *Gordon Matta-Clark, Internationaal Cultureel Centrum, Antwerp, 1977,* in *Gordon Matta-Clark,* ed. Corinne Diserens (New York: Phaidon Press, 2003), 187. Matta-Clark's own first New York apartment, where he grew up—located on La Guardia Place between Houston Street and Washington Square Park—was itself eventually demolished as the downtown footprint of New York University grew. See "Gordon Matta-Clark: Splitting the Humphrey Street Building, An Interview by Liza Bear," also reprinted (from *Avalanche,* December 1974, pp. 34–37) in Diserens, *Gordon Matta-Clark,* 169.

52. "Jane Crawford on Gordon Matta-Clark," November 13, 2003, lecture from the exhibition *Out of the Box: Price, Rossi, Stirling, Matta-Clark,* Canadian Centre for Architecture, Montreal, Quebec, videocassette.

53. Letter to Franco Raggi, February 2, 1976, GMCA (PHCON2002:0016:002, Letters: 1976, no. 35).

54. "NYC Maps," GMCA (PHCON2002:0016:012, Unfinished Projects Original Slides & Negatives, nos. 71, 72).

55. GMCA, Unfinished Projects Original Slides & Negatives, no. 47.

56. "Work with abandoned structures," Typewritten statement, ca. 1975, GMCA, also reprinted in Gloria Moure, *Gordon Matta-Clark: Works and Collected Writings* (Madrid: Museo Nacional Centro de Arte Reina Sofia, 2006), 141. See GMCA, also reprinted in Moure's *Gordon Matta-Clark,* 204.

57. Jane Crawford, "Gordon Matta-Clark: In Context," in *Gordon Matta-Clark,* ed. Lorenzo Fusi and Marco Pierini (Siena, Italy: SMS Contemporanea Santa Maria della Scala, 2008), 114.

58. "Jane Crawford on Gordon Matta-Clark."

59. Pamela Lee, *Object to Be Destroyed: The Work of Gordon Matta-Clark* (Cambridge, MA: MIT Press, 2001), 77–81.

60. April Kingsley, "Gordon Matta-Clark at 112 Greene Street," *Artforum,* January 1973, 89.

61. Rosalind Krauss, "Notes on the Index, Part 2," in *The Originality of the Avant-Garde and Other Modernist Myths* (Cambridge, MA: MIT Press, 1985), 217.

62. "Richard Serra's Urban Sculpture: An Interview by Douglas Crimp," in *Richard Serra: Writings, Interviews* (Chicago: University of Chicago Press, 1994), 125–128. Ironically, Serra picked that location partly because it was a dead-end street that had stairways going up to an adjacent street, which would enable a viewer to look down on the piece. As he describes, "183rd was a leftover street in a broken-down neighborhood, unencumbered by buildings; it had no public or institutional character." It seems the New York City Parks Administration was also instrumental, and just as cold in their consideration of the Bronx: "I wanted to build a work in a New York street and was told, 'Manhattan is out. Try the Bronx.'"

63. Bryson, "Xenia," 33–35.

64. Lee, *Object to Be Destroyed*, 81.

65. Miriam Milman, *Trompe-L'oeil: Painted Architecture* (New York: Rizzoli, 1986), 92.

66. Matta-Clark loved puns. *Threshole* was merely one of many cuttings that Matta-Clark made, all under the umbrella of *Bronx Floors,* thus giving the project a conceptual unity, no matter from where the cuttings were taken.

67. The understanding of the historical conventions of trompe l'oeil, perspectival painting, and illusionistic space here are equally indebted to Sybille Ebert-Schifferer's essay "Window and Veil: Painting as Illusion," in Giusti, *Art and Illusions,* 33–45, and to Milman's *Trompe-L'oeil.*

68. It may also be fruitful here to briefly note by way of comparison Matta-Clark's 1971 black-and-white film *Chinatown Voyeur,* which is a kind of languorous—and rather creepy—meditation on the skyline of New York's Chinatown, composed alternatively of long shots of water towers, chimneys, the Empire State Building through a thick haze, and uncomfortable close-ups of multiple apartment building windows through which the camera observes various domestic scenes.

69. Bellion, *Citizen Spectator,* 88.

70. Ibid., 89.

71. See Mary Jane Jacob, *Gordon Matta-Clark: A Retrospective* (Chicago: Museum of Contemporary Art, 1985), 49, 73, for further context on *Bronx Floors,* in particular an interview with friend Manfred Hecht, who describes in detail accompanying Matta-Clark on trips to the Bronx and to Brownsville, Brooklyn, in order to make cuttings.

72. The project *Fake Estates,* like much of Matta-Clark's artwork, appears under many titles. Among them are "Fake Estate," *Fake Estates,* "Realty Positions: Fake Estates," and "Reality Properties: Fake Estates."

73. Milman, *Trompe-L'oeil,* 9.

74. For an excellent treatment of Matta-Clark's *Window Blow-Out* in relation to James Q. Wilson and George Kelling's famous 1982 *Atlantic Monthly* article, "Broken Windows," and public art writ large, see "The Threshole of Democracy," in *Urban Mythologies: The Bronx Represented since the 1960s,* ed. Lydia Yee and Bettie-Sue Hertz (New York: Bronx Museum of the Arts, 1999), 94–101; for a more expansive view of public art and urban redevelopment in New York, see Rosalind Deutsche, *Evictions: Art and Spatial Politics* (Cambridge, MA: MIT Press, 1996).

75. One might read 1973's *Window Wash* as an important precursor to *Window Blow-Out:* here, Matta-Clark simply washed one upper-left-hand panel of a four-

paned loft window, leaving the lower portion uncleaned. Right next to the cleaned panel, the artist Robert Fiore taped a photograph depicting an exterior scene of a fire escape—yet another instance of a "picture-in-window."

76. Thomas Crow, "Gordon Matta-Clark: Away from the Richness of the Earth, Away from the Dew of Heaven," in Diserens, *Gordon Matta-Clark*, 105. Crow writes of *Window Blow-Out* in greater detail and in relation to site-specific sculpture and minimalism in *Modern Art in the Common Culture* (New Haven, CT: Yale University Press, 1996).

77. One 2007 blog post by a particularly observant lifelong Bronx resident encountered during my research is too irresistible not to mention. After recounting a recent trip on the Cross Bronx Expressway that apparently inspired a Proustian spate of nostalgia—surely the only time that this has occurred—a blogger writes of his discovery of an updated version of "window silhouettes": "A little further south in the almost equally revitalized Hunts Point I discovered a sight that I had once thought vanished from The Bronx. Four twenty-nine Bruckner Boulevard, between E. 144th and E. 149th Streets, caught my eye. . . . Given the neighborhood's notoriously rough history I found one window particularly ironic. It appeared that there was a man being held at gun point. When I made a u-turn for a closer inspection, I realized that it wasn't just a random criminal act, but a cop collaring a criminal. The window silhouettes also seem to have a film noir-ish quality to them—the one to the immediate left of this one features a female with a pin-up girl hairstyle smoking a cigarette—the femme fatale, if you will. A Google search revealed that the building belongs to Cayne Industrial Sales Corporation, a company which sells steel lockers and shelving. Despite the fact that the building is occupied and functional, its initially deceptive 'abandoned' quality speaks to a different period of time in New York when the city was once again on the verge of re-inventing itself." See Richard Buran, The Richard Buran Blog of Curiosities, P.C., December 23, 2011, http://richardburan.blogspot.com/2007_05_01_archive.html.

78. See Allan Mallach, *Bringing Buildings Back: From Abandoned Properties to Community Assets* (Montclair, NJ: National Housing Institute, 2006).

79. Ibid., 175.

80. To date, this is the only documented identification of this structure as corresponding to the one in Matta-Clark's photographs. The windows were replaced long ago.

### 3. DEATH AND TAXES

1. Wolfgang Schivelbusch, *In a Cold Crater: Cultural and Intellectual Life in Berlin, 1945–1948*, trans. Kelly Barry (Berkeley: University of California Press, 1998), 18, 19.

2. Rebecca Solnit, "The Ruins of Memory," in *Storming the Gates of Paradise: Landscape for Politics* (Berkeley: University of California Press, 2008), 356.

3. For more on Robert, see Paula Rea Radisch, *Hubert Robert: Painted Spaces of the Enlightenment* (Cambridge: Cambridge University Press, 1998); *Hubert Robert: The Pleasure of Ruins* (exhibition catalogue) (New York: Wildenstein, 1988). For more on Piranesi, see Arthur Michael Samuel's classic, *Piranesi* (London: B. T. Batsford,

1910); Harvey Miranda, *Piranesi: The Imaginary Views* (New York: Harmony Books, 1979); and Ian Jonathan Scott, *Piranesi* (London: St. Martin's Press, 1975).

4. New York City Municipal Archives (hereafter NYCMA), *Mayor's Management Report,* April 26, 1979, 223.

5. Gabrielle Esperdy, "A Taxing Photograph: The WPA Real Property Survey of New York City," *History of Photography* 28, no. 2 (Summer 2004): 128.

6. It is important here to note that New York City did not rely solely upon a set of photographs taken during and after the Depression Era until the early 1980s, when the collection was updated for property tax assessments. Periodically throughout the 1960s and 1970s, the collection was updated in fits and starts, especially in parts of the city that had seen great expansion and new construction, such as in Queens and Staten Island. The 1980s collection was the result of a recognition that the entire system needed to be made current, just as the 1940s photographs were taken because the real estate valuations that were devised in the 1880s were woefully out of date by the 1930s.

7. NYCMA, *Mayor's Management Report,* April 26, 1979, 223.

8. Ibid.

9. NYCMA, "Real Property Tax Policy for New York City: A Study Conducted under Contract with the Department of Finance, City of New York," Graduate School of Public Administration, New York University, December 31, 1980, 144. According to the report, New York was "beaten out for the booby prize only by Baltimore, Boston, and Buffalo, our sister city-in-sin."

10. Ibid.

11. Ibid.

12. Ibid.

13. NYCMA, Mayor Koch Papers, Roll 65, MN41065, Departmental Correspondence, Department of Finance, April 24, 1981.

14. NYCMA, *Mayor's Management Report,* January 1982, 346.

15. John Ridener, *From Polders to Postmodernism: A Concise History of Archival Theory* (Sacramento, CA: Litwin Books, 2009), 14.

16. Esperdy, "A Taxing Photograph," 123.

17. NYCMA, "Tax Photographs," NYC.gov/RECORDS, June 7, 2012, http://www.nyc.gov/html/records/html/taxphotos/home.shtml.

18. It is, however, important to note here that the 1940s collection registers what damage—economic, social, and most especially physical—the Depression wrought upon the city as well. In this way, both collections are united in their depiction of a built environment either in the midst of, or recently recovering from, traumatic events.

19. For more on Stryker, see James C. Anderson, ed., *Roy Stryker, the Humane Propagandist* (exhibition) (Louisville, KY: University of Louisville, 1977); Nancy C. Wood, *In This Proud Land: America, 1935–1943, as Seen in the FSA Photographs* (Boston: New York Graphic Society, 1975); Jack F. Hurley, *Portrait of a Decade: Roy Stryker and the Development of Documentary Photography in the Thirties* (Baton Rouge: Louisiana State University Press, 1972).

20. It may be worth considering how "expeditionary" in nature this work was, given that, though there is scant information on the identities of the photographers, many were not likely natives of or then-current residents of the Bronx.

21. Hal Foster, "An Archival Impulse," *October* 110 (Autumn 2004): 5.

22. See Keith F. Davis, *George N. Barnard: Photographer of Sherman's Campaign* (Albuquerque: University of New Mexico Press, 1990); Bonnie Yochelson, ed., *Berenice Abbott: Changing New York,* (New York: Museum of the City of New York, 1998).

23. See Mark Klett, *Second View: The Rephotographic Survey Project* (Albuquerque: University of New Mexico Press, 1984); Klett, *After the Ruins, 1906 and 2006: Rephotographing the San Francisco Earthquake and Fire* (Berkeley: University of California Press, 2006).

24. Joshua Shannon, "Uninteresting Pictures," in *Light Years: Conceptual Art and the Photograph,* ed. Matthew S. Witkovsky (Chicago: Art Institute of Chicago, 2012), 94. For more on Huebler, see Ronald J. Onorato, *Douglas Huebler: La Jolla Museum of Contemporary Art, May 27–August 7, 1988* (La Jolla, CA: The Museum, 1988); Alexander Alberro and Patsy Norvell, eds., *Recording Conceptual Art: Early Interviews with Barry Huebler, Kaltenbach, LeWitt, Morris, Oppenheim, Siegelaub, Smithson, Weiner* (Berkeley: University of California Press, 2001).

25. Shannon, "Uninteresting Pictures," 94.

26. Ibid.

27. Ibid.

28. Ibid.

29. See Matthew S. Witkovsky, "Introduction," in Witkovsky, *Light Years,* 15–23. For more on Ruscha, see Sylvia Wolf, *Ed Ruscha and Photography* (New York: Whitney Museum of American Art, 2004); Margit Rowell, *Ed Ruscha, Photographer* (New York: Whitney Museum of American Art, 2006).

30. Hal Foster, *The First Pop Age: Painting and Subjectivity in the Art of Hamilton, Lichtenstein, Warhol, Richter, and Ruscha* (Princeton, NJ: Princeton University Press, 2012), 231.

31. Shannon, "Uninteresting Pictures," 92.

32. Ibid.

33. From an interview with James Rheingrover, a former Finance Department official in charge of the 1980s photography project, conducted by Michael Lorenzini, senior photographer for and curator at the NYCMA, February, 4, 2009.

34. Robin Kelsey, *Archive Style: Photographs and Illustrations from U.S. Surveys, 1850–1890* (Berkeley: University of California Press, 2007), 27.

35. Schivelbusch, *In a Cold Crater,* 14.

36. Ibid. Schivelbusch credits the Polish writer and activist Isaac Deutscher with this insight.

37. Ibid.

38. Indeed, some of the images could pass for some of Timothy O'Sullivan's western United States survey photographs, so full are their frames of seemingly geological forms. See Kelsey, *Archive Style.*

39. My thinking here is greatly indebted to the work of Robin Kelsey—throughout, but particularly in the first chapter—in his indispensable *Archive Style,* 27.

40. Ibid., 166, 168.

41. Ibid.

42. Robert Smithson, "Unpublished Writings," in *Robert Smithson: The Collected Writings,* ed. Jack Flam (Berkeley: University of California Press, 1996), 364.

43. This particular patch of triangular land by coincidence also happens to vaguely suggest the similar shape of a particular piece of Smithson's artwork known as *A Non-Site, Franklin, New Jersey* (1968).

44. Rackstraw Downes in an interview with Philip Lopate, *BOMB Magazine,* September 2002, web only, http://bombsite.com/issues/999/articles/3602.

45. Minnesota Historical Society, "MHS Collections: Focus on Fine Art: The Photography of Jerome Liebling," *Minnesota History* 51, no. 8 (Winter 1989): 301–312.

46. Ibid., 301.

47. Estelle Jussim, "The Photographs of Jerome Liebling: A Personal View," in *Untitled 15: Jerome Liebling, Photographs, 1947–1977,* ed. Jerome Liebling and Estelle Jussim (Carmel, CA: Friends of Photography, 1978), 4. Her essay also appears in *The Eternal Moment: Essays on the Photographic Image* (New York: Aperture, 1989).

48. Alan Trachtenberg, "Jerome Liebling Memorial, June 10, 2012," *Massachusetts Review* 53, no. 3 (Autumn 2012): 490.

49. Minnesota Historical Society, "MHS Collections," 301.

50. Trachtenberg, "Jerome Liebling Memorial, June 10, 2012," 492.

51. Minnesota Historical Society, "MHS Collections," 302.

52. The destruction of the Metropolitan Building, designed by E. Townsend Mix, was a catalyst for historic preservation movements in Minneapolis and across the state and in terms of New York City history and the historic preservation movement writ large, was the equivalent of the destruction of McKim, Mead, and White's Penn Station, demolished there just two years later.

53. Jussim, "The Photographs of Jerome Liebling," 19.

54. For a thorough and entertaining treatment of Demuth's influences regarding the painting, see Karal Ann Marling, "*My Egypt:* The Irony of the American Dream," *Winterthur Portfolio* 15, no. 1 (Spring 1980): 25–39.

55. Jussim, "The Photographs of Jerome Liebling," 10.

56. Lewis Mumford, "The South Bronx Project," in "Jerome Liebling: The South Bronx," ed. Lewis Mumford and Ronald Sullivan, special issue, *Massachusetts Review* 19, no. 4 (Winter 1978): 783.

57. Jussim, "The Photographs of Jerome Liebling," 4.

58. Trachtenberg, "Jerome Liebling Memorial, June 10, 2012," 491.

59. The Casablanca Meat Market still exists today, and at the same address— though not in the same physical building. The meat market became the anchor property for a $15.2 million mixed-use complex in East Harlem, chronicled in Terry Pristin, "From Meat Shop to Mixed-Use Complex," *New York Times,* December 15, 2009, B5.

60. Trachtenberg, "Jerome Liebling Memorial, June 10, 2012," 490, 492.

61. Jussim, "The Photographs of Jerome Liebling," 8–9.

62. Randy Kennedy, "Crumbling South Bronx as a Muse," *New York Times,* December 1, 2008, C1.

63. The famous first verse, in its entirety: "Broken glass everywhere / People pissin' on the stairs, you know they just don't care / I can't take the smell, can't take the noise / Got no money to move out, I guess I got no choice / Rats in the front room, roaches in the back / Junkies in the alley with a baseball bat / I tried to get away but I couldn't get far / 'cuz a man with a tow truck repossessed my car." See the Original Hip-Hop Lyrics Archive, "The Message (lyrics)," http://www.ohhla.com/anonymous/rap_comp/sugrhill/message.sug.txt.

64. Interestingly, Mortenson notes that, in contrast to the Bronx tax photographers, his exploration of the Bronx was governed not by a strict geographic program (i.e., to shoot building after building, street upon street) but rather by his photographic eye: "I wasn't carrying a notebook or even a map. . . . I was just going where my eye took me." See Kennedy, "Crumbling South Bronx as a Muse," C1.

65. Ibid.

66. Sean Corcoran in Ray Mortenson, *Broken Glass: Photographs of the South Bronx 1982–1984* (New York: Museum of the City of New York, 2008), 2.

67. Ibid.

68. William Jenkins, *New Topographics: Photographs of a Man-Altered Landscape* (Rochester, NY: International Museum of Photography at the George Eastman House, 1975).

69. Andy Grundberg, "Beauty and Challenge in Modern Landscapes," *New York Times,* July 13, 1990, C14.

70. Indeed, Mortenson's process might have much to do with conveying this sense of elasticity and meditation: he would occasionally employ a large-format view camera, which he would then set up on the street or in an apartment interior on a tripod and make long exposures: "I'd set up the shot and open the lens and then just walk around the building, exploring, until it was done." See Kennedy, "Crumbling South Bronx as a Muse," C1.

71. See Jennifer L. Roberts, *Mirror Travels: Robert Smithson and History* (New Haven, CT: Yale University Press, 2004) for more on Smithson's model of time as "depositional continuance."

1. Rudi Fuchs, introduction to *Documenta 7,* vol. 1 (Kassel: D+V Paul Dierichs, 1982), xi–xv.

2. Fashion Moda donation form letter, ca. 1979, Fashion Moda Archive, MSS 91, Series I, Box 1, Folder 1A, Fales Library and Special Collections, New York University Libraries.

3. Benjamin H. D. Buchloh, "Documenta 7: A Dictionary of Received Ideas," *October* 22 (Autumn 1982): 110. See also Susan Hodara, "When a South Bronx Collective Went International," *New York Times,* March 25, 2012, 14, for an accounting of many of the items on sale at Documenta 7, some of which formed the centerpiece of an exhibition at the Neuberger Museum of Art of Purchase College in 2012, curated by Gabi Lewton-Leopold. See Neuberger Museum, "The Fashion Moda Stores 1982: Selections from Documenta 7," March 4–May 6, 2012,

https://www.neuberger.org/exhibitions/past/view1/249.html; and an unpublished exhibition catalogue, "The Fashion Moda Stores, 1982: Selections from Documenta 7" (2012).

4. Douglas Crimp, "The Art of Exhibition," *October* 30 (Autumn 1984): 49–81.

5. Ibid., 50.

6. Ian Wallace, "The Era of Judgement: The 7th Documenta," *Vanguard* 11 (1983).

7. Andreas Huyssen, "Mapping the Postmodern," *New German Critique* 33 (1984): 5–52.

8. Rudi Fuchs's Documenta 7 press release, as quoted in Lynn Zelevansky, "Documenta: Art for Art's Sake: Alternative Forms at Documenta 7," *Flash Art* 109 (1982): 39.

9. Crimp, "The Art of Exhibition," 51.

10. Stefan Eins, "Stefan Eins," in Lisa Kahane, *Do Not Give Way to Evil: Photographs of the South Bronx, 1979–1987* (Brooklyn, NY: Powerhouse, 2008), 40.

11. Hodara, "When a South Bronx Collective Went International," 14.

12. Robert Smithson, "A Provisional Theory of Non-Sites," in *Robert Smithson: The Collected Writings,* ed. Jack Flam (Berkeley: University of California Press, 1996), 364. We might imagine the "distance" between the "real" South Bronx and its symbolic self as Smithson imagines the following: "Between the *actual site* in the Pine Barrens and *The Non-Site* itself exists a space of metaphoric significance. It could be that 'travel' in this space is a vast metaphor. Everything between the two sites could become physical metaphorical material devoid of natural meanings and realistic assumptions."

13. Miwon Kwon, *One Place after Another: Site-Specific Art and Locational Identity* (Cambridge, MA: MIT Press, 2002), 3, 159.

14. Ibid., 94, 138.

15. Rudi Fuchs, introduction to *Documenta 7,* xi–xv.

16. Francesca Alinovi, "Come Usare un Quartiere Fuori Uso," *Domus* 627 (April 1982): 61.

17. Luis Cancel, preface to *Devastation / Resurrection: The South Bronx,* ed. Robert Jensen (New York: Bronx Museum of the Arts, 1980), 9.

18. "They're Coming Again," *New York Times,* August 11, 1980, A26.

19. Eins, "Stefan Eins," 40.

20. "Some Posters from Fashion Moda," *Artforum* 19, no. 5 (January 1981), Fashion Moda Archive, MSS 91, Series I, Box 1, Folder 4, Fales Library and Special Collections, New York University Libraries.

21. Fashion Moda Historical Overview, Fashion Moda Archive, MSS 91, Series I, Box 1, Folder 1, Fales Library and Special Collections, New York University Libraries.

22. My understanding of Fashion Moda's gesture of relocation is certainly inflected by—though diverges from—that articulated in an influential article by Rosalyn Deutsche and Cara Gendel Ryan, "The Fine Art of Gentrification," *October* 31 (Winter 1984): 91–111. See also Rosalyn Deutsche, *Evictions: Art and Spatial Politics* (Cambridge, MA: MIT Press, 1996).

23. Francesco Spampinato, "Head Space: Fashion Moda," *Wax Poetics 55* (May 2013): 90.

24. Ibid. Here, Spampinato offers intelligent discussion of Eins's guiding philosophy and sculptural practice at Three Mercer.

25. Thomas Lawson, "Fashion Moda," *REALLIFE Magazine* 3 (January 1980): 7–9.

26. Ibid, 7.

27. Francesca Alinovi, "Frontier Art," in *Arte di Frontiera: New York Graffiti* (Milan: Gabriele Mazzotta, 1984), 16.

28. Carrie Rickey, "Fashion Moda," *Village Voice*, December 30, 1981–January 5, 1982, Fashion Moda Archive, MSS 91, Series III, Sub. B, Box 5, Folder 4, Fales Library and Special Collections, New York University Libraries.

29. Interview with Tim Rollins by James Romaine, in Romaine, "Constructing a Beloved Community: The Methodological Development of Tim Rollins and K.O.S." (PhD diss., Graduate Center, City University of New York, 2007). See also Alan W. Moore, *Art Gangs: Protest and Counterculture in New York City* (New York: Autonomedia / New York State Council on the Arts, 2011); and Amy L. Raffel, "Merchandise, Promotion, and Accessibility: Keith Haring's Pop Shop" (PhD diss., Graduate Center, City University of New York, 2017).

30. Francesca Alinovi, "Interview with Stefan Eins," in *Arte di Frontiera: New York Graffiti* (Milan: Gabriele Mazzota, 1984), 25.

31. Ibid.

32. Ibid., 25–26.

33. Herb Tam, "Interview with Joe Lewis, Fashion Moda," in *Alternative Histories: New York Art Spaces, 1960 to 2010,* ed. Lauren Rosati and Mary Anne Staniszewski (Cambridge, MA: MIT Press, 2012), 72.

34. Eins, "Stefan Eins," 40.

35. Lawson, "Fashion Moda, 1980," 7.

36. Ibid.

37. Ibid., 8.

38. Ibid.

39. Kwon, *One Place after Another,* 89; see also Jane Kramer, *Whose Art Is It?* (Durham, NC: Duke University Press, 1994).

40. See Cecilia Alemani, ed., "John Ahearn: South Bronx Hall of Fame—2012, Frieze Projects," a broadsheet published by Frieze Projects to commemorate Ahearn's South Bronx show, which features a conversation between Alemani and Ahearn.

41. "Projects: Justen Ladda, November 15, 1986–January 6, 1987," press release, Museum of Modern Art, October 1986.

42. Bryant Rollins, "To Most Americans, the South Bronx Would Be Another Country," *New York Times,* May 4, 1975, 6.

43. Robert Smithson, "Frederick Law Olmsted and the Dialectical Landscape," in *Robert Smithson: The Collected Writings,* ed. Jack Flam (Berkeley: University of California Press, 1996), 160. Smithson's essay reads back through the works and parks of Frederick Law Olmsted to argue for a relationship between American land art as it relates to the British concept of the picturesque as derived from the theories of William Gilpin and Uvedale Price, which Smithson sees as resolving the

"dialectic between the sylvan and the industrial." See Smithson, "Frederick Law Olmsted and the Dialectical Landscape," 159–160, 162.

44. Ibid., 160.

45. Sally Webster, "Fashion Moda: A Bronx Experience" (February 1996), http://www.lehman.cuny.edu/vpadvance/artgallery/gallery/talkback/fmwebster .html.

46. Richard Flood, "Fashion Moda," *Artforum* 21, no. 2 (1982): 83.

47. Press release, Fashion Moda Archive, MSS 91, Series I, Box 1, Folder 4, Fales Library and Special Collections, New York University Libraries.

48. "Retrospective," *Documenta 7,* https://www.documenta.de/en/retrospective /documenta_7, accessed October 20, 2015.

49. "Some Posters from Fashion Moda."

50. As Crimp observes, Kassel was one of Hitler's strategic ammunition depots and was thus the focus of heavy bombing raids by the Allies during World War II. In the ruined urban environments depicted in much of the work submitted by Fashion Moda, one could not help but see that recent history of ruin reflected back onto the visitors and viewers of Fashion Moda's Documenta stores. See Crimp, "The Art of Exhibition," 50.

51. Smithson, "Frederick Law Olmsted and the Dialectical Landscape," 160.

52. My understandings of the art as presented at the incarnations of the store are indebted to the re-creations done by the Neuberger Museum in the exhibition organized by Gabi Lewton-Leopold, "The Fashion Moda Stores 1982: Selections from Documenta 7," March 4–May 6, 2012.

53. David Craven, "Marc Blane and Subaltern Art Forms," *Arts Magazine* 60, no. 5 (January 1986): 26–29, http://www.marcblane.com/articles/pdf/11Arts_Maga zine.pdf.

54. Richard Flood et al., "Documenta 7: Continued," *Artforum* 21, no. 2 (October 1982): 83.

55. Alinovi, "Come Usare un Quartiere Fuori Uso," 65.

56. One of the most famous graduates of a Bronx high school, James Baldwin, wrote *Another Country,* in which he imagines the rich possibilities of the idea of "elsewhere"—physical, mental, and otherwise—as an escape from the racial and sexual politics of Harlem and Greenwich Village in the 1960s. See James Baldwin, *Another Country* (1962; reprint, New York: Vintage, 1992).

57. The literary history regarding Bronx ruin is quite varied in the generosity or generality of its vision, and spans from fiction to poetry to memoir. See, for instance, Geoffrey Canada, *Fist Stick Knife Gun: A Personal History of Violence in America* (Boston: Beacon Press, 1995); Don DeLillo, *Underworld* (New York: Scribner, 1997); Sandra María Esteves, *Bluestown Mockingbird Mambo* (Houston: Arte Publico Press, 1990); Herb Goro, *The Block* (New York: Random House, 1970); Richard Price, *The Wanderers* (New York: Houghton Mifflin, 1974); Abraham Rodriguez Jr., *The Boy without a Flag: Tales from the South Bronx* (Minneapolis: Milkweed Editions, 1992); and Tom Wolfe, *Bonfire of the Vanities* (New York: Farrar, Straus and Giroux, 1987), among many others.

58. Interview with Stefan Eins by Calvin Tomkins, "The Art World: Alternatives," *New Yorker,* December 26, 1983, 55.

59. Kwon, *One Place after Another*, 165.

60. *Belchite/South Bronx: A Trans-Cultural and Trans-Historical Landscape* was presented at the University Museum of Contemporary Art at the University of Massachusetts, Amherst from January 30 to March 19, 1988. Torres captured on video the abandoned village of Belchite (in the Spanish province of Zaragoza), destroyed in 1937 during the Spanish Civil War and left in ruins as a monument to the ravages of war, as well as abandoned sections of the South Bronx—itself often described as resembling a "bombed-out" city. See also *Belchite/South Bronx*, Helaine Posner, Francesc Torres, Mar Villaespesa, and Marilyn A. Zeitlin, contributors (Amherst: University Gallery, University of Massachusetts at Amherst, 1988), and *Belchite/South Bronx*, https://fac.umass.edu/UMCA/Online/Article/FrancescTorres.

61. Tam, "Interview with Joe Lewis," 72.

62. "CRASH," John "Crash" Matos, as reproduced in *Documenta 7*, vol. 2 (Kassel: D+V Paul Dierichs, 1982), 381.

63. See Tam, "Interview with Joe Lewis," 72.

64. Hua Hsu, "Wild Style," in *The New Literary History of America*, ed. Werner Sollors and Greil Marcus (Cambridge, MA: Harvard University Press, 2009), 1002.

65. Ibid., 1003–1004.

66. Oldenburg was quoted originally in a March 1973 *New York* magazine article by Richard Goldstein entitled "The Graffiti Hit Parade," which is reproduced in part in Tracy Fitzpatrick, *Art and the Subway: New York Underground* (New Brunswick, NJ: Rutgers University Press, 2009), 187. See also Norman Mailer, "The Faith of Graffiti," in *The Faith of Graffiti*, documented by Mervyn Kurlansky and Jon Naar, text by Norman Mailer (New York: Praeger, 1974), where Mailer, too, employs Oldenburg's quote to strong argumentative effect.

67. "Wildstyle" was the form of lettering after which Charlie Ahearn named his seminal hip-hop and graffiti film. See Hsu, "Wild Style," 1002–1004.

## 5. SOUTH BRONX SURREAL

1. Leon Wieseltier, "Günter Grass Visits the South Bronx: A Fable," *New Republic*, February 24, 1986, 26–29. PEN International is an association of writers founded in 1921 with the goal of promoting friendship and intellectual cooperation while "celebrating writing in all its forms." The congress is its "Annual General Meeting." See http://www.pen-international.org/our-history/congress/. Wieseltier left his position at the *New Republic* in 2014. In 2017, while he was a contributing editor and critic at the *Atlantic*, allegations of sexual harassment, misconduct, and other inappropriate workplace behavior on the part of Wieseltier came to light. He was fired following those allegations. In August 2006, Grass, long a moralizing figure in literary and political circles, admitted that he had been a member of the Waffen-SS in World War II.

2. For more background, see Edwin McDowell, "Grass vs. Bellow over U.S. at PEN," *New York Times*, January 15, 1986, http://www.nytimes.com/books/99/12/19/specials/grass-pen.html; and Wieseltier, "Günter Grass Visits the South Bronx," 26. See also James M. Markham, "The Cold War of Letters Raging in Günter Grass," *New York Times*, February 5, 1986, http://www.nytimes.com/books/99/12/19

/specials/grass-coldwar.html. Bellow's quote was transcribed in "From Voice to Voice," *PEN America 14: A Journal for Writers and Readers* (2011): 127–132, as follows: "The founders of democracy succeeded very well, especially in our own case here in the United States. They gave us exactly what they promised: freedom, equality, liberty, food, clothing, shelter, and miraculous machines. There has never been much rapport between government and art in the United States. The thing was set up only, on the political level, to create a kind of democratic society in which we might do as we pleased. But there is absolutely nothing about the setup of American society which obliges the government to us in any sense in this respect."

3. "From Voice to Voice."

4. Wieseltier, "Günter Grass Visits the South Bronx," 26. Author Salman Rushdie recounted the literary face-off as follows: "And I remember being dragged into a heavyweight prize fight between Saul Bellow and Günter Grass. After Bellow made a speech containing a familiar Bellovian riff about how the success of American materialism had damaged the spiritual life of Americans, Grass rose to point out that many people routinely fell through the holes in the American dream, and offered to show Bellow some real American poverty in, for example, the South Bronx. Bellow, irritated, spoke sharply in return, and when Grass returned to his seat, next to me, as it happens, he was trembling with anger. 'Say something,' he ordered. I got up, went to the microphone, and asked Bellow why he thought it was that so many American writers had avoided—I think I actually said more provocatively, 'abdicated'—the task of taking on the subject of America's immense power in the world. Bellow bridled. 'We don't have tasks,' he said majestically. 'We have inspirations.'" Rushdie, "Introduction," *PEN America 14: A Journal for Writers and Readers* (2011): 85.

5. Wieseltier's singularly named character—as well as the "irony of a Goethe-sponsored trip to Charlotte Street"—is a nod to the narrator of Thomas Mann's reimagining of the classic German legend of Faust (as well as Goethe's reworking of it), *Doctor Faustus,* named "Serenus Zeitblom."

6. Wieseltier, "Günter Grass Visits the South Bronx," 26.

7. Ibid.

8. Ibid.

9. Mel Rosenthal, *In the South Bronx of America* (Willimantic, CT: Curbstone Press, 2000), 100.

10. Wieseltier, "Günter Grass Visits the South Bronx," 26.

11. Ibid.

12. Ibid.

13. Ibid., 28. Translation: "A spiritual motherfucker."

14. Ibid.

15. Grass was, of course, not the only author to express critique, or at least deep ambivalences, about his relationship to America, though other writers delivered them perhaps with more grace. Witness Toni Morrison: "And those reminiscences about what I believe is my relationship to the country in which I live . . . again called up things that I thought had been put to rest. But they had not been. Just the simple knowledge that at no moment of my life had I ever felt as though I were an American. At no moment. I have absorbed all the characteristics of Americans, which

are clear to me when I leave this country. I certainly have the habits, and the expectations perhaps, but at no moment has that word ever been something that belonged to me. And I know that whatever I feel is not exceptional." See Toni Morrison, Heberto Padilla, Susan Sontag, and Derek Walcott, "Citizens of Language," *PEN America 14: A Journal for Writers and Readers* (2011): 91.

16. See McDowell, "Grass vs. Bellow over U.S. at PEN."

17. Ibid.

18. Morrison et al., "Citizens of Language," 91. Scores of other authors also present at the congress joined in support either of Grass's critique or of Bellow's pronouncements.

19. Often—not always—such pining for the past came at the expense of the new populations—often black and brown—that moved into what was already rapidly degrading housing in need of maintenance.

20. Ringolevio is a children's game—a variation on the classic game of "tag"—that originated on the streets of New York and was often played there as far back as the late nineteenth century.

21. Philip Gourevitch, "Balzac of the South Bronx," *New York,* June 7, 1993, 24.

22. The existing literature on Wolfe's and DeLillo's novels is, of course, extensive. For articles that consider Wolfe's novel in context with New York politics and urban crisis, see Michael Brooks, "Stories and Verdicts: Bernhard Goetz and New York in Crisis," *College Literature* 25, no. 1 (Winter 1998): 77–93. On Wolfe and law, see Richard A. Posner, "The Description of Law in *The Bonfire of the Vanities,*" *Yale Law Journal* 98, no. 8 (June 1989): 1653–1661; and Helle Porsdam, "In the Age of Lawspeak: Tom Wolfe's *Bonfire of the Vanities* and American Litigiousness," *Journal of American Studies* 25, no. 1 (April 1991): 39–57. For popular reception, see Luc Sante, "Between Hell and History," *New York Review of Books,* November 6, 1997, and Vince Passaro, "*Underworld,*" *Harper's Magazine,* November 1997. For articles on DeLillo's novel and contemporary culture, see Tony Tanner, "Afterthoughts on Don DeLillo's *Underworld,*" *Raritan* 17, no. 4 (Spring 1998): 48' Adam Begley, "Don DeLillo: *Americana, Mao II,* and *Underworld,*" *Southwest Review* 82, no. 4 (1997): 478; and Damjana Mranovic-O'Hare, "The Beautiful, Horrifying Past: Nostalgia and Apocalypse in Don DeLillo's *Underworld,*" *Criticism* 53, no. 2 (Spring 2011): 213–239.

23. Don DeLillo, *Underworld* (New York: Scribner, 1997), 825.

24. Ibid., 807–808.

25. Tom Wolfe, *The Bonfire of the Vanities* (New York: Farrar, Straus and Giroux, 1987), 78.

26. This is critic James Wood's term for the novel from his review in the *New Republic.* James Wood, "Black Noise," *New Republic,* November 10, 1997, 38–44. For further popular critical reception to DeLillo's novel, see Michiko Kakutani, "Of America as a Splendid Junk Heap," *New York Times,* September 16, 1997, E1; Kakutani, "A Prescient Novel Retains Its Power," *New York Times,* July 14, 2011, C25; Martin Amis, "Survivors of the Cold War," *New York Times Book Review,* October 5, 1997.

27. This is how Wolfe himself described New York in a conversation with Ron Reagan (Ronald Reagan's son) in 1983. See "GEO Conversation: Tom Wolfe," *GEO*

5 (October 1983), in *Conversations with Tom Wolfe,* ed. Dorothy Scura (Oxford: University Press of Mississippi, 1990), 186–198. For a sense of the wider, and often negative, popular critical reception of Wolfe's novel, see Nicholas Lehmann, "New York in the Eighties," *Atlantic,* December 1987, 104; John Leonard, "Delirious New York," *Nation,* November 28, 1987, 636–642; Sanford Pinsker, "Imagining American Reality," *Southern Review* 29, no. 4 (September 1993): 767: and R. Z. Shepherd, "The Haves and the Have-Mores: *The Bonfire of the Vanities* by Tom Wolfe," *Time,* November 9, 1987, 101.

28. From a live interview with Don DeLillo. See Terry Gross, "Behind *Underworld,*" "Fresh Air," NPR/*New York Times,* October 2, 1997.

29. Tom Wolfe, "Stalking the Billion-Footed Beast," *Harper's Magazine,* November 1989, 45.

30. The urban theorist Kevin Lynch describes the South Bronx as such in his posthumously produced book, *Wasting Away.* See Kevin Lynch with Michael Southworth, *Wasting Away: An Exploration of Waste: What It Is, How It Happens, Why We Fear It, How to Do It Well* (San Francisco: Sierra Club Books, 1990), 216.

31. Ibid., 46.

32. Ibid., 56.

33. Brock Clarke, "The Novel Is Dead (Long Live the Novel)," *Virginia Quarterly Review* 82, no. 3 (Summer 2006): 166.

34. Liam Kennedy, "'It's the Third World Down There!' Urban Decline and (Post)national Mythologies in *Bonfire of the Vanities,*" *Modern Fiction Studies* 43, no. 1 (1997): 93–111.

35. Ibid.

36. Wolfe, *The Bonfire of the Vanities,* 505. For criticism on Wolfe and race and ethnicity, see Kennedy, "'It's the Third World Down There!,'" but also Joshua J. Masters, "Race and the Infernal City in Tom Wolfe's *Bonfire of the Vanities,*" *Journal of Narrative Theory* 29, no. 2 (Spring 1999): 208–227. For an excellent consideration of *Bonfire* with regard to whiteness studies and ethnicity, see James Kyung-Jin Lee, *Urban Triage: Race and the Fictions of Multiculturalism* (Minneapolis: University of Minnesota Press, 2004).

37. John Taylor, "The Book on Tom Wolfe," *New York Magazine,* March 21, 1988, 48.

38. Kennedy, "'It's the Third World Down There!,'" 104.

39. Keith Aoki, "Race, Space, and Place: The Relation between Architectural Modernism, Post-modernism, Urban Planning, and Gentrification," *Fordham Urban Law Journal* 20, no. 4 (1992): 757.

40. Wolfe, *The Bonfire of the Vanities,* 79.

41. Joe Flood, *The Fires* (New York: Riverhead, 2010), 1–24.

42. Wolfe, *The Bonfire of the Vanities,* 79.

43. Ibid.

44. Ibid.

45. Robert Caro notes in his biography of Robert Moses, *The Power Broker,* how the construction of the elevated expressway over Bruckner Boulevard, which was in 1953 when the road was first proposed "one of the most thriving commercial areas in the Bronx," caused an uproar from business owners who held property

along it, citing the fact that elevated structures "brought ineradicable blight to the streets along which they ran; the city had only recently finished tearing down the elevated Third Avenue subway line for that very reason." See Robert Caro, *The Power Broker: Robert Moses and the Fall of New York* (New York: Knopf, 1974), 749.

46. Hillary Ballon and Kenneth T. Jackson, eds., *Robert Moses and the Modern City: The Transformation of New York* (New York: W. W. Norton, 2007), 219.

47. Matthew Purdy, "Left to Die, the South Bronx Rises from Decades of Decay," *New York Times*, November 13, 1994, 1.

48. President, Borough of the Bronx, and Triborough Bridge and Tunnel Authority, "The Traffic Improvement of Bruckner Boulevard from the Major Deegan Expressway and the Triborough Bridge to the Bronx River Expressway near Longfellow Avenue, Borough of the Bronx, New York," New York, New York, 195.

49. Ibid.

50. Ray Bromley, "Crosstown Expressways," in Ballon and Jackson, *Robert Moses and the Modern City*, 212.

51. Ibid., 217.

52. Ibid.

53. The Cross Bronx Expressway was called "Heartbreak Highway" before it was even built—by housewives who went to City Hall protesting its path through their neighborhood. See John Tierney, "The Winner, Axles Down," *New York Times*, April 3, 1994, A20. "Communities disintegrated as thousands of homes were blasted and bulldozed, and the project acquired an international reputation among urban planners as the model of how not to build a highway."

54. See Caro, *The Power Broker*, for the classic and comprehensive critique of Moses; and Ballon and Jackson, *Robert Moses and the Modern City*, for a revisionist reconsideration of his work and complicity in the urban crisis.

55. Wolfe, *The Bonfire of the Vanities*, 80.

56. Ibid.

57. Ibid., 83.

58. Ibid., 82.

59. Ibid.

60. Ibid., 82–83.

61. Peter Eisenman, "En Terror Firma: In Trails of Grotextes," in *Theorizing a New Agenda for Architecture: An Anthology of Architectural Theory, 1965–1995*, ed. Kate Nesbitt (New York: Princeton Architectural Press, 1996), 568.

62. Ibid.

63. Kate Nesbitt, "The Sublime and Modern Architecture: Unmasking (an Aesthetic of) Abstraction," *New Literary History* 26, no. 1 (1995): 180.

64. Anthony Vidler, "Theorizing the Unhomely," in Nesbitt, *Theorizing a New Agenda for Architecture*, 574.

65. Ibid.

66. Nesbitt, "The Sublime and Modern Architecture," 180.

67. "The Symbol of Charlotte Street," *New York Times*, December 12, 1978, A22.

68. Roland Barthes, *Camera Lucida* (New York: Hill and Wang, 1981). Barthes's book develops the twin concepts of *studium* and *punctum: studium*, which denotes the cultural, linguistic, and political interpretation of the photograph, and *punctum*,

which denotes the wounding, personally touching detail that establishes a direct relationship with the object or person with it.

69. Wolfe, *The Bonfire of the Vanities,* 85.

70. Ibid.

71. Bill Moyers, *Bill Moyers' World of Ideas,* January 26, 1988 (Public Affairs Television, 1989), in Scura, *Conversations with Tom Wolfe,* 246.

72. John Taylor, "The Book on Tom Wolfe," *New York Magazine,* March 21, 1988, 46–58.

73. Wolfe, *The Bonfire of the Vanities,* 508.

74. Paul I. Montgomery, "Neat Apartments with a Park Envisioned at Site of Bronx Ruin," *New York Times,* February 5, 1973, 17.

75. *People* Staff, "New York's Rx for Urban Blight: Hide It behind a Wall of Decals," *People,* December 12, 1983.

76. John Freeman Gill, "A Place That Redefines Resilience," *New York Times,* November 12, 2010, 7.

77. Ibid.

78. "Decalomania," *New York Times,* May 30, 1982, R1.

79. Horace Walpole was the author of *The Castle of Otranto,* the first Gothic novel in English and one of the earliest literary horror stories.

80. Wolfe, "Stalking the Billion-Footed Beast," 50.

81. Clarke, "The Novel Is Dead (Long Live the Novel)," 177.

82. DeLillo, *Underworld,* 247.

83. Candice M. Giove, "Politicians Furious over Bronx Bus Company's 'Ghetto' Tour," *New York Post,* May 19, 2013, http://nypost.com/2013/05/19/politicians-furious-over-bronx-companys-ghetto-tour/. The article notes that three times a week, the company would take riders, "mainly white Europeans and Australians, . . . on a trip that includes stops at food-pantry lines and a 'pickpocket' park." The tour, which cost forty-five dollars, was led by a Pittsburgh native, Lynn Battaglia, who mocked the Grand Concourse, modeled after Parisian boulevards—to a couple from Paris, "Do you feel like we're on the Champs-Elysees?" and asked the group, upon arriving at St. Mary's Park, "If it were 1980 and you said to me, 'Lynn, I want to die.' My answer would be, 'You're in the right neighborhood.'"

84. Thomas Heise, *Urban Underworlds: A Geography of Twentieth-Century American Literature and Culture* (New Brunswick, NJ: Rutgers University Press, 2011), 241.

85. Ibid., 228.

86. DeLillo, *Underworld,* 238. For more on Smithson's conception of history, see Jennifer Roberts, *Mirror-Travels: Robert Smithson and History* (New Haven, CT: Yale University Press, 2004), 4. Smithson, through his study of "the growth of crystals, the structure of mirror reflections, and the discourse of hyperspace, . . . posited history as an entropic process of material deposition that settles itself into a final crystalline stillness."

87. Don DeLillo, "The Power of History," *New York Times Book Review,* September 7, 1997.

88. Ibid.

89. Ibid.

90. DeLillo, *Underworld*, 238.

91. Ibid., 239.

92. *Meanwhile, in the South Bronx* . . . : *A Report of the South Bronx Development Organization, Inc.*, ed. Edward Logue (New York: SBDO, 1983), 26–27. The process of dynamic compaction worked as follows: "A six-ton steel weight, lifted forty feet by crane boom, is dropped freefall so that it hits the ground in 1½ seconds. After eight to ten drops, the level of rubble sinks more than two feet and the surface is sturdy enough to build on. The crane and weight, nicknamed the Pounder, were lent to SBDO by the Port Authority. The cost of dynamic compaction is $2 a square foot. Conventional methods of site preparation cost three times as much." Dynamic compaction was used on the Charlotte Street site and on part of Bathgate Industrial Park, the complex of buildings built upon what formerly were trash-filled empty lots and "77 largely vacant and abandoned buildings," which were clearly visible from the Cross Bronx Expressway and "reinforced the image of the South Bronx as a total ruin."

93. DeLillo, *Underworld*, 247.

94. Ibid., 245. DeLillo's allusions to Bruegel's painting are further strengthened in his evocation of Sister Edgar's progress down a tenement hallway: "They went single file down the passageways, a nun at front and rear, and Edgar thought of all the infants in limbo, unbaptized, babies in the semi-ether, and the nonbabies of abortion, a cosmic cloud of slushed fetuses floating in the rings of Saturn, and babies born without immune systems, bubble children raised by computer, and babies born addicted—she saw them all the time, three-pound newborns with crack habits who resembled something out of peasant folklore" (246).

95. Ibid, 248.

96. Lynch with Southworth, *Wasting Away*, 202.

97. Ibid., 216.

98. Ibid., 218.

99. Ibid., 219.

100. Ibid. This image, of "apartments in cross-section," is a memorable, and perhaps even commonly cited, one in discussions of representations of ruins. See especially Werner Sollors, *The Temptation of Despair: Tales of the 1940s* (Cambridge, MA: Harvard University Press, 2014), 103–112.

101. Lynch with Southworth, *Wasting Away*, 219.

102. Philip Nel, "'A Small Incisive Shock': Modern Forms, Postmodern Politics, and the Role of the Avant-Garde in *Underworld*," *Modern Fiction Studies* 45, no. 3 (Fall 1999): 724–752.

103. As Nel records in a note to his article: "This isn't the first time DeLillo has used the imagery of Bruegel in this fashion. 'In the Men's Room of the Sixteenth Century' (1971) calls upon *The Triumph of Death*, and *Great Jones Street* (1973) also draws parallels between contemporary and medieval worlds. As DeLillo says of the latter work, 'I remember thinking of New York as a European City in the fourteenth century' (Begley 288). And in *Mao II*, a television image of crushed soccer fans in Sheffield, England resembles 'a crowded twisted vision of a rush to death as

only a master of the age could paint it' (34), again echoing the 'Flemish master.'"
For more on DeLillo, the uncanny, and this fascination with a kind of public trauma,
see Leonard Wilcox and Don DeLillo, "Don DeLillo's *Underworld* and the Return
of the Real," *Contemporary Literature* 43, no. 1 (Spring 2002): 120–137.

104. DeLillo, *Underworld*, 249.

105. Brian Dillon, "Fragments from a History of Ruin," *Cabinet,* no. 20, "Ruins"
(Winter 2005/2006), http://www.cabinetmagazine.org/issues/20/dillon.php. Addi-
tionally, DeLillo makes the specter of the Cold War and of nuclear annihilation ap-
parent in Chapter 8 in an exchange between Grace and Edgar after a passing refer-
ence to North Korea "Gracie joked about this. But it was not a thing Edgar could
take lightly. She was a cold war nun who'd once lined the walls of her room with
Reynolds Wrap as a safeguard against nuclear fallout. The furtive infiltration, deep
and sleek. Not that she didn't think a war might be thrilling. She often conjured the
flash even now, with the USSR crumbled alphabetically, the massive letters toppled
like Cyrillic statuary" (245).

106. Kakutani, "Of America as a Splendid Junk Heap," E1. For more on
DeLillo and waste, see Peter Boxall, "'There's No Lack of Void': Waste and Abun-
dance in Beckett and DeLillo," *SubStance* 37, no. 2 (2008): 56–70; and Johanna
Isaacson, "Postmodern Wastelands: Underworld and the Productive Failures of
Periodization," *Criticism* 54, no. 1 (Winter 2012): 29–58.

107. My understanding here of the geographic implications of trash and its the-
oretical historiography is deeply indebted to Julie Sze's *Noxious New York: The
Racial Politics of Urban Health and Environmental Justice* (Cambridge, MA: MIT
Press, 2007), 117.

108. Ibid., 122. Sze notes by way of illustration of the "reach" of New York
State's garbage (of which a large percentage is New York City's) that it ends up in
Connecticut, Maryland, Massachusetts, Michigan, Ohio, Pennsylvania, Virginia, and
West Virginia, and increasingly may end up in Mexico or other Third World na-
tions "where environmental regulations are laxer and pollution control technology
less sophisticated." By way of example, she notes "the voyage of the *Mobro* and
the 1986 voyage of the *Khian Sea,* which left with Philadelphia toxic incinerator
ash; traveled to the Bahamas, Bermuda, the Dominican Republic, Honduras, Guinea-
Bissau, the Netherlands Antilles, and Panama; then dumped part of its load on a
beach in Haiti." These incidents likely inspired the perhaps apocryphal tanker of
mysterious origin and unknown cargo and consistently denied port that is discussed
by a few of DeLillo's characters in the novel.

109. DeLillo, *Underworld*, 120, 791.

110. Ibid,, 505.

111. Sze, *Noxious New York,* 112. Fresh Kills landfill was closed by Mayor Ru-
dolph Giuliani and Governor George Pataki in 1996.

112. DeLillo, *Underworld*, 485. Matta-Clark's short film *Freshkill,* shot partly at
the Staten Island landfill, chronicled the final hours of the artist's own red panel truck
named "Herman Meydag," driven out to Fresh Kills, where it was summarily smashed
by a bulldozer while seagulls scavenged the massive dump's eerie landscape.

113. Ibid., 486.

NOTES TO PAGES 185-196

114. See Mervyn Kurlansky and Jon Naar, *The Faith of Graffiti* (New York: Praeger, 1974). For an excellent primer on graffiti in New York the 1970s and 1980s, see Hua Hsu's essay "Wild Style," in *The New Literary History of America,* ed. Greil Marcus and Werner Sollors (Cambridge, MA: Harvard University Press, 2009), 1002–1004. For more background on New York graffiti, see also Martha Cooper and Henry Chalfant's classic *Subway Art* (New York: Chronicle, 2009), reissued on its twenty-fifth anniversary with dozens of original photographs (yet lacking the original glossaries and guides); Charlie Ahern's *Wild Style: The Sampler* (New York: Powerhouse Books, 2007); and *Wild Style* (dir. Charlie Ahearn), 1982. Also see Vincent Fedorchak's fascinating memoir of growing up in the 1970s Bronx, *Fuzz One: A Bronx Childhood* (New York: Testify Books, 2005).

115. DeLillo, *Underworld,* 822.

116. Ibid.

117. Carmen Dolores Hernandez, "Abraham Rodriguez, Jr.: 'The Island Is a Myth to Me. It Doesn't Exist for Me at All,'" in *Puerto Rican Voices in English: Interviews with Writers* (Westport, CT: Praeger, 1997), 153.

118. Ian Fisher, "Chronicler of Bleak Truths in South Bronx," *New York Times,* August, 9, 1993, 19.

119. Hernandez, *Puerto Rican Voices in English,* 153.

120. Ibid.

121. Fisher, "Chronicler of Bleak Truths in South Bronx," 19.

122. Ibid.

123. Abraham Rodriguez Jr., *The Boy without a Flag: Tales of the South Bronx* (Minneapolis, MN: Milkweed Editions, 1992), 31.

124. Ibid., 33.

125. Ibid.

126. Ibid., 39–40.

127. Ibid., 41–43.

128. Ibid., 44.

129. Paul Allatson, *Latino Dreams: Transcultural Traffic and the U.S. National Imaginary* (Amsterdam: Rodopi, 2002), 109.

130. Ibid.

131. Ibid., 110.

132. See Glenda R. Carpio, ed., *The Cambridge Companion to Richard Wright* (Cambridge: Cambridge University Press, 2019), especially George Hutchinson, "The Literary Ecology of *Native Son* and *Black Boy,*" 23–38.

133. Abraham Rodriguez Jr., *Spidertown* (New York: Hyperion, 1993), 322.

134. Ibid.

135. Ibid., 301.

136. Ibid., 275.

137. Ibid.

138. Fisher, "Chronicler of Bleak Truths in South Bronx," 19.

139. Ibid.

140. Hutchinson, "The Literary Ecology of *Native Son* and *Black Boy,*" 24.

141. Richard Wright, "How Bigger Was Born," quoted in ibid.

142. Rodriguez, *Spidertown*, 5.

143. Ibid.

6. THE PARANOID STYLE OF SOUTH BRONX FILM

1. Richard Hofstadter, "The Paranoid Style in American Politics," *Harper's Magazine*, November 1964, 77.

2. Tricia Rose, "A Style Nobody Can Deal With: Politics, Style, and the Postindustrial City in Hip Hop," in *Microphone Fiends: Youth Music, Youth Culture*, ed. Andrew Ross and Ticia Rose (New York: Routledge, 1994), 71–88.

3. Cinemafantastique Magazine Records *(1990 The Bronx Warriors)*, Margaret Herrick Library, Academy of Motion Picture Arts and Sciences.

4. Cinemafantastique Magazine Records *(Emperor of the Bronx)*, 27.f-534, Margaret Herrick Library, Academy of Motion Picture Arts and Sciences.

5. Wilkins Avenue was renamed Louis Niñé Boulevard in honor of the Puerto Rican state assemblyman from the Bronx in 1984, and it retains that name today. (This was ascertained by comparing screenshots from the film with tax photographs of the relevant lots along Wilkins Avenue in the early 1980s and more recent Google Street View photographs of Louis Niñé Boulevard.)

6. David Denby, review of *Fort Apache, The Bronx, New York Magazine*, February 16, 1981.

7. The Forty-First Precinct had been known among police officers by the nickname "Fort Apache" since the late 1960s for its high incidence of violent crime, which drew the attention of the press and other news media.

8. Fred Ferretti, "After 70 Years, South Bronx Street Is at a Dead End," *New York Times*, October 21, 1977. 51.

9. Margot Hornblower, "South Bronx, 10 Years after Fame," *Washington Post*, August 25, 1987, A1.

10. Ibid.

11. Ira Rosen, "The Glory That Was Charlotte Street," *New York Times*, October 7, 1979, 44.

12. Ibid.

13. Alexis de Tocqueville, *Democracy in America* (New York: D. Appleton and Co., 1899), book I, chapter XVII, 318.

14. "Soviet Aid Requested for Bronx," *New York Times*, June 21, 1980, 25.

15. There is a rich vein of writing on film and New York City during this era, most recently Brian Tochterman, *The Dying City: Postwar New York and the Ideology of Fear* (Chapel Hill: University of North Carolina Press, 2017). See also Katherine Simpson, "Media Images of the Urban Landscape: The South Bronx in Film," *Centro Journal* 14, no. 2 (2002): 99–113; Michael Ventura, "The Films of the South Bronx: The Face of Dissolution: *Fort Apache, Wolfen, Koyaanisqatsi, Wild Style,*" *High Performance* 7, no. 1 (1984), 30–31, 94–95.

16. Alan Trachtenberg, *Brooklyn Bridge: Fact and Symbol*, 2nd ed. (Chicago: University of Chicago Press, 1979), 136.

17. Indeed, the South Bronx was a hotbed for, and birthplace of, many forms of Latin jazz from the 1940s through the 1980s. See Will Hermes, *Love Goes to Build-*

*ings on Fire* (New York: Faber and Faber, 2011), for a particularly entertaining account of the Latin and loft jazz scenes of the 1970s and 1980s.

18. Cinemafantastique Magazine Records *(Fort Apache, The Bronx),* 31.f-617, Margaret Herrick Library, Academy of Motion Picture Arts and Sciences.

19. Ibid.

20. Ibid. Of note: Ken Wahl, who plays wisecracking sidekick to Newman's principled straight man, had his Hollywood debut in a starring role in another Bronx-based film, the 1979 adaptation of Richard Price's 1974 novel about early 1960s ethnic American gangs of New York, *The Wanderers.*

21. Ibid.

22. Ibid.

23. Joy Gould Boyum, "Urban Blight; Suburban Fright," *Wall Street Journal,* February 6, 1981, 21.

24. Denby, review of *Fort Apache, The Bronx.*

25. Boyum, "Urban Blight," 81.

26. Richard Goldstein, "Paul Newman: The Culture of Cruelty," *Village Voice,* April 14, 1980, 33.

27. Ibid.

28. Richard F. Shepard, "Newman Rebuts 'Apache' Bias Charge," *New York Times,* April 8, 1980, C5.

29. Richard Goldstein, "Susskind v. the South Bronx," *Village Voice,* April 7, 1980, 29.

30. Shepard, "Newman Rebuts 'Apache' Bias Charge," C5.

31. Ibid.

32. Richard Goldstein, "Fort Apache: What Is to Be Done?," *Village Voice,* February 18–24, 1981, para. 1.

33. Carrie Rickey, "Why They Fight: Subjects' Rights and the First Amendment," *American Film,* October 1, 1981, 58.

34. Barry Brennan, "Fort Apache: For the Benefit of Those Whose Idea of a Good Time Is a Bad Time," *KIIS The Newspaper,* February 26, 1981, Core Collection, Margaret Herrick Library, Academy of Motion Picture Arts and Sciences.

35. Goldstein, "Paul Newman," 33.

36. Ibid.

37. Ibid., para. 4.

38. Carrie Rickey, "White Mischief: Hollywood Reruns Racism," *Village Voice,* February 25, 1981, 43.

39. Ibid.

40. Christian Williams, "Stop the Movie—We Want to Get Off!," *Washington Post,* May 4, 1980, para. 5.

41. Ibid.

42. Melvin Maddocks, "The Age of Touchiness," *Time,* May 10, 1971, 27.

43. Richie Perez, "Committee against Fort Apache: The Bronx Mobilizes against Multinational Media," Media Justice History Project, https://www.mediajustice historyproject.org/archives/82, accessed April 20, 2019.

44. Williams, "Stop the Movie—We Want to Get Off!," para. 12.

45. Goldstein, "Susskind v. the South Bronx," 29.

46. Ibid.

47. Perez, "Committee against Fort Apache."

48. Heywood Gould, "More Talk, Less Hock #2: Heywood Gould," webpage, https://www.stevehockensmith.com/2011/06/more-talk-less-hock-2-heywood -gould.html, accessed February 26, 2019.

49. Ring Lardner Jr. shared an Oscar for best original screenplay with Michael Kanin for 1942's *Woman of the Year*, before his refusal in 1947, as part of the "Hollywood Ten," to answer the HUAC's questions. Lardner was sentenced to twelve months in prison and fined $1,000. Blacklisted by the Hollywood studios, Lardner worked under pseudonyms for many years until the blacklist was lifted in 1965. He won an Academy Award for Writing Adapted Screenplay for 1970's *M\*A\*S\*H*.

50. Ring Lardner Jr. Papers, Folder 213, Margaret Herrick Library, Academy of Motion Picture Arts and Sciences. Lardner's script is over 100 pages long and is divided into acts, which suggests that it was a feature-length project designed for television—as typical scripts for feature films number from 100 to 120 pages and are thus divided into acts organized around commercial breaks—as opposed to a television series.

51. Boyum, "Urban Blight," 21.

52. "Saturday Night at Fort Apache," National Broadcasting Company, March 4, 1973, https://archive.org/details/saturdaynightatfortapache.

53. Whether the product of Ford's movie or Bronx policemen, "Fort Apache" has been used to nickname US military outposts in Afghanistan and Iraq. And *Fort Apache, The Bronx* was the explicit reference for the Buenos Aires housing development of Barrio Ejército de los Andes—also known as "Fuerte Apache," or "Fort Apache"—a name that was coined in just as problematic a fashion: a journalist made reference to the 1981 film to describe the community after a shoot-out happened in front of the local police station.

54. There are various stories, likely apocryphal, about how the name came to be. Tessitore, for instance, who worked at the precinct in the 1960s, remembers that the building got its name after somebody shot arrows through the third-floor locker room windows. The Forty-First Precinct had another, and not unrelated, nickname—the Little House on the Prairie—which, though perhaps a clever cop was inspired by the series of children's novels by Laura Ingalls Wilder, was more likely derived from the American television series, which ran from 1974 to 1983. See "On Location: 'Fort Apache,' A War Zone in the Bronx," *NPR: All Things Considered,* August 24, 2011, https://www.npr.org/2011/08/24/139916927/on-location-fort -apache-a-war-zone-in-the-bronx.

55. Dave Kehr, "How the West Was Filled with Loss," *New York Times,* March 25, 2012, https://www.nytimes.com/2012/03/25/movies/homevideo/john -fords-fort-apache-on-blu-ray-from-warner-home-video.html. As Kehr notes, Ford treated the Apache warriors in the film "with sympathy and respect, depicting them as fully justified in their revolt against the deceitful and exploitative policies of the United States government."

56. Ring Lardner Jr. Papers, Folder 213, Margaret Herrick Library, Academy of Motion Picture Arts and Sciences.

57. Ibid.

58. Ibid.

59. Tom Walker, *Fort Apache: Life and Death in New York City's Most Violent Precinct* (New York: Thomas Y. Crowell, 1976), dust jacket.

60. Ibid., 7.

61. Near the end of Ford's film, upon learning that Jimmy Stewart's "Senator Ransom Stoddard" has built virtually his entire reputation on the myth that he killed an outlaw named "Liberty Valance," the reporter interviewing him tears up his notes and says, "This is the West, sir. When the legend becomes fact, print the legend."

62. Rickey, "White Mischief," 43.

63. Ring Lardner Jr. Papers, Folder 213, Margaret Herrick Library, Academy of Motion Picture Arts and Sciences.

64. J. Hoberman, *An Army of Phantoms* (New York: New Press, 2011), 78.

65. Ibid.

66. For work on the relationship of *Wolfen* to gender, neoliberalism, finance, and more, see Carol J. Clover, "Her Body, Himself: Gender in the Slasher Film," *Representations,* no. 20 (Autumn 1987): 187–228; Gesa Mackenthun, "Haunted Real Estate: The Occlusion of Colonial Dispossession and Signatures of Cultural Survival in U.S. Horror Fiction," *Amerikastudien/American Studies* 43, no. 1 (1998): 93–108; and Evan Calder Williams, *Combined and Uneven Apocalypse: Luciferian Marxism* (Ropley, UK: Zero Books, 2010). See also Tyler Sage, "Wolfen: They Might Be Gods," *Jump Cut: Review of Contemporary Media,* https://www.ejumpcut.org/archive/jc56 .2014-2015/SageWolfen/1.html#t1, accessed March 2, 2019; Scott Ross, "All for the Hunting Ground: *Wolfen* (1981)," https://scottross79.wordpress.com/2014/11/09/all -for-the-hunting-ground-wolfen-1981-2/, accessed March 2, 2019.

67. William Gleason, "Black Folk, Brownstones," in *Race and Real Estate,* ed. Adrienne Brown and Valerie Smith (Oxford: Oxford University Press, 2015), 13.

68. Michael Webb, "The City in Film," *Design Quarterly,* no. 136 (1987): 31.

69. Seymour Rudin, "The Urban Gothic: From Transylvania to the South Bronx," *Extrapolation* 25, no. 2 (1984): 116.

70. Ibid.

71. Sidney Schanberg, "Retreating in the Bronx," *New York Times,* October 6, 1981, A31.

72. Whitley Streiber, *The Wolfen* (New York: Morrow, 1978), 154.

73. Ibid., 157.

74. F. Scott Fitzgerald, *The Great Gatsby* (New York: C. Scribner's Sons, 1925), 69.

75. Streiber, *The Wolfen,* 44.

76. Ibid.

77. Ibid., 44–45.

78. Marty Weiser Papers, *Wolfen,* promotion 1980–1981, 18.f-598, Margaret Herrick Library, Academy of Motion Picture Arts and Sciences.

79. Carrie Rickey, "Hour of the Wolfen," *Village Voice,* July 28–August 4, 1981, 38.

80. Marty Weiser Papers, *Wolfen,* promotion 1980–1981. Interiors for the film, including Van Der Veer's "posh Manhattan penthouse" in which the film's climax occurs, were created by Sylbert on the soundstages of New York's Astoria Studios.

81. David Vidal, "Bronx Gets 'Charlotte Street Project'—a Movie Set," *New York Times,* November 3, 1979, 23.

82. Ibid.

83. Patricia R. Harris to Jimmy Carter, October 1, 1977, Office of Staff Secretary, Presidential Files, Folder 10/4/77, Container 45, Jimmy Carter Library.

84. Rickey, "Hour of the Wolfen," 38.

85. Gleason, "Black Folk, Brownstones," 13.

86. Cinemafantastique Magazine Records *(Fort Apache, The Bronx).*

87. Margot Hornblower, "South Bronx, 10 Years after Fame," *Washington Post,* August 25, 1987, A1.

88. Owen Moritz, "Second Spring: The Rebirth of the South Bronx," New York *Daily News,* August 14, 2017.

89. Les Christie, "The Greatest Real Estate Turnaround Ever," CNNMoney, November 25, 2009, https://money.cnn.com/2009/11/09/real_estate/greatest_neigh borhood_turnaround/index.htm.

90. See *Walker v. Time Life Films, Inc.,* 615 F. Supp. 430 (1985); *Walker v. Time Life Films, Inc.,* 784 F.2d 44 (2d Cir. 1986).

91. Leslie A. Kurtz, "Copyright: The Scenes a Faire Doctrine," *Florida Law Review* 41 (1989): 79.

92. Ibid.

93. *Walker v. Time Life Films, Inc.,* 784 F.2d 44, 49 (2d Cir. 1986).

## CONCLUSION

1. Russ Musto, Jerry González, and the Fort Apache Band, *Obatala* (Munich: Enja Records, 1989), liner notes.

2. Eric Gonzáles, "The Cultural Warrior," *Herencialatina,* http://www.heren cialatina.com/Andy_Gonzalez/Andy_Gonzalez.htm, accessed August 1, 2019.

3. José E. Cruz, "Fort Apache Lives: In Memoriam, Jerry González (1949–2018)," *Centro Voices e-Magazine,* https://centropr.hunter.cuny.edu/centrovoices /arts-culture/fort-apache-lives-memoriam-jerry-gonz%C3%A1lez-1949-2018, accessed August 1, 2019.

4. Nate Chinen, "Jerry González, Latin Jazz Visionary, Dies after House Fire," NPR.org, October 1, 2018, https://www.npr.org/2018/10/01/653431819/jerry-gon zalez-latin-jazz-visionary-dies-after-house-fire.

5. Marshall Berman, "Views from the Burning Bridge," in *Urban Mythologies: The Bronx Represented since the 1960s,* ed. Lydia Yee and Betti-Sue Hertz (Bronx, NY: Bronx Museum of the Arts, 1999), 70–83.

6. There is a signature in the top-left-hand part of the door that appears to read "KYLE GREENE." It's possible that this was the work of graffiti writer KYLE, who did hail from Queens. For more information on KYLE, see Jonone, "In the Beginning . . . ," *156ALLSTARZ WorldWide* (blog), July 3, 2011, http://156worldwide .blogspot.com/2011/07/in-begining.html.

7. Indeed, there are more pernicious developments that hasten an entire other series of debates too lengthy to address here, primarily dealing with issues of

surveillance and privacy: since its launch in 2007, Google has seen many privacy advocates raise objections to its program in the United States and around the world. For instance, in 2009, a number of Swiss citizens complained to Google about its failure to adequately encrypt faces and license plates that were visible online in the street view service. It was also discovered that "Street View included images of areas that generally would not be visible to street pedestrians—areas such as private driveways and walled gardens." See Nicholas D. Wells, Poorvi Chothani, and James M. Thurman, "Information Services, Technology, and Data Protection," *International Lawyer* 44, no. 1, International Legal Developments Year in Review: 2009 (Spring 2010): 355–366. Also note that Google has recently disclosed that its Street View vehicles have "intercepted and stored a vast amount of Wi-Fi data from nearby home networks," gathering MAC addresses (unique device IDs for Wi-Fi hotspots) and network SSIDs (user-assigned network ID names), as well as intercepting and storing Wi-Fi transmission data, including email passwords and email content, a series of admissions that the Electronic Privacy Information Center has taken to calling the "Spy-Fi" scandal. See http:// epic.org/amicus/google-street-view/ and *Joffe v. Google,* 729 F.3d 1262, 1267–1268 (9th Cir. 2013).

8. Eoin Devereaux, Amanda Haynes, and Martin J. Power, "At the Edge: Media Constructions of a Stigmatised Irish Housing Estate," *Journal of Housing and the Built Environment* 26 (2011): 123–142.

9. Ibid., 136–137.

10. Ibid., 137.

11. Ibid.

12. Doug Rickard, *A New American Picture* (New York: Aperture, 2012), introduction.

13. Winnie Hu, "Bronx Pop-Up Art Show Prompts Criticism That It Invoked Borough's Painful Past," *New York Times,* November 6, 2015, A18.

14. Ruth La Ferla, "The Rebranding of the Bronx," *New York Times,* August 16, 2017, D1.

15. Lucy Block and Benjamin Dulchin, "How Is Affordable Housing Threatened in Your Neighborhood? 2019," Association for Neighborhood Housing Development, https://anhd.org/report/how-affordable-housing-threatened-your-neighborhood -2019, accessed August 10, 2019.

16. "Report: University Heights & Fordham Face Biggest Displacement Threat in NYC," Welcome2TheBronx, https://www.welcome2thebronx.com/2019/04/29 /report-university-heights-fordham-face-biggest-displacement-threat-in-nyc/, accessed August 10, 2019.

17. Keiko Morris, "Silvercup Studios Buys Bronx Site; Production Company's Third New York Facility Will Be in Port Morris," *Wall Street Journal (Online),* July 6, 2015, http://search.proquest.com.ezp-prod1.hul.harvard.edu/docview/1693 574865?accountid=11311.

18. Sarika Gangar, "Bronx Readies for York Studios Opening," *Commercial Observer,* December 10, 2019, https://commercialobserver.com/2019/12/bronx-york -studios-opening/#slide4, accessed December 27, 2019.

19. See "Okwui Okpokwasili by Jenn Joy," *BOMB Magazine*, no. 137, September 15, 2016, https://bombmagazine.org/articles/okwui-okpokwasili/, accessed December 27, 2019.

20. Antwaun Sargent, "A Performance Artist Testing the Limits of Her Own Endurance," *New York Times Style Magazine*, August 7, 2019, ST3.

Being someone who is as allergic to writing almost anything about himself—in this, often meant to be the most personal part of a scholar's (first) book—it is a welcome relief to write here about the friends and colleagues who have meant a great deal to me during the course of this project and allow me to maintain the fiction that such writing is not revealing in its own right.

My indebtedness to my advisors is deep, abiding, and without hope of full restitution. Jennifer Roberts inspired me not just to think like a scholar of art, of history, and of literature, but to be certain to make ample time to see like one as well. The care that she demonstrated as a teacher, scholar, reader, and editor (all while serving as chair of American Studies) was remarkable, and I can only hope to match her generosity with students of my own. Luke Menand offered a model of concision that I continue to aspire toward. Glenda Carpio has shared with me her time as a brilliant reader and a patient listener at many different stages—of this project and of life—as well as provided an early, treasured opportunity to demonstrate my love for *Wild Style* in front of her class. And Werner Sollors has been there since the very beginning—not just with regard to this research, which he guided with gentle, always essential suggestions, but also at the first few moments of doctoral life. It was in his serene, warming tones that I was informed, via voicemail, of my admittance into the Program in the History of American Civilization (now American Studies) at Harvard University many years ago. And it would be in a succession of handsome and picturesque offices at Ca' Foscari University in Venice, Italy—so graciously offered by him and the incomparable Alide Cagidemetrio—and at Widener Library that large portions of this book were researched, written, and completed. The erudition and staggering output of his scholarship—even now in retirement—are both inspirational and intimidating, not to mention his turnaround time for dissertations, chapters, and graded essays, all of which constantly made me and others wonder if he had a twin toiling away in a no doubt well-appointed room somewhere.

Precisely because the road that brought me here has been long and frequently circuitous, I want to acknowledge the mentors who were there in the time before time: Cassandra Cleghorn, Grant Farred, E. J. Johnson, Michael J. Lewis, Amy Podmore and Frank Jackson, Shawn Rosenheim, and Shelley Salamensky all played tremendously important parts in mentoring and caring for what was then a young

mind, and I can't imagine making it this far without their early encouragement and support.

I am grateful to the faculty and staff of the (now) Program in American Studies and most of all, Arthur Patton-Hock, whose support, guidance, boisterous enthusiasm, and generous commiserating over many an issue during these years was always welcome, and without which I would not have made it to graduation some years ago. Before him, Christine McFadden offered hours of gentle counsel and a willing ear, and John Stauffer warmly welcomed me to the program. And because elements of this project began to take shape in many of the courses that I took, eventually taught, or whose syllabuses I merely admired from afar, thanks are due to Werner, Glenda, Luke, Jennifer, Vincent Brown, Joyce Chaplin, Lizabeth Cohen, Nancy Cott, Margaret Crawford, Henry Louis Gates, Jr., Walter Johnson, Robin Kelsey, Carrie Lambert-Beatty, and Rebecca Anne Sheehan, who provided models for teaching, for writing, and for scholarship. I owe much to the inspiring thinkers I befriended in graduate school, in particular Steven Brown, Shane Campbell-Staton, Kyle Gipson, Brian Goldstein and Theresa McCulla, Brian Goodman, David Kim, Liz Maynes-Aminzade, Sandy Placido, Evander Price, Kathryn Roberts, and Stephen Vider. Scott Poulson Bryant and Anthony Abraham Jack were always there to share a bench, their offhandedly brilliant observations, and too many jokes—most times, all three. I appreciate y'all.

I am greatly indebted to the Charles Warren Center for Studies in American History at Harvard University, where I spent the 2014–2015 academic year as a faulty fellow and where I completed much of the research for this book. Vince Brown and Glenda Carpio were codirectors of the Workshop on Multimedia History and Literature: New Directions in Scholarly Design, and it was in their weekly seminars, and over entertaining lunch conversations with Vivek Bald, Seth Fein, and Doug Seefeldt, that I developed the confidence to stay true to myself and to pursue exactly the kind of project of which I would be proud. I thank both Larissa Kennedy and Arthur Patton-Hock, in particular, for making my life easier at countless stressful junctures, but mostly for their relentlessly good cheer and calming conversation at all hours of the workday.

I am still amazed at having had the opportunity to work with a legend—urban or otherwise—in his own right: Lindsay Waters at Harvard University Press, who took an interest in this project early on, and his encouragement at every stage along the way meant more to me than perhaps he knows. Joy Deng has been a caring interlocutor, correspondent, and patient responder to every anxious question of mine, as she meticulously brought my manuscript across various finish lines. She deserves both my thanks and many apologies. Thanks also to Stephanie Vyce at Harvard, and especially to my anonymous readers, who offered countless critical insights and suggestions that helped make the book better than it had any right to be. Much of Chapter 4 was first published as "The South Bronx International: Fashion Moda between Site and Symbol," *ASAP/Journal* 2, no. 3 (2017): 603–626. I thank the journal editors for providing such targeted responses to my writing and ideas.

I've had the opportunity to present material from this book to audiences at conferences and venues across the country, but two overseas opportunities stand out in terms of giving new life and energy to the project: The Annual Conference of the

Historians in the German Association for American Studies funded a short lakeside stay in snowy Tutzing, Germany, in 2013, and more recently, the 2017 meeting of the American Comparative Literature Association in Utrecht, The Netherlands, helped to clarify the style and substance of the book's later chapters.

I have been fortunate to find a supportive network of colleagues across many different departments and programs at Bard College, particularly in Literature, American Studies, Africana Studies, and Environmental and Urban Studies. Over the past few years I've benefited immensely from the wisdom and mentorship of Christian Crouch, Michèle Dominy, Éric Trudel, and Marina van Zuylen, and from the support of the Dean of the College, Deirdre d'Albertis. I consider myself lucky to work alongside such fabulous Americanist colleagues in Literature, Alex Benson, Elizabeth Frank, and Matthew Mutter, and already in my time at Bard I have benefited from the kindness and insight of Myra Armstead, Katherine Boivin, Mary Caponegro, Maria Sachiko Cecire, Omar Cheta, Robert Cioffi and Lauren Curtis, Lauren Cornell, Adhaar Noor Desai, Eli Dueker, Tabetha Ewing, Donna Ford Grover, Tom Keenan, Alex Kitnick, Peter Klein, Marisa Libbon, Alison McKim, Dinaw Mengestu, Susan Merriam, Phil Pardi, Dina Ramadan, Miles Rodriguez, Susan Fox Rogers, Julia Rosenbaum, Nate Shockey, Drew Thompson, Olga Touloumi, Olga Voronina, Thomas Wild, and Tom Wolf. Teaching at Bard has informed the writing and research of this project in ways that I'm still discovering, so a good deal of thanks are due to my students as well.

I am grateful to the institutions that provided research and publication assistance over the years. A grant from the National Endowment for the Humanities allowed me to travel to Los Angeles to complete research for Chapter 6 of this book, and the Bard Research Fund supplied a crucial grant that supported the permission expenses that made possible the publication of this book with illustrations. My thanks to the anonymous reviewers at the NEH and to the Bard Research Fund, whose comments were especially helpful in fine-tuning the project at its late stages. I wish to thank (again) the Charles Warren Center for American History and the Real Estate Academic Initiative at Harvard, which provided crucial assistance early on in my career. I'm also grateful to the librarians at Widener Library, the Fine Arts Library, and the Loeb Design Library at Harvard. The research for this project would have been impossible without the assistance of Michael Lorenzini at the New York City Municipal Archives, who spent many an afternoon viewing photographs and deciphering mildly outdated technologies with me, and Ken Cobb, who handled my requests for image after image from their collection with grace and attention to detail. Renata Guttman at the Canadian Centre for Architecture provided hours of time alone with Gordon Matta-Clark's papers, drawings, photographs, films, and ephemera—and all within what is surely the most stylish archive in North America. Louise Hilton and the librarians and archivists in Special Collections at the Margaret Herrick Library at the Academy for Motion Picture Arts and Sciences are, almost to a fault, expert in their field, and kind to boot. I am especially thankful to Lisa Ballard at the Artists Rights Society, Rachel Liebling, The Estate of Gordon Matta-Clark, Marc Miller of Gallery 98, Ray Mortenson, the New York City Municipal Archives, and

Bernard Yenelouis at L. Parker Stephenson Photographs for their help in allowing this book to be published with illustrations.

To those writers, editors, critics, curators, artists, scholars, and creative folk who continue to inspire me, whose work or insight has challenged me or prompted extended reflection, whose humor or brilliance brought me through tough times, or who provided me with moments of joy while writing this book, whether fleeting or lasting, directly or indirectly: Edgar Arceneaux, Daniel Baker and Joel Martinez, Jon Caramanica, Kris Chen, Nate Chinen, Teju Cole, Amanda Dobbins, David Haglund, Matthew Hart, Arthur Jafa, Joshua Jelly-Schapiro, Ben Lerner, Philip Leventhal, Emily Lordi, Fred Moten, Piotr Orlov, Joseph Patel, Jana Prikryl, Maurice Q. Robinson, Carlo Rotella, Elihu Rubin, Nicole Rudick, Luc Sante, Greg Tate, Dave Tompkins, and Oliver Wang. This is also where I thank Eric Cantona and Sir Alex Ferguson. To Zach Baron, Tom Breihan, Ryan Dombal, Sean Fennessey, Chris Ryan, Nick Sylvester, and Jamin Warren: surely there exists a corner table at Odessa of the mind. I'll meet you all there. To Dennis Lim, Susie Linfield, Andrew O'Hehir, Ed Park, and the late Ellen Willis, my internal editors in perpetuity.

I have been fortunate to find a brilliant and supportive network of friends, readers, and occasional pick-and-roll offense partners who have sustained me throughout the last decade and more. The ways in which gentleman George Blaustein has offered friendship and French omelets in equal measure, as well as his ruthless eye for lean, lyrical prose—on the level of the sentence—is legendary. Brian Hochman has been, to me, a brother, hype man, three-point threat, and model scholar and father. Tim McGrath and I commuted to the same high school from opposite ends of New York for two years without knowing it, only to meet in Cambridge and become fast friends and footballing enemies—but only the best of both. With Brian and Laura McCammack I share a love of bourbon, Sunday evenings, and trivia, and for that I will always be grateful. Eli Cook, Nick Donofrio, and Jack Hamilton provided endlessly variable styles of humor, impassioned critique, and porous defense over the years, and for that my scoring average is also grateful. Derek Etkin, however, is a walking matchup headache; I look forward to strolling through Cambridge with him, Becca, Bianca, and Juniper sometime. Tenley Archer did not run with us during our nonexistent heyday, but that's because she's the only one who actually knows how to ball. And I would trust Verena von Pfetten to run point in any aspect of life. I considered Evan Kingsley and Eva Payne family long before I became an honorary, satellite member of theirs. And I'm sure Maggie Gram, who joins me in this familial troupe, will bring all of the world-aliveness that's humanly possible to bear toward our young charge.

In recent years, as the book took final shape, Katarina Burin, Dan Byers, Andy Graydon, Henriette Huldisch, Damon Krukowski, Matt Saunders, and Naomi Yang welcomed me into what felt like a real community, and I look forward to repaying their warmth and levity many times over. The same goes for Brigid Boyle, Barry Gross, Antonio Petrov, Patricia Sakata and Nick Follett, and Saif Vagh, who were the architects of enjoyable introductory years in Cambridge and Somerville. Liz Angowski, Leanna Barlow, Ty Davis, Heather Grant, Katie Kohn, Thomas Maffai, Carl Malm, Joanna Miller, Mathilde Montpetit, Ben Naddaff-Hafrey, Gregg Pee-

ples, Kip Richardson, Peter Tu, and Audrey A. White made living in a fishbowl for much too long enjoyable and entertaining. Giovanna Micconi, Ernie Mitchell, Ross Mulcare, Francesca Pangallo, Megan Rae, and the staff at Al Timon made a few consecutive summers in Venice more fun than teaching summer school has a right to be, and Peter Muñoz and Valentin von Arnim have shown greater hospitality to this Bronx boy while on foreign shores than he deserves.

I'm grateful to friends and family with whom I can pick up immediately where we left off, especially since I've spent much too long away from them writing this book. To Daniel Corry, Renata Verdelli Corry, Walker Waugh, Mary Dawson Waugh, Jed and Britta Mularski, Nick Waugh, Riley Bove, Kansas and Britney Waugh, Tyler Waugh, Maggie Clark and Trevor Babb, and Andre Mohr and Cynthia Yukari Mohr: one shouldn't have such excellent brothers and sisters. To Chico, Benedito, Alma, Henry, Zelda, Luca, Mazi, Bear, and Mila: I have so much to tell you about your parents. Bonnie and Donnie Clark, Nancy Hunt, and Curt and Shelley Waugh raised superlative children, all of whom I am lucky to have in my life. To "Miss" Emily Driscoll and the WORK Gallery: we miss you. Special thanks go to Janelle Bonet, Alexander L'Official, Joe and Viviana L'Official, and Dan Nicasio—the kind of family one is always happy to see. And one can't write a book about place and space without naming a few other deeply significant ones that sheltered me from the storms of writing: Shays, The Cellar (shouts to Quentin and Greg), The Bar at Rialto, Sarma, the old Holyoke Street Clover (shouts to Domingo), the B-Side, and to Via Carota. But who am I kidding? Shoutout to the BX—to Fordham, to University Heights, to Kingsbridge, and to Van Cortlandt Park—without which neither this book, nor this writer, would exist.

Neither would this book exist (cue "Leflaur Leflah Eshkoshka") without the influence, insights, and friendship of Hua Hsu, the first person I ever met with whom I share a birthday, and without whom I might not have considered applying to something called "AmCiv." It's rare in this racket to find folk one can vibe with, learn from, and laugh with even more heartily, and rarer still to find a job working just up the country road from them. Carol Wang is one of the few people to have photographed any such good cheer, and as the years go by I can already tell that I will be thankful that she did. And there is no way that I would have gotten this far—figuratively, literally, and emotionally—without the help, care, and deep wells of warmth and generosity of Sue DeGennaro and Tom Munsell, Carolyn Keating, and Marisol Marrero.

The final few pages of a book seem hardly sufficient to thank one's parents for a lifetime of love, support, humor, and help with my homework, but given that some of my most cherished memories of growing up are of spending entire weekends and summers with my mother and father reading—in the park, in bookstores, or at home—perhaps this is the perfect place. They gave me everything I needed, and much more than that.

To Sylvia Quiñones L'Official (1948–2017), who will not get to read these particular words, but whose voice and presence is behind every page of this book, and whose gentle, loving spirit will inspire everything that I am lucky enough to accomplish for the rest of my days: I love you and I miss you. Pops, it's up to us to keep the candle lit.

To Viva Anaís Sylvia, who one day may read these words, but likely at her father's annoying insistence: the world is yours. And finally, to Liz Munsell, who birthed her own beautiful book and a brilliant baby into the world—in the same year, like it ain't no thing—because she has all of the strength and passion and love in the world to give. Each day, I count myself eternally grateful that she chooses to share so much of that love with me, and I with her.

*Note:* Page numbers in *italics* indicate figures.

*Fort Apache: Life and Death in New York City's Most Violent Precinct* (memoir; Walker), 210, 216–217, 218, 220–221, 222–223, 233–236
Fort Apache Band, 237–239
*Fort Apache, The Bronx* (film; Petrie): history/descriptions, 16, 199, 202–225, 228, 231–233, 280n53; protest and lawsuits, 209–215, 233–236, 238. *See also* Committee Against Fort Apache
Forty-First Precinct, South Bronx: *Fort Apache* project portrayals, 205–206, 210, 216–224, 234; public sculpture, 135; station and "Fort Apache" naming, 200, 218, 220, 223, 278n7, 280n54
Foster, Hal, 53, 82, 85, 104
*Freshkill* (Matta-Clark), 55, 276n112
Fresh Kills landfill, 55–56, 184, 276nn111–112
*Fresh Widow* (Duchamp), 47
Fried, Joseph, 32
Friedberg, Anne, 50
Friedkin, William, 213
Friedrich, Otto, 257n30
Fuchs, Rudi, 124, 125–126, 127–128, 139
Futura 2000, 143

Garbage and sanitation. *See* Landfills; Municipal services; Waste management and elimination
*Garbage Wall* (Matta-Clark), 55
Generative metaphors, 21, 31
Genre films, 16, 199, 204–205, 235. *See also* Westerns (genre)
Gentrification and displacement, 245–247
Geography, personal, 173
Geography of the Bronx, 166; anti-abandonment interventions, 23–24, 32, 256–257n23; gentrification and displacement, 245–247; history, 17–18, 19, 24–25; population density, 19–20, 25, 252n2; representative regions, 202, 207, 249; roadways, 17, 102–103, 165–166, 172, 178. *See also* Charlotte Street; Space and place

Geologic processes and models, 122, 176, 179, 274n86
George, Nelson, 11
George Washington Bridge, 166
George Wilson (fictional character), 227–228
Gerena-Valentin, Gilberto, 202
Germany: art scenes and exhibitions, 15, 86, 124–128, 126, 136–144, 137, 268n50; post–World War II, 71, 96, 126, 259n50, 268n50
*The Get Down* (television program), 247–249
"Ghetto" tours, 175–176, 180, 201, 274n83
Gilligan, John, 242–243
*Glass Wine Bottles* (Blane), 140
Gleason, William, 225, 231
Gliedman, Anthony B., 40, 42–44, 47, 240, 257n27
Glier, Mike, 140
"Global Bronx" aesthetic and marketing, 15, 124–144
Goldstein, Richard, 209, 211–212
González, Andy, 237–238
Gonzalez, Evelyn, 20
González, Jerry, 237–238, 245
Goodden, Carol, 258n42
Google: privacy issues, 282–283n7; Street View, 241–244, 283n7
Gothic and the grotesque: in architecture, 168; in film, 224, 225, 226, 230; geographic details, 172; in literature, 15–16, 161–162, 167, 168, 169, 170, 171–172, 179–180, 183
Gould, Heywood, 216, 217, 218, 221, 222, 234
Government communications: data collection and sharing, 88; housing and urban development, 2, 3, 6, 230
Government photography and documentation, 14–15, 72–123, 255n1
Grace, Claire, 53
Graffiti: art and writers, 15, 124, 130, 132, 134, 143–144, 240, 248, 282n6; as language/literature, 144, 150, 185, 248–249; in literature, 185; styles and critique, 144, 269n67, 277n114

13, 19, 24–27, 30, 75, 173; symbolic images, 13, 19, 32, *73*, 74–75, 77, 119–122. *See also* Abandoned buildings and abandonment; Occupied Look and decorative seal program; Residents, Bronx

Residents, Bronx: arts subjects and viewership, 61–62, 88–89, 135, 141, 142–143, 260n62, 265n63; despite/amid "abandonment," 19, 20, 22, 23, 25–27, 28, 32–33, 38, 43–44, 46, 47–49, 50, 77, 82, 91–94, 110–111, 119, 122, 142–143, 147, 188, 191; film portrayals and stereotypes, 200, 203, 204, 212–215, 221–222, 224–225; history, 19–21, 28; identities, 10, 11, 28–29, 135, 248; interviews/reports, 28–29, 181, 182, 188; literary portrayals and stereotypes, 156, 160–161, 167–168, 171, 174–175, 180, 186–187, 188, 189–192, 193–197; media portrayals' effects on people and neighborhoods, 7, 10–11, 163, 174–175, 187–188, 209–210, 214, 224–225; population density, 19–20, 25, 75, 252n2; visibility and erasure, 32–33, 61, 88–89, 91, 221–222; visual narratives and documentation, 14–15, 76–77, 82, 88–96, *89, 90, 93, 95,* 110–111, 112, 135. *See also* Neighborhoods, South Bronx; Residential buildings

Reyes, Francisco, II, 238
Richards, Martin, 234
Rickard, Doug, 243–244
Rickey, Carrie, 132, 212, 221–222, 229, 231
Right to privacy, 282–283n7
Rivera, José, 209–210
*The River Is Deep* (Fort Apache Band), 238
Roads. *See* Streets, conditions; Transportation infrastructure
Robert, Hubert, 75, 83
Rodriguez, Abraham, Jr., 15, 152–153, 154, 157, 159, 187–197, 247
Rodriguez, Robert, 189
Rollins, Bryant, 254n24
Rollins, Tim, 132
Root, Elihu, 19
Rose, Tricia, 11, 198

Rosenblum, Walter, 105
Rossi, Andrew, 247
Rudin, Seymour, 226
Ruff, Thomas, 86
Ruin. *See* Blight; Urban decline and decay
Rupp, Christy, 53, 134, 140
Ruscha, Ed, 83, 85–86, 87, 117–118
Rushdie, Salman, 270n4

Sanitation. *See* Municipal services; Streets, conditions; Waste processes
Sarcey, Francisque, 234
Satire: literary arguments, 146–149; novels, 156, 158
*Scènes à faire,* 234–236
Schanberg, Sidney, 226
Scharf, Kenny, 140
Schieffer, Bob, 6
Schivelbusch, Wolfgang, 71, 74–75, 96, 108
Schön, Donald, 21–22, 31, 251n11
Schott, Arthur, 94
Scott, William, 132
Scrappers, scavengers, and salvage, 28, 41, 55, 185, 200
Sculpture and installations: architectural, *58, 59, 60,* 62, 122, 260n62; event/performance art, 54–55, 244; life casts, 135; readymades, 47
Sealing, buildings: "aesthetic boarding," 69–70; Occupied Look program, 42, 43, 46, 67, 166, 196, 239
Seals, decorative. *See* Occupied Look and decorative seal program
Senator Ransom Stoddard (film character), 7, 281n61
*Serenade* (Cain), 234–235
Serra, Richard, 62, 260n62
Services, residential. *See* Landlords and tenant services; Municipal services
*7000 Oaks* (Beuys), 138
"Shadow archives," 12–13
Shannon, Joshua, 84, 91
Sherman McCoy (literary character), 155–156, 161, 162, 163–165, 166–168, 169, 170, 171–172, 186, 195
Silvercup Studios, 246–247